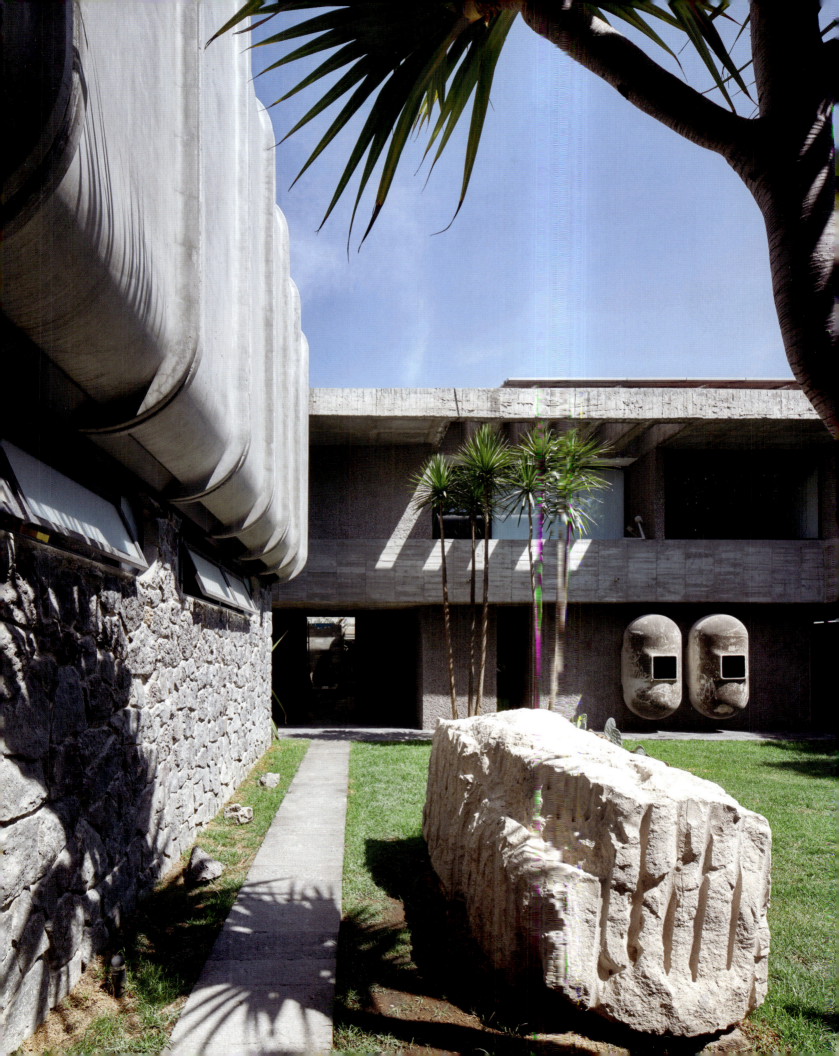

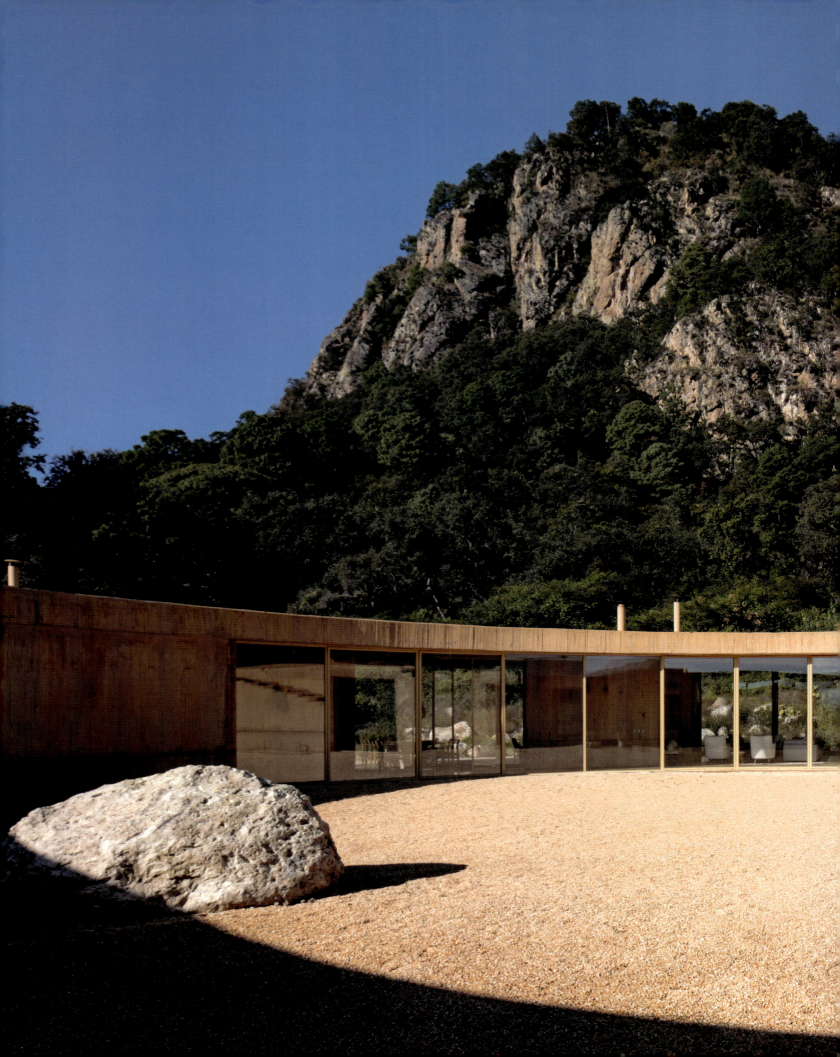

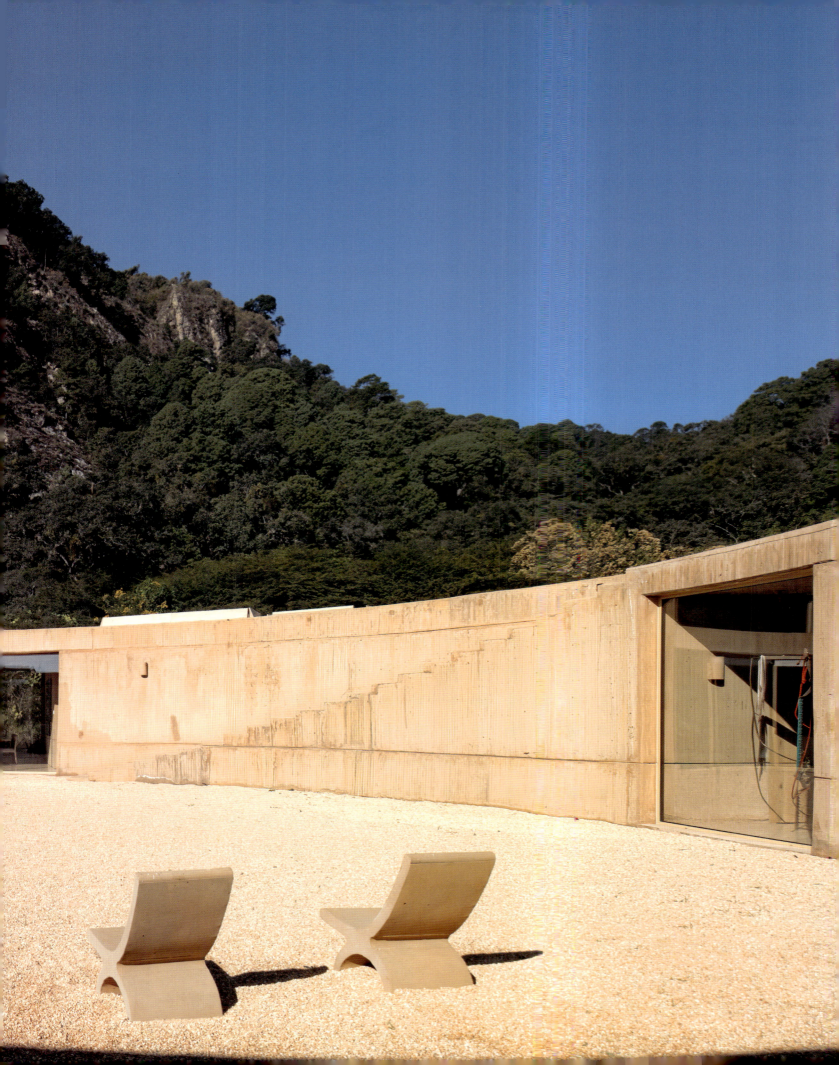

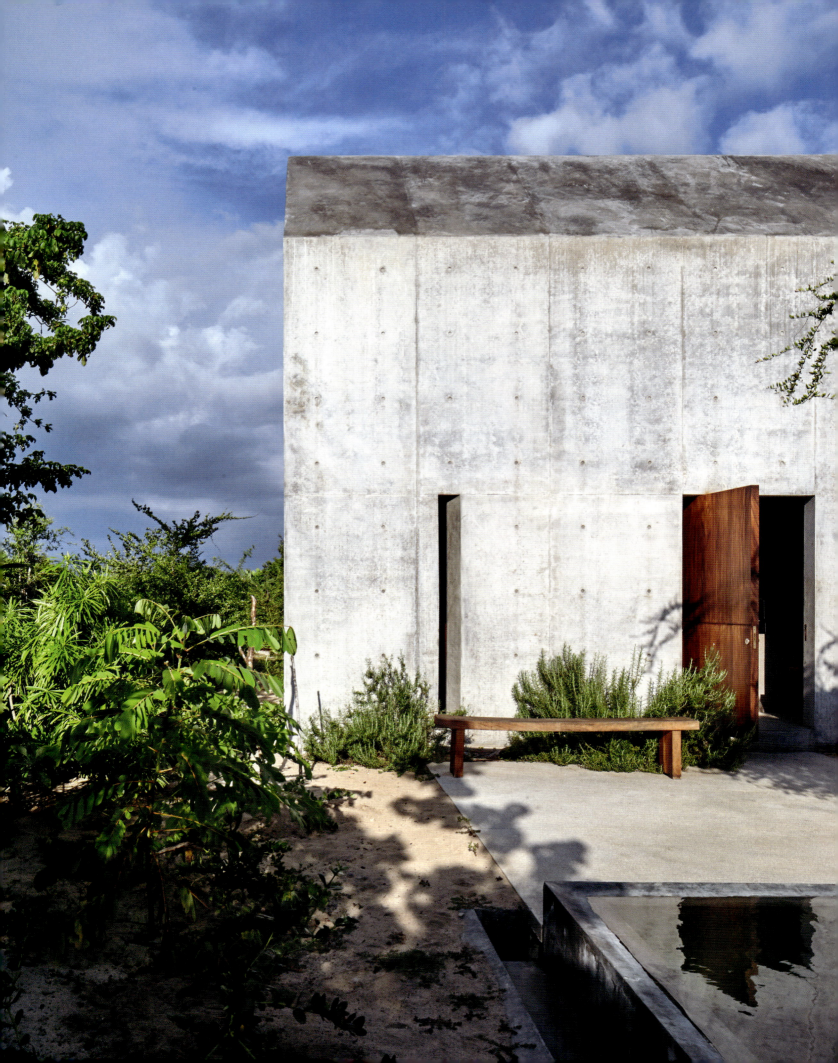

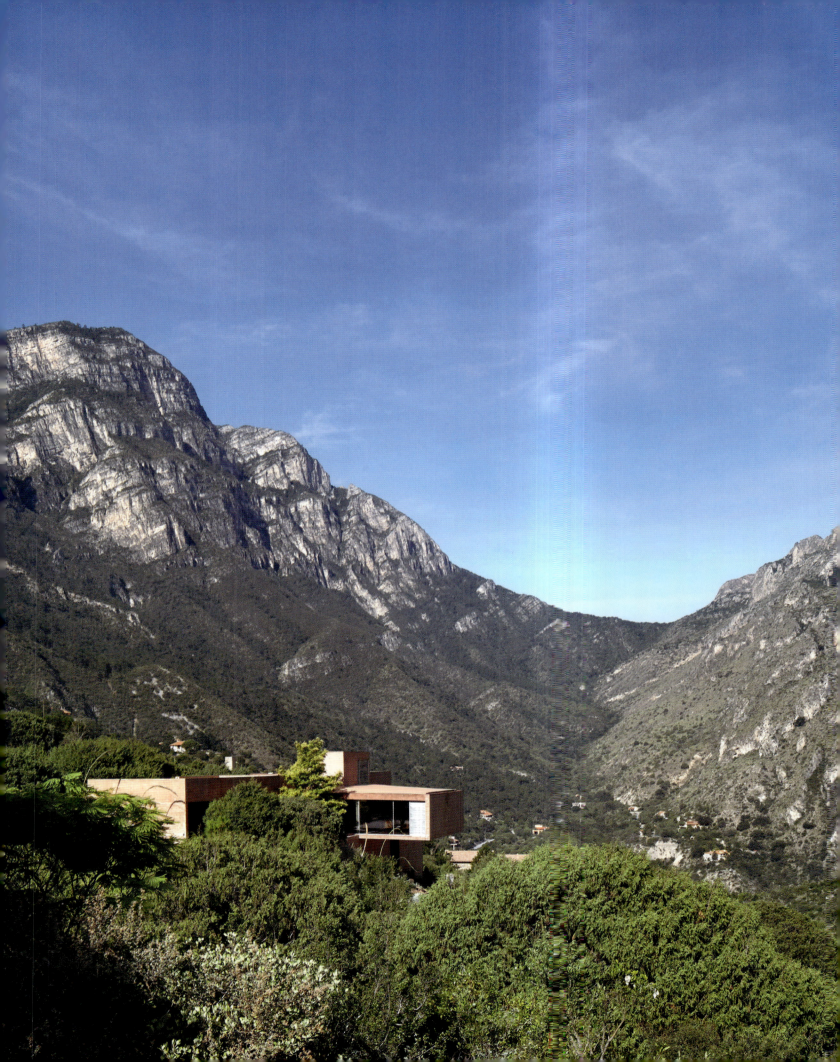

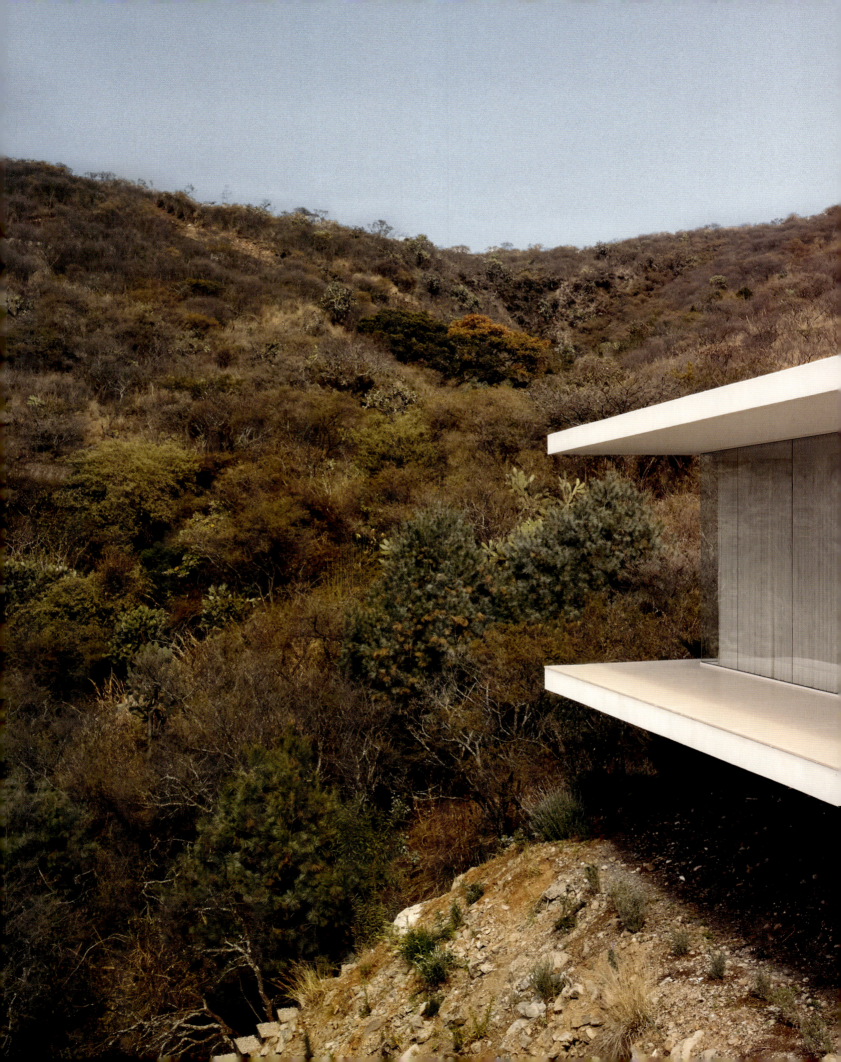

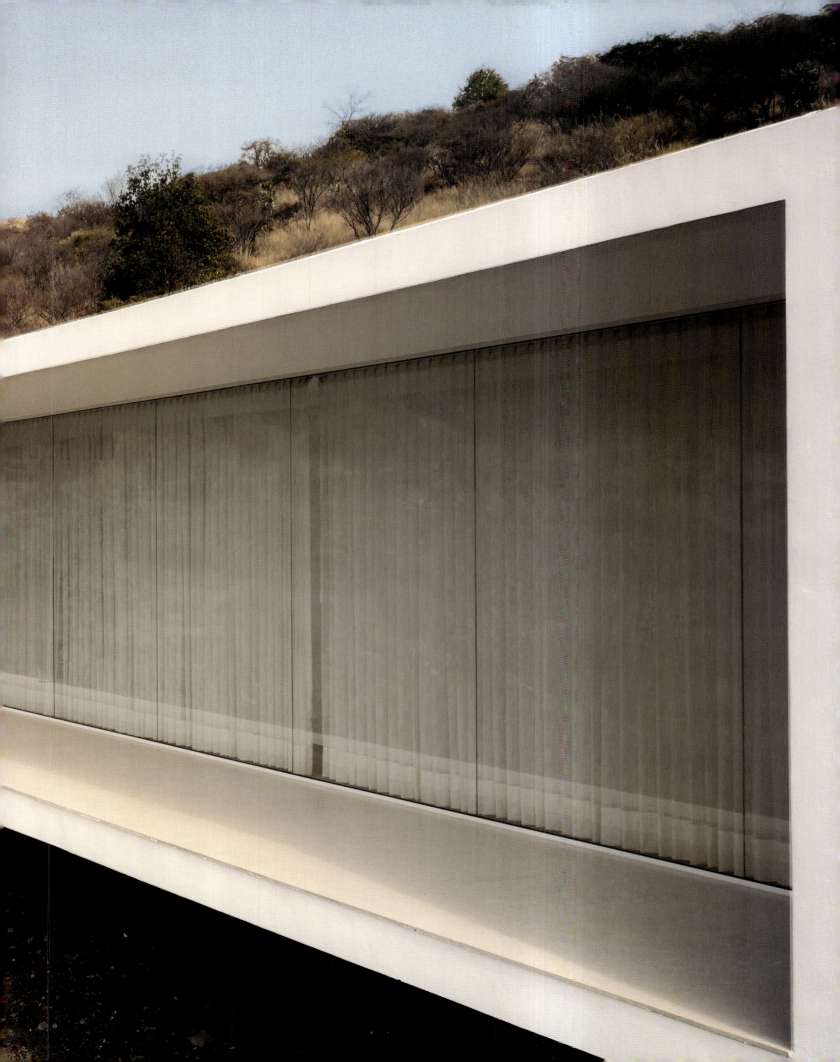

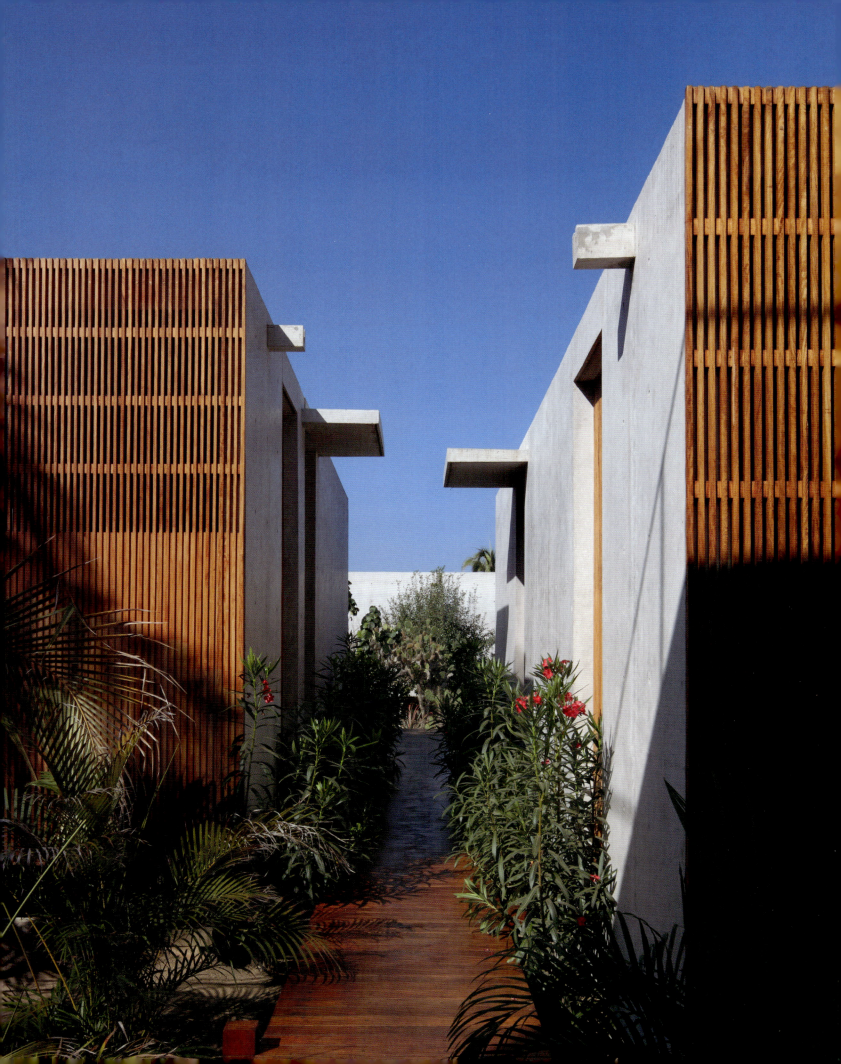

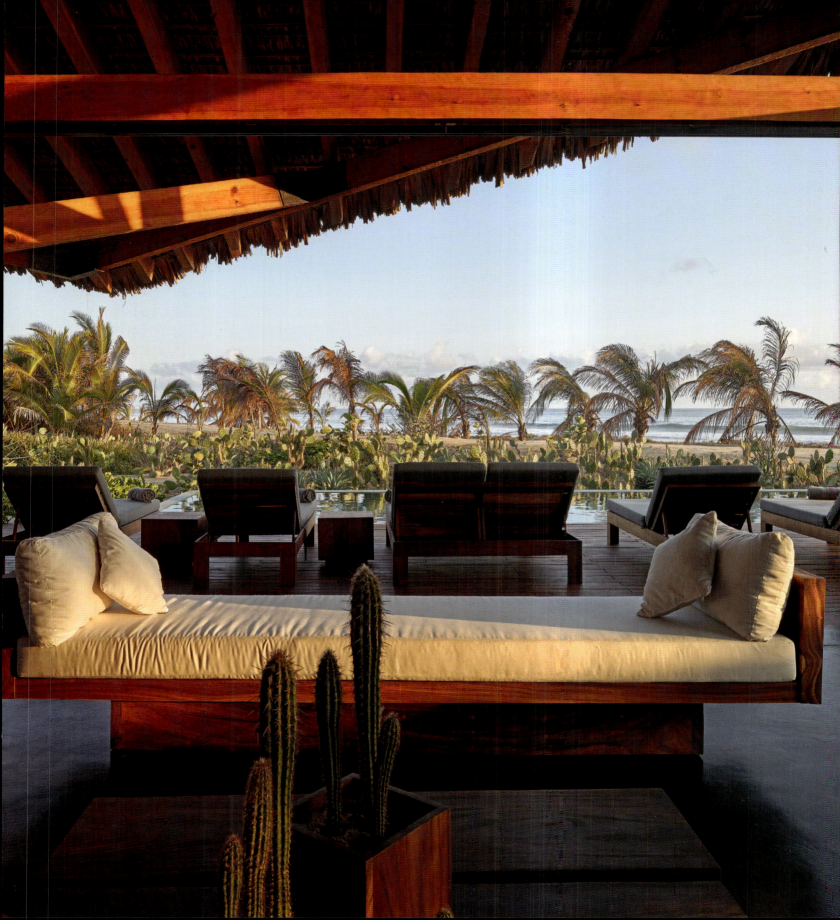

Written by
Jonathan Bell

Photography by
Edmund Sumner

With over 320 illustrations

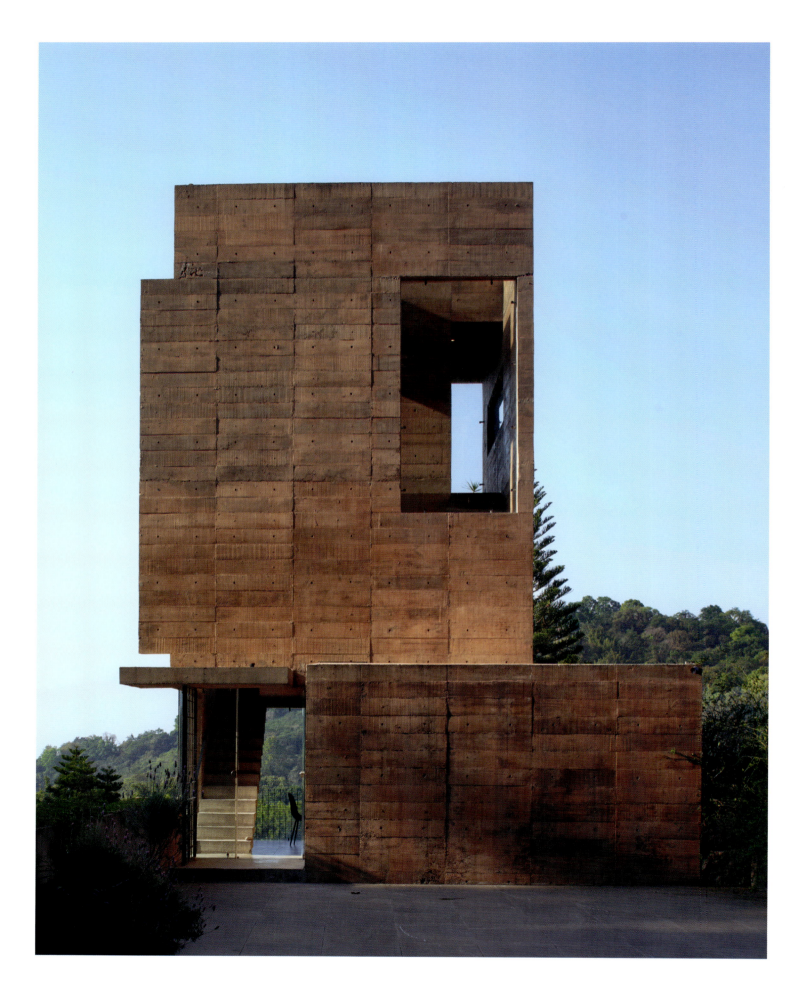

014 **WHAT MAKES A HOUSE MEXICAN?** Fernanda Canales
016 **THE MODERN HOUSE IN MEXICO**

CREATIVE SPACES
020

024 **CASA WABI** Tadao Ando Architect & Associates
036 **PLANTEL MATILDE** Fundación Javier Marín
046 **CASA REYES** Pedro Reyes, Carla Fernández
058 **CASA ESTUDIO** Manuel Cervantes Estudio
068 **CASA SANJE** Ludwig Godefroy
076 **CASA TERRENO** Fernanda Canales Arquitectura

EXPERIMENTAL STRUCTURES
086

090 **CASA TINY** Aranza de Ariño
100 **CASA HMZ** Lucio Muniain et al
110 **ZONCUANTLA APARTMENTS** Rafael Pardo Arquitectos
122 **THE HILL IN FRONT OF THE GLEN** HW Studio
130 **CASA 720** Fernanda Canales Arquitectura
140 **CASA ALFÉREZ** Ludwig Godefroy
150 **CASA NARIGUA** P+0 Arquitectura

ARCHITECTURAL RETREATS
160

164 **CASA NAILA** BAAQ'
174 **CASA CATARINA** Héctor Barroso
184 **CASA COMETA** Taller de Arquitectura Mauricio Rocha + Gabriela Carrillo
196 **CASA VOLTA** Ambrosi Etchegaray
206 **PUNTA PAJAROS** Alberto Kalach / T.A.X.
212 **CASA CARRIZO** BAAQ'
222 **SAN BRUNO BEACH HOUSE** Reyes Ríos + Larraín Arquitectos
232 **CASA LERIA** TAC

FAMILY HOUSES
240

244 **CASA KEM** Gantous Arquitectos
256 **CASA MULA DE SEISES** Gantous Arquitectos
266 **CASA SHI** HW Studio
278 **CASA DECO** Reyes Ríos + Larraín Arquitectos
288 **CASA MO** Lucio Muniain et al

298 Architect Biographies
300 Project Credits
302 Directory

WHAT MAKES A HOUSE MEXICAN?

This question became a fundamental political dispute after the Mexican Revolution (1910–20), when a new modern nation was to be built as an independent country born out of the Spanish and the indigenous past, simultaneously old and new, American, Latin, pre-Hispanic and in many ways even Mediterranean. Mexican architecture reflects the nature of one of the most biodiverse countries in the world, where more than 60 indigenous languages are still spoken today. Like the country's culture and geography, Mexico's architecture is colourful, vigorous, generous and rich in contrasts. The Mexican house embodies this blend of traditions: it is a reinterpretation of the living rooms of colonial convents, Aztec and Mayan courtyards, hacienda terraces, Islamic balconies, Native American wooden lodges, Le Corbusier's Villa Savoye, Frank Lloyd Wright's Fallingwater, the Bauhaus and the adobe constructions of pueblos. Today, the Mexican house is all of this plus Luis Barragán, Frida Kahlo, Tadao Ando, Instagram and Pinterest images, and earth constructions.

How can a handful of generic elements — roofs, walls, floors, doors and windows — that are employed in every house in the world suddenly define the identity of a place and its inhabitants, and differ from any other existing house? Architecture has the miraculous potential to allow dialogues to be established between different authors, times and territories. It can simultaneously be part of a universal history and construct a sense of identity capable of defining a nation. Similar to the artistic expressions and the gastronomy of a country, architecture is embedded in what characterizes a place, its people and their history. Furthermore, it represents their dreams.

To talk about the particularities that define the architecture of a country is to speak about spirit, not about shapes, materials or colours. This is what differentiates the caricaturized versions of any country's architecture and the deeply rooted, profoundly provocative and ungraspable, almost hidden, virtues that represent each local spirit. Mexican architecture is characterized by its free spirit, bold solutions and irreverent responses in a country where everything is possible.

A synonym for experimentation, Mexican architecture manifests itself in daring sculptural staircases, Brutalist volumes and rough textures, possibly thanks to the benevolent climate, local craft and wide variety of materials. The combination of robust pink walls, sleek white surfaces, handwoven straw roofs, irregular wooden pillars, torn bricks, hand-cut stone, terracotta puzzles, metal and reed grass is enriched with the use of lattices, pools and terraces. Architecture, no matter the size of the buildings, extends towards the outside and becomes a landscape.

Through Edmund Sumner's gaze, this book is evidence that creativity and improvised solutions are part of daily life in Mexico. Edmund eloquently represents the challenging volumes that interact in surprising ways with their surroundings. His images reflect the sense that everything is yet to be built in Mexico. Beaches, forests, mountains, historical cities and deserts are transformed by the inventiveness of architects who reinterpret local conditions filled with divergent histories. These environments are also transformed through the foreign view, by such photographers as Hugo Brehme and Esther Born, and architectural historian Esther McCoy, who, in the twentieth century, provided a new definition of the local, changing the meaning of the Mexican house to allow it to be endlessly rewritten.

Fernanda Canales

Right:
View from the courtyard at Casa 720.

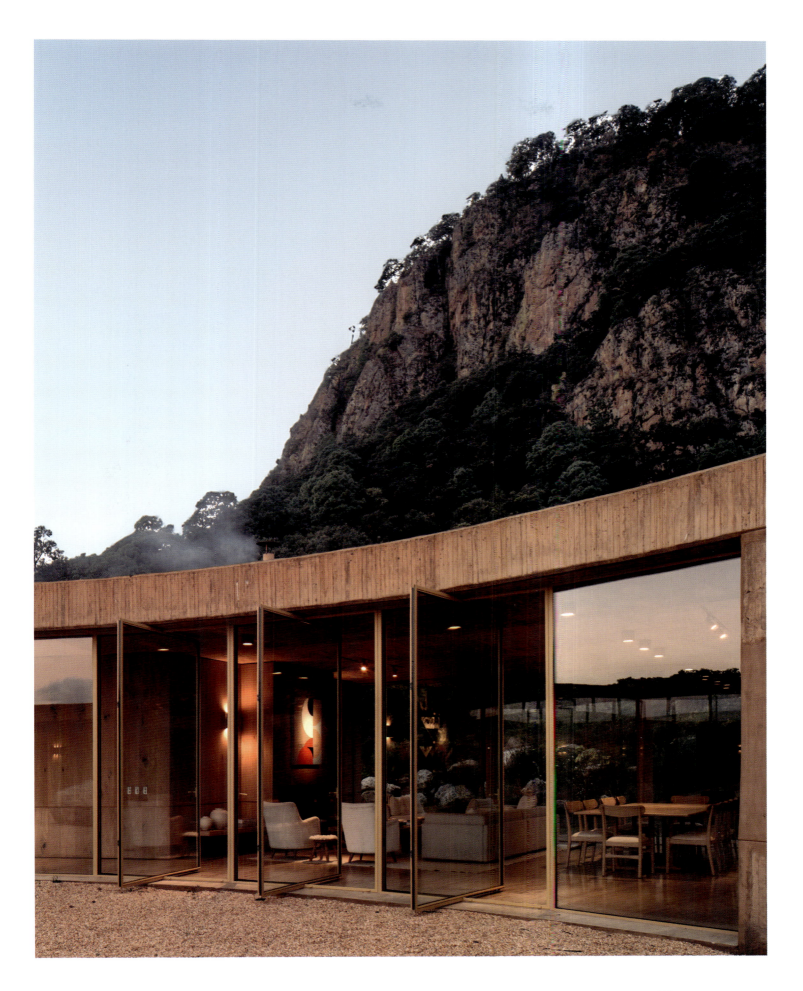

016 Introduction

THE MODERN HOUSE IN MEXICO:

Architectural and Aesthetic Exploration

Left:
Alongside traditional methods of construction, Tadao Ando incorporated his signature concrete into Casa Wabi.

Mexico's modern architecture is as diverse and varied as any country's in the world. A survey of just one facet of recent built work cannot hope to be comprehensive or al-encompassing. But as these residential projects illustrate, through a rich collection of forms, materials, locations, budgets and briefs, innovation and experimentation remain an inherent component of contemporary Mexican practice.

The case for a clearly defined 'national' architecture has never been weaker in this pluralistic age, yet there are certain shared values that thread through these projects, all contemporary houses built within the last decade and chronicled by the London-based photographer Edmund Sumner. They show a country of contrasts, a place where the juxtaposition of wealth and poverty is often uncomfortably stark, and where architecture can serve contradictory causes.

It is worth rewinding to the dawn of Mexico's modern era, to the period of revolution that shaped the country as we know it today. The Mexican Revolution, a decade of upheaval and change from 1910 to 1920, was bloody and hard fought but it

transformed the country's politics and outlook. The new constitution of 1917 acknowledged the need for wide social and economic reform, as well as establishing a baseline of workers' rights that raised expectations and awareness. In the century that followed, Mexican politics and society has spun this way and that, with progress frequently buffeted by corruption, the corrosive impact of the drugs trade, and the economic and cultural push and pull that comes from a long and often contentious border with the USA.

Like that other nexus of early twentieth-century revolution, the Soviet Union, Mexico saw a huge cultural fallout spread across the visual arts and architecture. As one of the earliest countries to absorb the tenets and strictures of the Modern Movement, a quirk of timing and geography, architecture and radicalism learned to co-exist. The colonial era had been physically embodied in the Neoclassical architecture imported from Europe and for many, change and upheaval could not come quickly enough. Yet even progressive and powerful political leaders like José Vasconcelos (1882–1959), the Minister for Education in the early 1920s, focused their revolutionary fervour on the visual arts, most notably the work of muralists like José Clemente Orozco (1883–1949), David Alfaro Siqueiros (1896–1974), and of course Diego Rivera (1886–1957), rather than architecture.

Architecture's close connections with the European and American avant-garde helped spur change in the built environment. Initially, a form of stripped, Deco-esque classicism had found official favour, but gradually a new Mexican functionalism emerged. Pioneering structures, like the house and studio designed for Rivera and Frida Kahlo by Juan O'Gorman (1905–1982) in 1932, were a high-profile synergy of principled artistry and innovative technology. Notably, the Rivera–Kahlo house used colour as an integral part of its composition, much in the same way that many early European modern architects had done. Some of the most defining works of twentieth-century Mexican architecture use colour in a bold, definitive way, especially that of Luis Barragán (1902–1988), widely promulgated in the digital era.

The relative absence of polychromatic expression in the projects in this book signals yet another shift, this time towards materiality. The country's role as an early adopter of Modernism was not accompanied by the industrial and state-driven economic booms seen in Europe and the USA. Instead, evolution was slow and pragmatic, eschewing the more structurally elaborate and audacious

Mexico is a country of contrasts into which comes this new architecture determined to find a path through the country's maze of contradictions.

> Like all countries where Modernism found a welcome home, Mexico displays a massive range of architectural ambition, from the strictly functional to the unattainably aspirational.

forms of American and Brazilian Modernism. It is this pragmatism that has survived to the present day, a culture of doing more with less, adapting, reusing and working with local materials and techniques, all the while striving for a different sort of minimalism. Environmental concerns have been brought to the fore, as has local sourcing of labour and materials.

This does not always result in a modesty of scale – many of the houses in this book are substantial – but there are clear lineages that often go back to pre-colonial times. The use of palm-leaf-based chukum stucco, wooden shutters, hardwood finishes and naturally tinted render and concrete all serve to ground these works in time and place.

This book is also a chronicle of topographical variety. Mexico's expansive countryside and nearly 9,300 kilometres (5,800 miles) of coastline (nearly 80% of which faces the Pacific) runs through many biomes, from lush jungle to arid desert to coastal dunes. Then there are the cities, and the many flavours of urbanism ranging from concentrated city blocks to suburban sprawl. In all these situations, a house's relationship to its site depends on many facets of its environment. Is a house a withdrawn, shuttered enclosure, an open celebration and embrace of landscape, or a statement of pride and status?

As the projects here prove, some houses can simultaneously be all three. For ease of navigation, we have grouped the works into four categories, starting with a chronicle of the close relationship between contemporary art and architecture that began with the era of the muralists and continues to this day. The section on experimental structures explores the opportunities that come from the interaction of programme, design, and Mexico's varied climate and topography, while a focus on a disparate collection of architectural retreats and another on family houses reiterate the sheer diversity on display.

Mexico is a country of contrasts, a land where luxury beach resorts co-exist with narco-states, where extreme poverty abuts generational wealth, the latter often barricaded against the animus of the former. Into this dichotomy-strewn landscape comes this new architecture, often practised by young architects determined to find a path through the country's maze of contradictions.

Like all countries where Modernism found a welcome home, Mexico displays a massive range of architectural ambition, from the strictly functional to the unattainably aspirational. These modern houses are where it all comes together, the culmination of a century of social upheaval colliding with the constantly shifting histories of architectural ethics, aesthetics and technologies, all wrapped up in the hopes and successes of a new generation of architects and clients.

CREATIVE SPACES

Spaces shaped for art and design bring with them a unique set of challenges, not least the tyranny of a free and open brief when creating your own personal studio. The projects in this section are a combination of self-directed work by architects and artists, and studio spaces designed explicitly for a specific creative. There are no rights or wrongs when working on such a particular and bespoke architectural challenge, but Mexico's association with unique studios and live-work spaces can be traced back to Juan O'Gorman's house and studio for the painters Frida Kahlo and Diego Rivera, completed in 1932. Modernism's legacy of rigour and simplicity became a more expressive seam of creativity, one that continues to be mined today.

Right:
A sculpture studio in the annexe to Casa Reyes.

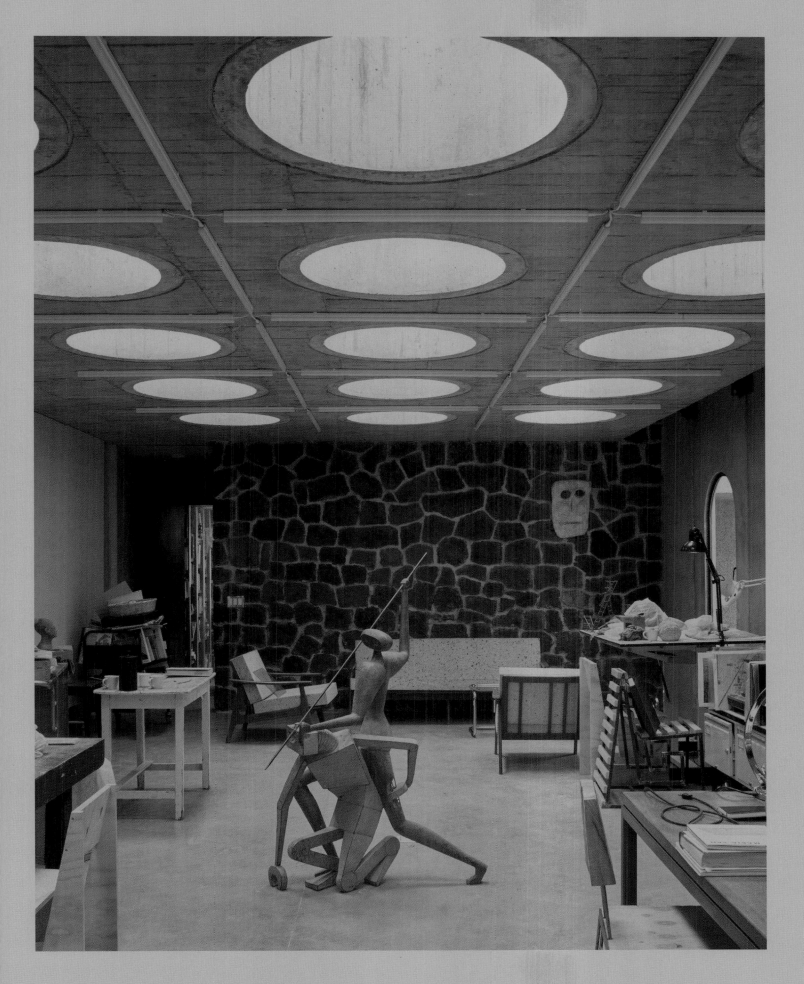

CASA WABI

Location: Puerto Escondido, Oaxaca
Architect: Tadao Ando Architect & Associates

Casa Wabi is a sprawling arts complex that embraces the raw power of the Oaxaca coast. Designed by Japanese architect Tadao Ando in close collaboration with his client, Mexican artist Bosco Sodi, and with local developers and design studio BAAQ', the complex serves as a residence, studio and retreat. This is a self-contained encampment, a place for artists to engage with the landscape of ocean, beach and sky, as well as a site for community outreach, all surrounded by 30 hectares (74 acres) of newly planted local vegetation, including a plantation of guayacan trees, along with figs, palms and the vivid red tabachin, or flame tree. The landscaping was overseen by Mexican architect Alberto Kalach, whose own coastal resort, the ultra-low-energy and minimal Punta Pajaros (see page 206) is located just down the coast (as is Aranza de Ariño's Casa Tiny, see page 090).

The Bosco Sodi studio and house lies at the heart of the scheme, which runs along 550 metres (1,800 feet) of coastline and is bordered by the Pacific Ocean to the south. Ando has chosen to emphasize this frontage with a characteristic architectural device: a concrete wall that extends 312 metres (1,024 feet) across the site, located 150 metres (492 feet) from high tide. The 3.6-metre-high (12 feet) wall 'creates the horizontal separation between the public programmes on the north side and private programmes on the south side,' according to Ando's studio, as well as generating 'the main circulation path [that cuts] across every programme by serving as a dual interior and exterior wall.'

The main villa lies at the centre of this coastal wall, with its traditional palapa roof viewed above the concrete. This has a large open-plan kitchen, dining and living area at its heart, open to the elements, with the principal bedrooms contained within triangular-shaped forms that direct views outward to the horizon. Set alongside this main villa are six smaller villas, designed for both guests and artists in residence. The site is also scattered with works by other notable architects, all downplaying their signature approach to match the low-key modesty of the local vernacular. These include veteran Portuguese architect Álvaro Siza's pavilion for hosting pottery workshops, a tree nursery by Ambrosi Etchegaray (whose Casa Volta, see page 196, is located nearby), a hen house by Kengo Kuma, and other works by Sodi himself, with more to come.

Regardless of this architectural diversity, Ando remains the star. His site-defining wall exists as a canvas for the shifting light, with the fiery sunsets transforming the concrete into an approximation of Sodi's own vivid canvases. Sodi can also work from a studio on the site, located on the southeast end of the long wall; on the northeast side it is complemented by a large gallery space (the only structure in the whole complex to have conventional glass windows). Ando describes the complex as a 'very unique project,' thanks to both the scope of the brief and the 'use of various uncommon materials [that allowed] me to create architecture and spaces that could not be created anywhere other than in this specifc location.'

Right:
The Bosco Sodi studio, with the observatory building in the distance.

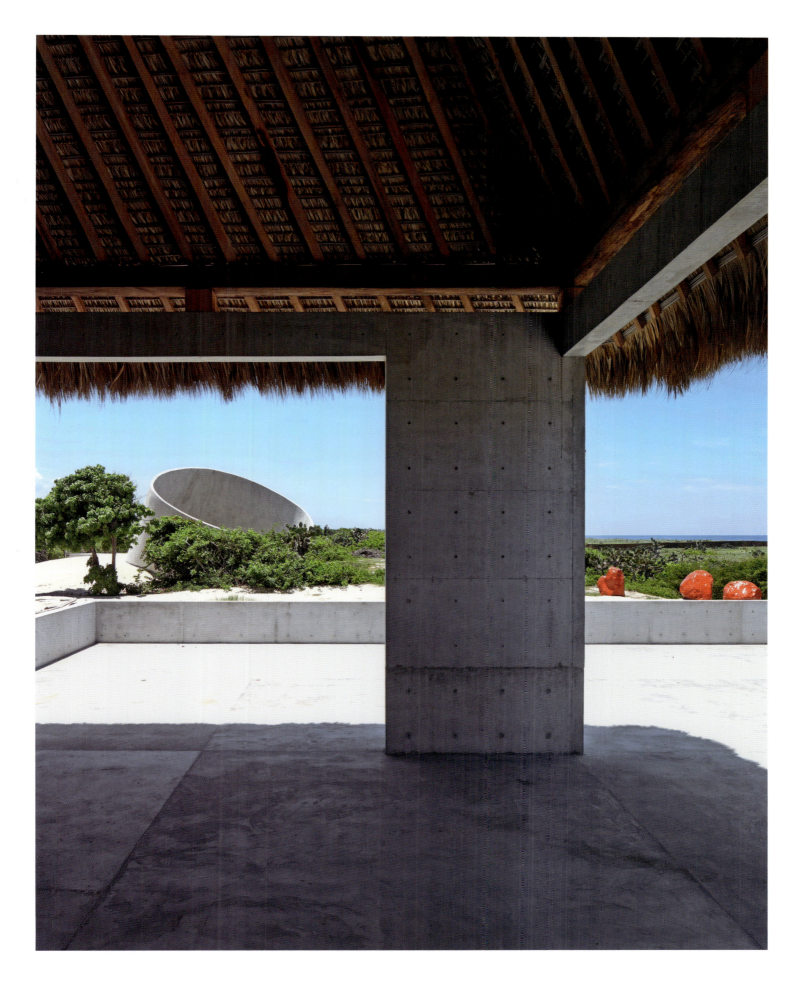

Casa Wabi 025

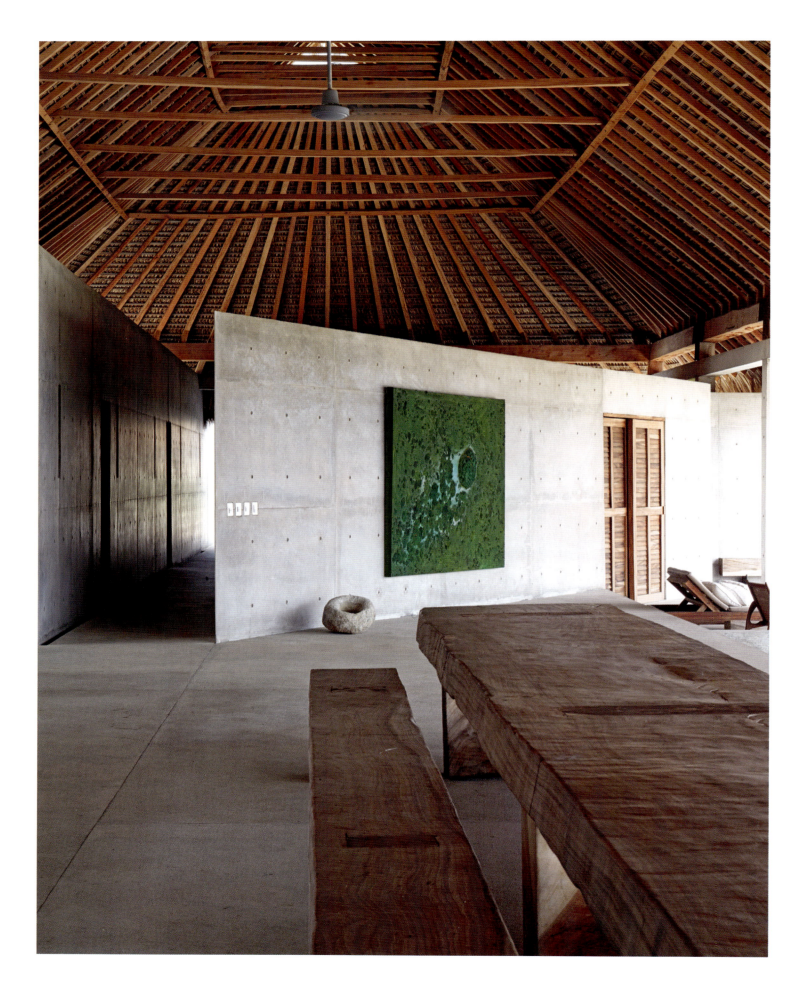

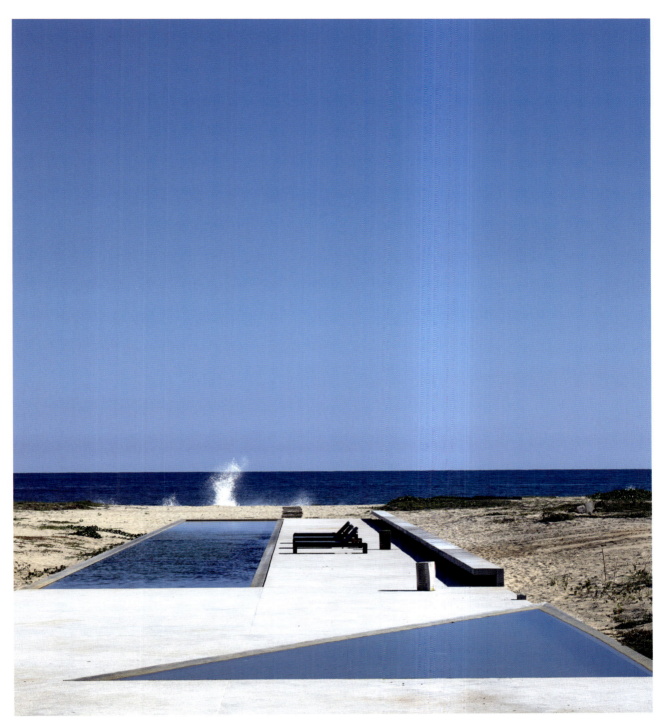

Above:
The pool with the Pacific
Ocean beyond.

Left:
The main living space
is a modern iteration
of a traditional palapa
structure.

Casa Wabi 027

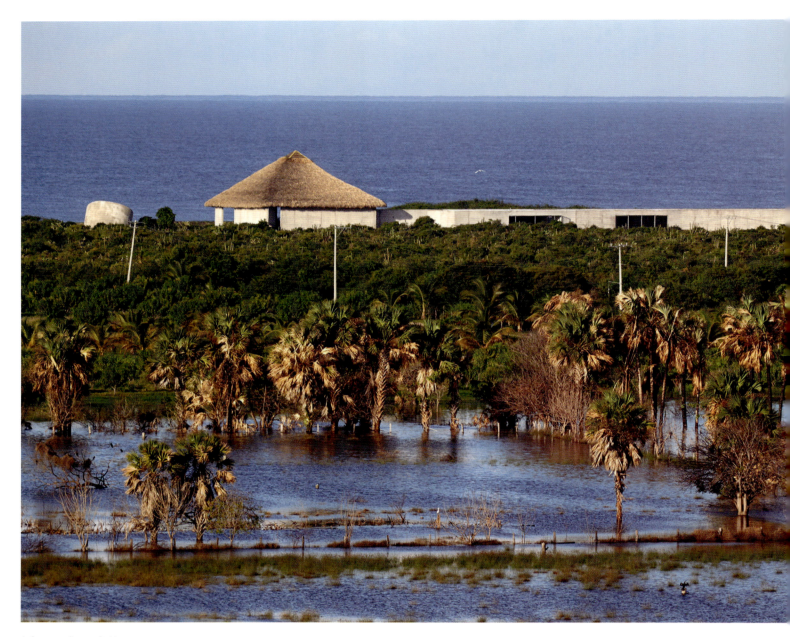

A long view of the oceanfront site, showing Ando's meticulous concrete finish with a traditional roof structure.

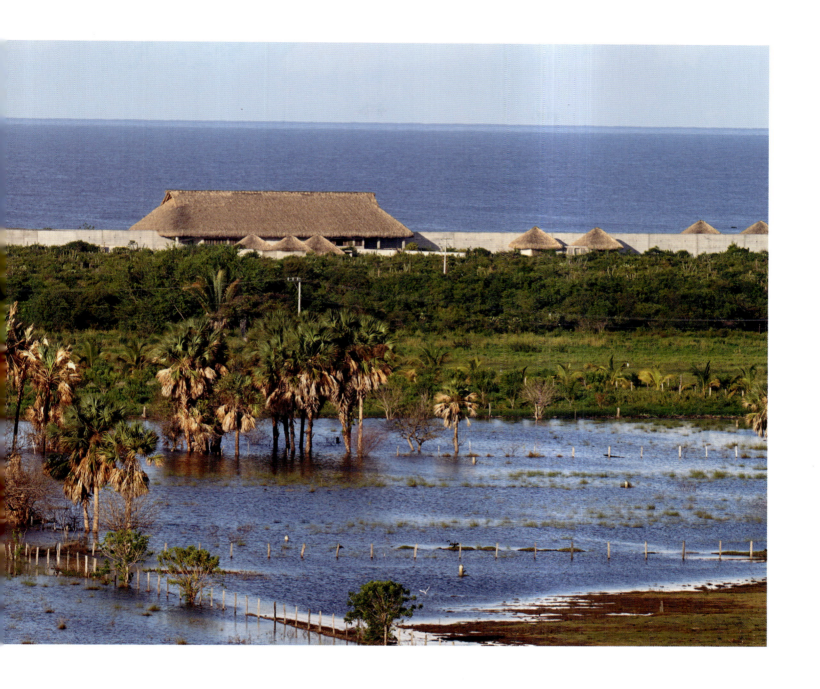

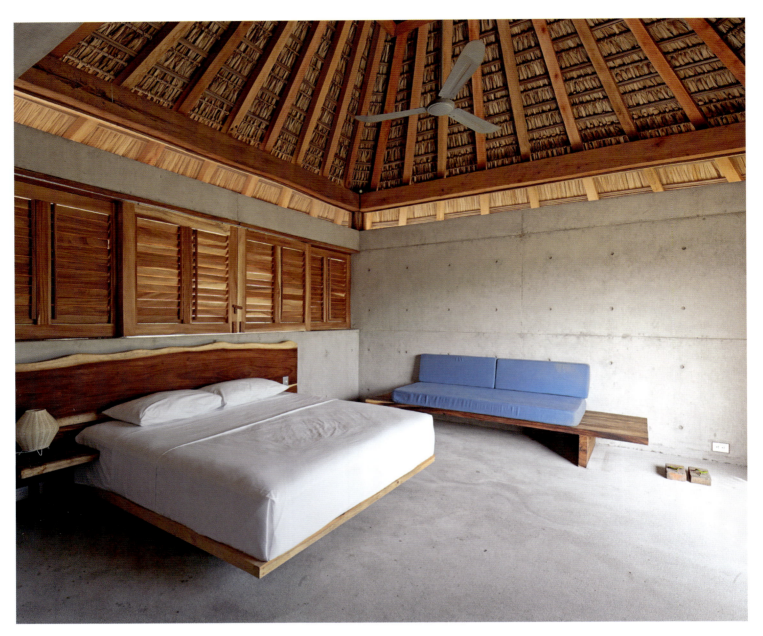

Above:
Artist's bedroom in
Casa Wabi's residence.

Right:
A view down the external
corridor of the complex.

030　　　Creative Spaces

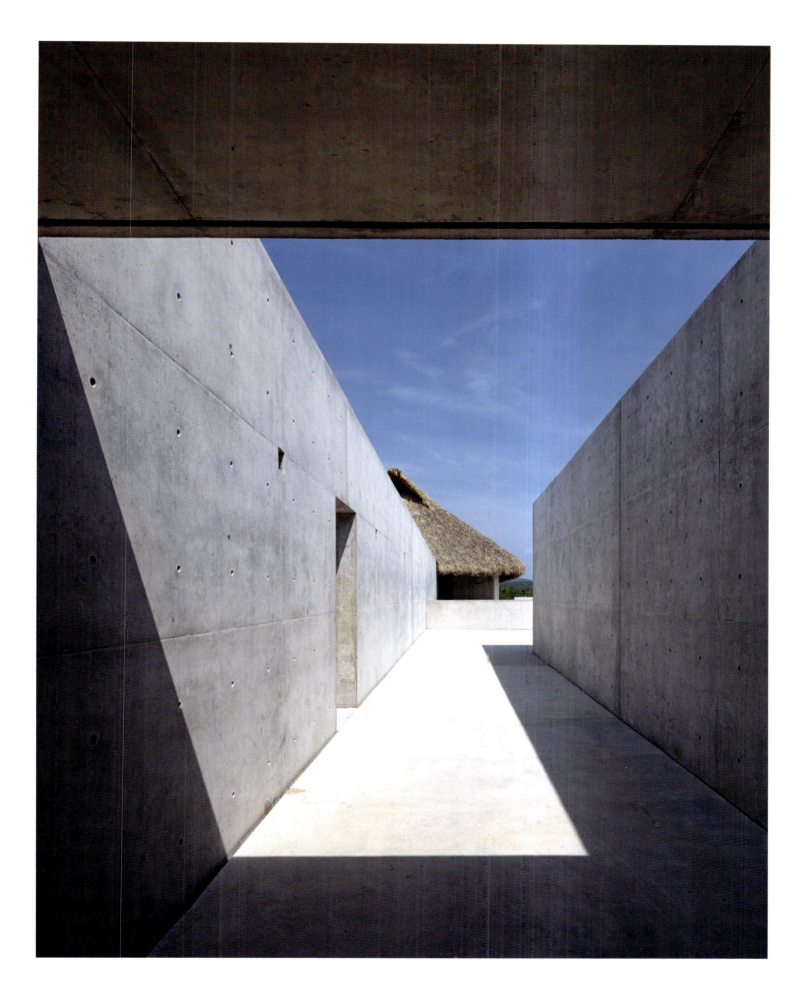

Casa Wabi 031

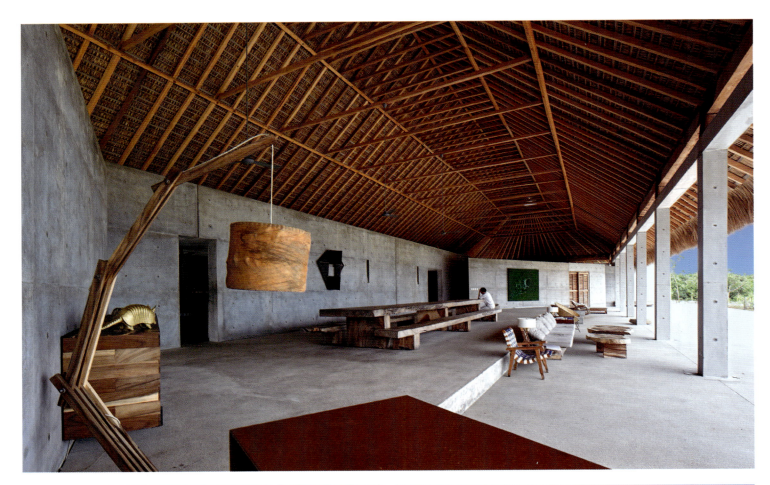

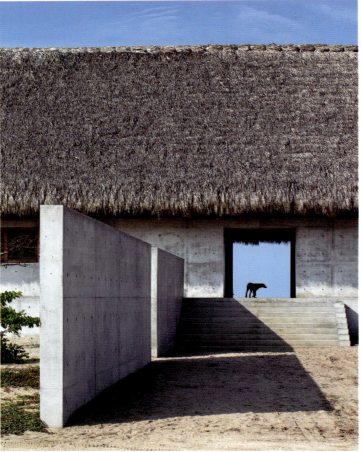

Creative Spaces

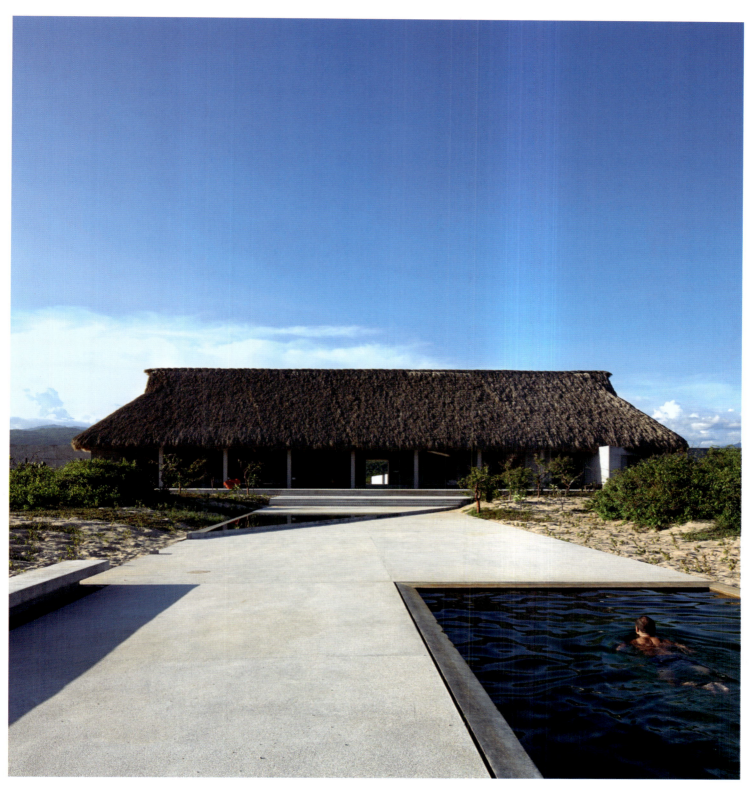

Left, clockwise from top-left:
The main communal living space; the juxtaposition of traditional roof and concrete walls; an artist's workstation.

Above:
Looking back at the main communal hall from the pool.

Casa Wabi

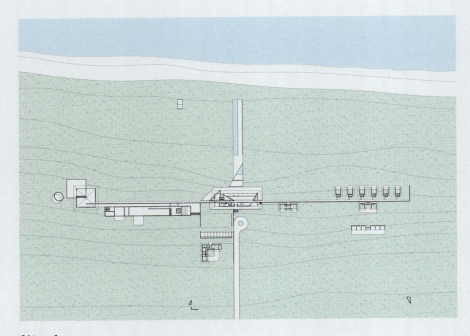

Site plan

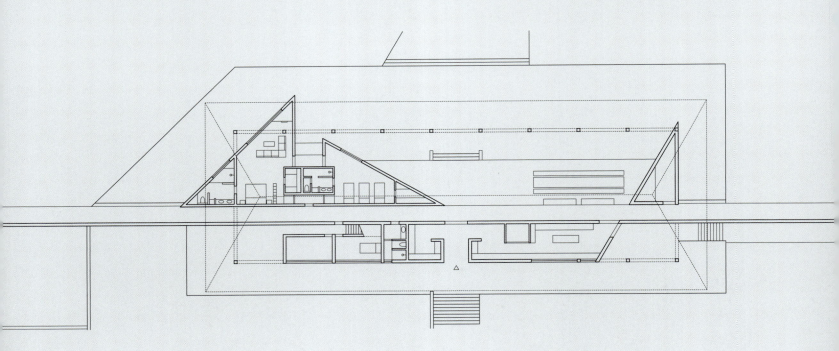

Floor plan

Creative Spaces

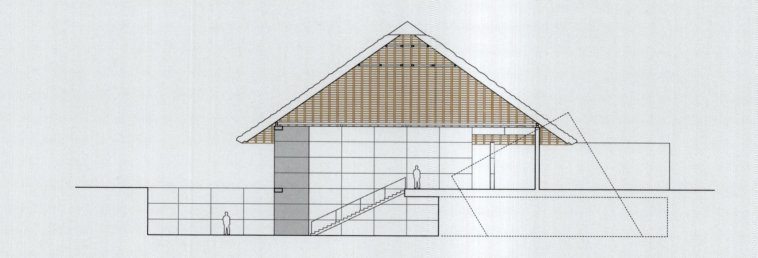
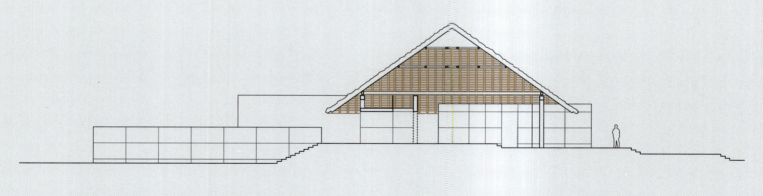

Elevations

PLANTEL MATILDE

Location: Sac Chich, Yucatán
Architect: Fundación Javier Marín

Set in the heart of the Yucatán jungle, Plantel Matilde is a retreat and art foundation designed by artist and architect Javier Marín. Born in Uruapan, Michoacán, in 1962, Marín has exhibited widely across Latin America and the USA. Best known for distinctive sculptural pieces of expressive, oversized heads and figures, Marín also paints and prints, often incorporating unorthodox materials into his canvases and clay.

Plantel Matilde is described as a refuge, but it appears to the outside world like a temple in the wilderness. The clearing in the jungle was once an agave plantation and lies within the Sac Chich community, which the foundation supports with cultural and social development. A square structure built on a vast 4,900-square-metre (52,700-square-foot) podium, it is surrounded by a narrow moat. Two of the 70-metre-long (230 feet) sides are composed of a rigorous colonnaded facade, with the other sides containing a large single-storey exhibition and creative space, beneath impressive 12-metre (30-foot) ceiling heights. At the centre of the complex is a large reflecting pool.

The oversized scale of Marín's artworks is mirrored in the building's grandiose dimensions, with tall columns and generous clear-span spaces that convey openness and monumentality. Hard-wearing, low-maintenance materials have been chosen to minimize the running costs of the structure, with an absence of air conditioning, for example. Nevertheless, in this climate, nature will inevitably start to encroach on the structure, and Marín celebrates this eventuality, describing the building as an '"inhabitable sculpture" in constant mutation.'

With visual nods to traditional building forms like church cloisters and hacienda courtyards, as well as the scale of pre-Hispanic structures, Plantel Matilde has a meditative atmosphere, enhanced by the juxtaposition of the formal structure against the backdrop of the jungle. Access to the roof provides a 360-degree view of the surrounding forest, referencing ancient Mayan astronomical observatories. The building has been designed for residencies and exhibitions and is not currently open to the public.

It took Marín several years to identify the site, create the structure and establish the foundation. Javier worked alongside his brother, architect Arcadio Marín, on the project, which was partly driven by their experiences growing up as the sons of architect Enrique Marín López. Here, however, Marín is shaping space in response to his work, using the scale of the architecture to frame the pieces in new ways. In addition to the series of galleries, there is an undercroft containing living areas for the artists in residence, cell-like structures accessed by a common room. Another basement houses a private living area for Marín himself, with direct access to the pool.

The primary construction material is concrete, left raw on the exterior and polished on the internal floors. In addition to the moat and central pool, a narrow lap pool is also included in the cloisters, setting up reflections on the underside of the ceilings. The moat serves a practical purpose – keeping animals out of the open spaces – but also references the major Mayan waterside structures as seen in the city of Nojpetén in neighbouring Guatemala.

Right:
Aerial view of the site in the Yucatán jungle.

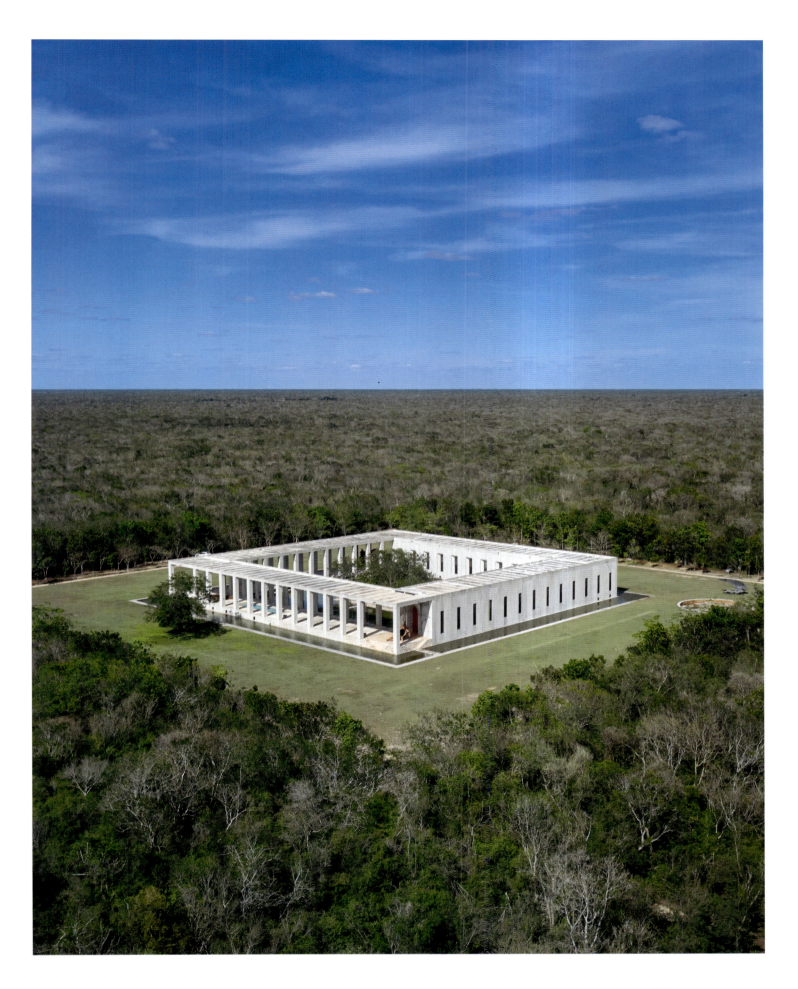

Plantel Matilde 037

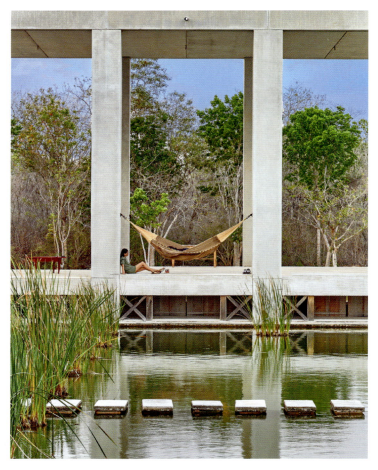

Above:
Looking across the central pool to the open colonnades of the structure.

Right:
The structure resembles a giant temple in the jungle.

Top-right:
Aerial view of the site.

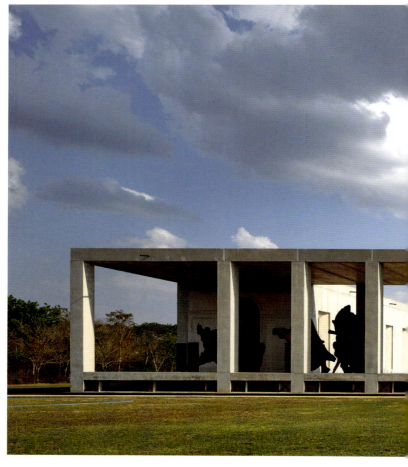

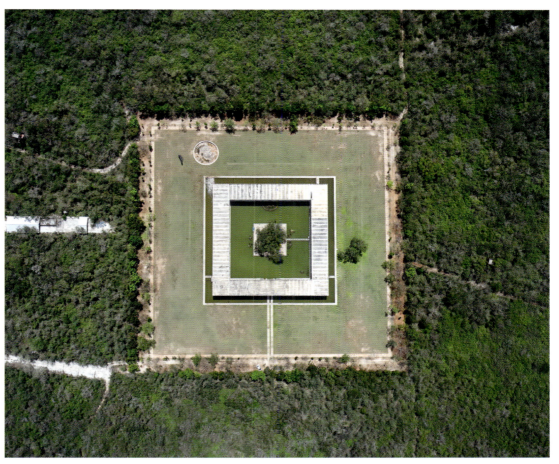
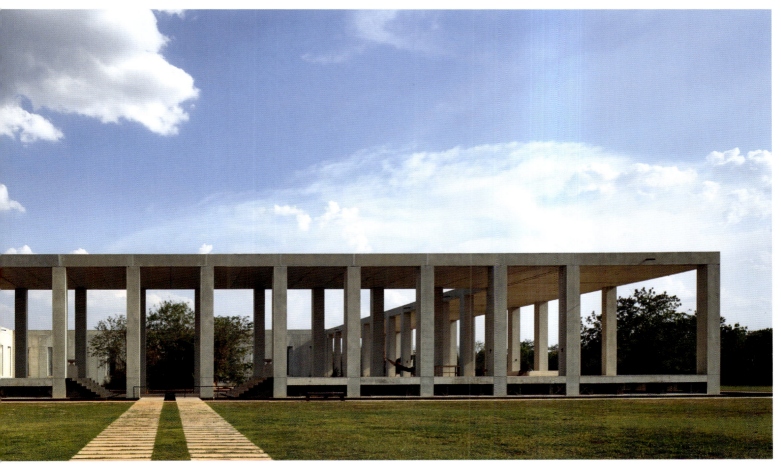

Plantel Matilde

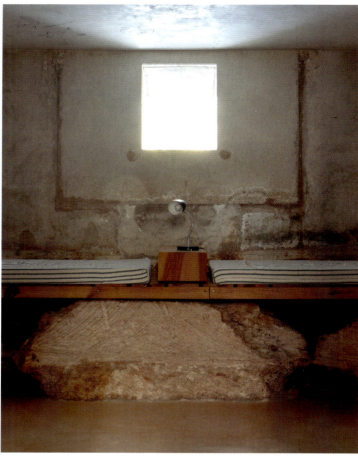
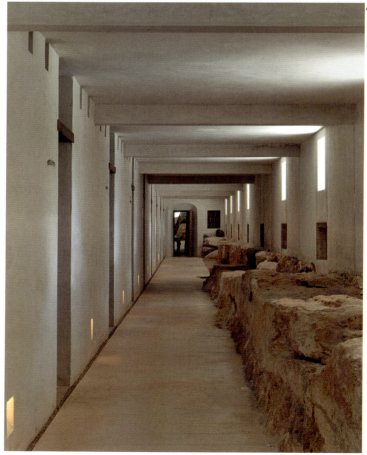

Clockwise from top-left: the island in the centre of the pool; a subterranean residential unit above the ancient foundations; and the old foundations juxtaposed with modern concrete.

040 Creative Spaces

Below:
One of the high-ceilinged gallery spaces, complete with custom chandelier.

Following spread:
The lap pool inside the colonnade.

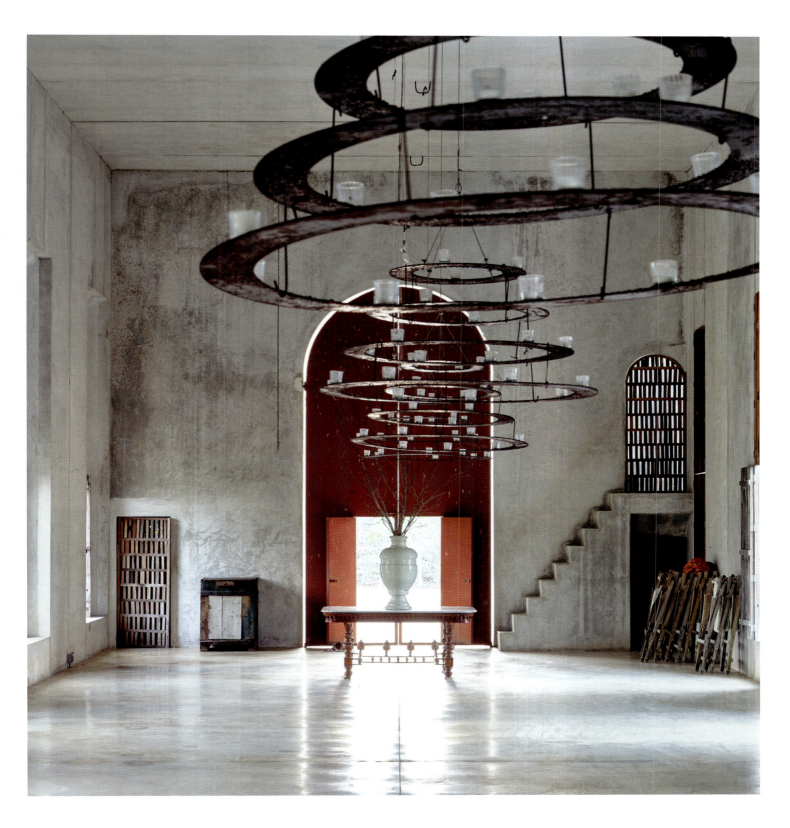

Plantel Matilde 041

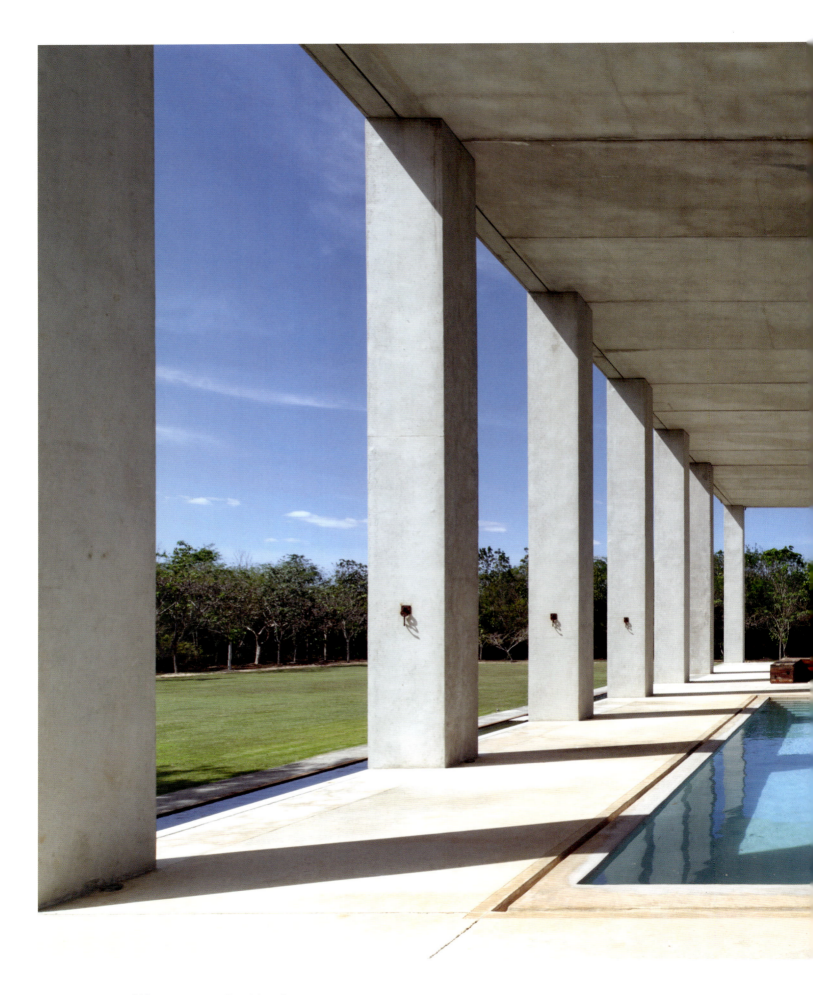

Creative Spaces

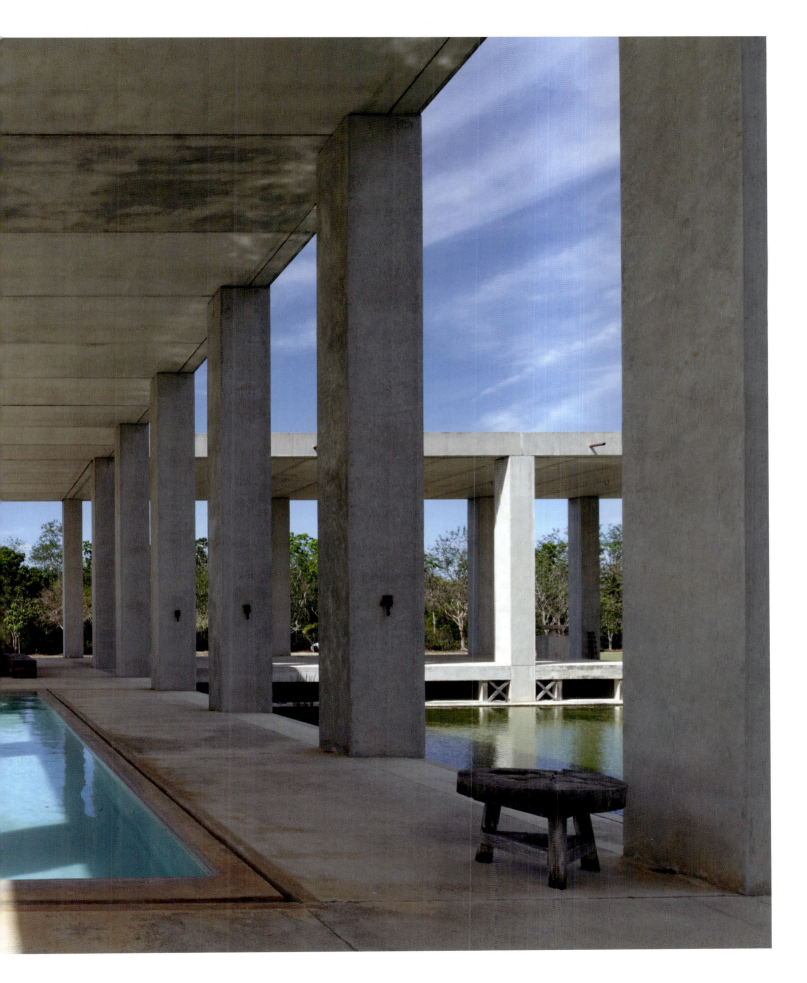

Plantel Matilde

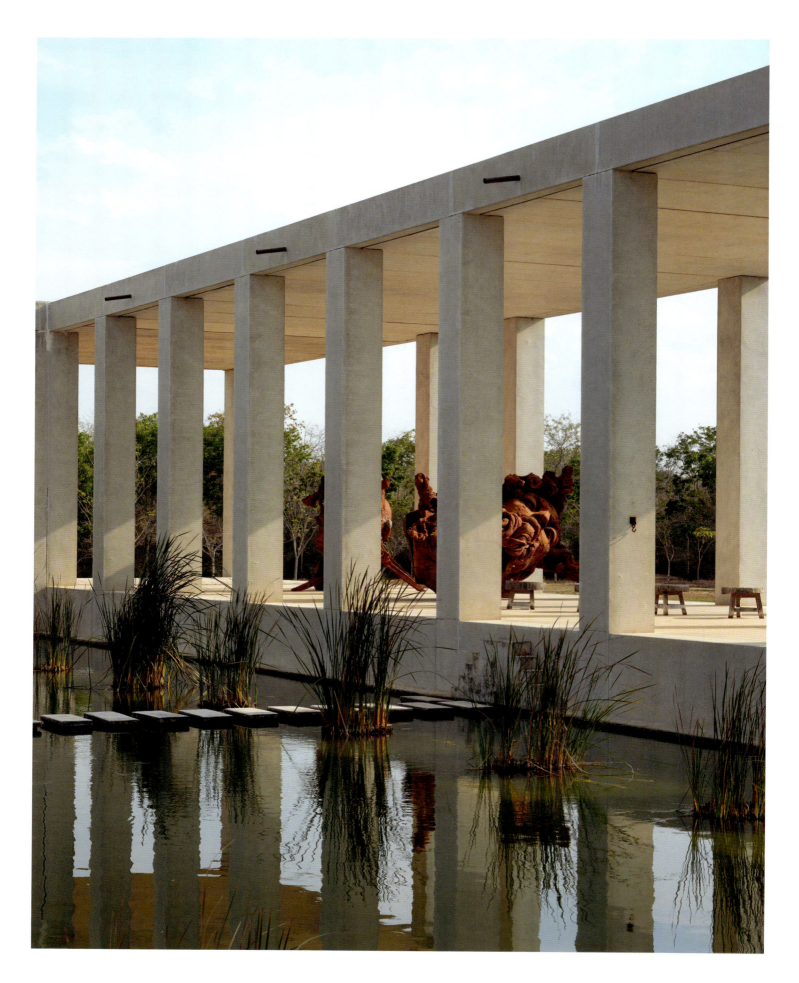

Left:
Javier Marín's sculpture on the terrace.

Right:
Concept sketches

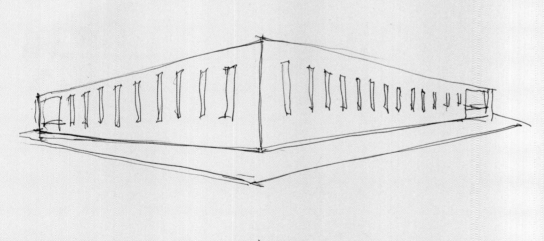

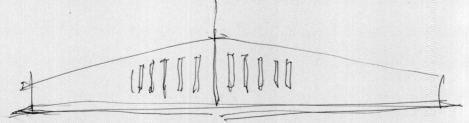

Plantel Matilde 045

CASA REYES

Location: Coyoacán, Mexico City
Architect: Pedro Reyes, Carla Fernández

Casa Reyes is a virtuoso piece of contemporary architecture, one that owes more to the life, work and aesthetic outlook of its inhabitants and designers than any more conventional commission. Conceived and designed by artist Pedro Reyes and fashion designer Carla Fernández, the new house sits alongside a new studio building that contains Reyes's sculpture practice.

The complex is located in Mexico City's southern Coyoacán neighbourhood, one of the oldest parts of the capital, and an area that has been continuously inhabited since pre-Columbian times. Reyes and Fernández made the move here for more space, first constructing a house on the site before completing the studio in 2022.

The house takes architectural inspiration from both 1960s Brutalism and the colourful palette of Luis Barragán (who built several projects in the area). These influences are combined with Reyes's own artistic perspective – a true multimedia approach that is grounded in the physicality of monumental sculpture, along with found objects and technology-shaped installations. His work, which has been exhibited globally, builds on the totemic power of abstraction, drawing a direct line between the ancient forms and figuration of pre-Columbian art and modern concerns such as environmentalism, activism and the military-industrial complex. Reyes also trained as an architect, a discipline he indulged through the creation of the house and studio.

This sensibility is threaded through every aspect of the couple's home, from the geometric Brutalist facade to the mix of concrete finishes on the interior, from polished and poured to rough hewn and shuttered. The bathroom features a tub carved from a solid block of stone set beneath a roughly shuttered concrete ceiling. Lit from above, it has a prehistoric, cavern-like ambience, as if it has been extracted from within the local rock. The house's most distinctive feature is the concrete library, a double-height wall of volumes stacked on concrete-framed shelving, bisected by a walkway that terminates in an open-tread concrete stair. At one end of this long living space is a ziggurat of concrete blocks, concealed within which is a study area.

Throughout the house, large skylights punctuate the floor plan, with splashes of primary colour and indoor planting tempering the palette of concrete and stone. Reyes's processes, both artistic and architectural, are physical and analogue. There are no CNC machines or 3D printing in his workflow. This emphasis on craft and materiality can also be found in the designs of Carla Fernández, which utilize traditional methods of weaving and stitching to make elegant clothes that are hard-wearing, repairable and responsibly sourced.

The new studio is built on the frame of a project damaged by the September 2017 Puebla earthquake. Prefabricated concrete panels give the new facade a rounded, retrospective look that references both Brutalism and High Tech architecture, stressing the sense of a building created out of a kit of components. The curved theme continues through the detailing, with rounded doorframes, circular and oval windows, and lighting roundels in the upstairs office space. The top-lit double-height studio is connected to the first floor via a poured-concrete spiral staircase. All interior formwork, including the staircase, is made from bamboo, giving the concrete a distinct patterned surface, much more granular and textured than conventional board-markings. The more intimate workspaces are characterized by a more polished concrete finish, as well as circular lighting that gives the space the feel of a petrified mid-century office given over to art and culture.

Right:
The rich red finish on the inward-facing walls.

Casa Reyes

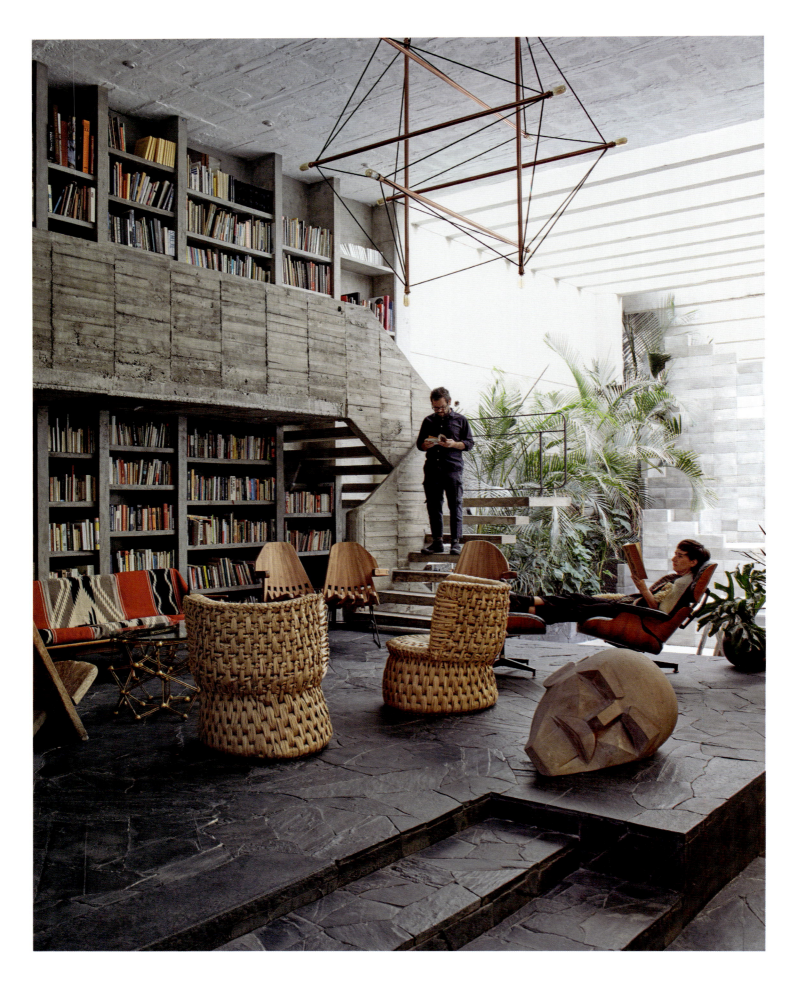

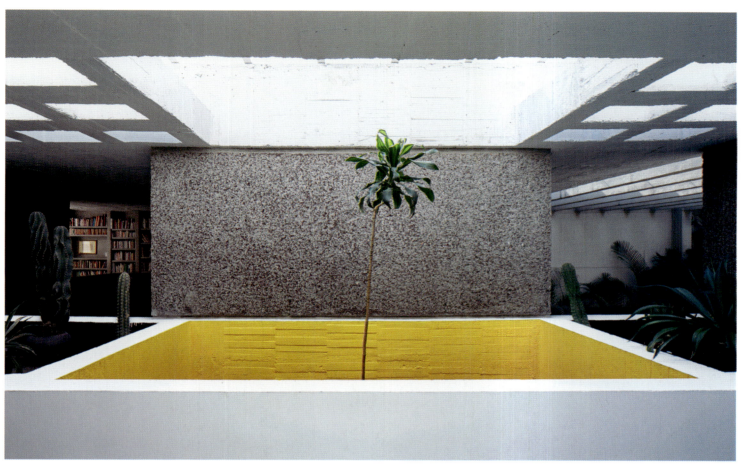

Above:
A yellow-painted light well on the upper level of the house.

Left:
A planter beneath the light well adjoining the main living space.

Far left:
Pedro Reyes and Carla Fernández in the main living space, with the galleried library.

Casa Reyes

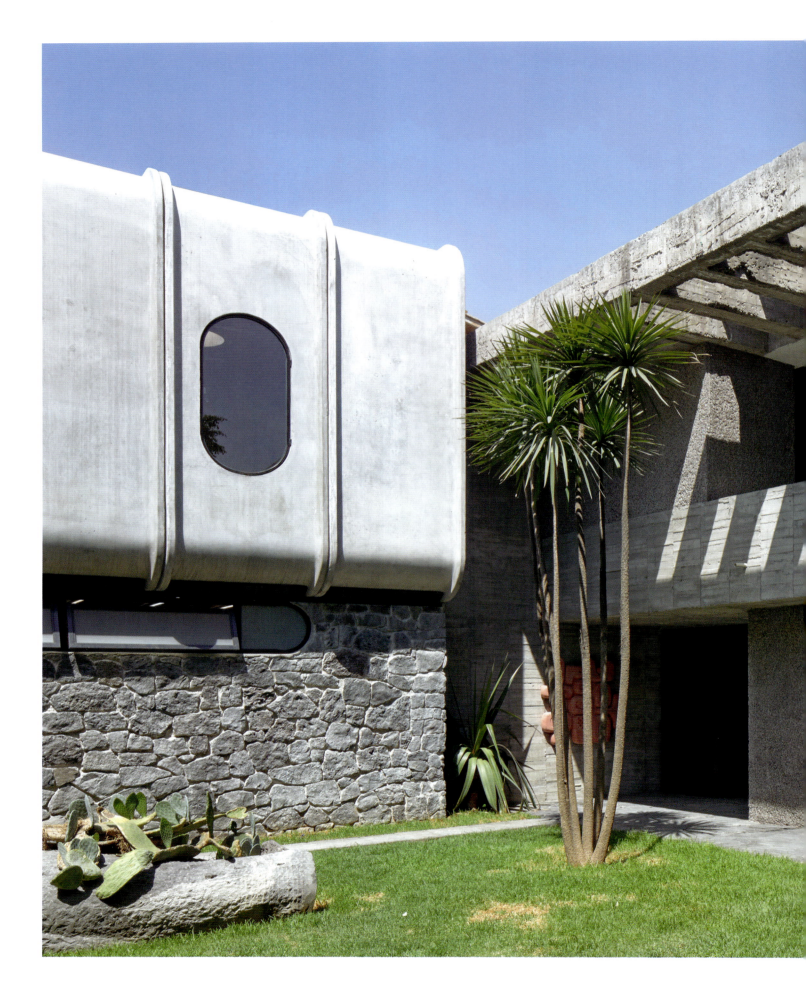

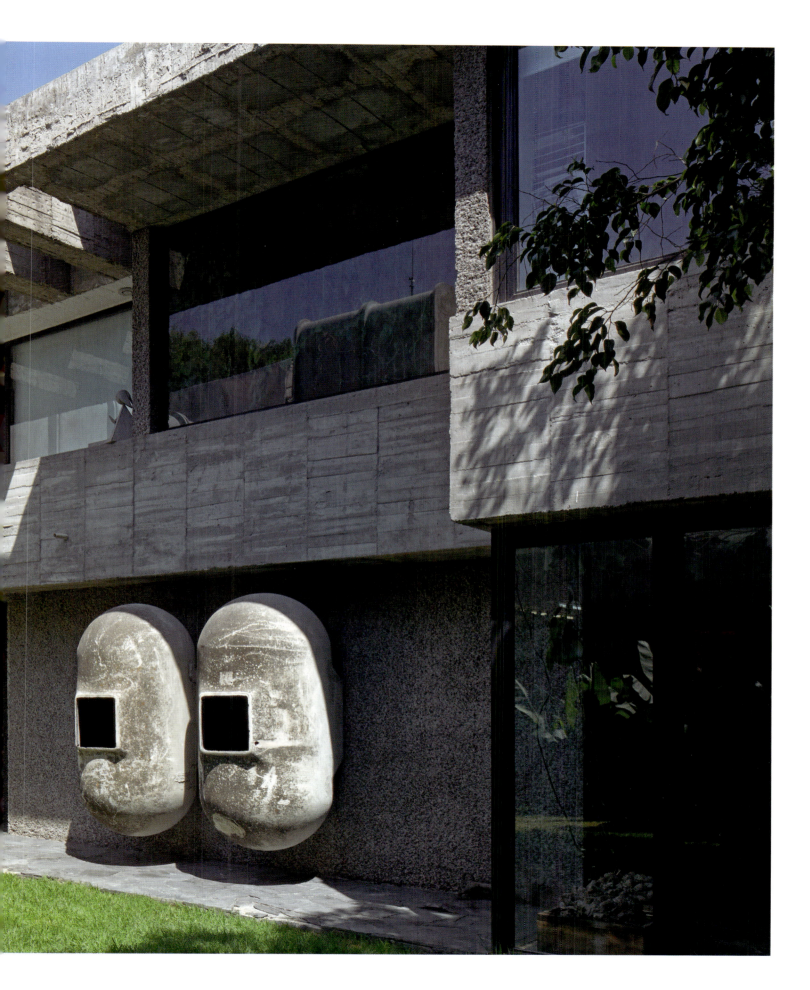

Casa Reyes 051

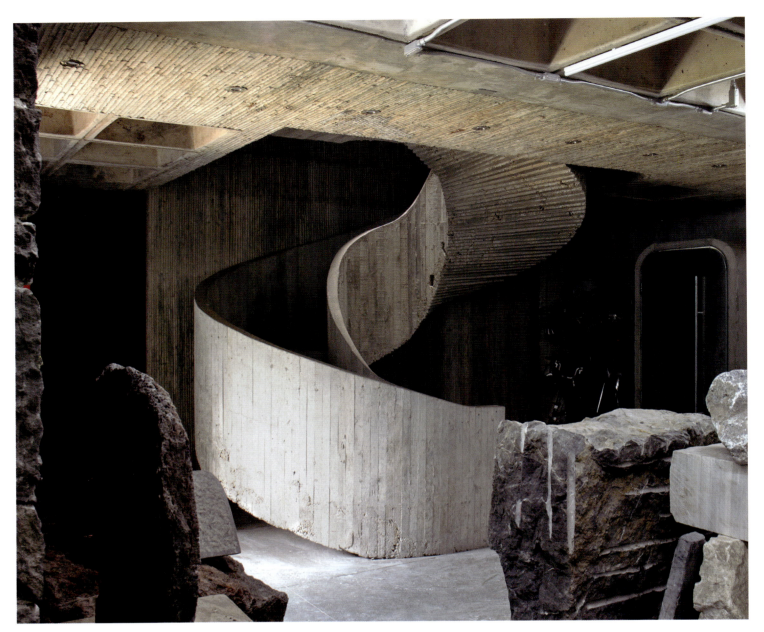

Above:
A concrete spiral staircase in the studio.

Right:
The double-height library in the main living space has rough-hewn concrete shelves.

Previous spread:
The new studio addition on the left, alongside the main house, with Pedro Reyes's sculptures mounted on the garden wall.

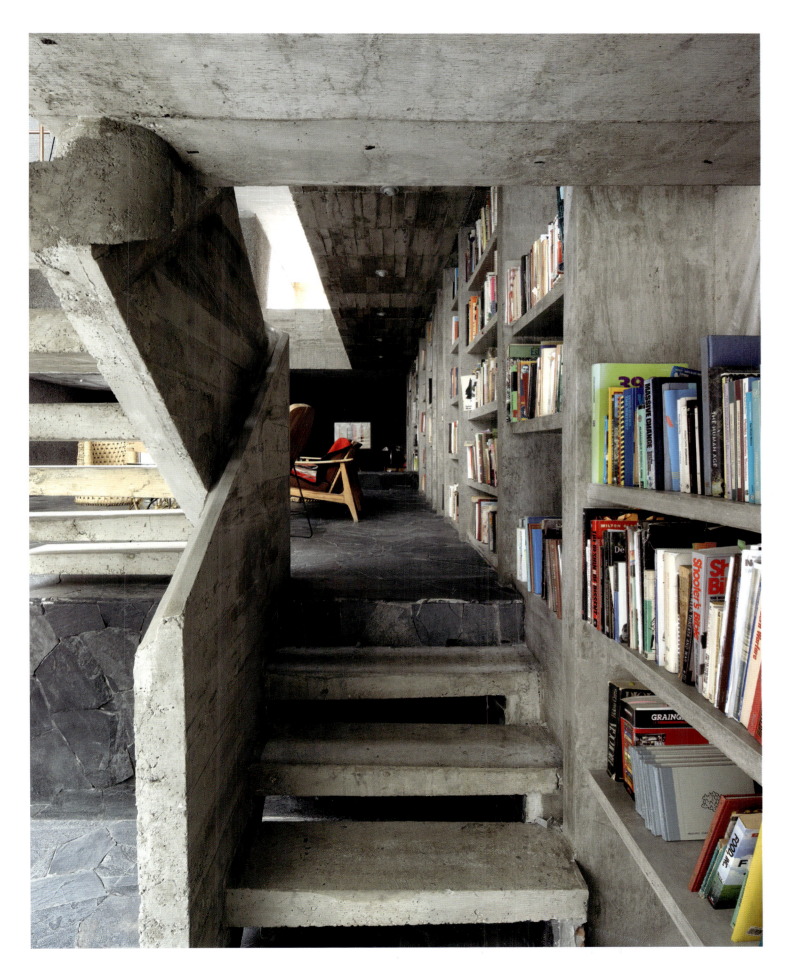

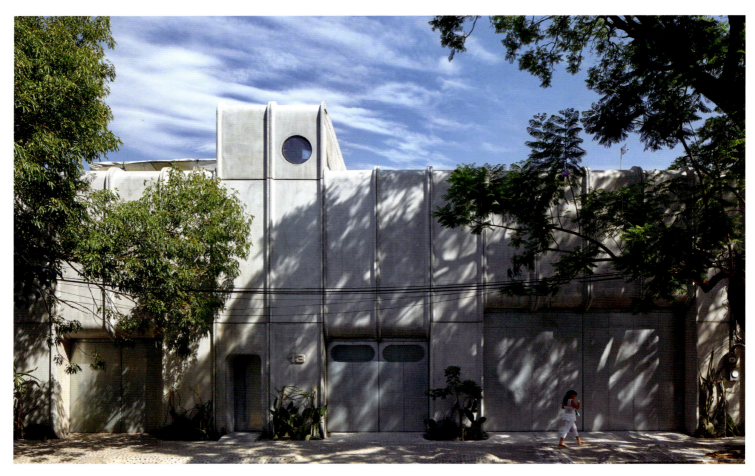

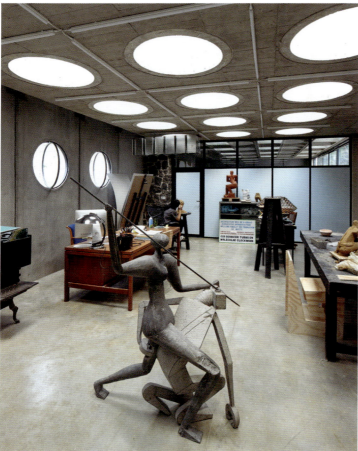

Above:
Street view of the studio.

Left:
Sculpture studio
in Casa Reyes.

Right:
Carved volcanic-stone
basin in the bathroom.

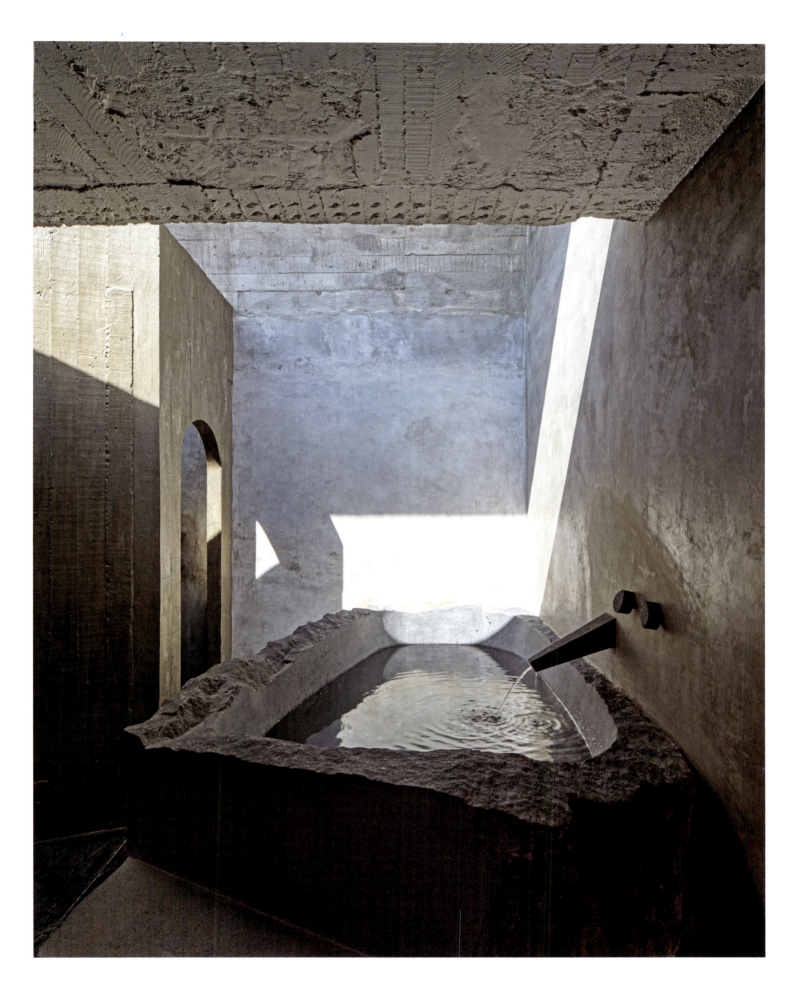

Casa Reyes 055

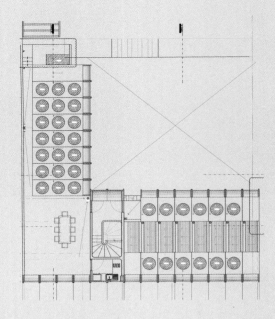

Roofop

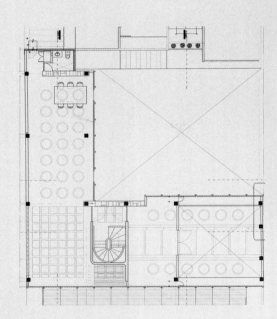

First floor

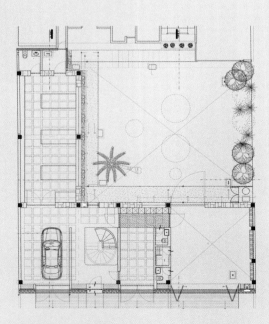

Ground floor

056　　　　Creative Spaces

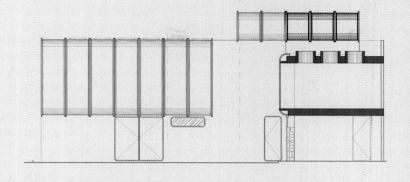
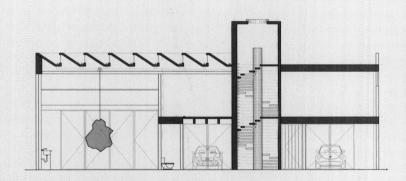
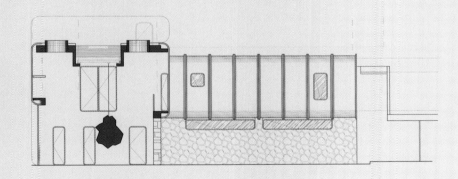
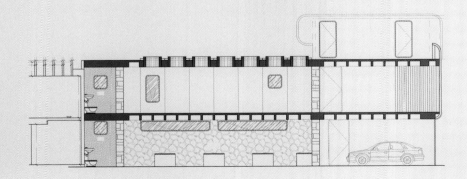

Sections

CASA ESTUDIO

Location: Amatepec, Mexico City
Architect: Manuel Cervantes Estudio

Architect Manuel Cervantes founded his eponymous studio in 2004, with a broad portfolio that accommodates projects at a variety of scales, from private houses to city-wide transport networks. Cervantes is also an educator, teaching at the University of Virginia School of Architecture. As well as working in Mexico, Cervantes has worked across Latin America, the USA, Europe and the UAE.

His studio is located in Amatepec and forms part of a complex that also includes two houses (one of which is the architect's own). Set on a sloping site in one of Mexico City's more undulating districts, the 125-metre-long (410-foot) wedge-shaped site could only accommodate 70 metres (230 feet) of built space due to the gradient. As a result, the various functions and spaces are arranged across five different levels, united by cascading staircases and a number of different ceiling heights and mezzanine spaces.

The site's topographic changes also allowed for the creation of a series of terraces stepping down the slope, spaces that could be brought into the interiors via glazed walls. The two houses are located at the highest level and share an entrance lobby. The first, the 'pent-house', is set just beneath street level, with a courtyard garden above and a terrace overlooking the ravine. Bedrooms are arranged across the upper level, with common areas and services on the floor below.

The second residential property, the 'pent-garden', has bedrooms and a family room on an upper level, with an exterior staircase leading down to the common areas, as well as a separate entrance to the architectural studio below it. The emphasis is on verticality, shifting levels, and oblique views, maximizing the sight lines across and up and down the site. All bedrooms have their own terrace in order to make the most of the regional climate.

Cervantes's studio sits on the lowest level. With raw concrete walls, a dramatic 4.8-metre (16-foot) ceiling height and a wall of glass overlooking the landscape, it is a spectacular setting for creating, with a museum-worthy arrangement of architectural models occupying racks of shelving that nearly reach to the ceiling. Although the architect notes that the proximity to his own home allows him to take 'meetings over lunch or dinner', the raw materiality of the space is a dramatic calling card for potential clients.

Cervantes had originally intended to study art, but his father encouraged him to study architecture, which he did at Mexico City's Universidad Anáhuac del Norte. The houses and studio were shaped to make clients more aware of the importance Cervantes places on personal relationships, with living spaces that draw on traditional Mexican family dynamics. Warmth is conveyed by wood, with concrete creating a sense of place and solidity, anchoring the structure to the hillside. Cervantes has spoken of how the studio prefers not to be motivated by material concerns, but by the relationship to culture, location and climate.

Throughout the houses and studio, artworks and sculptures are on display, in addition to the many and varied models depicting projects past and present. The award-winning practice has exhibited at the Seoul Biennale and been published extensively, including in Spain's *El Croquis*.

Right:
The kitchen and dining room.

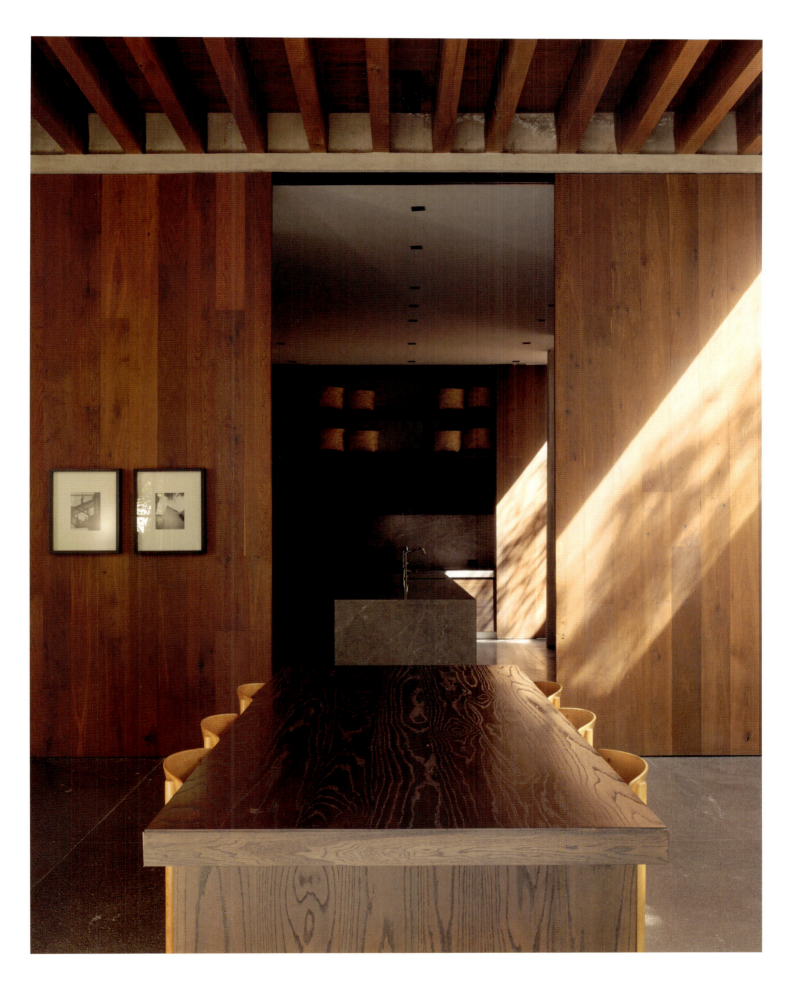

Casa Estudio 059

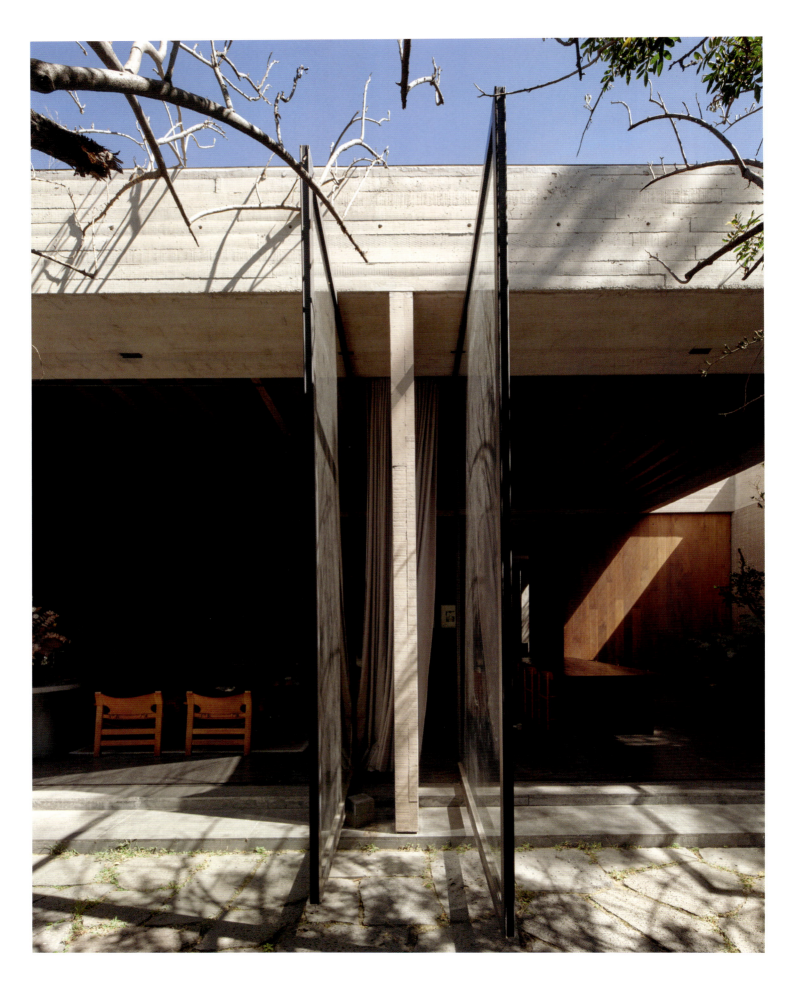

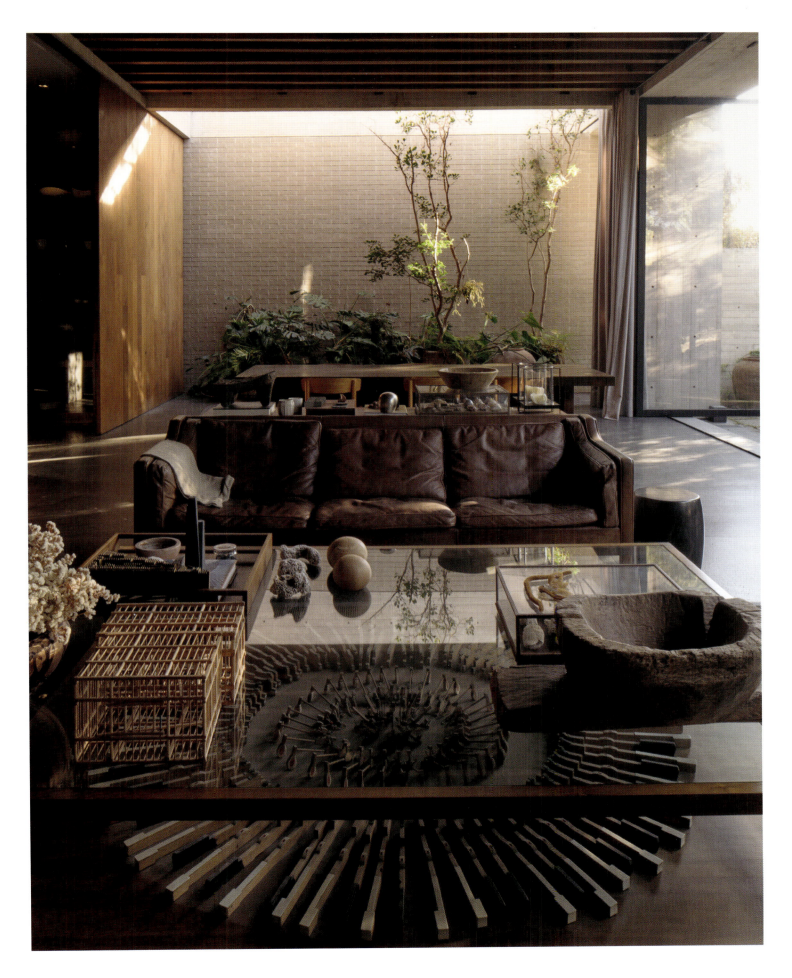

Casa Estudio

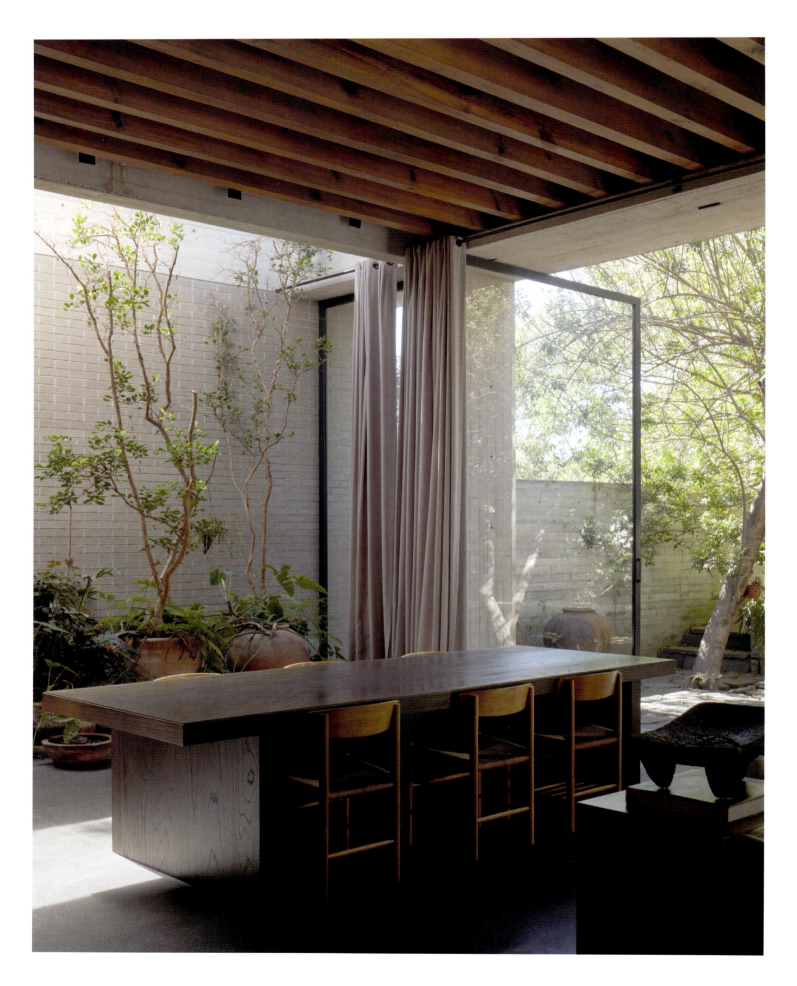

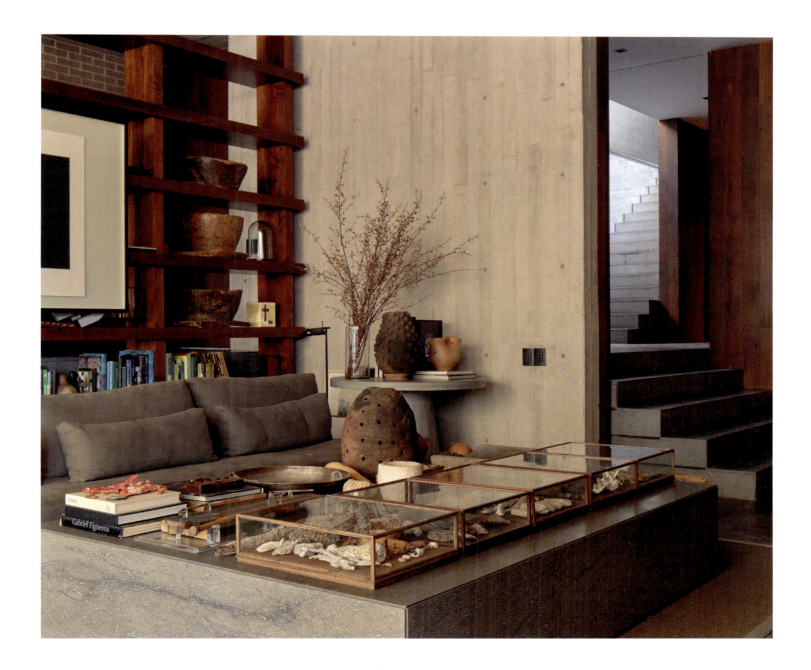

Above:
The living room has cabinets of found objects on the coffee table.

Left:
View from the dining room into the terraced garden.

Previous spread, left:
Large pivoting glass doors open up the living spaces to the terraced garden.

Previous spread, right:
The garden-facing living room with doors that open on to the rear terrace.

Above:
An internal/external staircase steps down the site.

Right:
Stairs lead down to the architect's personal studio.

Far right:
The architect's atelier with bespoke shelves for storing models.

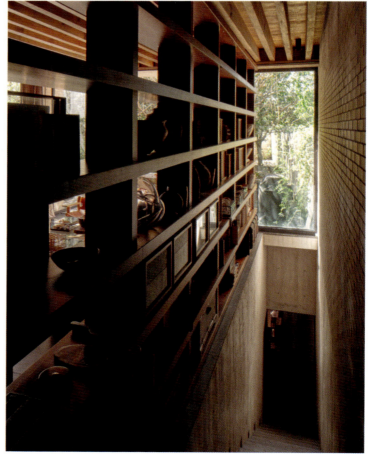

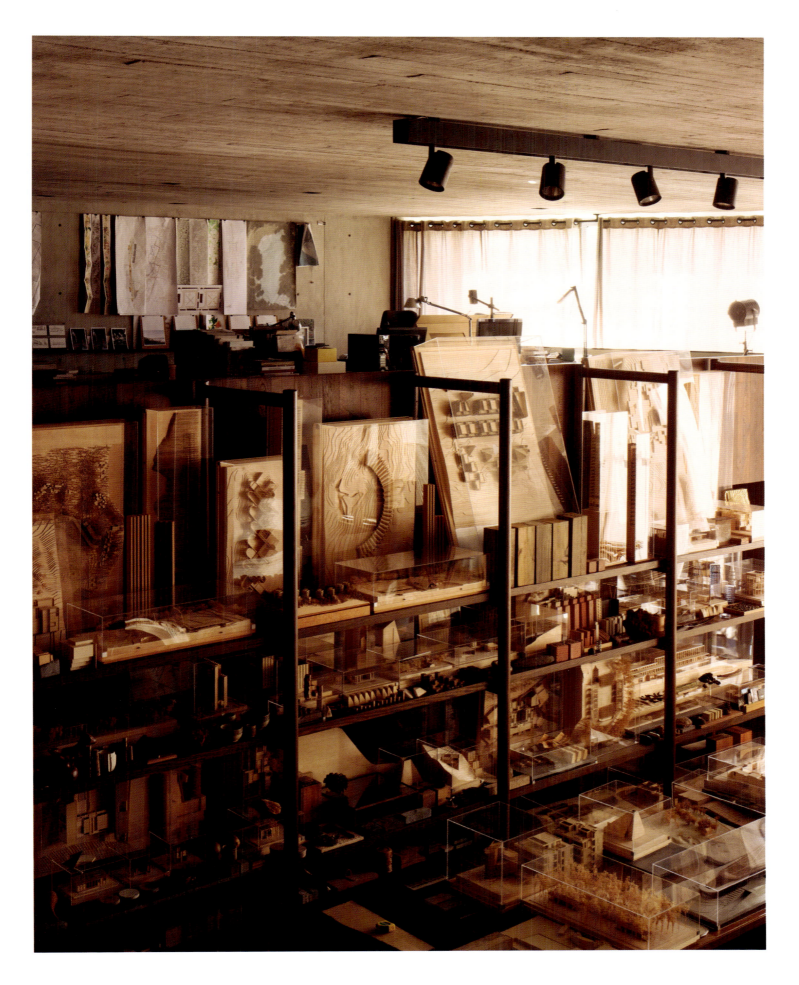

Casa Estudio 065

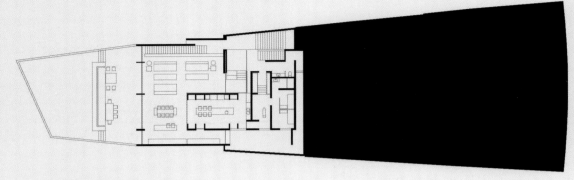

Ground-floor plan (studio)

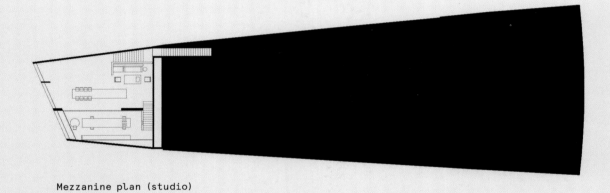

Mezzanine plan (studio)

Basement plan (studio)

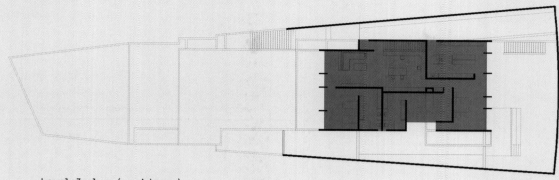

Level 3 plan (residence)

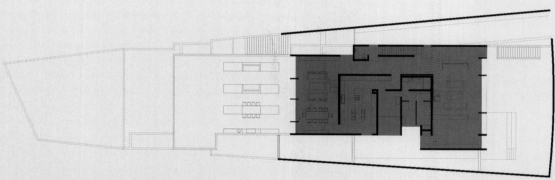

Level 2 plan (residence)

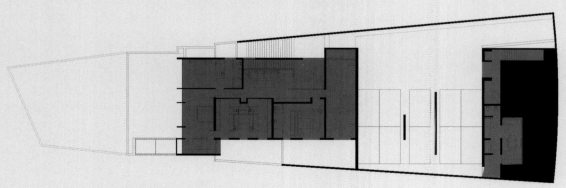

Level 1 plan (residence)

Casa Estudio 067

CASA SANJE

Location: Mexico City
Architect: Ludwig Godefroy

Designed by architect Ludwig Godefroy for his own family, what is now known as Casa SanJe had an inauspicious beginning. 'It was an ordinary Mexican house from the 1980s,' says Godefroy, who has forged an aesthetic driven by a reassessment of concrete's fundamental materiality (as shown in Casa Alférez, see page 140).

The architect and his family were inspired to overhaul the house during the Covid-19 pandemic, primarily to get access to some much-needed outside space and a garden. The original structure had traditional tiled floors and textured plaster on the walls, a form of 'Tyrolean render' that gave the interior a rough, cave-like feel. Some of the qualities of this material have been retained, alongside the introduction of new concrete structural and decorative elements that reshape the relationship between interior and exterior.

The rhomboid-shaped plot is divided roughly between house and garden, with new openings created throughout the ground floor. This space includes an office and library area to the left of the front door, as well as the open-plan kitchen, dining and living room. The latter features new vertical steel windows overlooking the courtyard garden, while new poured-concrete walls extend the scope of the living space, allowing for a continuous textured surface to run behind the window fittings.

Key elements, such as the bench in the sitting room, the kitchen counter and dining table, have been formed from monolithic poured concrete. The inverted triangular forms of the cantilevered counter and table sprout from the walls, which are themselves punctured by a series of oval- and lozenge-shaped holes to allow views and conversations through the space.

The playful materiality continues with the wall of Tezontle at the rear of the property. This distinctive reddish volcanic stone is a common feature of interior and exterior walls in Mexican architecture, and here forms a complementary backdrop to the dark hardwood treads of the steel and wooden staircase.

'In and out are always connected in this house,' says Godefroy, 'We wanted to reverse the space and enable the garden to become more important than the house itself.' The entrance courtyard features stepping stones across a carpet of Tezontle, interspersed with local planting, large terracotta pots and Godefroy's sculptural square column of concrete and stone. The rear garden is laid to lawn, fringed with palms and other tropical plants. An addition to the garden facade, a semicircular shuttered concrete planter is shaped to evoke the form language of a Modernist staircase and juts out over the garden.

'We wanted the space to become timeless, without any trends or decoration, just made of simple materials,' the architect says. 'It's a house designed to age without being damaged by the action of time.' The stripped-back interior, with its idiosyncratic network of imposed connections between spaces, uses a sparse palette and bold geometric forms to subvert the original layout of the house. These include the sunken circular shower and bath, the monumental built-in concrete shelving, and the use of maquette-style furniture elements made from a mix of concrete and volcanic rock that are dotted around the interior and exterior landscape.

Right:
The main entrance to Casa SanJe.

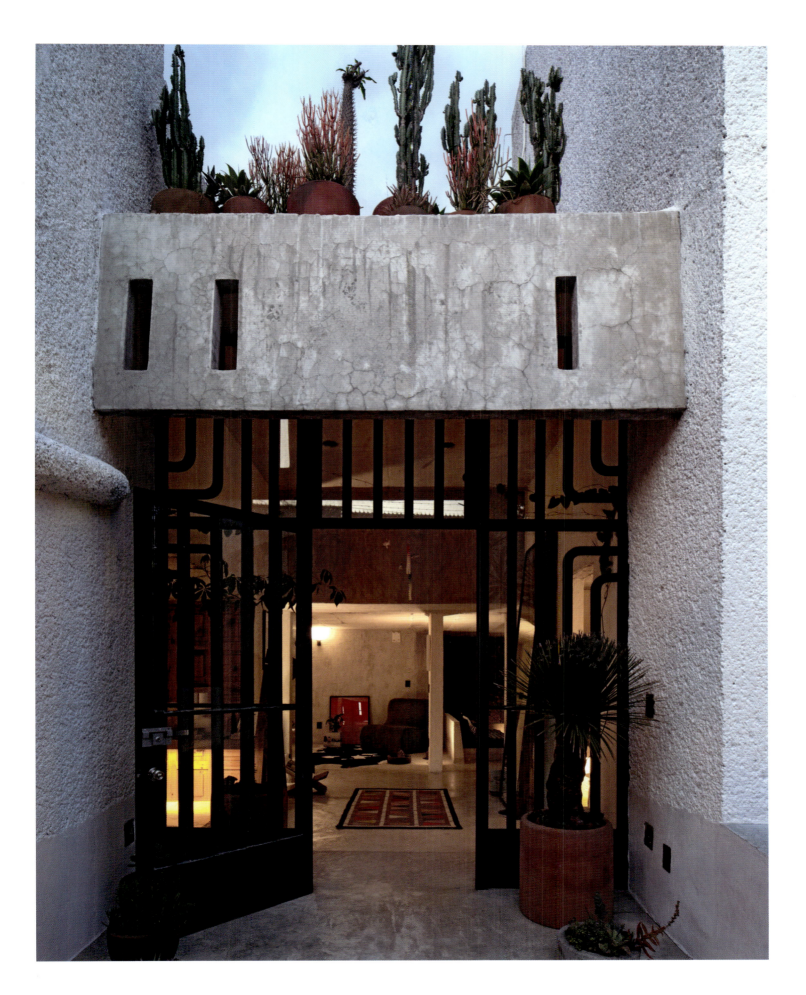

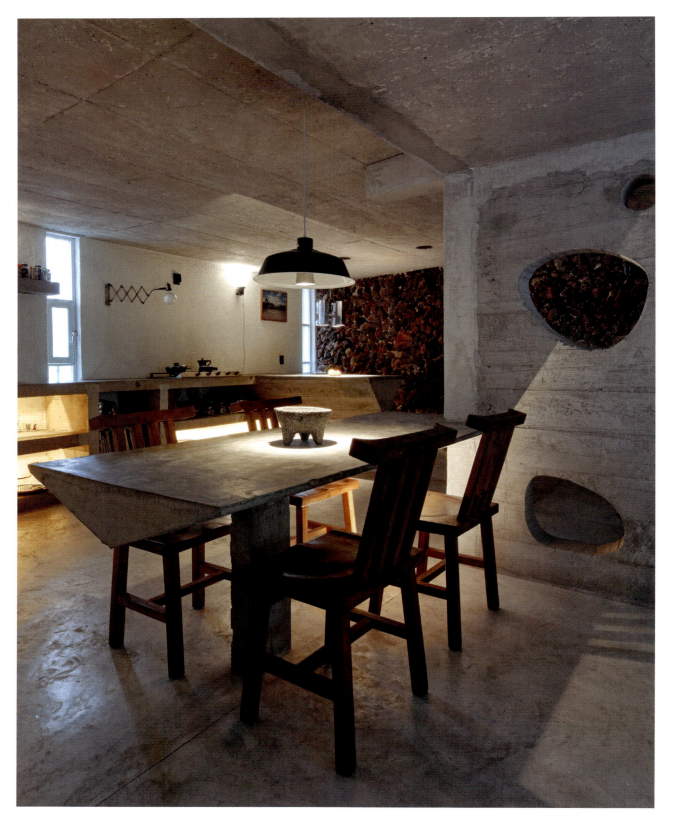

Above:
The kitchen with bespoke concrete furniture and volcanic stone wall.

Right:
Godefroy's sculpture for the central courtyard, combining concrete and red volcanic stone.

070 Creative Spaces

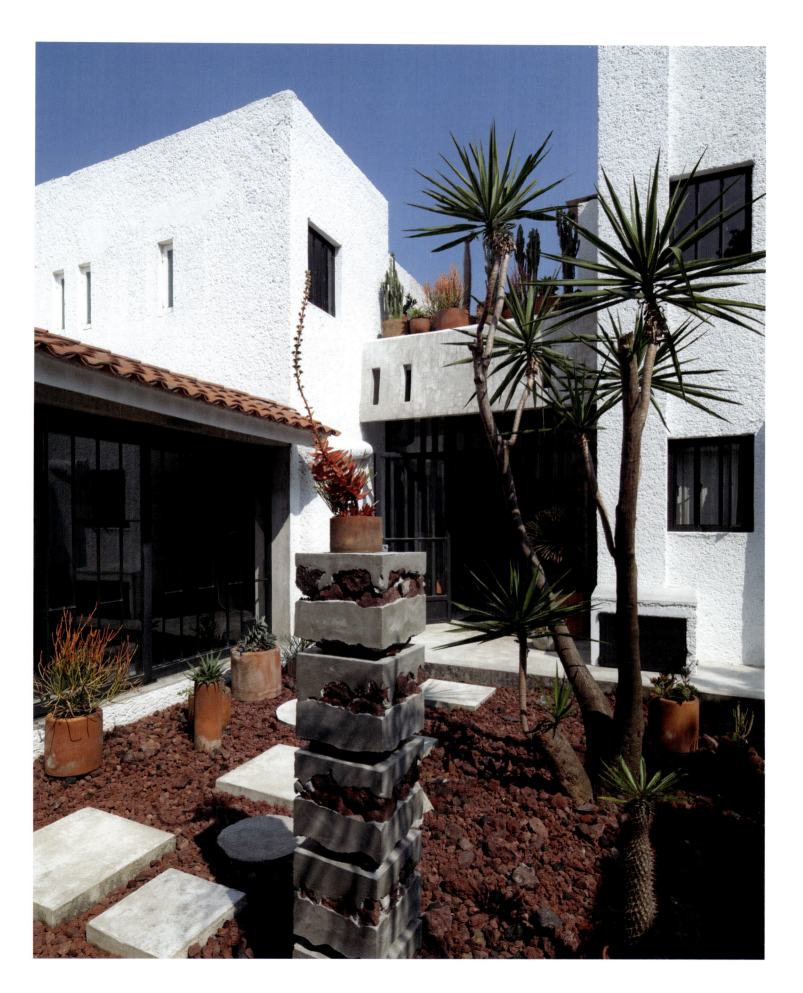

Casa SanJe 071

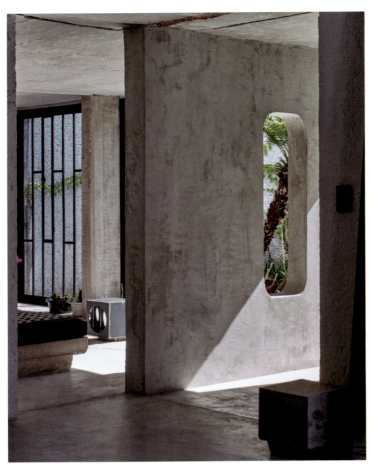

Clockwise from top-left: Cut-outs in the poured-concrete walls allow light and views through the living space; the house is filled with sculptural vignettes, with hard-edged framing devices; the cantilevered concrete kitchen counter.

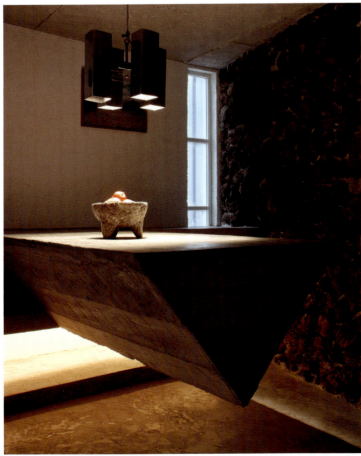

Creative Spaces

Above:
The bathroom is made up of geometric concrete forms.

Following spread:
The concrete elements are taken into the house's external spaces.

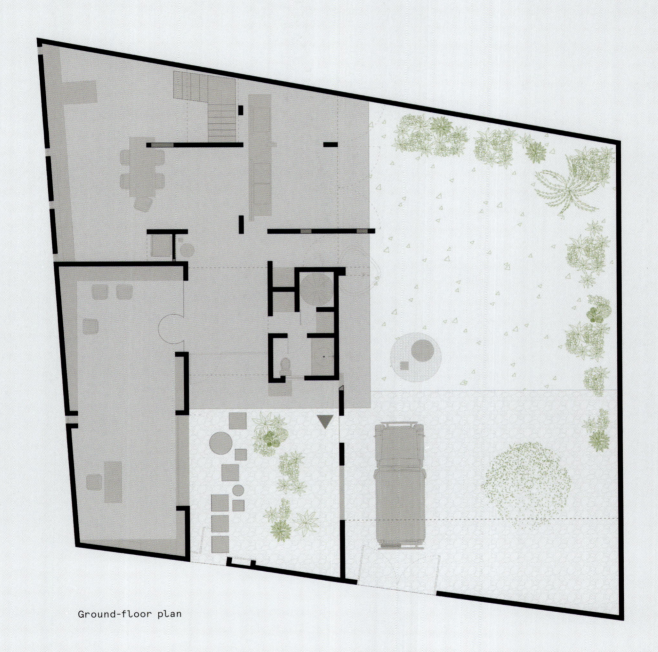

Ground-floor plan

CASA TERRENO

Location: Valle de Bravo
Architect: Fernanda Canales Arquitectura

Casa Terreno – 'house of the land' – was designed for occupancy by two families by Fernanda Canales Arquitectura. Set on a remote mountain site about three hours' drive from Mexico City, the house is completely off grid, with no connection to any services, including water, sewage and electricity. As a result, the brief called for the creation of a retreat that was completely self-sufficient, with facilities to generate electricity and recycle waste, as well as making a minimal impact on the land through its plan, silhouette and use of materials.

'The house addresses two apparently contradictory conditions: seclusion and aperture,' says architect Fernanda Canales. The first is necessary because of the varied and spirited climate of the region; within the course of a single day, temperatures can vary by up to 30 degrees Celsius. Weather is also a major consideration, with rainy days accounting for around 50% of the year. Nevertheless, the brief called for a house that can be opened up to its surroundings as much as possible, and the arrangement of internal walls, covered areas and screens creates something of a microclimate within the structure.

'The walls act as membranes, which span two temperate zones (forest and prairie), two seasons (dry and wet) and three spatial conditions (centre, inside and outside),' says Canales. These distinctions are achieved by four different courtyards scattered around the plan. The entrance courtyard welcomes guests to the house, with a curved wall that shields the building from the landscape. In the middle of the house is another, larger courtyard that marks the point between the public and private areas of the plan. A third small courtyard provides access to the rooftop terrace, and a final courtyard is located adjacent to the service area.

'These four patios create different atmospheres within a vast landscape and frame specific views of the exterior,' Canales explains, 'Each space is directly related to at least one patio on one side and to the open landscape on the other, allowing for cross-ventilation and sunlight during the whole day.' The house becomes a statement about the relationship between the built and the unbuilt, shelter and open space, raw nature and the ways in which to artificially control it.

This dichotomy is exemplified by the use of materials. Broken recycled bricks make up the external walls, with concrete banding that harks back to Corbusian proto-Brutalism, as well as perforated brick for cross-ventilation and illumination. Inside, the walls and surfaces are concrete and wood, a smooth, neutral surface treatment, intended as a contrast with the building's exterior facades. Even the roof structure has been arranged to highlight a difference between uses, with concrete vaults over the bedrooms and living room – another nod to Brutalism – paired with flat planted roofs above service areas.

In addition to the brick lattices, there are other openings and perforations in the plan. A covered walkway leads from the entrance courtyard all the way to the rear of the house, past the vaulted living spaces, while the main open space is subdivided by two intersecting walls, subtly angled so as to create a passage between them. Self-sufficiency is achieved through a number of different systems, including rainwater storage, photovoltaic panels, and a biodigester and composter for recycling organic waste. All the materials used to build Casa Terreno were bought from nearby hardware stores and builder's merchants, and the house was constructed by a local contractor and carpenters.

Right:
The main entrance incorporates a mix of monumental volcanic stone and terracotta.

076 Creative Spaces

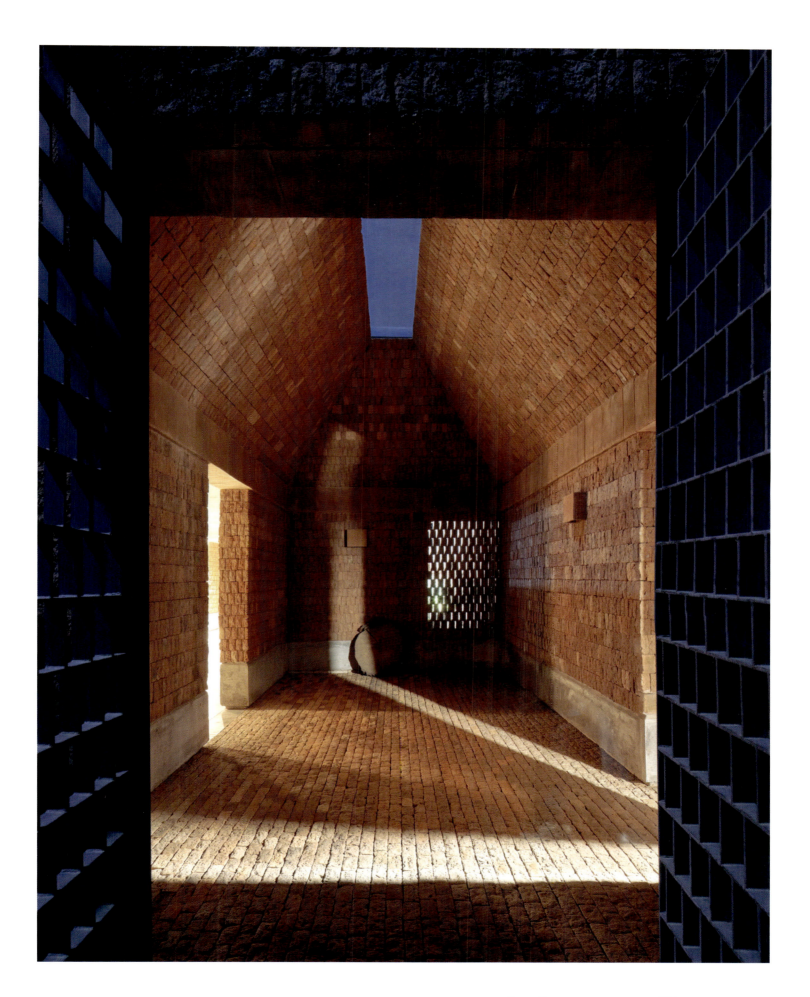

Casa Terreno 077

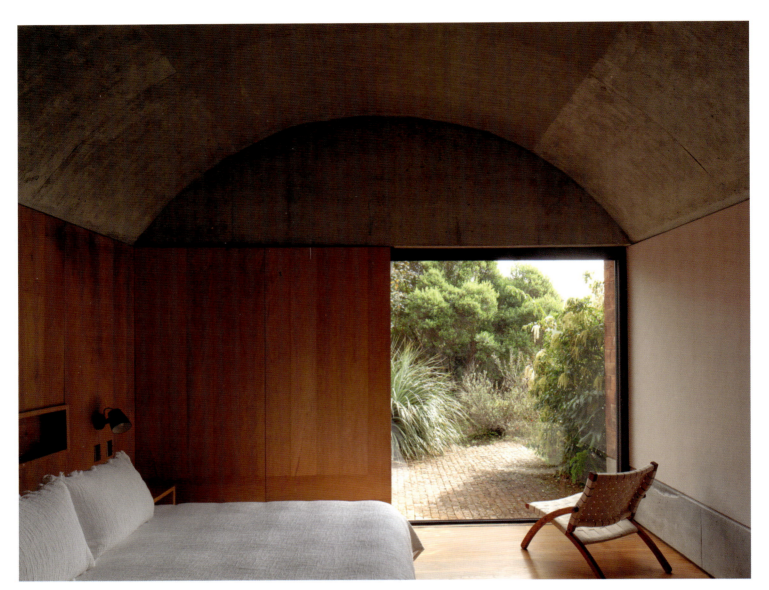

Above:
Bedrooms are set beneath
the vaulted concrete roof.
Each bedroom has its own
fireplace for heating.

Right:
A top-lit bathroom.

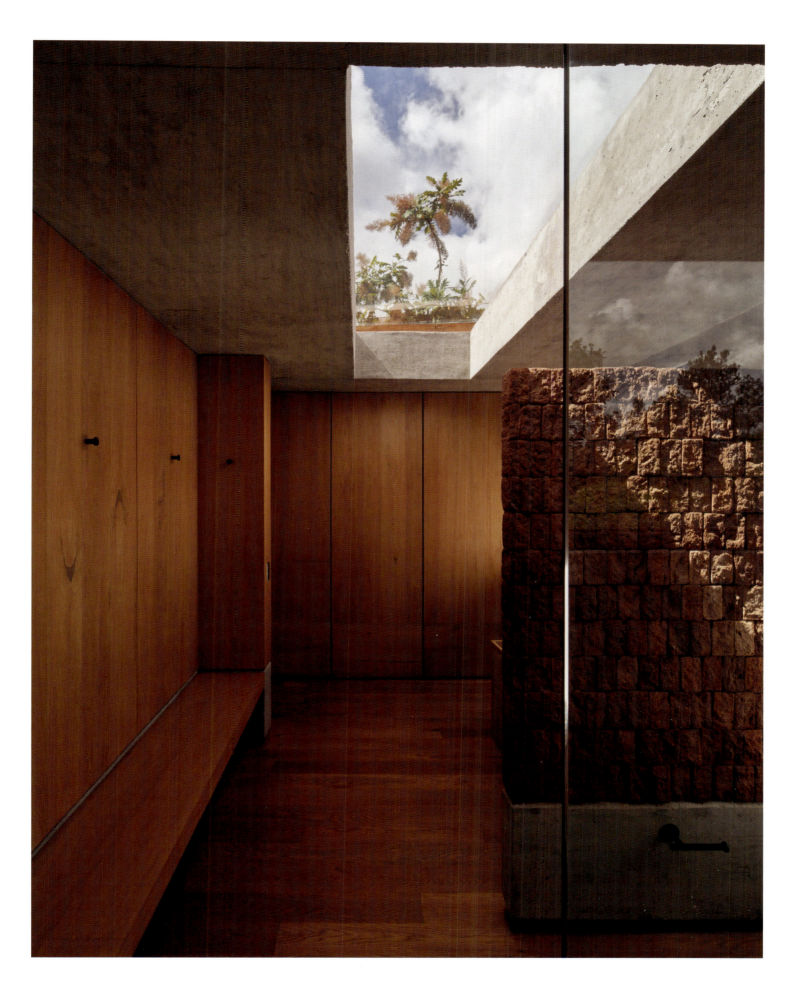

Casa Terreno 079

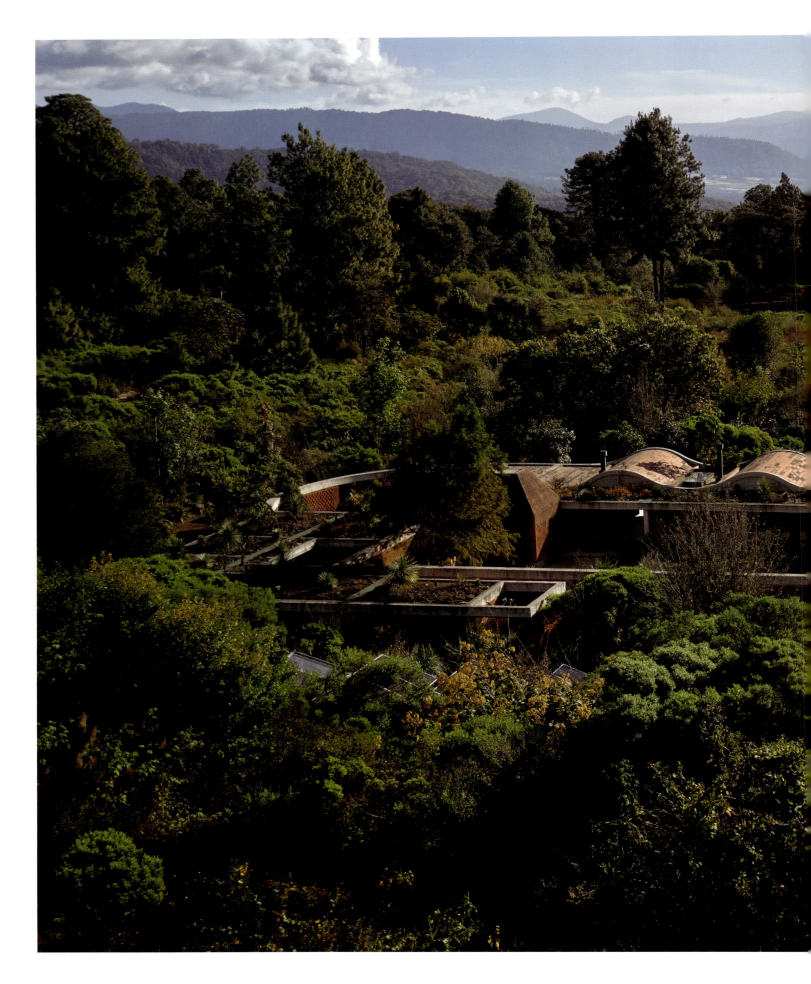

Creative Spaces

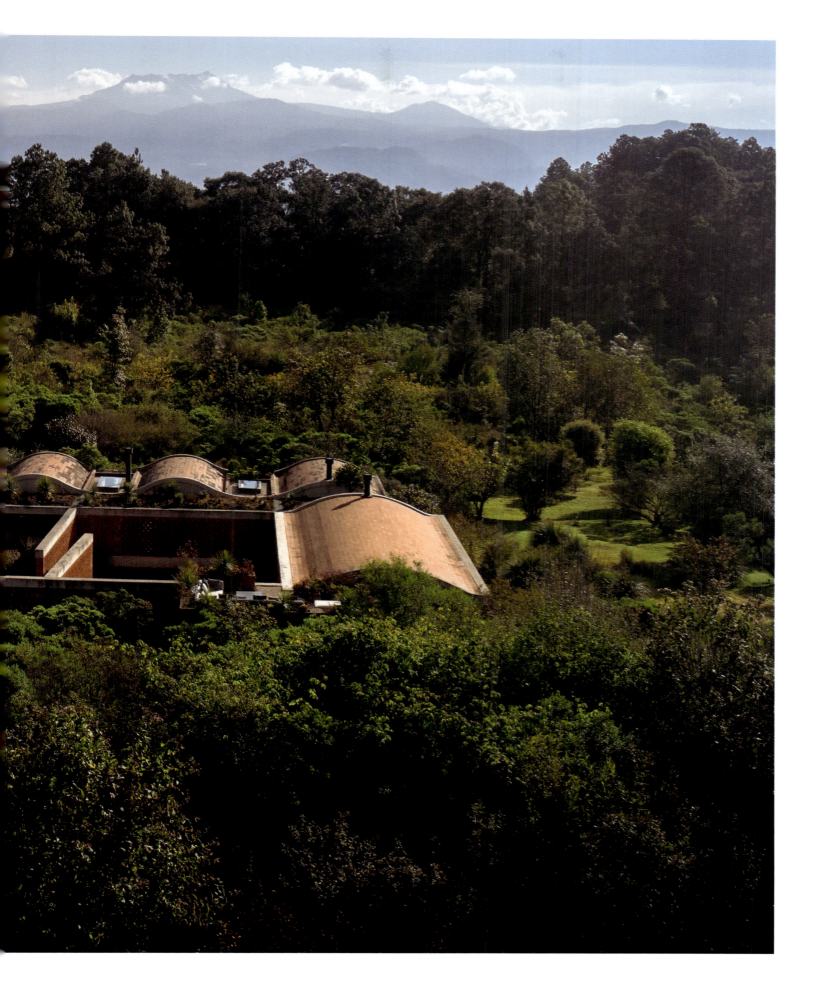

Casa Terreno

Above:
A small study area overlooks the garden.

Left:
Wood-lined bedrooms open off a long corridor, with shutters replacing curtains throughout the house.

Previous spread:
The undulating roof form above the bedrooms is interspersed with rooflights. The enclosed garden courtyard has intersecting walls.

Facade

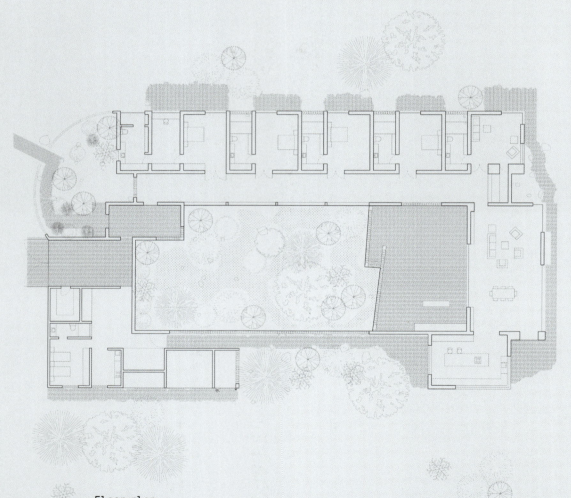

Floor plan

084 Creative Spaces

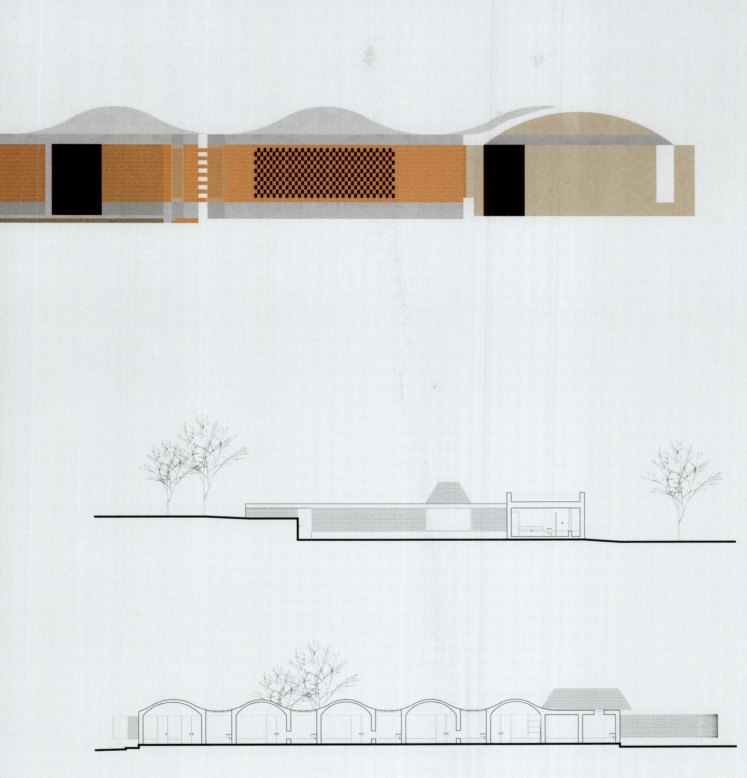

Sections

EXPERIMENTAL STRUCTURES

Innovation and experimentation form the core of architectural practice, but rarely result in enduring built works. Mexico's unique combination of climate, geology and pockets of economic prosperity has resulted in some of the most dramatic expressions of residential architecture of the past decade. These projects run the gamut of scale and materiality, their form dictated by budgetary constraints, the shape of the landscape, or simply the desire to take a different approach to the domestic realm. Client patronage and indulgence are core components of architectural experimentation, as shown in the collaborative projects in this section.

Right:
The interior of Ludwig Godefroy's Casa Alférez, which is set amid a pine forest outside Mexico City.

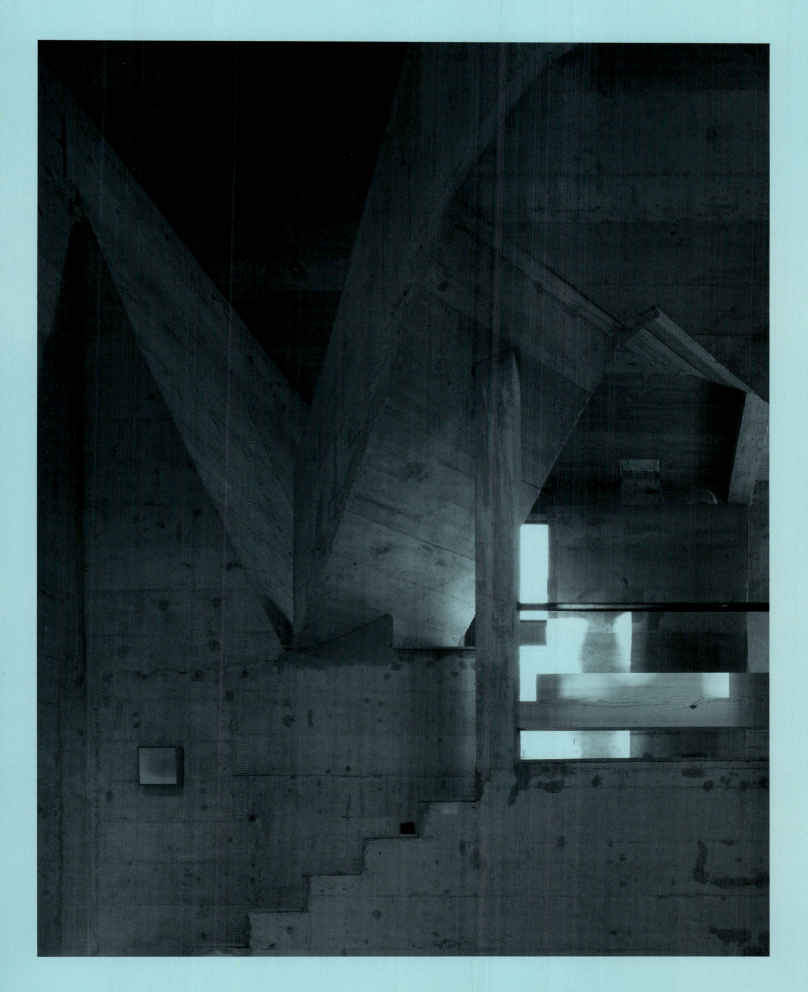

CASA TINY

Location: Puerto Escondido, Oaxaca
Architect: Aranza de Ariño

Designed by architect Aranza de Ariño, Casa Tiny continues the longstanding tradition of the secluded holiday cabin. This romanticization of shelter harks all the way back to Henry David Thoreau's *Walden*, first published in 1854, through to the very contemporary phenomenon of online 'cabin porn'. At its heart is how to express a purist relationship with nature through architecture.

Casa Tiny directly addresses its role in this aesthetic through its name, which nods to the American 'tiny house' movement, a counterpoint to ever-expanding house sizes and housing costs. The tiny house ethos also embraces craft and self-reliance, and is driven by aesthetics, social media and the dissemination of this strand of alluring online content. This particular tiny house is not a home, but a holiday retreat, set amid the surfing beaches of Puerto Escondido in Oaxaca, the heart of Mexico's Pacific coast. Sited just 200 metres (650 feet) from the sea, the house covers just 36 square metres (388 square feet) with a straightforward plan consisting of a double-height downstairs kitchen and living area, with a raised platform for the bed, beneath which is the shower room.

The tall gable ends are aligned north–south and the region's prevailing winds ensure that the tall space can be naturally ventilated. Detailing is kept minimal and precise, with preformed concrete elements forming the structure and left unfinished inside and out. At bedroom level, reached by a hit-and-miss staircase, a full-width rectangular window in the gable end offers a cinematic view, with wooden shutters to keep out light, wind and insects.

The mezzanine sits above the bathroom, which has a separate door to open the space up to the elements. There are two concrete terraces extending out from the floor plan. The first is the kitchen terrace, with its 5.4-metre-long (18-foot) central concrete dining table, a fixed element that runs from inside to outside. This entire gable end is clad in wooden louvres with shutters at ground-floor level; these are specially notched so the house can be closed up around the fixed table. The second terrace is at 90-degrees to the main axis of the house and includes a rectangular swimming pool. All timber elements use Parota wood (also known as Guanacaste), a coarse textured hardwood. As well as the shutters and windows, it is used for internal cupboards and shelving.

Located close to Casa Wabi (and commissioned by a relative of the arts and culture organization's founder; see page 024), Casa Tiny was the first project designed by the young architect Aranza de Ariño before she took a master's degree at Harvard Graduate School of Design. De Ariño was able to draw on a talented pool of local craftspeople for the joinery and even the concrete, perhaps buoyed and boosted by the presence of a Tadao Ando building in their midst. Concealed amid the coastal vegetation, the house fulfils its brief as a secluded retreat from reality, open to the elements but hidden from the world.

Right:
One facade is made up of wooden shutters, shaped to accommodate the built-in concrete furnishings.

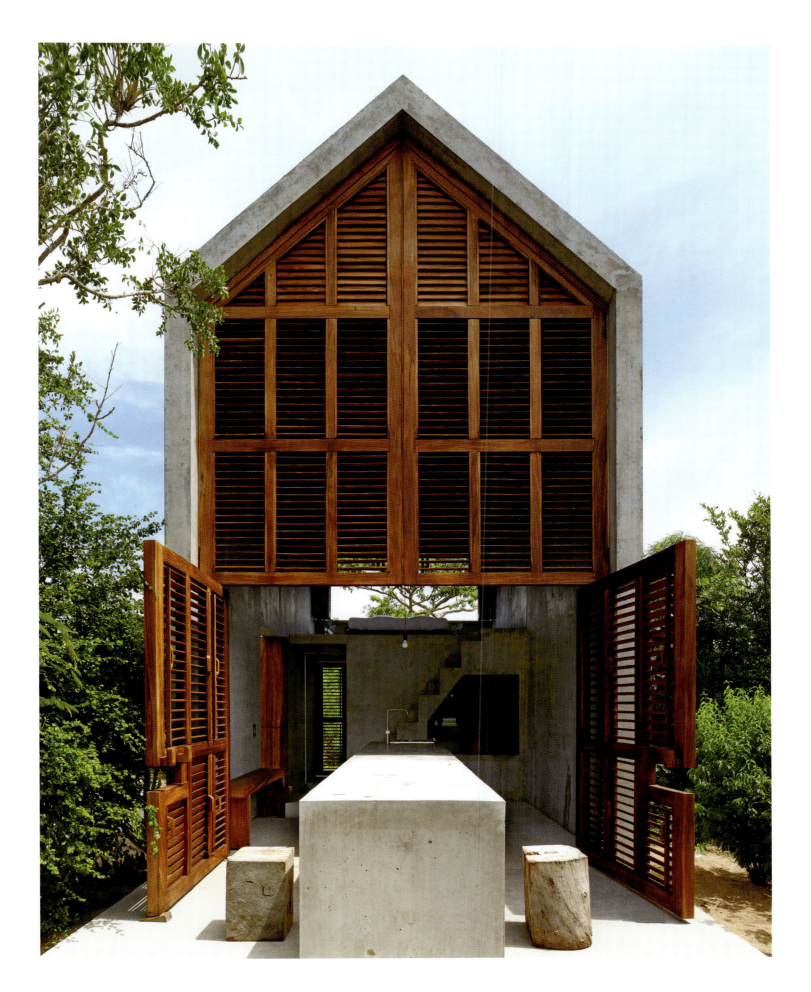

Casa Tiny

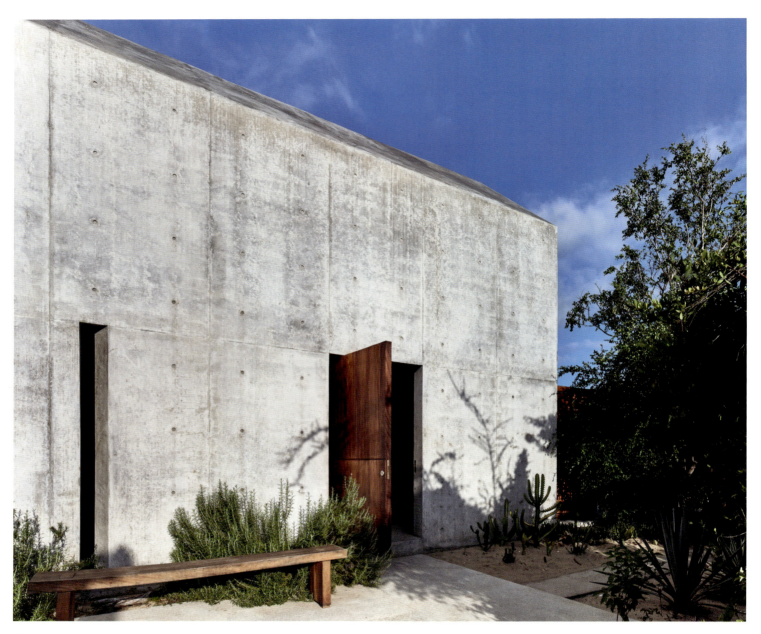

Above:
The entrance facade is modest and unadorned.

Right:
The kitchen contains an island formed from the same concrete as the structure, and a wall of shutters.

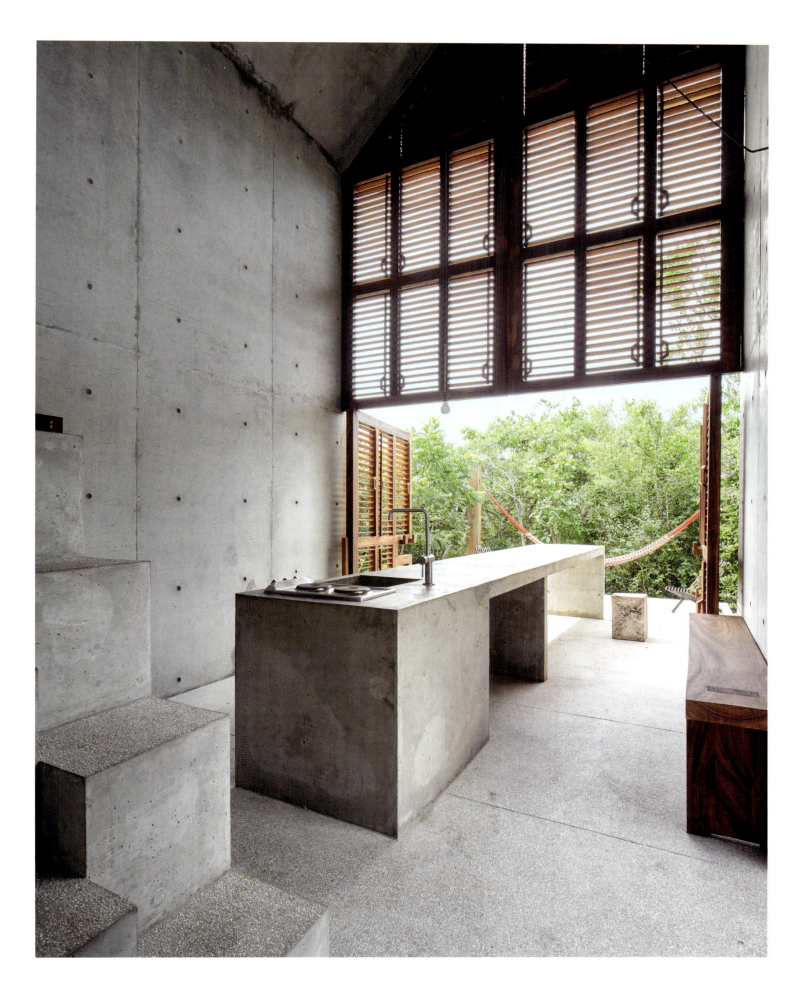

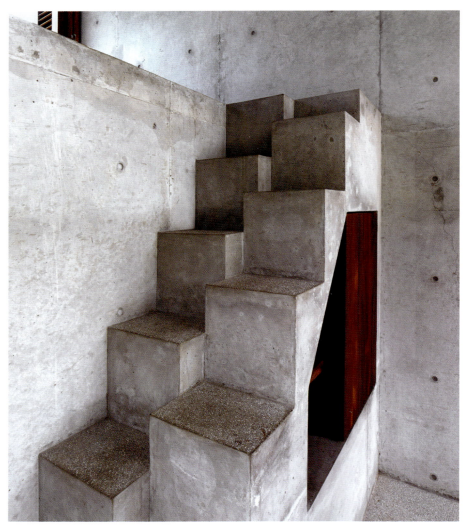

Above:
The hit-and-miss concrete staircase leads up to the sleeping platform.

Right:
The sleeping platform is raised above the bathroom, with wooden shutters and fittings contrasting with the concrete.

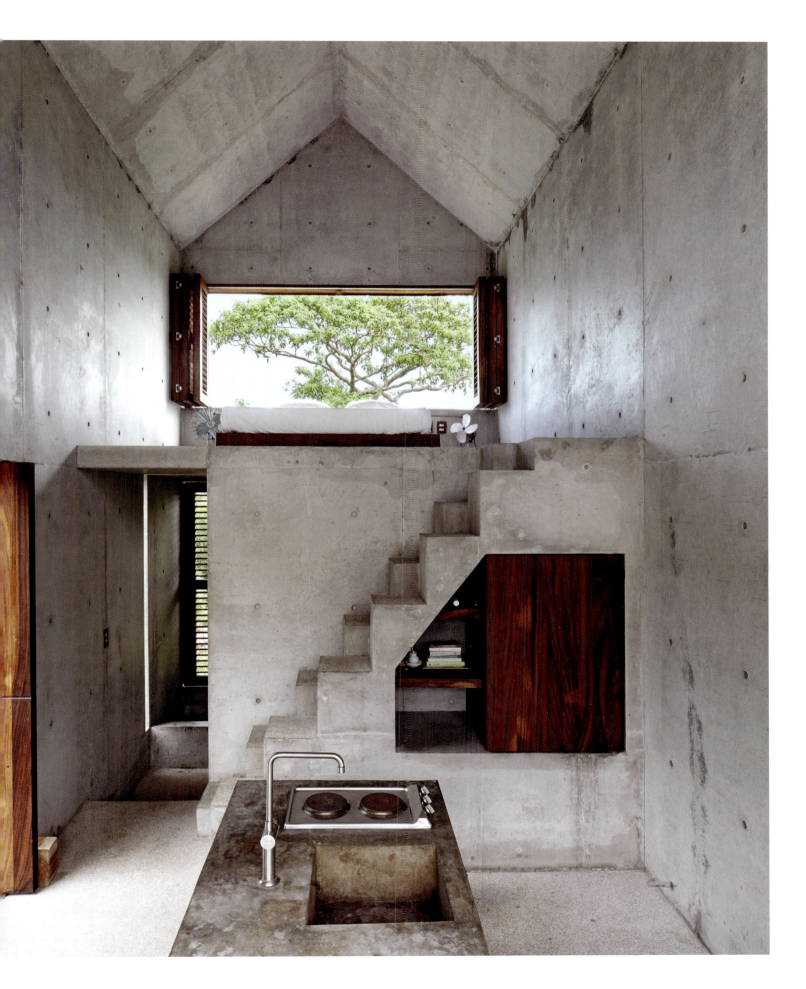

Casa Tiny 095

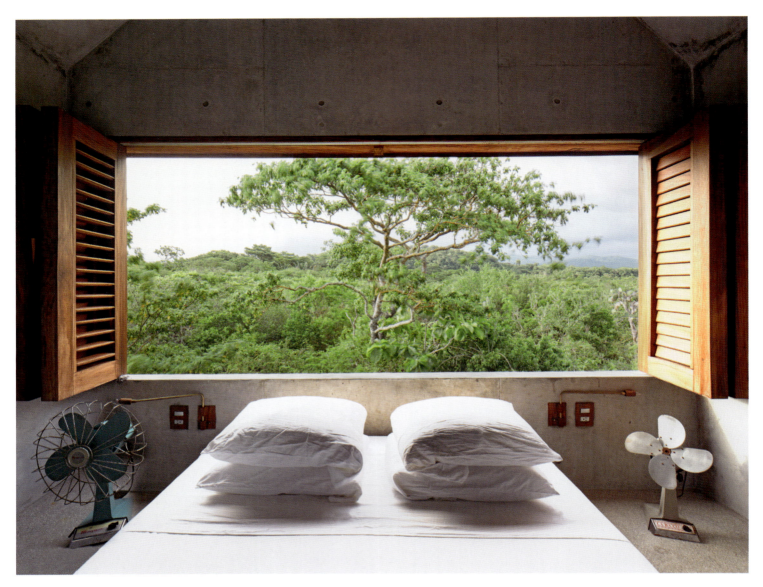

Above:
A full-width shuttered window above the bed provides far-reaching views.

Right:
A plunge pool is located off the terrace to the side of the house.

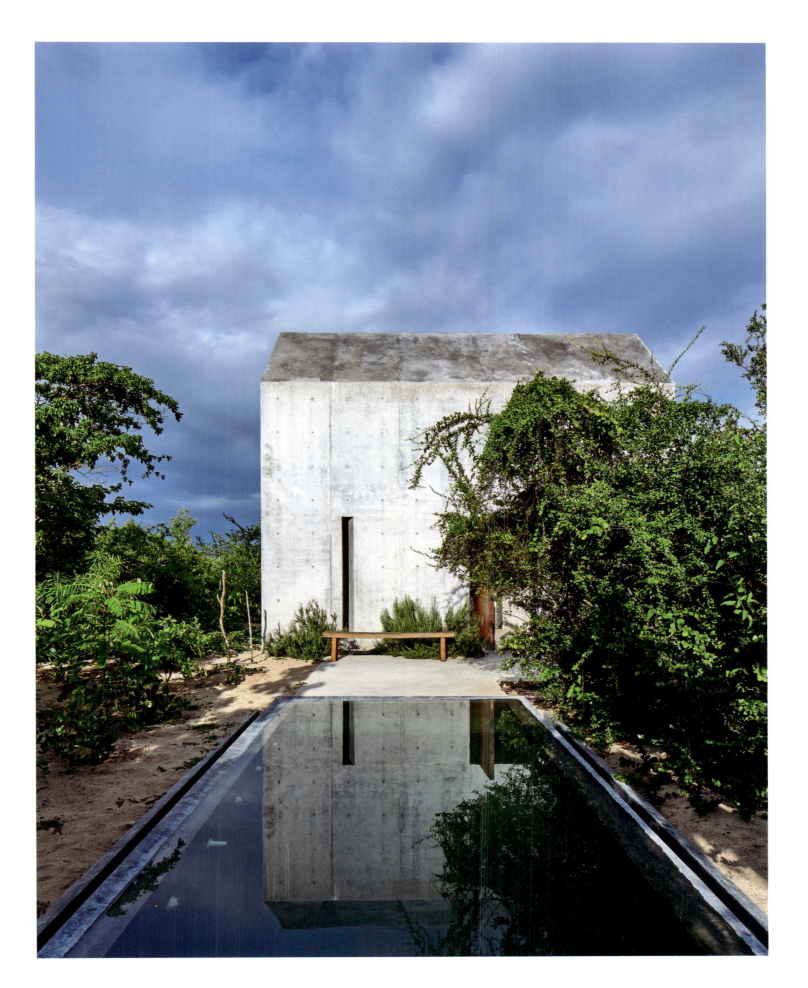

Casa Tiny 097

The concrete form rises up above the jungle.

Casa Tiny 099

CASA HMZ

Location: San Luis Potosí
Architect: Lucio Muniain et al

Set on the fringes of a golf course in the north-central state of San Luis Potosí, Casa HMZ was completed in 2023 to designs by Lucio Muniain et al (the Latin words for 'and others' signify the collaborative nature of the practice). The house presents itself as a monolithic concrete structure, whose facade is an arrangement of cubes and voids that have been pushed, pulled and extruded. Traditional readings of a domestic interior are deliberately confused. Instead, the two long facades feature an arrhythmic phrasing of form and shadow, united only by the poured-concrete walls.

Muniain describes the project as one that 'transcends conventional boundaries, drawing inspiration from a dedication to sensory architecture, inner life and the seamless integration of natural elements.' The design was developed in close collaboration with the clients, a family of six, but its key elements were those that diverted from the original brief, injecting what the architect considers a 'narrative of mystery and exploration... pathways that elevate the journey between typical domestic spaces into an immersive experience.'

The rectangular plan is corralled by the virtually impermeable ribbon of concrete at first-floor level, punctuated only by balconies, setbacks, cantilevered forms and prominent concrete gutters, adding to the sense of an impenetrable labyrinth. The openings at ground-floor level are similarly mysterious, with a semi-enclosed courtyard garden accessed via the main living space and library, with a partially open concrete pergola-style roof.

At 800 square metres (8,600 square feet), the house is expansive, creating an inner landscape that offers carefully framed glimpses and views of its surroundings. In addition to the main living spaces, the ground floor also houses the primary bedroom suite and an integral three-car garage. The monumental concrete construction bears the imprint of the wooden formwork throughout, with careful allocation of space to sliding doors, utility and storage cupboards, and staircases embedded within the plan. These raw-concrete finishes are juxtaposed with Tzalam hardwood flooring and joinery, along with travertine flooring and steel-framed windows. The first-floor landing illustrates Muniain's mastery of the interplay between light and shadow, with a cast-concrete balustrade mirrored by a rooflight that illuminates the surface via a light channel descending from the ceiling. Softly undulating wall textures are prominent throughout, with concealed slot windows and rooflights used to accentuate the rough surfaces, generated partly by the contractor's inexperience in working with the material – imperfections that were welcomed by the architect.

The upper floor is also where the floor plan is at its most dramatic. As Muniain notes, 'height, narrowness, distance, shadows and light [all] assume pivotal roles,' and the three individual bedroom suites and two en-suite staff rooms, are threaded into the concrete framework, making the most of the irregular, stepped facade. Dressing areas, bathrooms, sitting spaces and desks occupy the house's myriad nooks and crannies, with a steel spiral staircase rising up from the ground-floor library to a galleried landing of shelving.

Muniain cites Luis Barragán as an influence, albeit swapping the master's bold palette for a more sober, natural approach that emphasizes form and shadow instead. This is particularly evident in the vast concrete beams above the internal courtyard, a monolithic pergola that filters light, generates strong shadows and provides a private, secluded place for the family to sit together. Casa HMZ is a bold waypoint on the continuous line of evolution of Mexican residential architecture. Aesthetics are dominant, but function is never forgotten.

Right:
The house presents a Brutalist facade to the landscape.

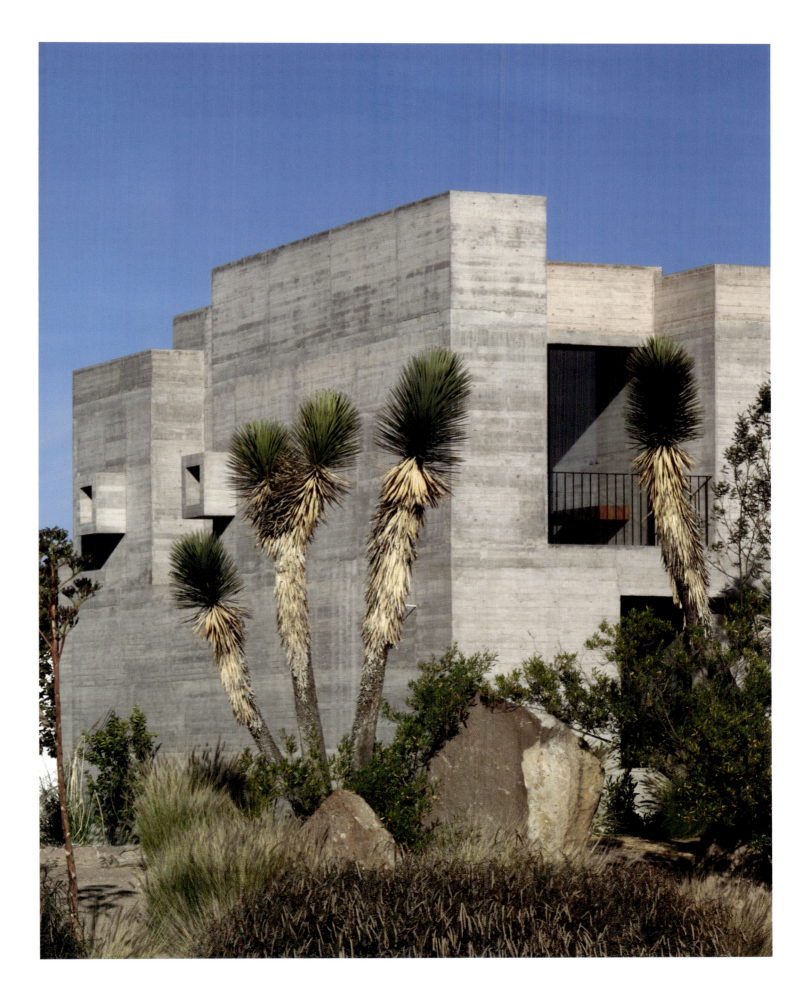
Casa HMZ

The facade is a series of vertical planes, creating an asymmetric, rhythmic composition.

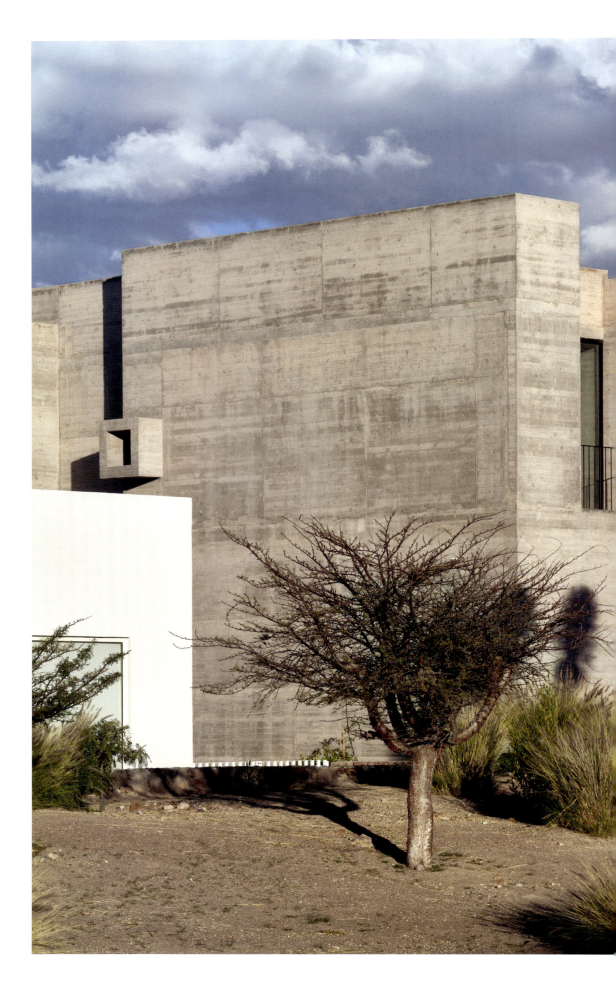

102 Experimental Structures

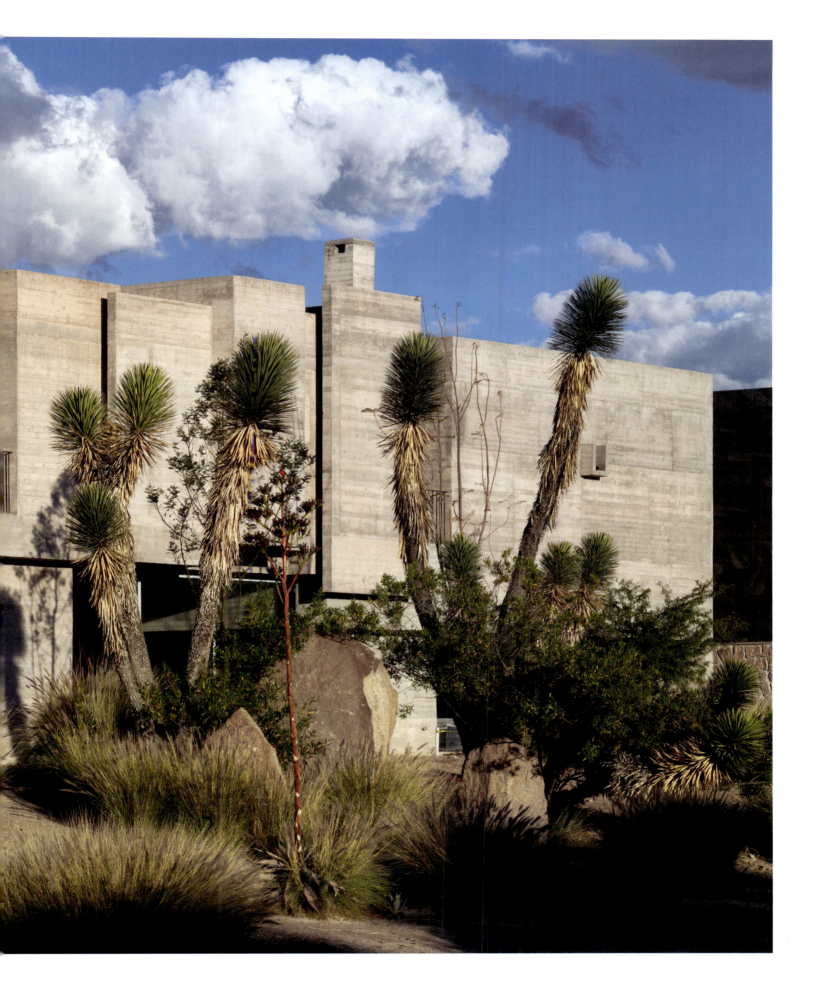

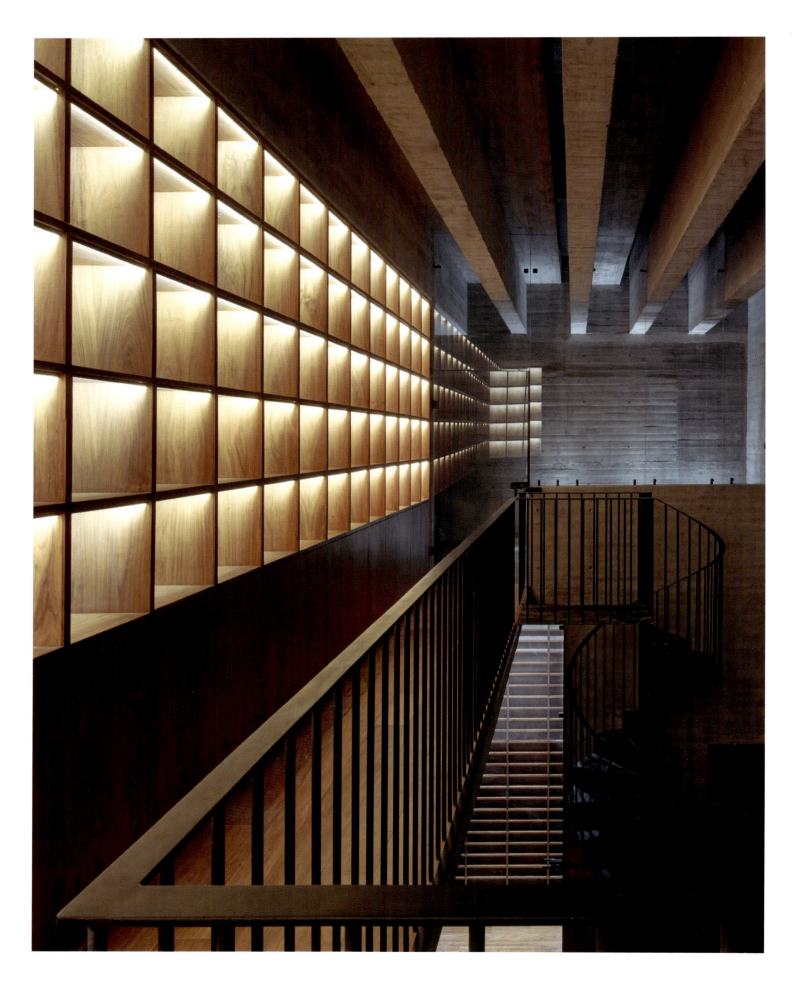

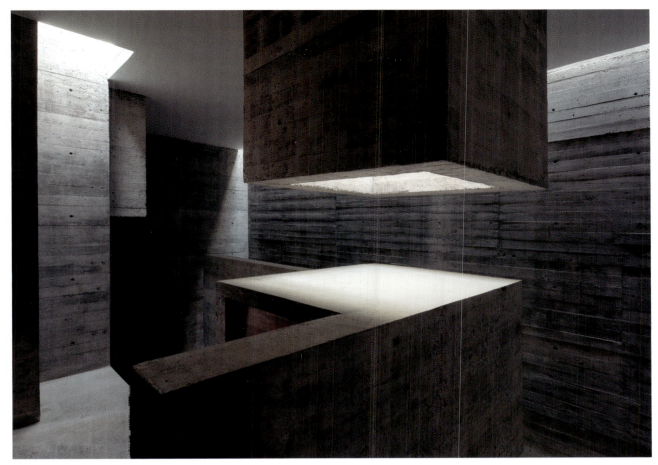

Above:
Natural light is carefully filtered through rooflights, some concealed, some made into prominent features.

Left:
The dramatic double-height interior space with galleried library beneath a concrete-beamed ceiling.

Right:
The concrete is offset by an elegant folded-steel spiral staircase.

Following spread, left:
The covered terrace also features prominent roof beams, creating an indoor-indoor space for socializing.

Following spread, right:
The layered facade highlights the changing play of light throughout the day.

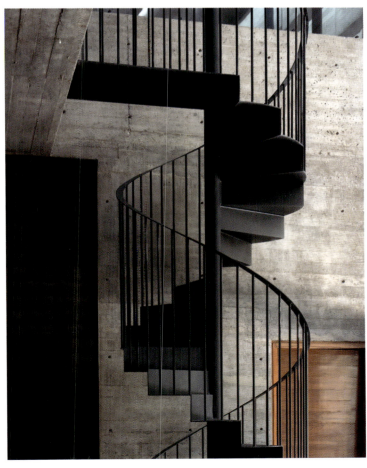

Casa HMZ

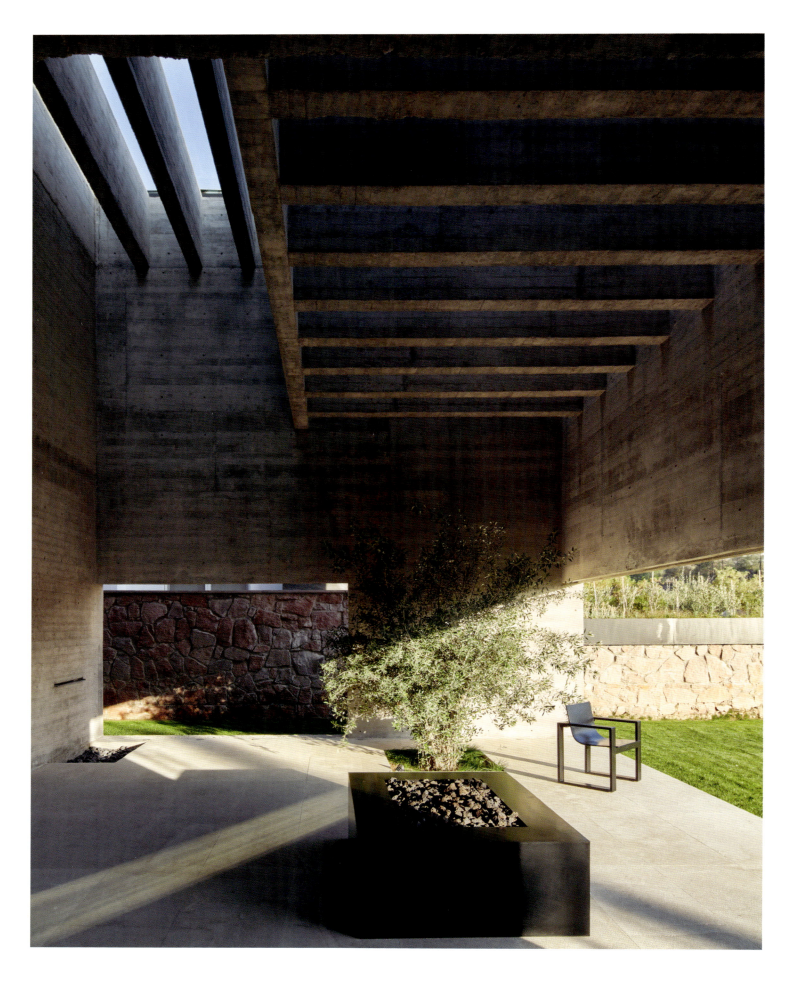

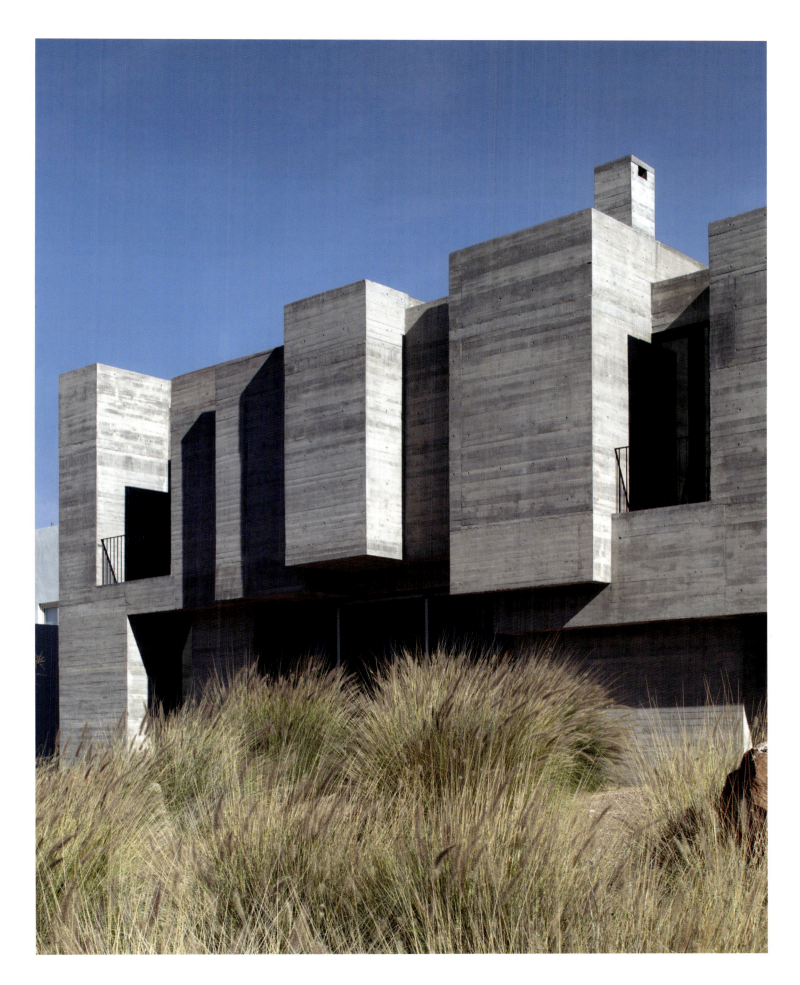

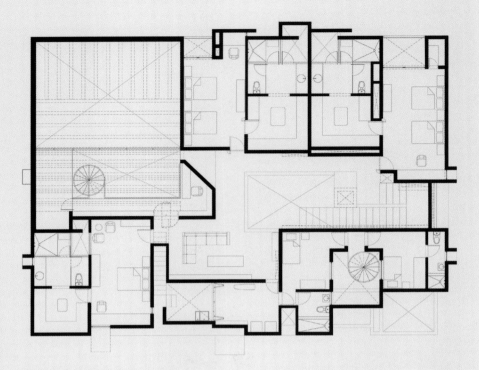

First-floor plan

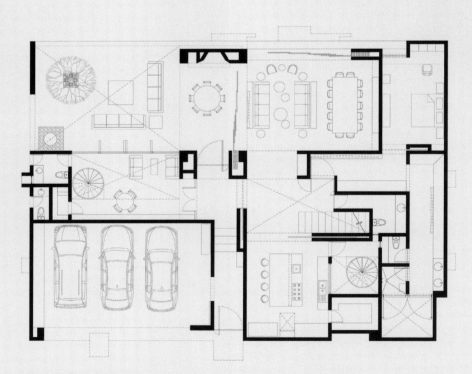

Ground-floor plan

Experimental Structures

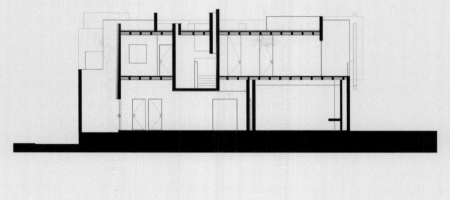
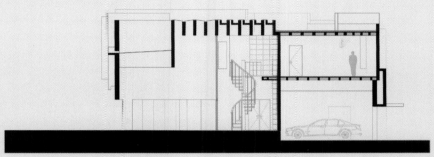

Sections

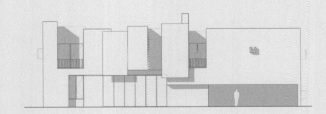

Elevations

ZONCUANTLA APARTMENTS

Location: Xalapa, Coatepec, Veracruz
Architect: Rafael Pardo Arquitectos

Zoncuantla Apartments rise from their forested surroundings like a Jenga tower or a piece of industrial architecture. Built on a sloping site in Xalapa in the municipality of Coatepec, east of Mexico City, the stack of apartments was designed by Rafael Pardo Ramos. Interwoven floor plans see the four apartments arranged across seven levels, with three set below entrance level. Despite this, neither the building's sense of verticality or the views available from each apartment are compromised.

The ground-floor level is effectively the fifth storey above the valley floor, and contains a two-bed triplex that occupies the top three floors of the building. The second apartment is arranged laterally across the two floors below, dovetailing with the third more expansive apartment that is spread across two floors. Finally, a studio is located at the lowest level. In total, the built area accounts for 470 square metres (5,060 square feet) of the 860-square-metre (9,257-square-foot) plot, but with the inclusion of green roofs and courtyards, the architect has ensured that over 50% of the site is given over to green space.

The primary material is shuttered concrete, left exposed inside and out, with the rough strata created by the boards adding a layer of texture that is amplified by surface lighting in the evenings. Openings are filled with frameless glass, which not only preserves the sculptural form of the entire structure but gives tantalizing insights into the layering of the apartments and the different volumes contained within the building. In particular, concrete staircases – with clear glass balustrades – can be seen criss-crossing the interior, giving the concrete facade the appearance of a skin enveloping a series of interlocking spaces.

This puzzle-like quality is further enhanced by the physicality of the concrete interior elements – not just staircases, but walkways, balustrades, ledges and columns, all of which offer a solidity and complexity that demands exploration and contemplation. Appropriately enough, the apartments were designed for short-term lets, the best way of conveying the sense of discovery and immersion in what is both building and artwork.

At the base of the apartment block, the concrete gives way to locally quarried stone walls. The inclusion of planted green roofs and a grid of terraced gardens that expands out from the plan of the structure helps integrate the building into its surroundings, despite its clear Brutalist credentials.

Right:
Set on the slopes of a valley, the apartment building rises up like a compact skyscraper.

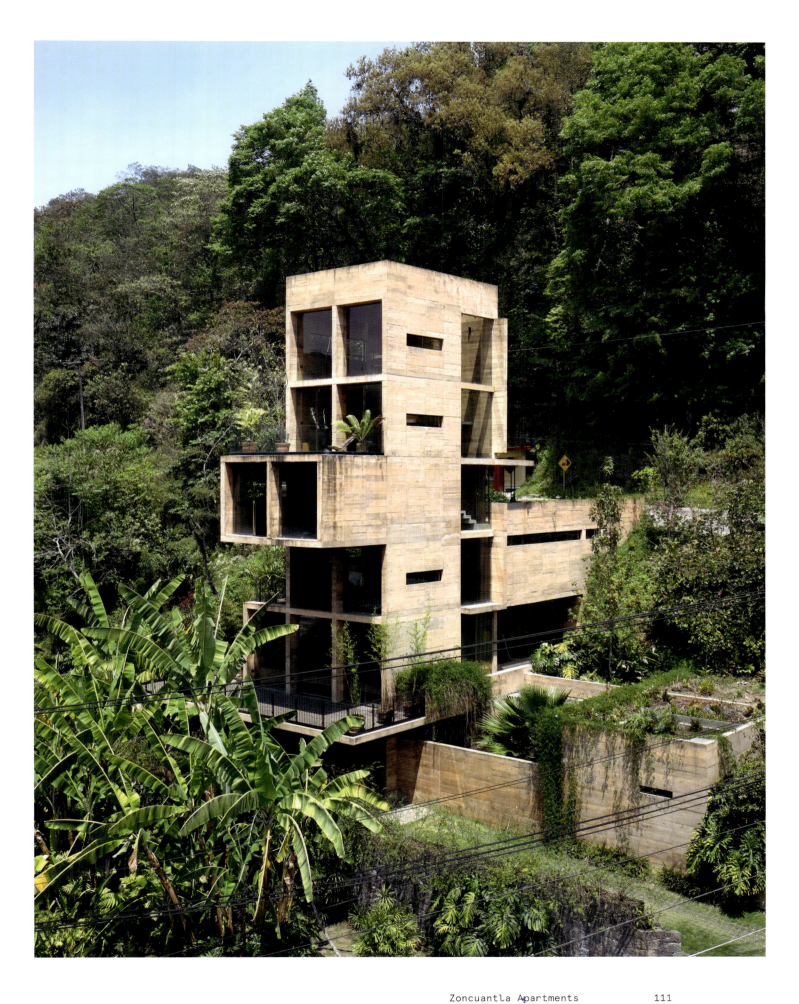

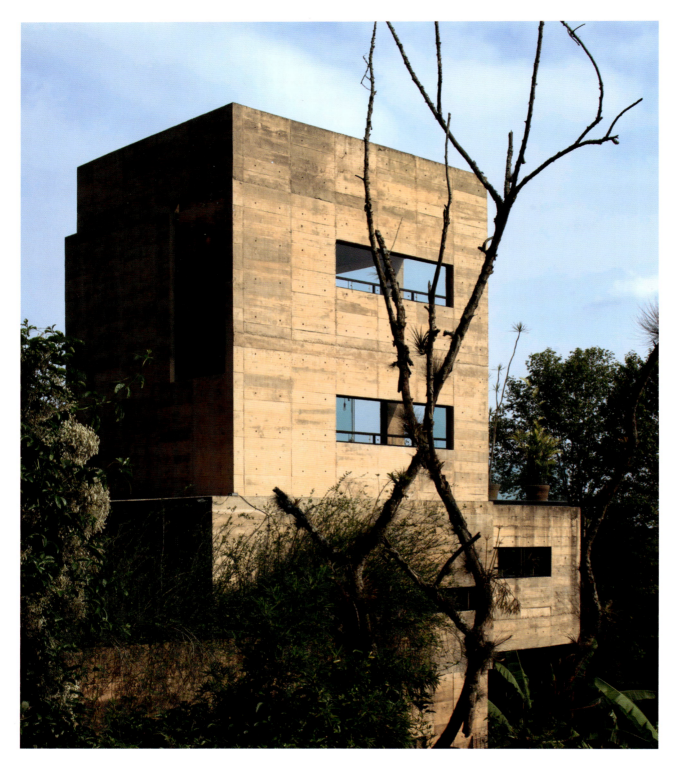

Above:
The structure is built from concrete with a reddish hue, with simple frameless windows integrated into the facade.

Right:
The house comprises four apartments set across seven levels, with staircases clearly expressed behind the glazing.

112 Experimental Structures

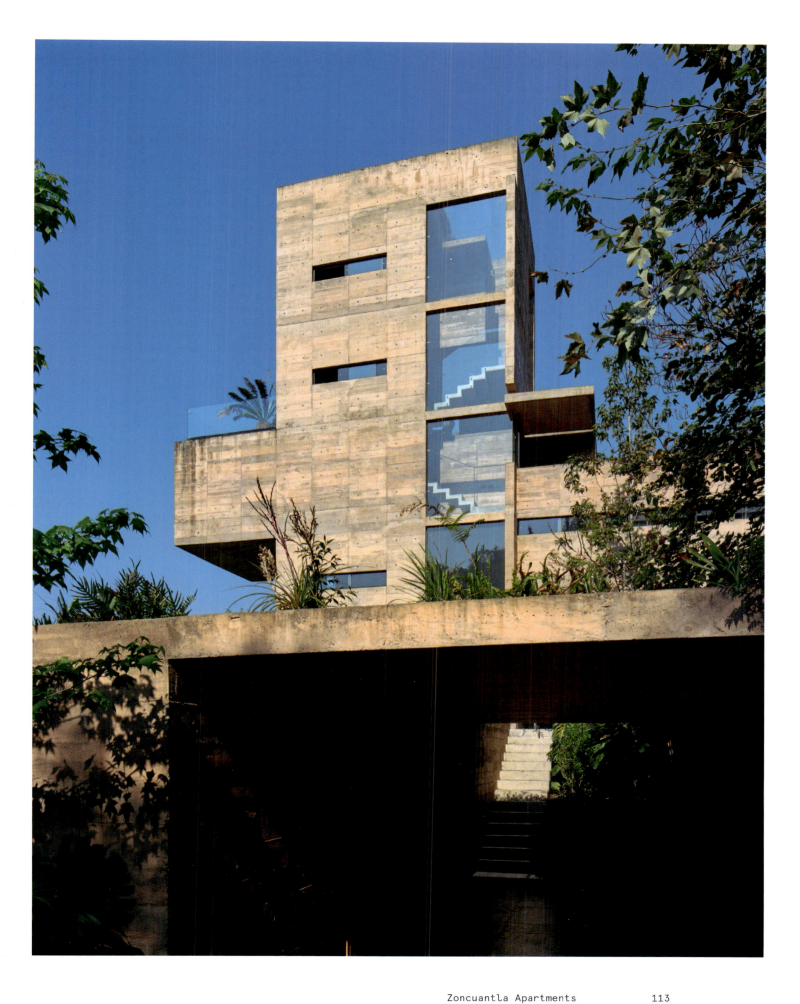

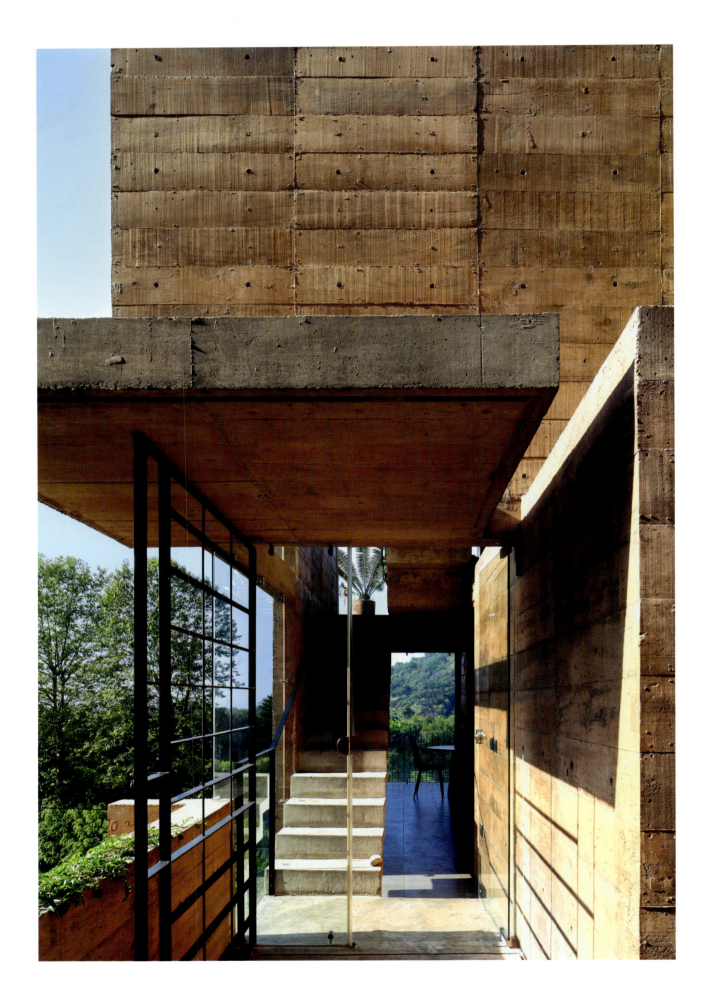

114　　　Experimental Structures

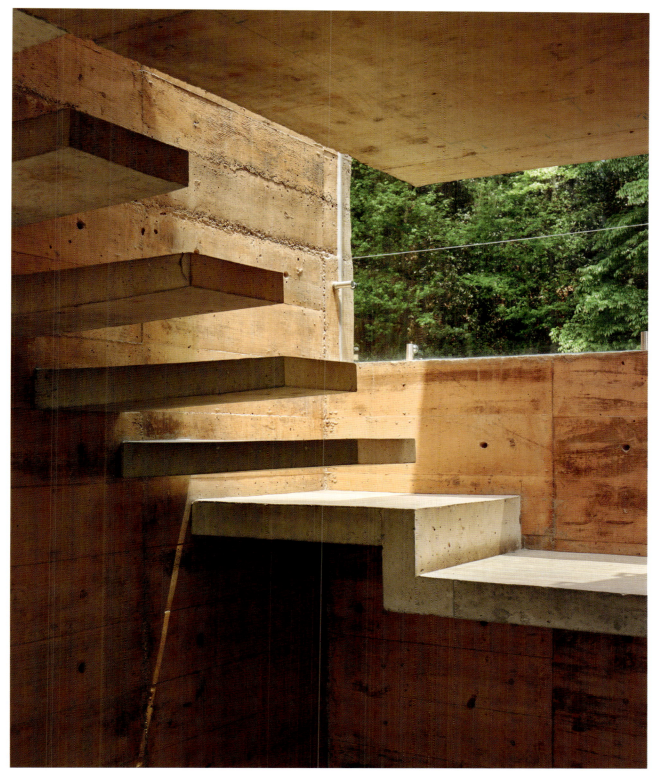

Left:
Small uniform boards were used to create the shuttering for the concrete, giving the house a rich textured surface.

Above:
Cantilevered concrete steps and frameless glass balconies and balustrades are just some of the consistent details across the structure.

Zoncuantla Apartments

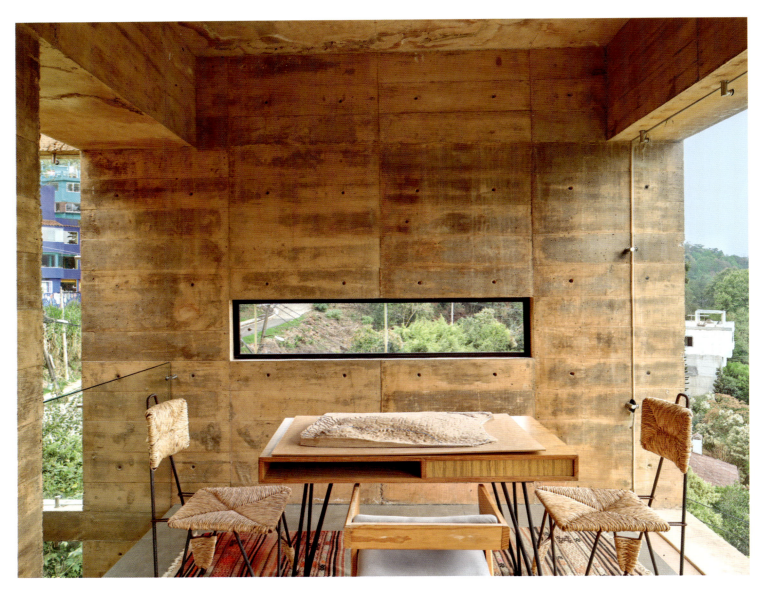

Above:
Smaller windows are paired with vast openings and terraces.

Right:
Some of the apartments span different levels, creating vertical views and dynamism throughout the space.

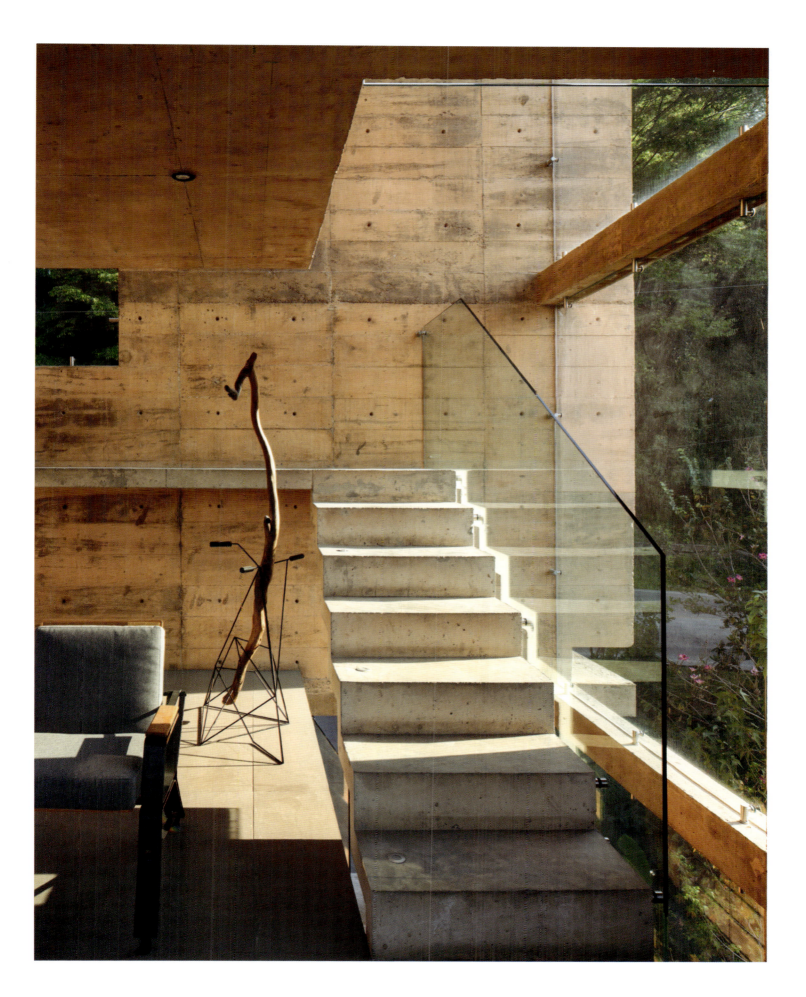

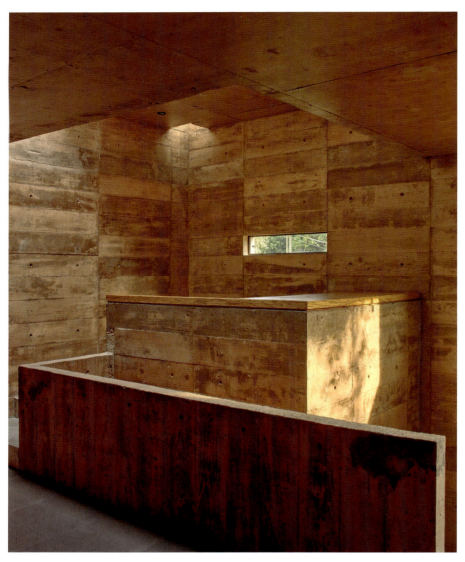

Above:
Concrete finishes are paired with wooden detailing at the top of the primary staircase.

Right:
Dusk highlights the many openings, terraces and windows within the structure.

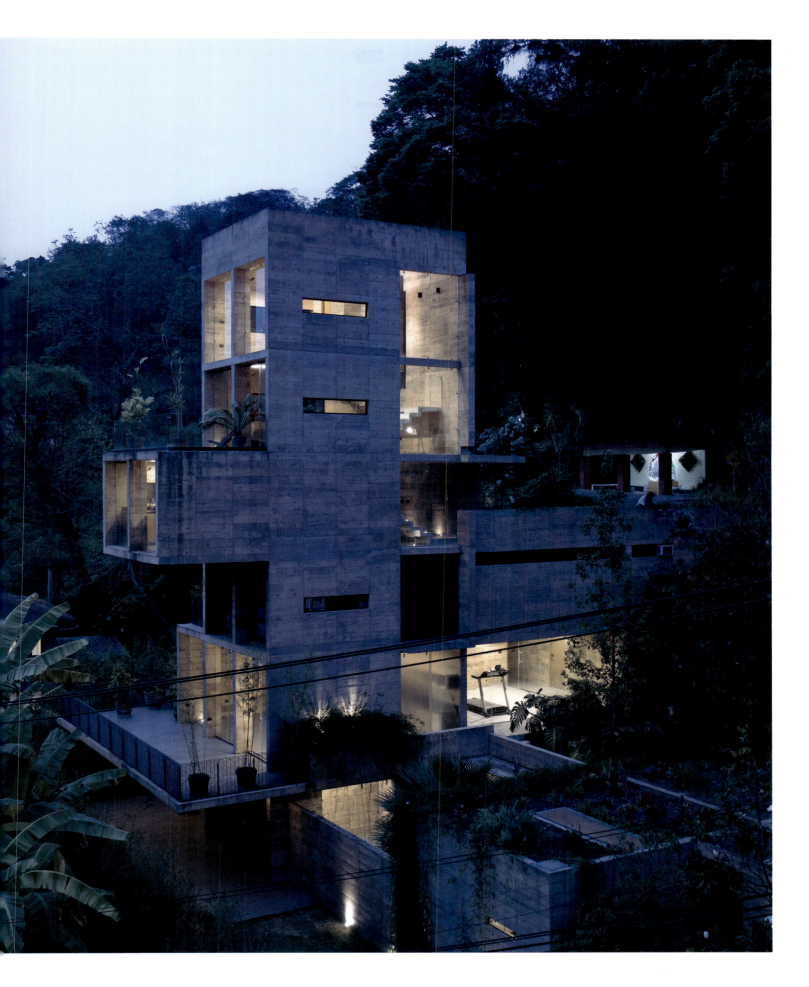

Level -1 plan

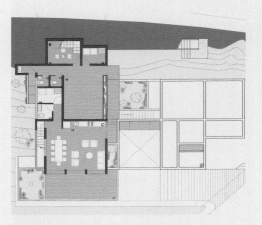

Level -2 plan

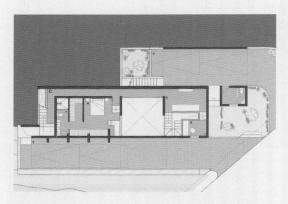

Level -3 plan

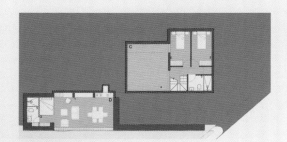

Level -4 plan

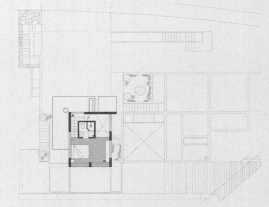

Level 2 plan

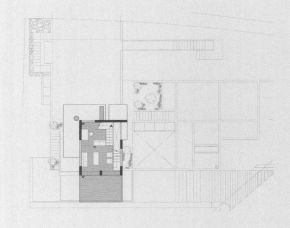

Level 1 plan

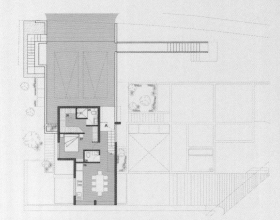

Entrance-level plan

120 Experimental Structures

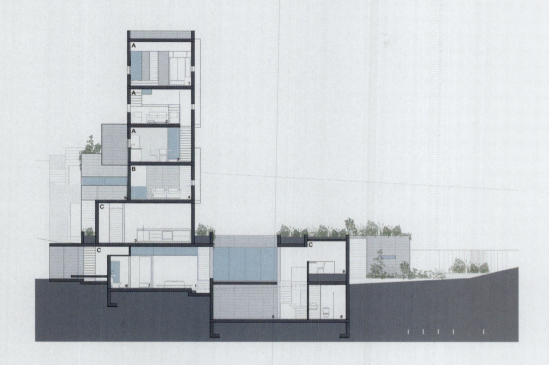

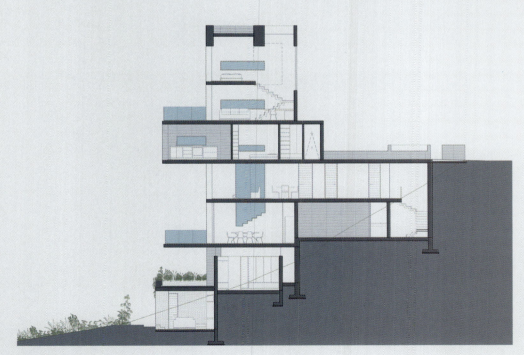

Sections

THE HILL IN FRONT OF THE GLEN

Location: Morelia, Michoacán
Architect: HW Studio

Landscape architecture and raw Brutalism come together in this house in Morelia by HW Studio. Known as The Hill in Front of the Glen (La Colina Frente a la Cañada), the project is an epic blend of earth-moving and concrete construction. According to the architects, the origins of the plan were the 'client's search for protection and shelter', and the idea of pulling up a bedsheet around oneself for security was used as a metaphor for the kind of comfort and enclosure required.

By translating this image into the forested landscape of Morelia, HW Studio has created a house that doubles up as a piece of land art, a ribbon-like structure threaded through the existing retained trees. The 'sheet' is a field of grass, raised up above a concrete undercroft that serves as the blanket fort of the client's imagination. 'Pulling up a bed sheet is a very elemental act that alludes to the most basic part of the self,' the architects write. 'A bed sheet hides, protects, wraps and creates a space underneath so safe and intimate that it is able to keep away any spirit, ghost, or demon that may be surrounding the room.'

The great advantage of this approach, aside from the sense of spiritual and physical protection, has been the preservation of the existing landscape. Arranged in a long, linear plan, the house is accessed via a sunken concrete walkway, which leads one deep into the artificial 'cave'. Atop this 'hill in front of the glen', the landscape has been left au naturel, with naturalistic planting and reshaped contours.

Physically, the house appears as four concrete walls in the landscape: two framing the path and two appearing to support the landscape above as if they were a bridge inserted into the hillside. The floor plan is bisected by the entrance hall, with kitchen, dining and seating areas arranged in a row in an open-plan, shallow vaulted space that occupies the entire north facade. These spaces overlook the woodland through a semicircular glazed wall.

To the south are three bedrooms, each facing south into a sunken courtyard for total privacy. Raw concrete is used throughout, paired with solid-wood floors and built-in furniture and storage. The cave-like qualities of the space are enhanced by the curved ceiling, as well as the sunken entrance path, which kinks slightly to accommodate a large mature tree. The architects note that 'this path is wide enough to walk it comfortably alone but too narrow to do it accompanied,' meaning that visitors to the site are 'cast into a solitary pilgrimage'. The path leads down stone steps, through a steel door into the concrete cave.

The wooded environment of the world outside the windows provides a constantly changing contrast to the greys of the concrete vaults. Wherever possible any incursion by modern technology is concealed, with kitchen appliances hidden away, lighting set into floors and soffits, and simple bespoke details created throughout, such as the steel hanging rails in the bedrooms. The limited palette of stone, wood, steel and concrete adds to the monastic mystique and sense of isolation.

'It was very important for the client to preserve the rough and primitive atmosphere of the mountains,' say the architects. 'In this case, the architecture is an accent mark on the words of a poem – a comma or question mark, for example. It should never be the poem itself. The poem is already created by the pines, the oaks, the sweet acacia, the fireflies, the road, the fence, the neighbour's water well, the earth, the orchard and the nightingale.'

Right:
Tucked beneath the forested landscape, the house is a contemporary cave formed from concrete and glass.

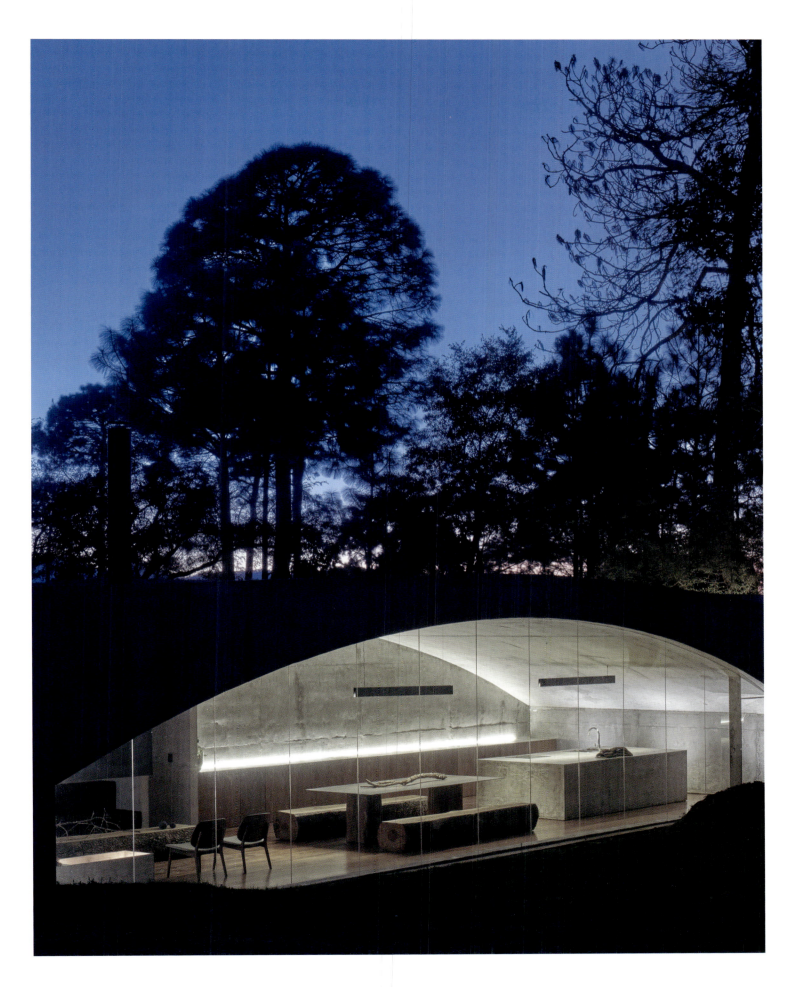

The Hill in Front of the Glen

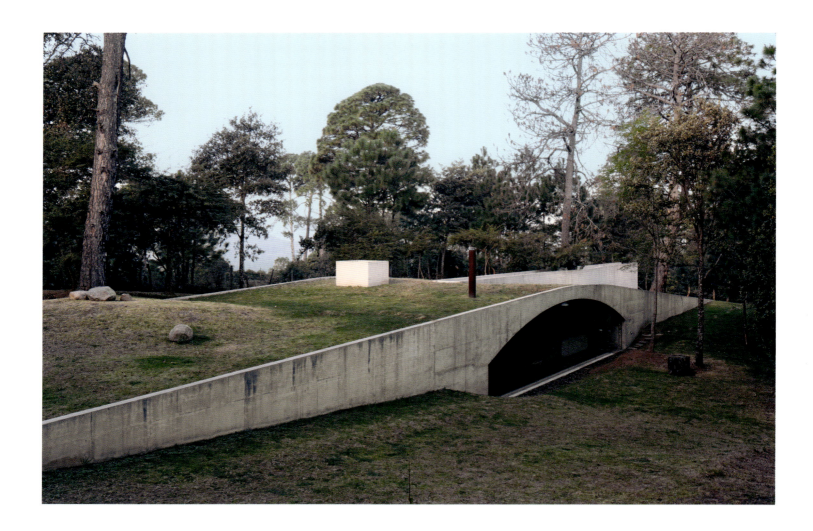

Above:
The house has a strong affinity with engineering infrastructure like bridges and tunnels.

Right:
The sunken entrance pathway is deliberately kinked to accommodate this mature pine tree.

Experimental Structures

The Hill in Front of the Glen

Right:
Cell-like rooms direct all their focus on to views of the forest.

Far right:
Slender glazing bars dissolve the barrier between inside and outside.

Below:
The main living space, with its minimal, Brutalist wooden furniture, sits at the heart of the house.

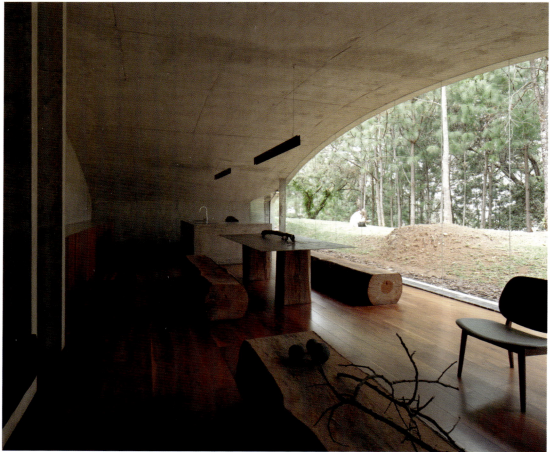

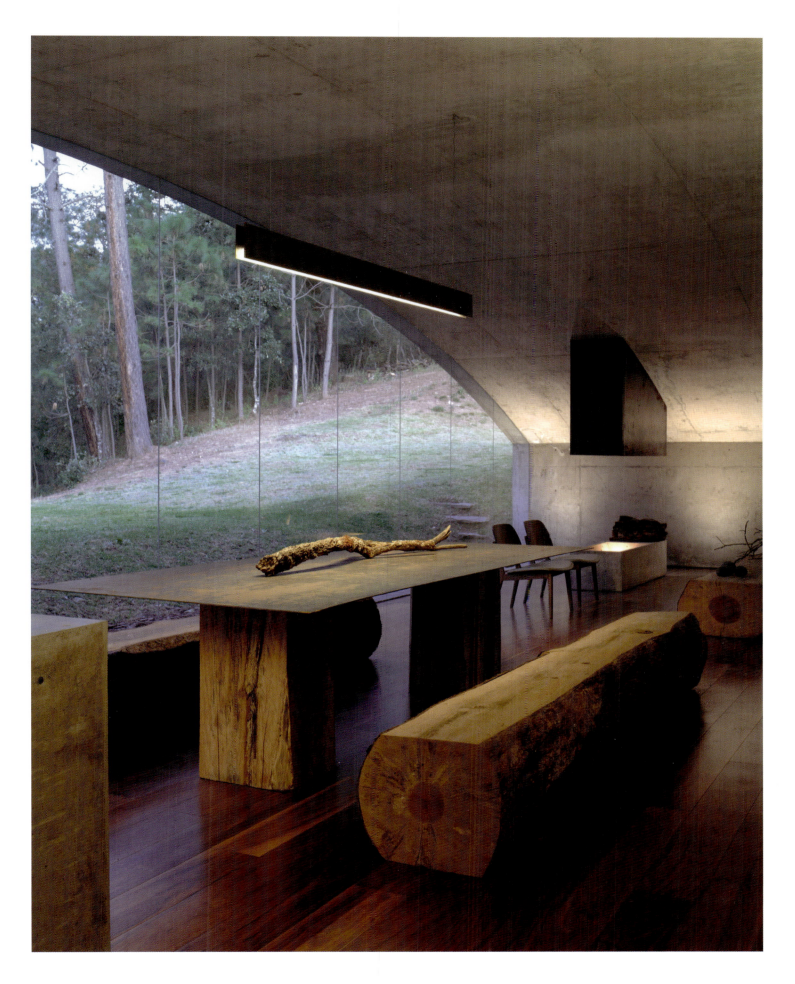

Section

Concept sketches

128　　　　　Experimental Structures

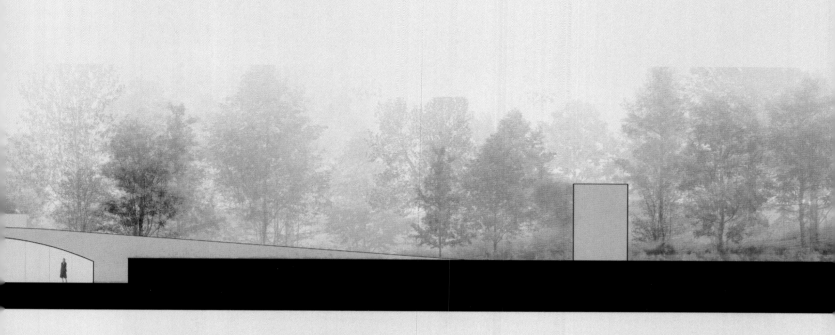

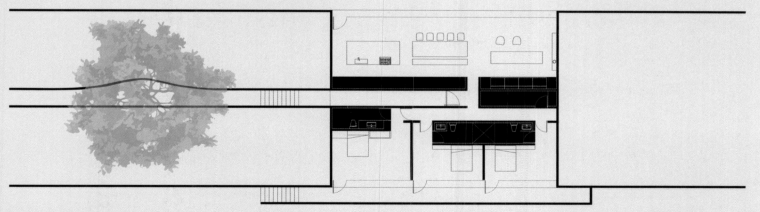

Floor plan

The Hill in Front of the Glen

CASA 720

Location: Valle de Bravo
Architect: Fernanda Canales Arquitectura

Set in the heart of the country, due west of Mexico City, La Reserva Peñitas is a sustainably focused development area close to the popular lakeside town of Valle de Bravo. Fernanda Canales's Casa 720 is an off-grid retreat arranged around a single-storey, circular floor plan. The plot is part of the 182-hectare (450-acre) site, in which there are lakes, ponds and untouched natural landscapes, alongside amenities like a lakeside social area, cafeteria and store, camping site, sports facilities and 16 kilometres (10 miles) of paths.

The project had its origins during the pandemic, when the architect's clients requested a design for a single-family weekend house in the community. As the project evolved, and the impact of the pandemic shifted attitudes and circumstances, the design was refined into a 1,000 square-metre (10,800-square-foot) structure that could accommodate three separate families, all with their own space to live and socialize.

Canales describes the project as consisting of 'many houses in one', with the long interior and exterior perimeter walls setting up very different outlooks and atmospheres. The former looks inward into the large circular central courtyard, a Zen-infused space laid with small pebbles and a solitary large boulder. The disc-shaped plan is divided into segments, united by covered walkways that thread themselves in and out of the structure, with various sections left open or transparent to create landscape views from within. Other sections are obscured by the monolithic walls and roof structure. The local soil was mixed into the concrete, using a handheld cement mixer, giving the structure a warmth and texture that sits easily in the natural surroundings.

The exterior character is quite different, as the views out are more varied and distinctive. In addition, the roofscape presents another character altogether. Just as certain interior angles make it hard to discern any domestic elements, the unadorned, geometrically precise roof terrace gives the structure the feeling of a ceremonial space or unknown monument.

'It is an extroverted house during the day, framing a mountain and a volcano, and another house during the evening, one that's completely introverted,' says Canales, who also points out that the form acts as a vast solar clock to track the passing of time through shifting light and shadow. Other paradoxes include the incorporation of rigorously straight and squared-off spaces in all the internal rooms. 'The circular-shaped walls are left only for circulation spaces, which extend as terraces towards the courtyard and as gardens towards the exterior,' says Canales.

In keeping with the spirit of La Reserva Peñitas, Casa 720 has been designed to be self-sufficient, with rainwater harvesting and solar-powered electricity. The climate varies wildly in this spot, by up to 30 degrees in a single day, with high levels of annual rainfall. The form allows for natural cross-ventilation throughout, with radiant underfloor heating using solar-heated rainwater. Local wood was employed for much of the interior fixtures and fittings, and even elements like lamps and furniture were built on site.

The concrete structure is hard-wearing and low maintenance, and Canales draws parallels between the stealthy texture of the material and the porous nature of the plan: 'Varied sequences and openings, sometimes through lattices that create privacy, sometimes through large windows that can open fully and hide inside the walls in order to transform interior spaces as open terraces, and sometimes through windows that frame particular views, make the house a transforming element that integrates with nature.'

Right:
Set at the foot of a soaring cliff face, the house makes a deliberate geometric counterpoint to its wild surroundings.

Experimental Structures

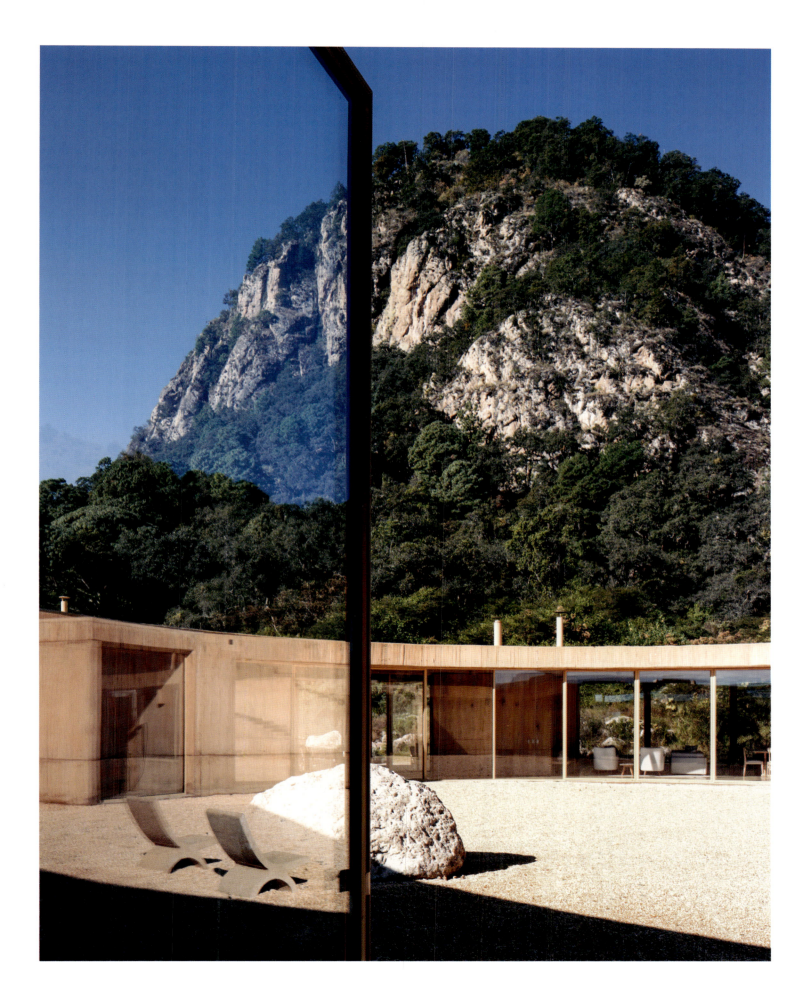

Casa 720

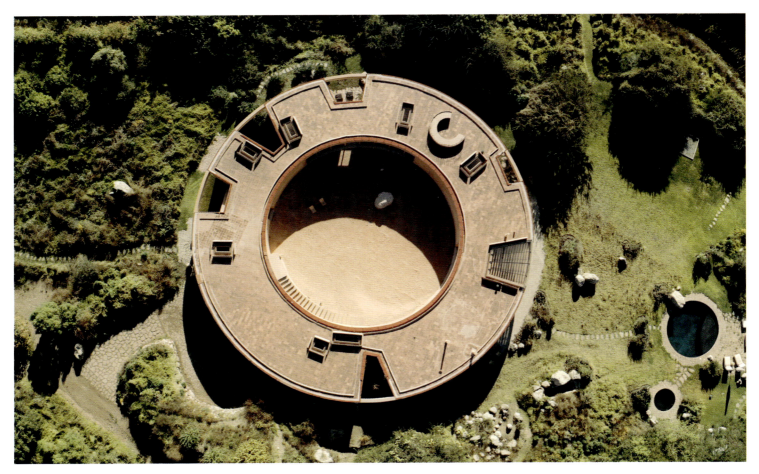

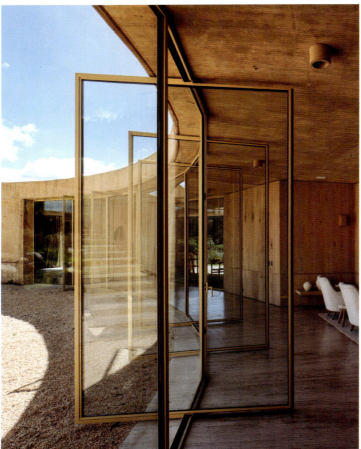

Above:
The house's perfectly circular form is revealed in this aerial view.

Left:
Pivoting doors open up the house to the internal courtyard.

132 Experimental Structures

Below:
The landscape is visible from within the central courtyard.

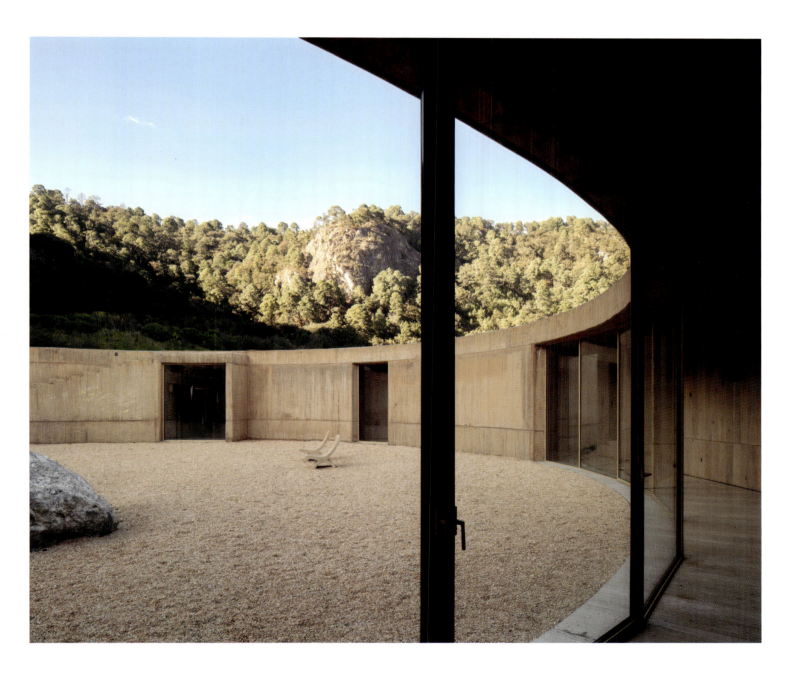

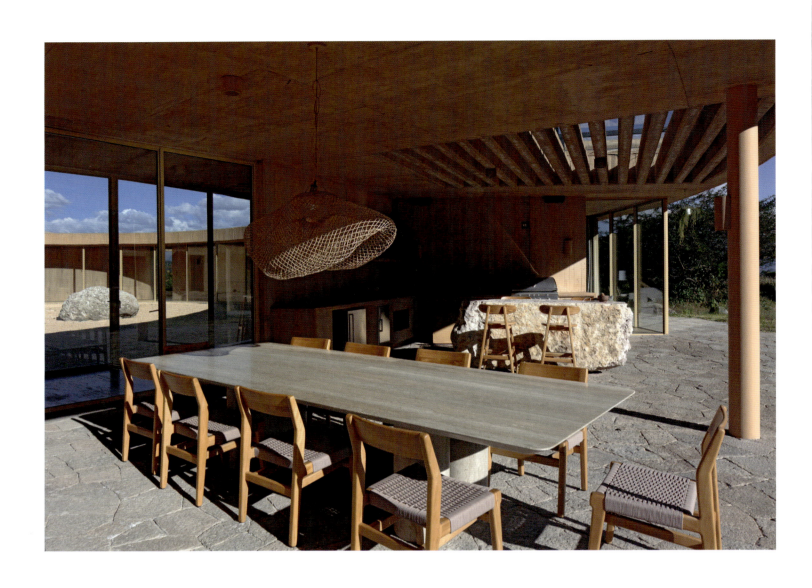

Above:
A covered outdoor living and dining space.

Right, clockwise from top left:
The main living room; a sculpture framed against the courtyard; a suspended fireplace in the outdoor living room; and the staircase to the roof.

Following spread:
The courtyard at dusk, with the mountains creating dark forms looming over the low-slung house.

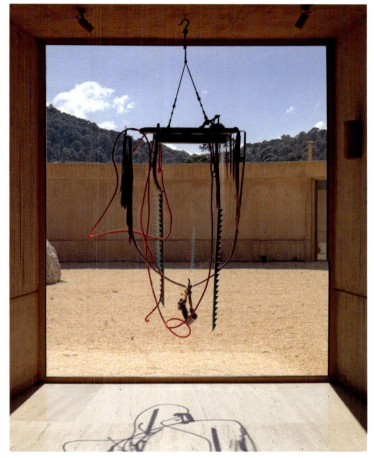

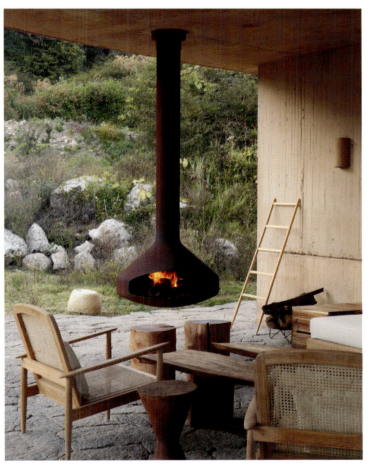

Casa 720 135

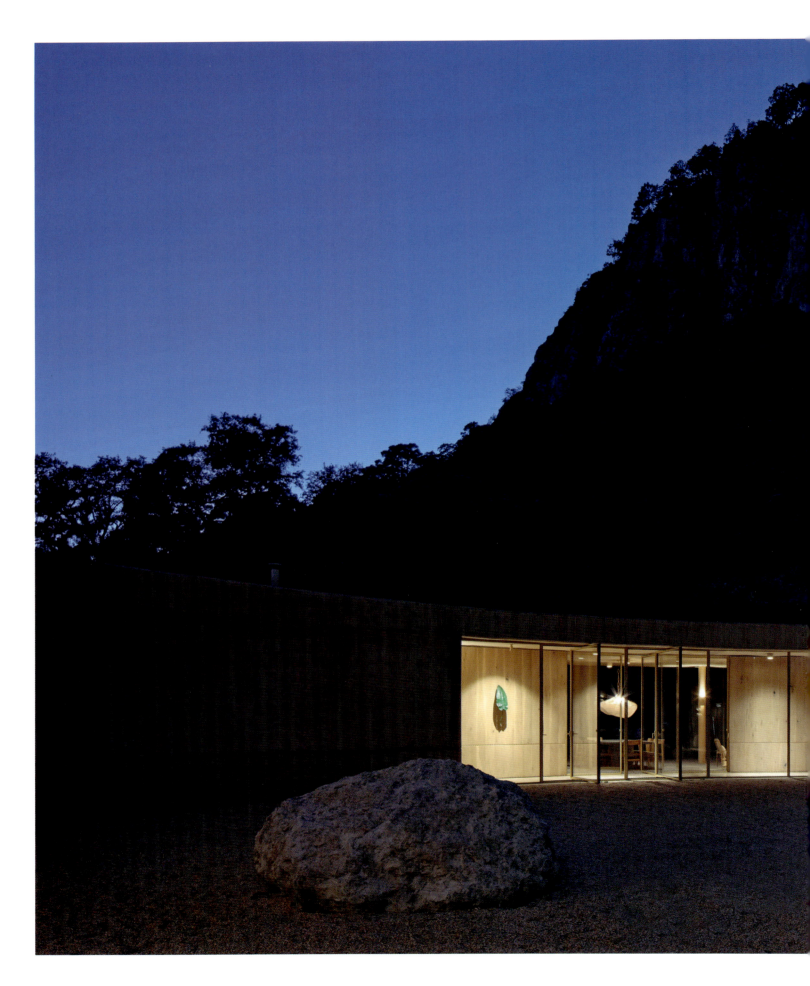

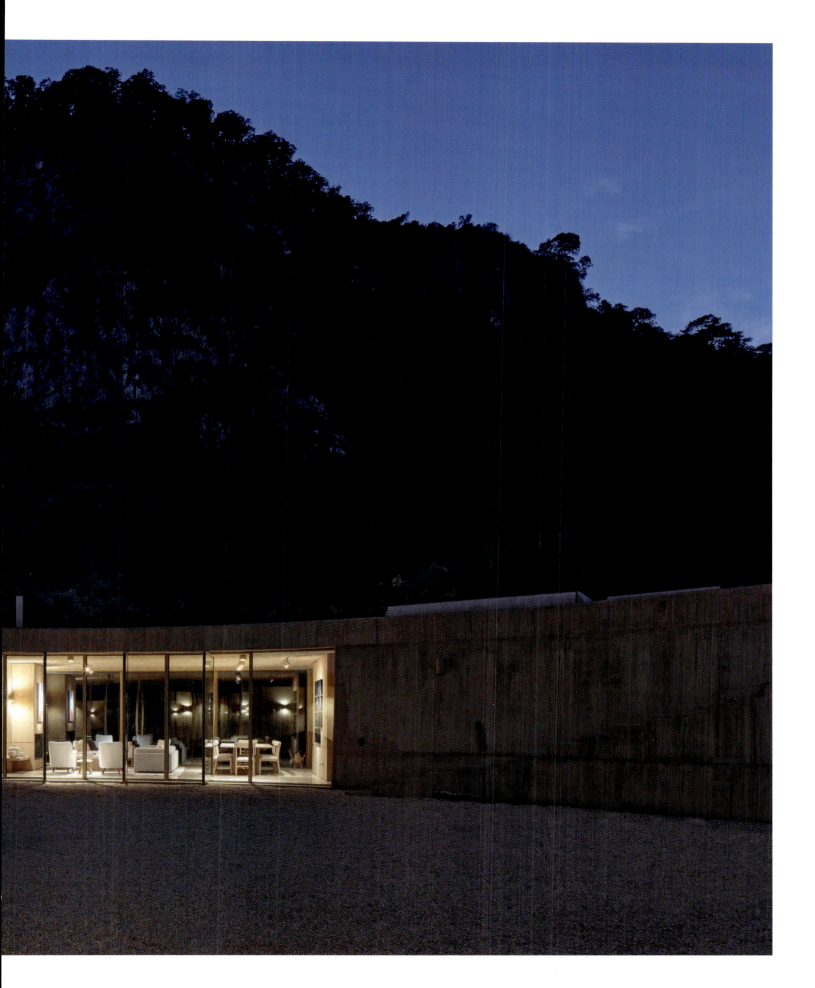

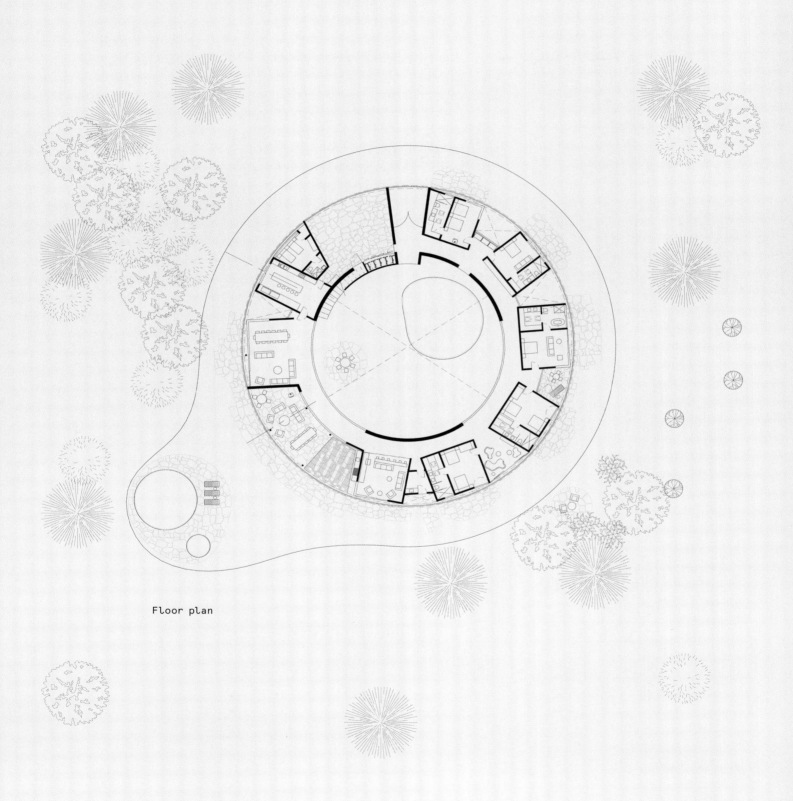

Floor plan

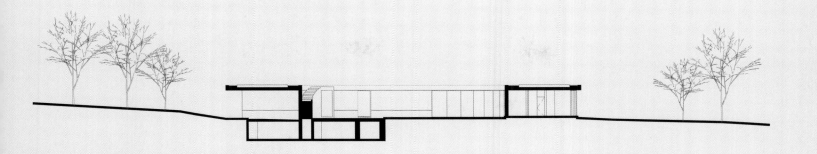
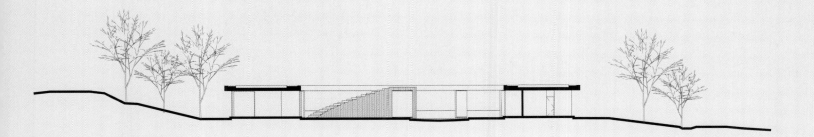

Sections

CASA ALFÉREZ

Location: Cañada de Alferes
Architect: Ludwig Godefroy

A fortress in the woods, Casa Alférez stands in a clearing in a pine forest about an hour from Mexico City. Designed by architect Ludwig Godefroy, this two-bedroom holiday home is deliberately stark and unrefined, a raw concrete shell punctured by windows and slots, with a shielded front door and a dramatically sculptural roof terrace.

Godefroy shaped the house in the form of a precise cube, treating the programme as a three-dimensional puzzle. Instead of being divided into conventional floor levels, Casa Alférez is arranged across five half levels; the house must be read in terms of its section as well as its plan, as different levels interlock as they ascend from the forest floor to the roofscape. The cubic form is deliberately alien and antithetical to the sylvan landscape – the architect has spoken of it resembling a cube that appears to have crashed on to the site.

Inside, the house eschews obvious creature comforts in favour of creating an expressive, textured shelter. The concrete bears the board marks of the framing structure inside and out, with practically the only concession to a varied palette being the blond-wood doors and floors, and the windows. Everything else, from shelves to bed platforms, kitchen counters to tables, sinks, shower trays and canopies, is formed from monolithic concrete. The front door is reached via a set of rustic stone stairs and is concealed beneath an angled wall that appears to rest against the facade, giving the impression of bracing the house against the slope. A secondary opening, set behind an oversailing curved cantilevered canopy, allows the kitchen and dining space to open up to the exterior. Other than that, the house appears impenetrable and fortress-like.

This feeling is accentuated by the high window line and sloping walls that allow light to cascade down into the interior without a hint of what lies within. Conversely, the views out show only trees and sky, further enhancing the sense of isolation and retreat. The entire house sits on a slight hill, with the floor slab raised above the angle of the ground to maintain the purity of the cubic form, just as the rear of the house is dug into the slope. As well as the canopy and front sloping wall, gutters, protruding window bays, inset glazing and the angled stair tower on the top-floor terrace all serve as visual counterpoints to the basic shape. The floor plan is just 81 square metres (870 square feet), with a half-level bedroom set above a double-height main living area. The two bedrooms are identical and cell-like, with poured-concrete shelves and shower screen, and high-level windows; one is open to the main living area, while the other is more concealed.

The roof terrace is designed to be treated as just another living space, only secluded and hidden up among the treetops. The roofscape is clad in terracotta tiles and punctuated by circular and teardrop-shaped rooflights that bring daylight down into the living space. By forming much of the furniture and fixtures from concrete, Godefroy implies that the house is a static, impermeable structure; in truth, it is the product of a number of carefully considered choices made by the client, who uses it as a weekend retreat to escape from the city. Everything has been planned down to the last millimetre, with the rawness and simplicity of the final result allowing for a more mindful and less distracted stay. Nothing has been left to chance.

Godefroy has long been acclaimed for his material approach and commitment to a form of concrete Brutalism that is humanist in scale and bears the imprint of human touch and thought. Despite the deliberate reference to fortifications and bunkers, Casa Alférez feels protective and cossetting, rather than defensive and aloof.

Right:
A symphony of concrete forms ascends up through the space.

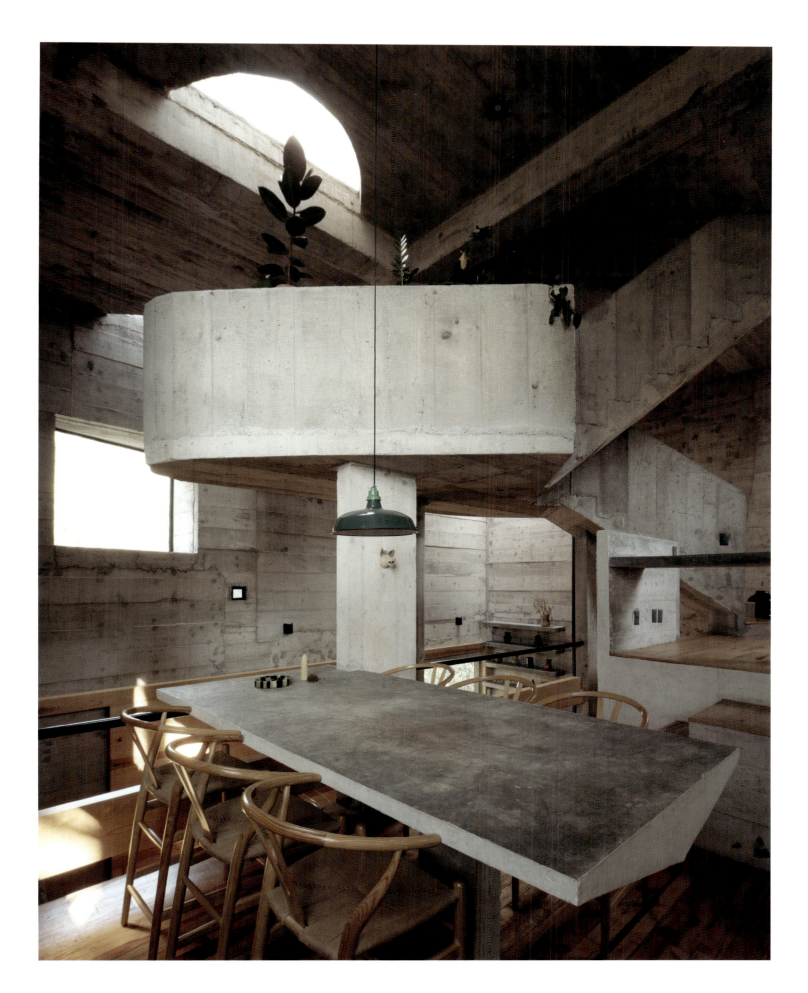

Casa Alférez

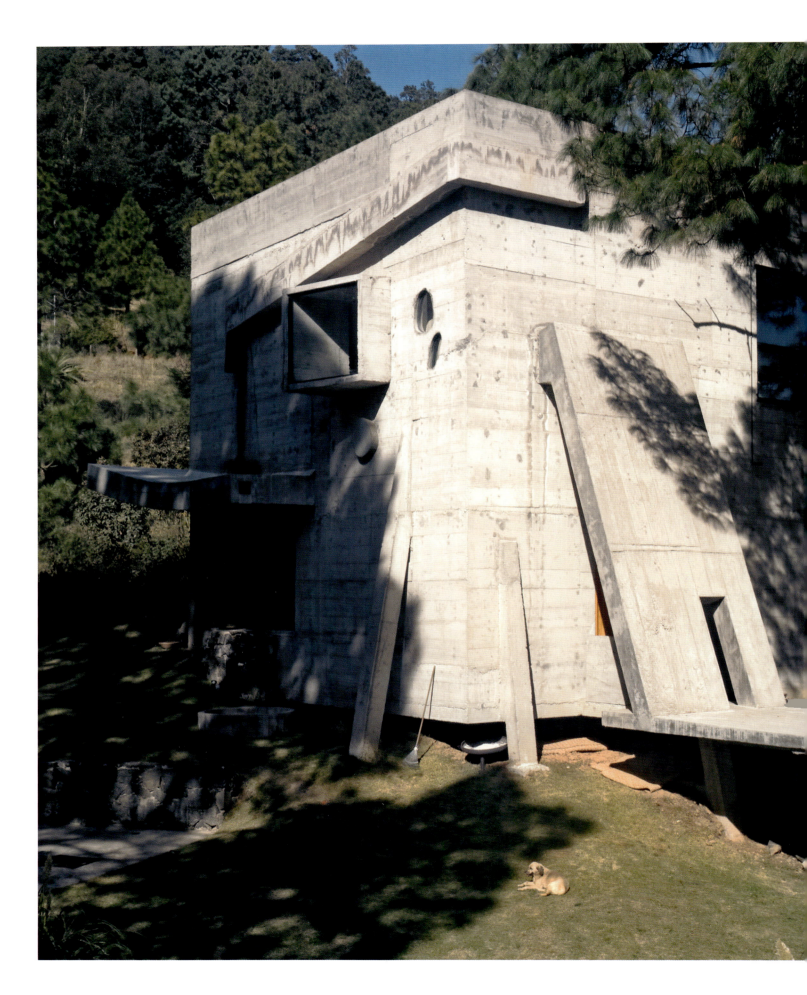

142 Experimental Structures

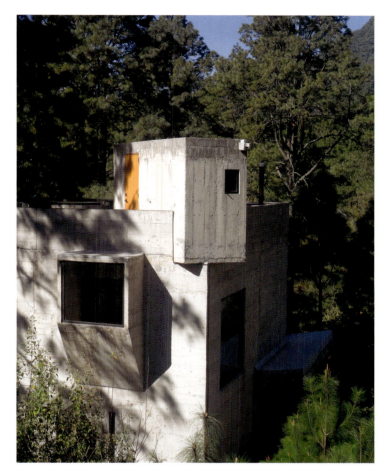

Above:
The stairs to the roof terminate in this fortification-like turret, set at 45 degrees to the structure.

Left:
The exterior facades are playful and abstract, pairing function with whimsy.

Casa Alférez 143

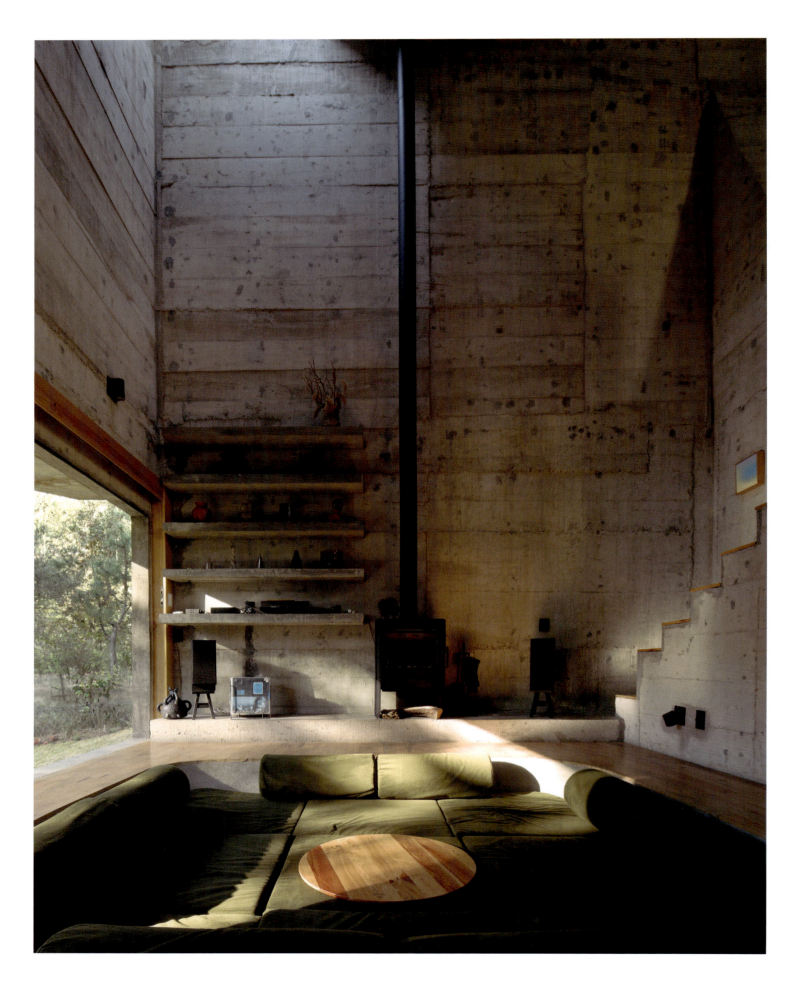

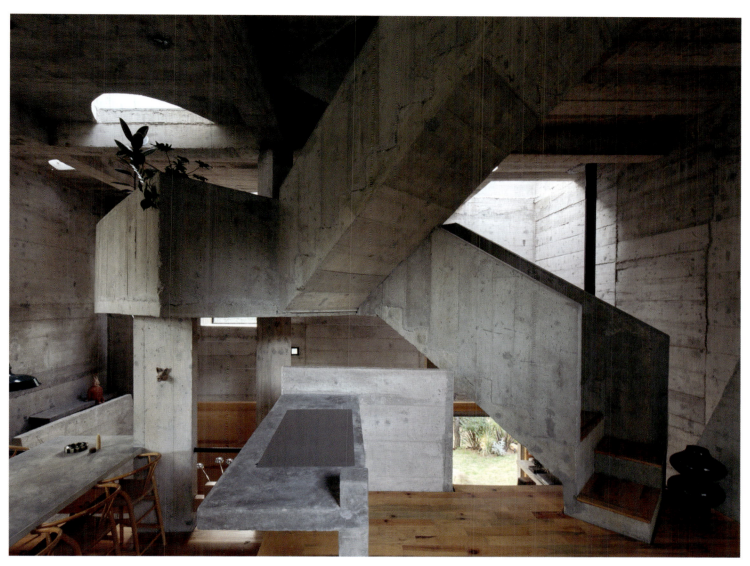

Above:
The staircase folds itself through the space, with a half landing above the dining space.

Left:
The sunken seating area in the main living space has a cavernous ceiling.

Casa Alférez 145

Above:
Integral concrete shelving was part of the original concrete pour.

Right:
Rooflights cast strange shadows and pools of light across the columns and angular walls in the multi-level interior.

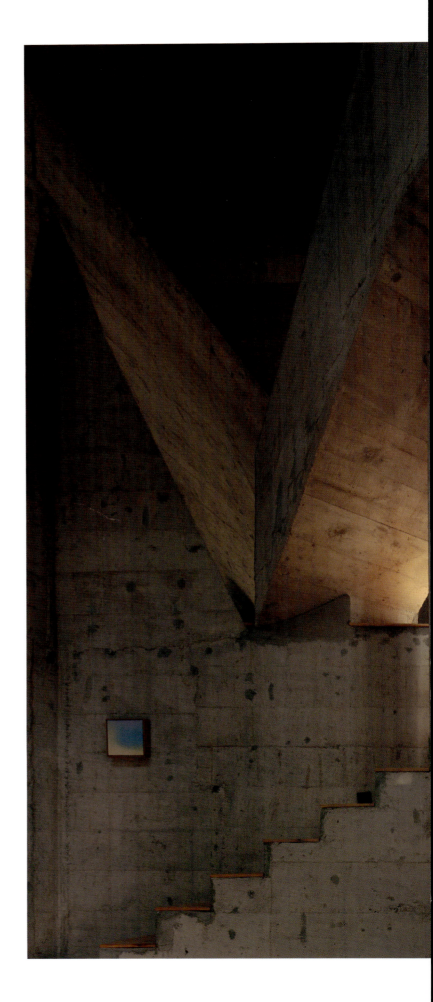

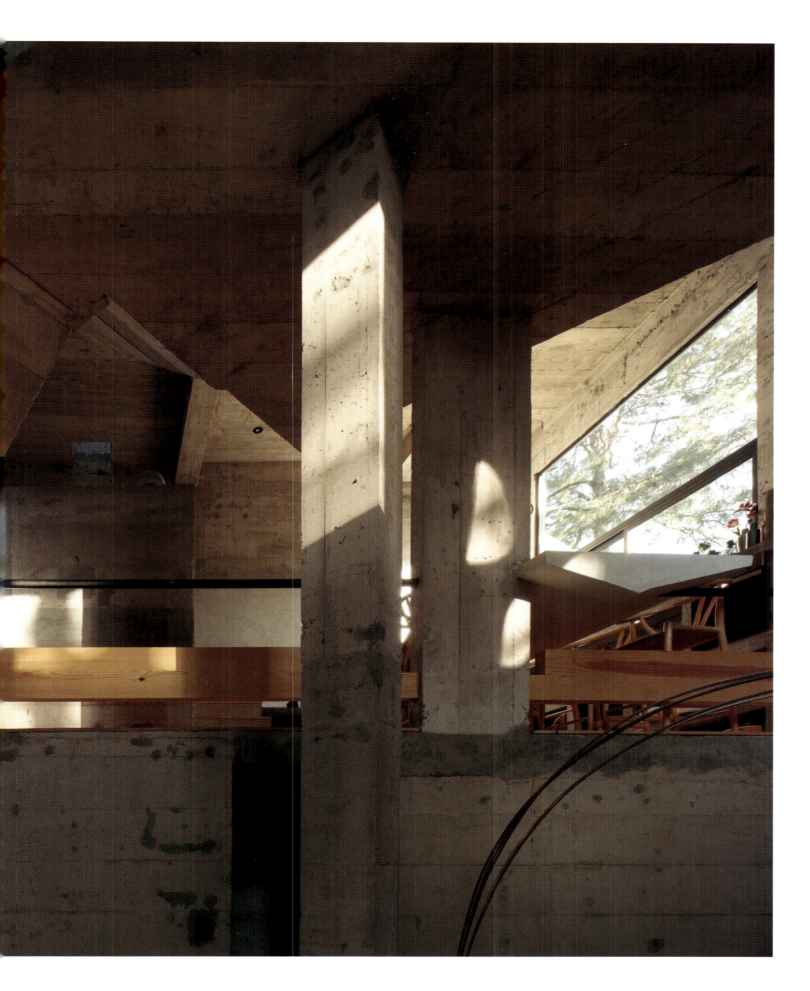

Casa Alférez 147

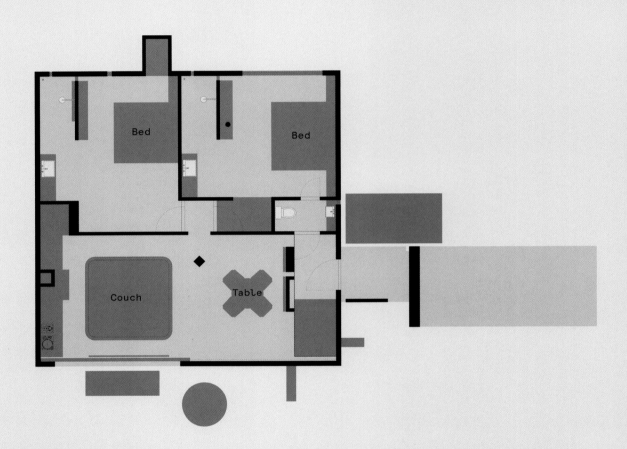

Floor plan

148 Experimental Structures

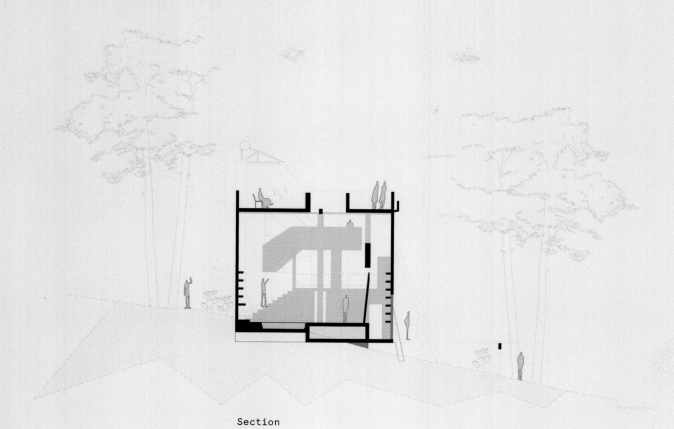

Section

Elevation

Casa Alférez

CASA NARIGUA

Location: El Jonuco, Monterrey, Nuevo León
Architect: P+0 Arquitectura

Located on the edge of a scattered development in the El Jonuco park region to the west of Monterrey, Casa Narigua is a family house designed to engage directly with its surrounding topography. Embedded in a steep wooded hillside, the accommodation steps up and across a number of different levels, preserving a degree of privacy between public spaces and bedrooms, as well as making the most of the view across the valley.

The main body of the house runs east-west, with two generous cantilevered rooms reaching out above the site. On the lower level, which is dug into the hillside, is a family room and gym, alongside a cellar, technical space, storage, bathrooms and a studio. The primary accommodation is located on the ground-floor level, with an entrance sequence reached by a drive that snakes under the cantilevers before doubling back 180 degrees to the entrance courtyard on the high point of the site.

This floor is subdivided into three zones, partly to preserve as many of the existing cedar trees as possible, but also to allow for different viewing angles across and through the house to give every section its own distinctive vista and character. The entire building is raised up above the treetops, thanks to a rigorous and muscular structure of load-bearing concrete walls and beams; from lower down the hill the house appears to float above the site.

The choice of materials was also of paramount importance. 'To reduce the impact of the building on the surroundings, the exterior walls and slabs are made of reddish ochre concrete,' says P+0 Arquitectura founder David Pedroza Castañeda. 'From a distance the house is lost among the mountains. Up close, the concrete makes strong dialogues with the tones and textures of the landscape.' Walls of glass with minimal framing bring the topography into the home, with frameless glass balustrading on the terraces and balconies avoiding any forms that distract from the primary volumes.

Inside, the rich red walls contrast with natural stone and hardwood flooring, an effect that is surprisingly rustic given the precision and complexity of the structure. Exposed wooden beams on the ceilings also reference traditional Mexican architecture, further enhancing the feeling of a house that exists as a frame for culture and landscape.

The architect describes Casa Narigua as 'a stone sculpture implanted with humility in an admirable environment,' and every design and material decision has been made to further embed the structure within the local ecosystem. The three different volumes start on the ground floor with a generous garage to conceal the owners' and guests' cars, along with storage space. The second volume includes the entrance hall and cantilevered main bedroom, which has its own separate seating area, along with a staircase down to the lower levels. These spaces are transformable, with the option to turn into guest bedrooms if needed, along with bathrooms and a gym. Technical spaces are also located on this level, helping free up the entire roofscape into an unencumbered terrace.

The third volume houses the kitchen, utility space and living rooms, with a large wraparound terrace incorporating a plunge pool and outdoor kitchen. The mountains rise up above the house on all sides, looming above the structure and visible from all points within thanks to the extensive use of internal and external glazing. This transparency contrasts strongly with the monumental thick walls, heavy beams and stone flooring, traditional materials that are further enhanced by the clients' collection of vernacular objects and folk art.

Right:
The concrete structure is infused with red ochre to give it a sense of geological presence in the landscape.

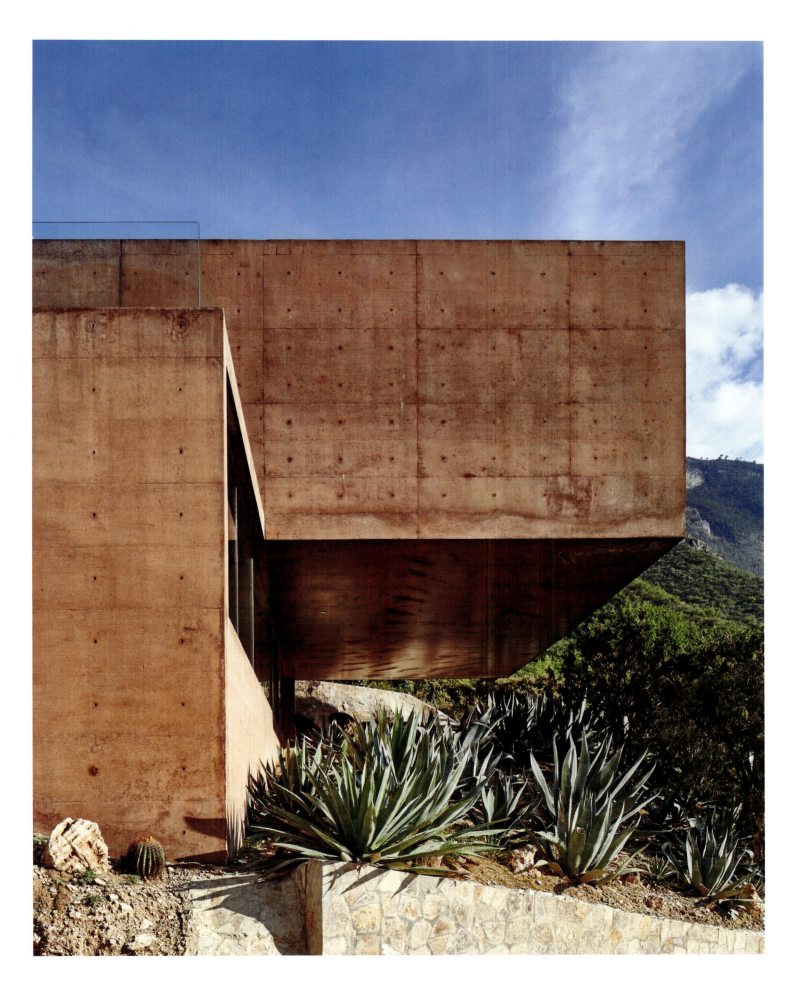

Casa Narigua

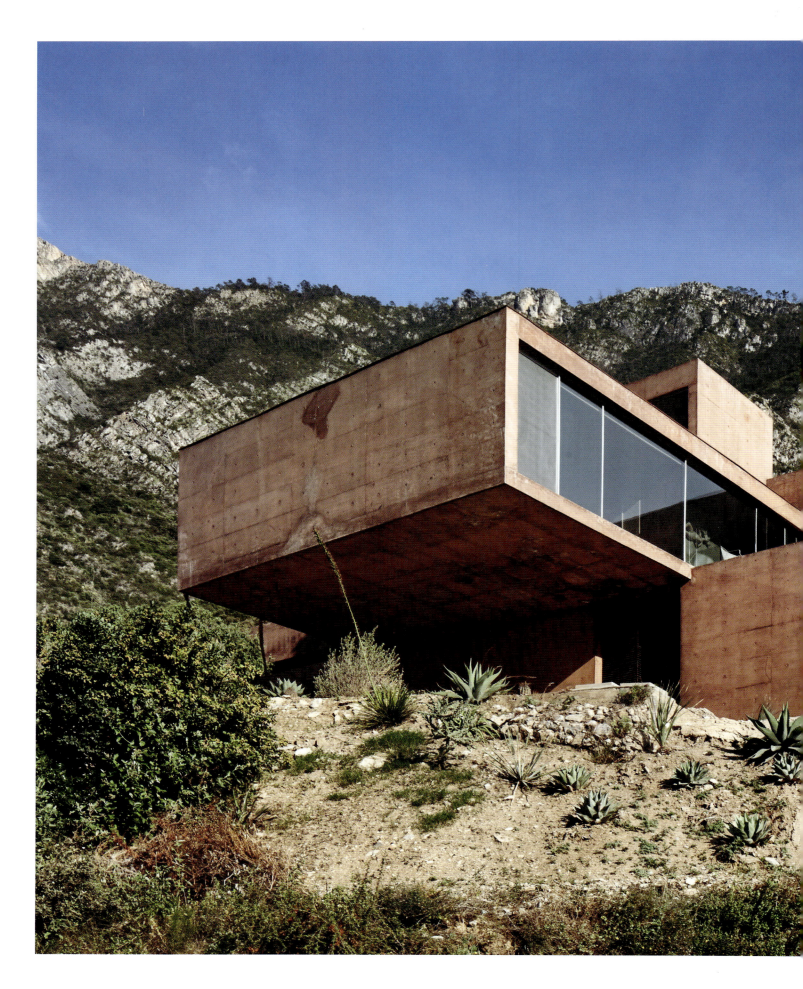

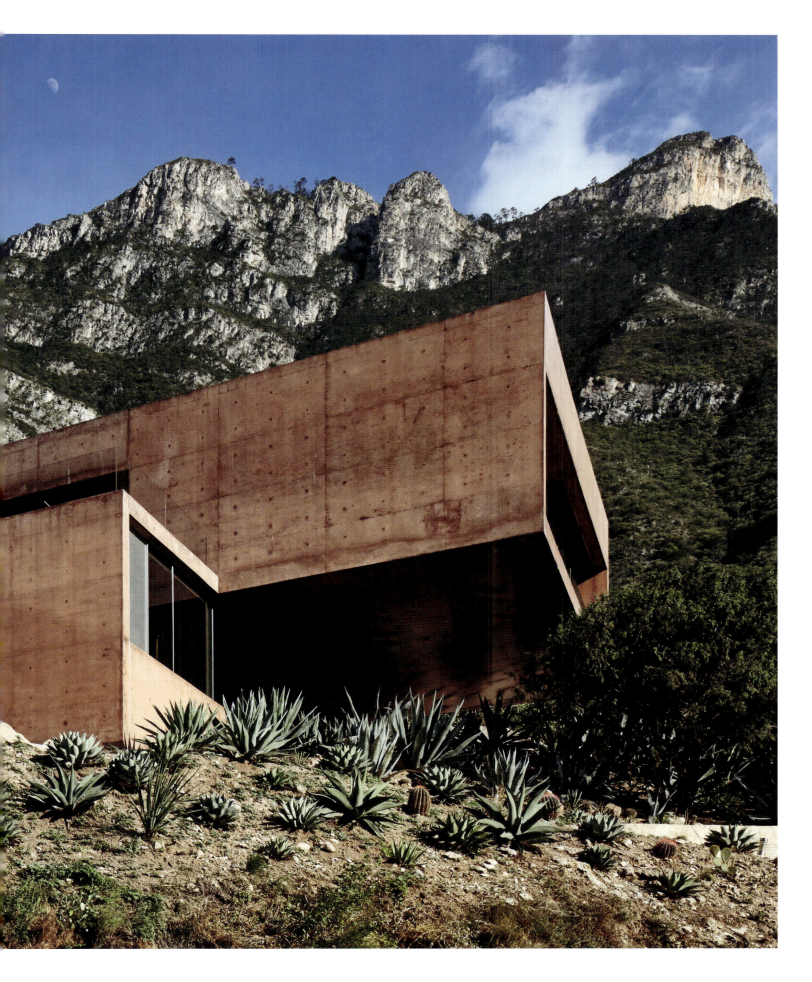

Casa Narigua 153

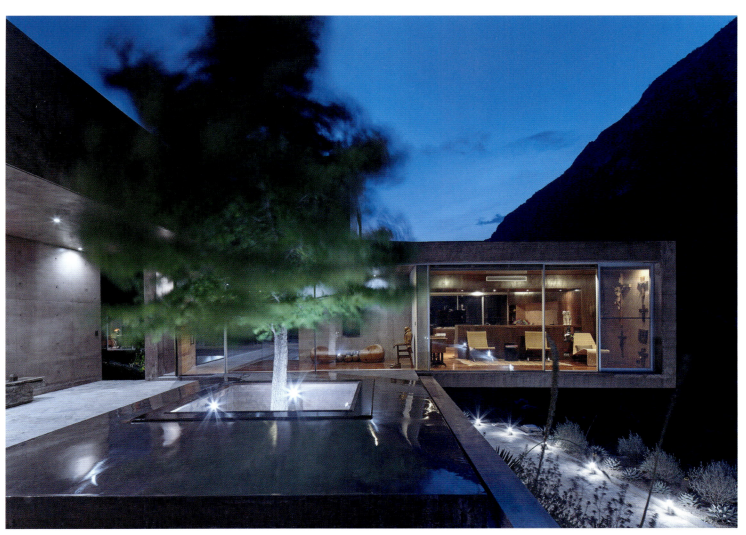

Above:
The entrance is accessed past a reflecting pool, with the primary suite seen to the right.

Right:
The cantilevered structure acts as a roof for external seating areas.

Previous spread:
The main bedroom is cantilevered out dramatically over the access road.

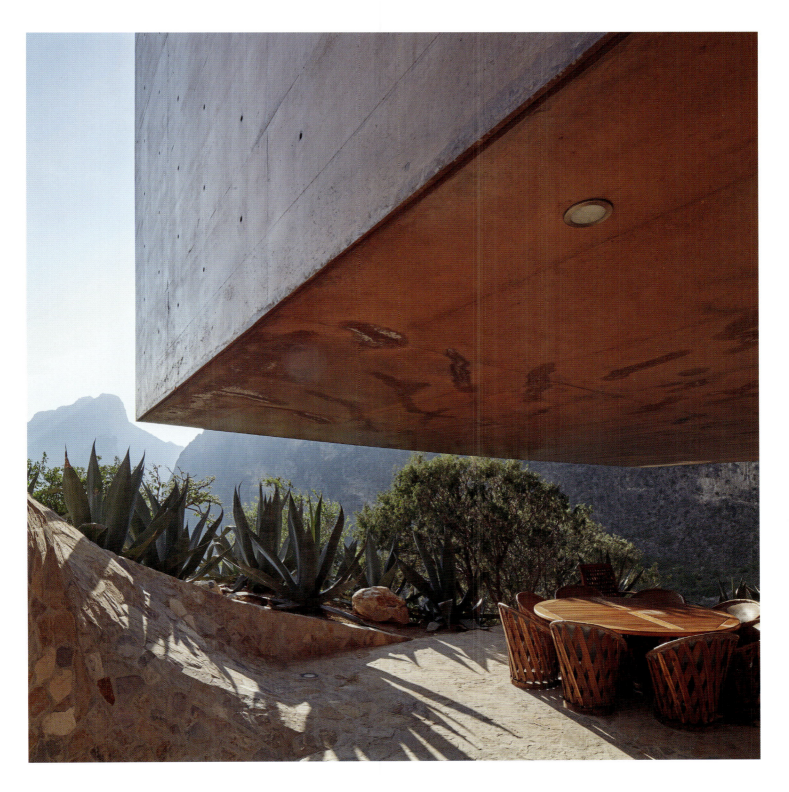

Casa Narigua

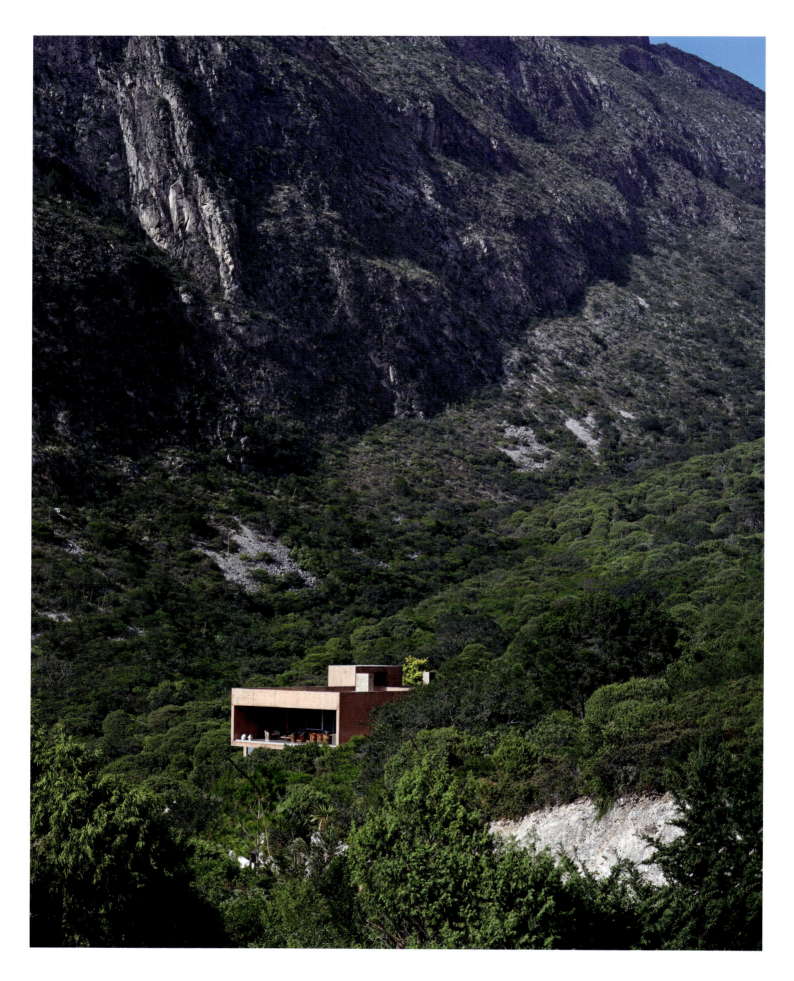

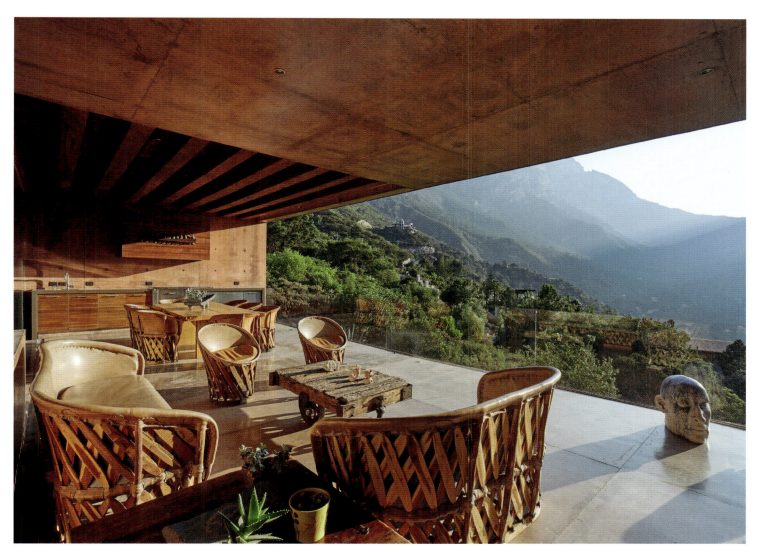

Above:
Seen from within, the terrace has clear glass balustrades for an unbroken view of the valley.

Left:
Within the landscape, the house is a stark contrasting form.

Casa Narigua 157

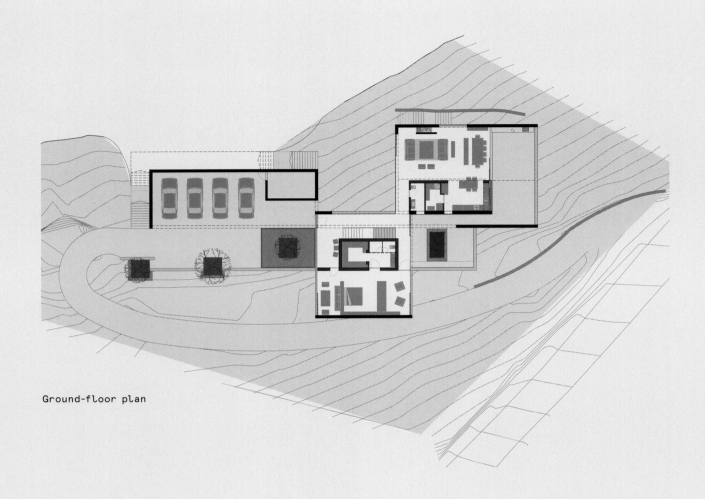

Ground-floor plan

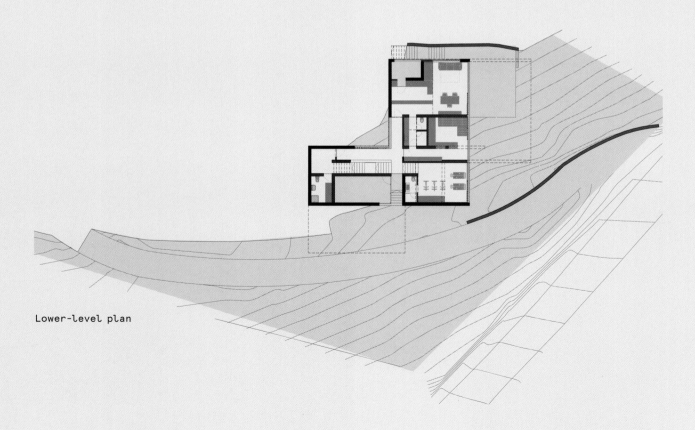

Lower-level plan

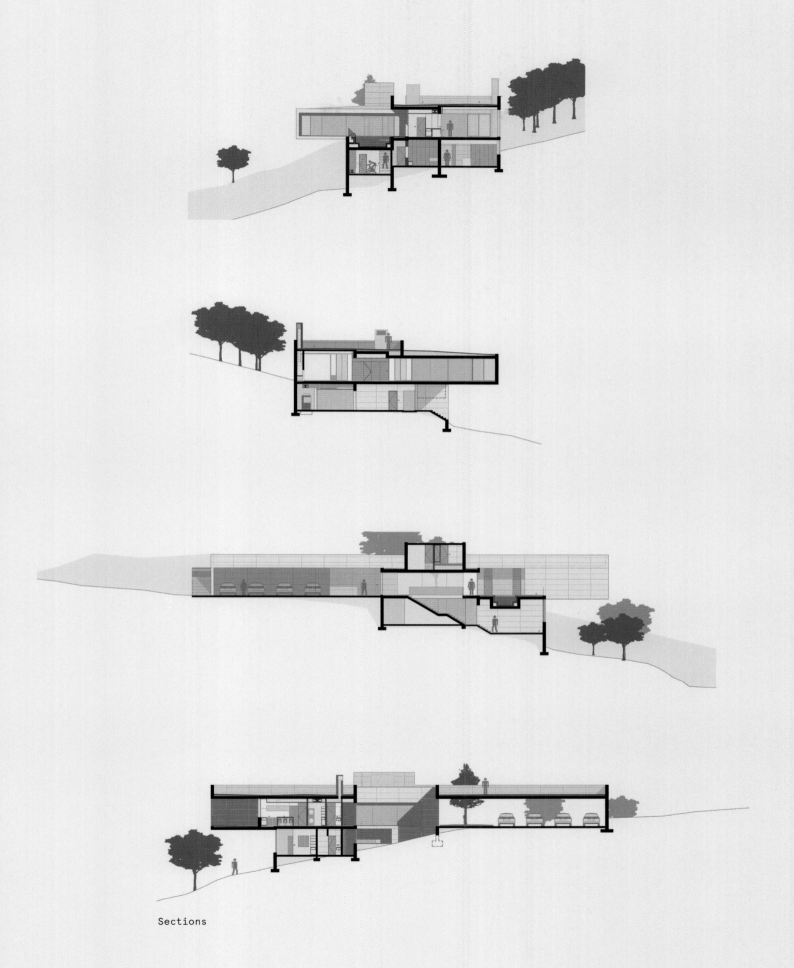

Sections

Casa Narigua

ARCHITECTURAL RETREATS

Mexico's vast and sprawling territories are well suited to the architectural retreat, whether bespoke one-offs or part of a larger complex. This is a landscape to retreat into, with architecture serving as the shelter, the frame and the generator of the experience. The modern beach retreat needs only to touch lightly on its surroundings and be muted in scale, while other topographies demand more enclosure and solidity. Climatically, the country offers an environment of strong contrasts, with feasible indoor–outdoor living much of the year, leading to a very different approach to form, plan and materiality.

Right:
The deck at Casa Leria in Puerto Escondido.

Architectural Retreats

CASA NAILA

Location: El Puertecito, Oaxaca
Architect: BAAQ'

Casa Naila distils the essence of a beach house down to four components, perfectly aligned around a central courtyard. Located on the Pacific coastline in the village of El Puertecito in the state of Oaxaca, the house is named after a traditional song from the region. The site itself is at the southern end of the village, where a peninsular reaches out into the ocean, offering sea views on three sides.

BAAQ' began by constructing a solid-concrete plinth to serve as the foundations and the core structural walls for each of the four pavilions. This concrete structure has been left exposed and stands in strong contrast to the lightweight timber panels that form the rest of the house. These panels are clad in dried palm fronds and a mesh to protect them from insects. The result is walls that are both translucent and permeable to allow the ocean breeze to air the rooms and for light to shine through like a lantern in the evening. At ground-floor level there are bi-fold door panels made following the same process, enabling the facade to be opened up completely to the beach.

This 'palm bone skin' is a refined version of the construction technique used for the traditional beach huts that are scattered up and down the coast, a form of vernacular building that employs materials that are close at hand and readily replenished. Each pavilion is pushed to the corner of the plinth, creating a cross-shaped internal courtyard that serves as an exterior dining room and garden, planted with native species. The central rectangle houses the pool, with a rough-hewn plank cut from a single tree trunk acting as a bridge between the two ends of the plinth.

At the northerly end of the plan is the kitchen, with an open-plan wooden staircase leading up to the first of five bedrooms. It sits adjacent to the dining room, the only single-storey structure, albeit with a raised ceiling height. The kitchen contains a traditional-style clay stove, a Lorena, which is characteristic of the region. On the other side of the plinth is a bedroom block, with a double bed and bunk room set beneath a pair of twin rooms, and a studio/living room underneath another double bedroom. Each pavilion is self-contained, with its own bathroom and bathing facilities, meaning that guests can retire discretely to their own spaces.

The combination of natural materials, unadorned concrete and a complete lack of barriers between beach and house, gives Casa Naila an ad-hoc, raw quality. All wood was locally sourced and often reclaimed, and much of the furniture, including the tables and beds, was built using these offcuts. There are clay and mud floors throughout, further emphasizing the simplicity of the spaces.

Sited on a popular local beach, the holiday home has an informal relationship between public and private space, further enhanced by the accessibility of the pool and terrace, both of which are used by visitors to the beach when no-one is home. 'Casa Naila seeks to pay tribute to Oaxaca in all its aspects, from the choice of materials and construction systems to its customs and the experience of the spaces,' says BAAQ's co-founder Alfonso Quiñones.

BAAQ' is committed to restoring and renovating old buildings in Mexico City, highlighting the importance of the circular economy to architectural practice by serving as both client and architect. Casa Naila's emphasis on reclaimed local materials is part of this approach, as is the idea that although the lightweight structure might one day be sacrificed to the elements, the concrete skeleton will remain for future generations to reuse.

Right:
The beachside house is arranged as a series of pavilions, all of which can be shuttered against the elements.

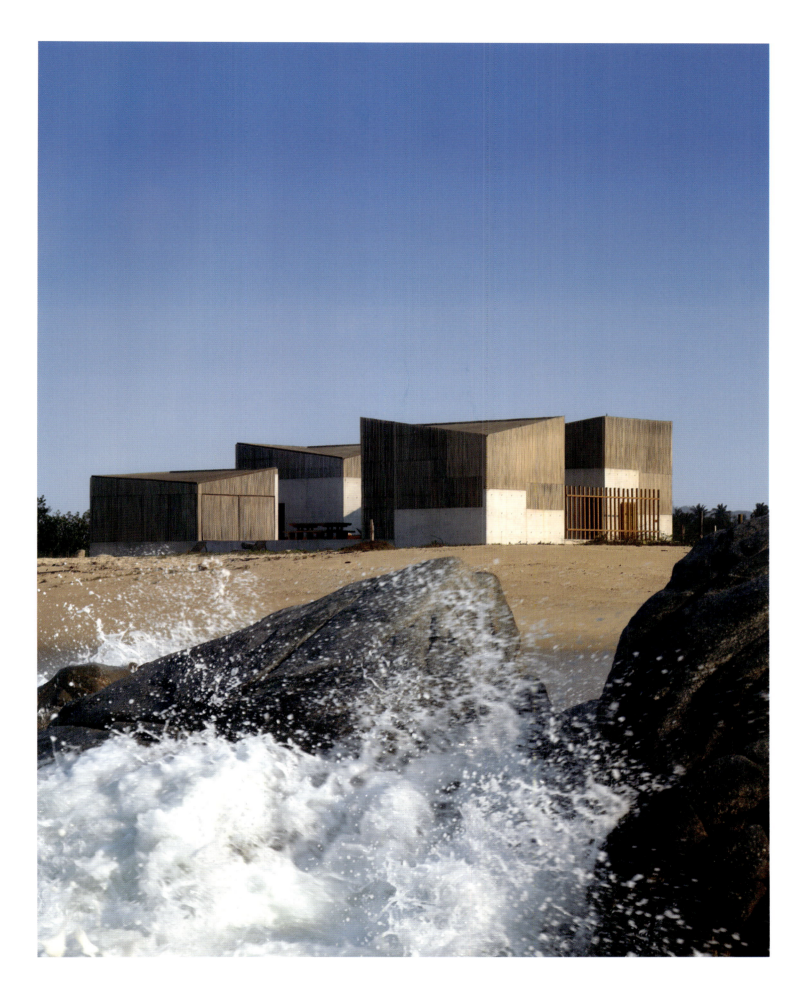

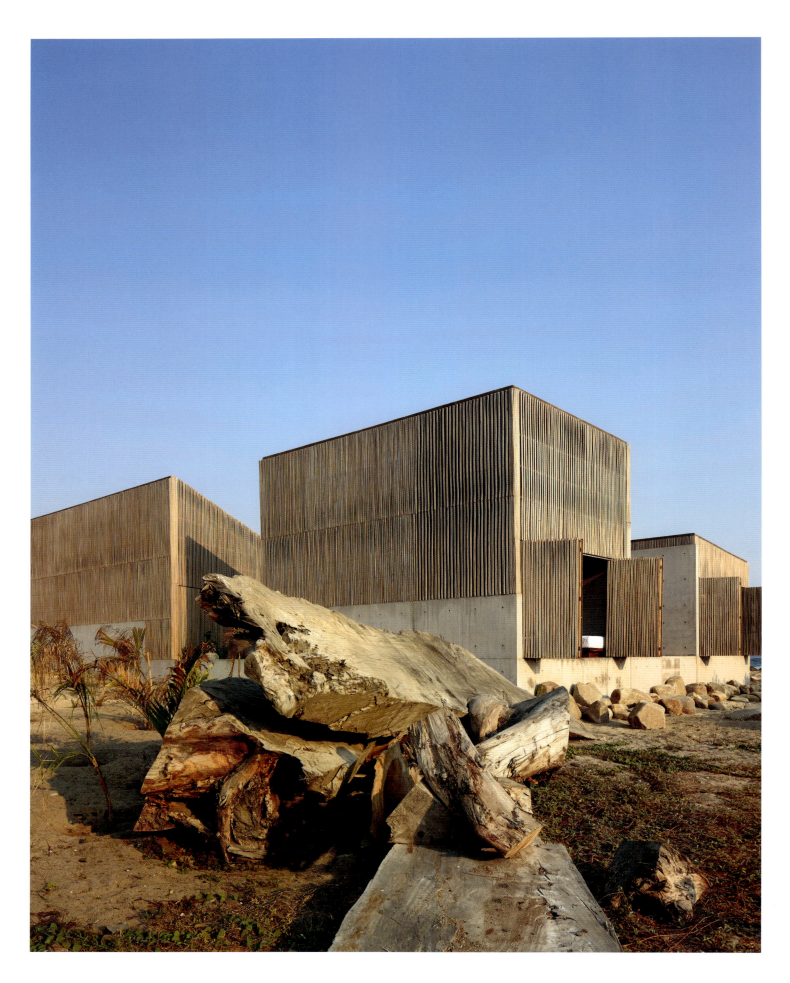

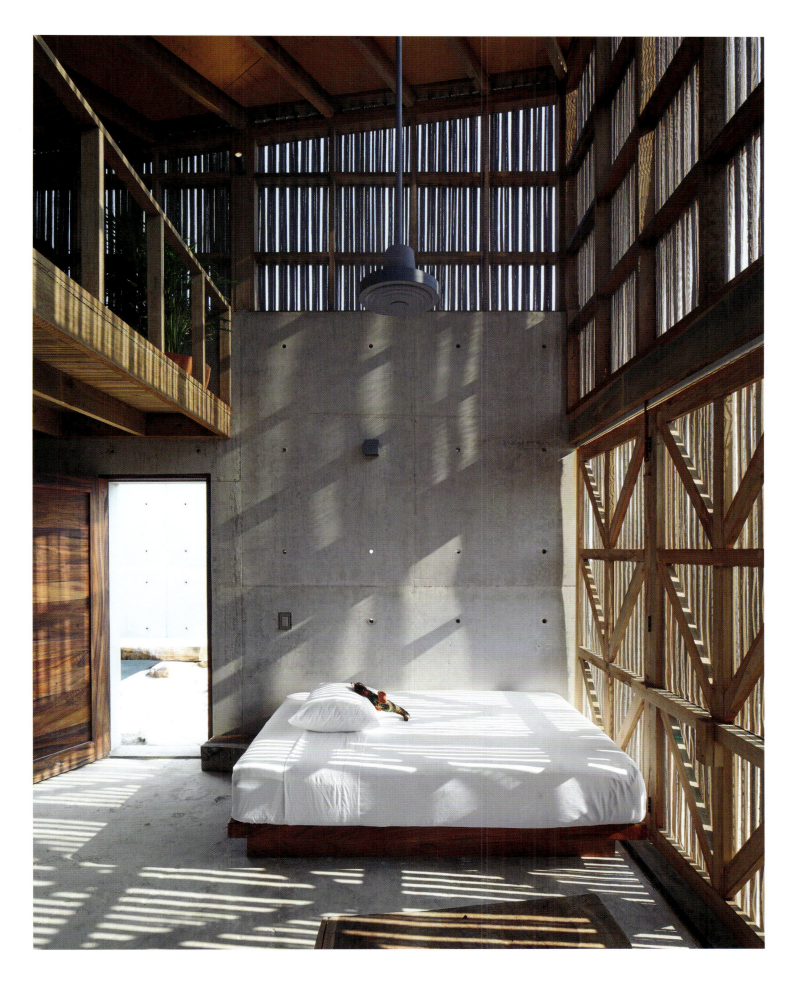

Casa Naila

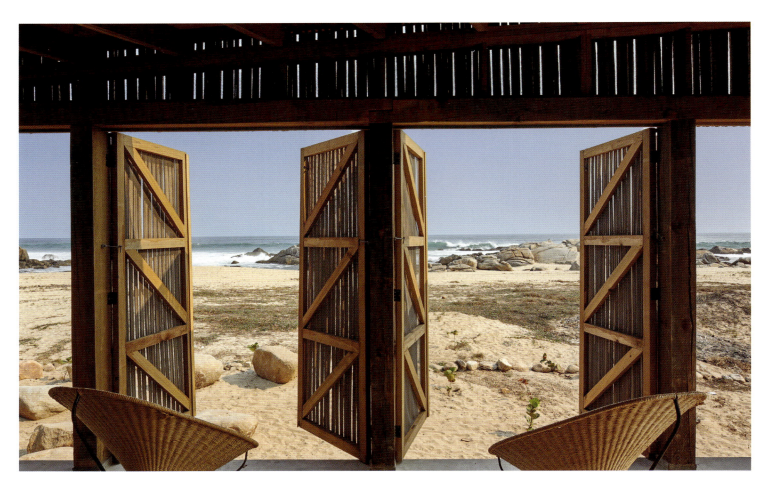

Previous spread, left:
Built atop a concrete plinth, the structure uses a combination of monolithic concrete walls and lightweight timber screens and shutters.

Previous spread, right:
Fixtures and fittings are kept to a minimum, with light filtered through narrow wooden slats.

Above:
The main living spaces open directly on to the beach.

Right, clockwise from top-left:
Walls are formed from folding shutters; the pavilions are arranged around a pool, with a rustic plank bridge; details are simple and low key; reclaimed timber and driftwood were used to make the furniture.

Following spread:
At night, the facade becomes translucent, with light shining through the slatted walls.

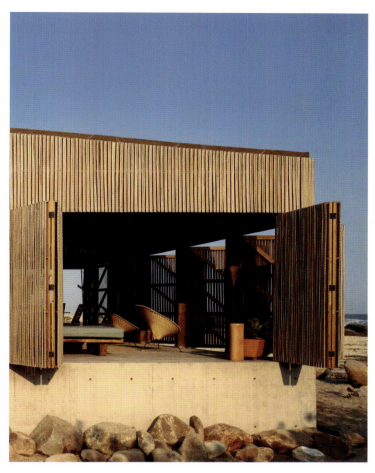
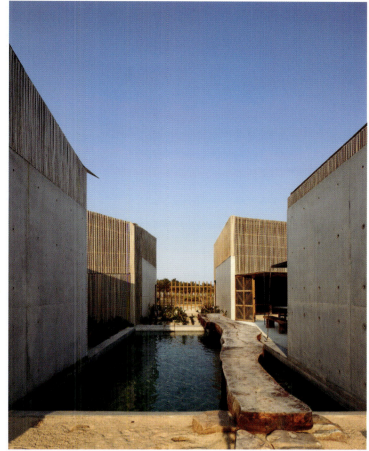
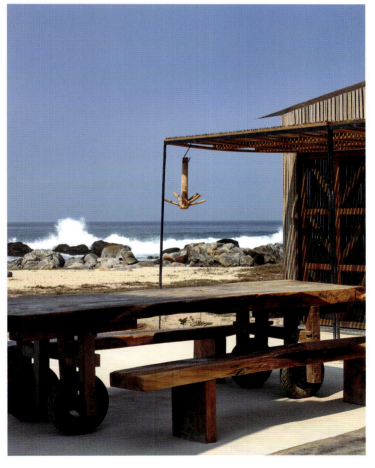

Casa Naila 169

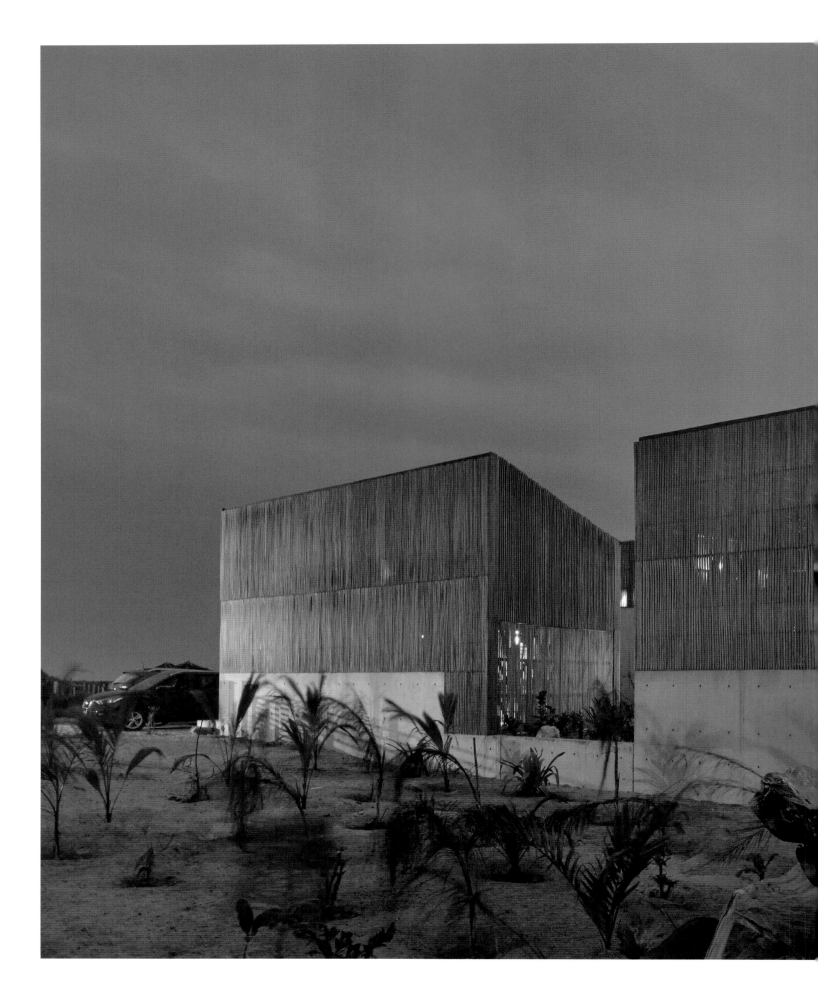

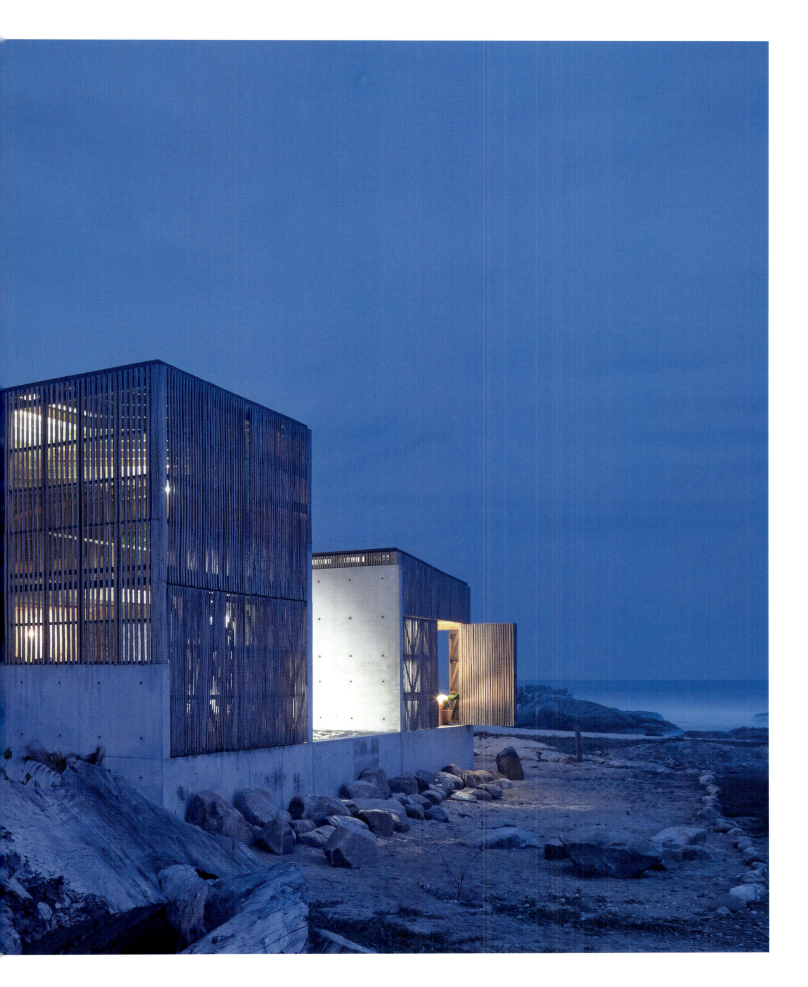

Casa Naila 171

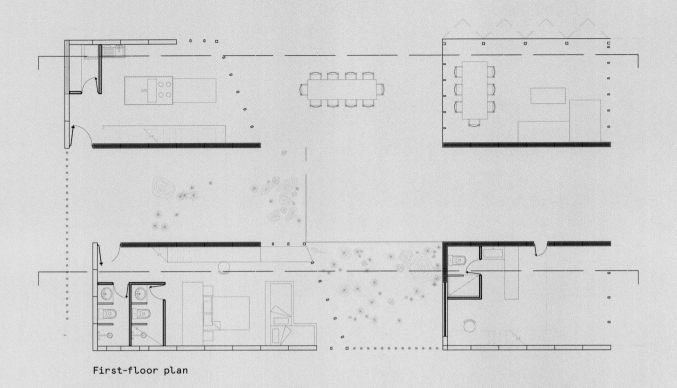
First-floor plan

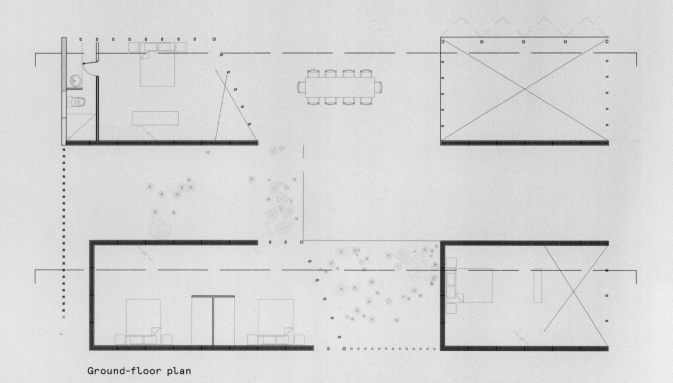
Ground-floor plan

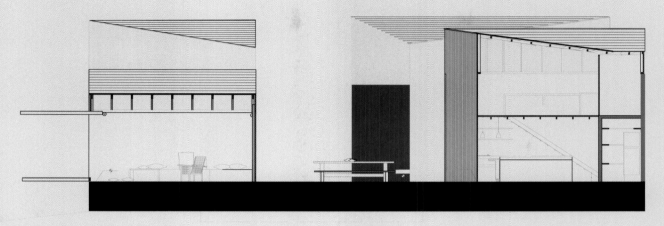

Section

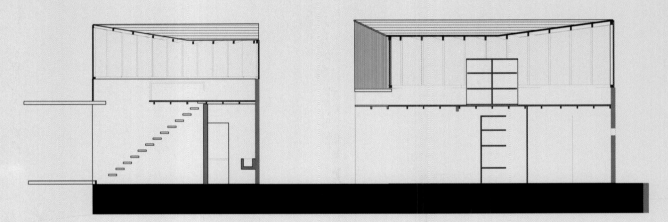

Section

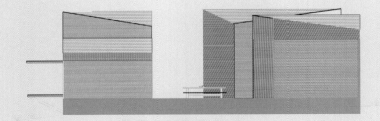

Elevation

Casa Naila

CASA CATARINA

Location: Valle de Bravo
Architect: Héctor Barroso

In plan form, Héctor Barroso's Casa Catarina resembles a cascade of pavilions, loosely arranged in a V-shape that steps down a shallow valley. Arranged across 900 square metres (9,700 square feet), the house is generously scaled, with accommodation scattered across a site that nestles between a towering cliff and a small lake in the Valle de Bravo region. The entrance is sited at the intersection of the V-shape, adjacent to a small pavilion containing a staff apartment and the car port. From the entrance hallway, the view looks south, straight through the open-plan living areas, past a terrace to the swimming pool.

The central living space is double-height, with clerestory windows bringing in added light as well as views to the towering landscape outside. It is relatively enclosed and self-contained, with a mixture of bespoke wooden cabinetry, beams and cladding combined with stone finishes. It contrasts strongly with the frameless glazed walls of the bedroom wings.

Two wings of private accommodation flank the main living space, with two rooms to the left of the entrance and three to the right. Each room is treated like its own self-contained pavilion, with a glazed corner that can open up to the landscape, alongside small windows for ventilation. Each bedroom has its own bathroom, complete with internal courtyard; two of the larger bedrooms are arranged as children's dormitories. Facing east and west, the bedrooms overlook a naturally planted garden with indigenous plants and shrubs, while a long lawn leads away from the south elevation, with an unbroken view across the lake to the hills beyond. The individual courtyards in each private bathroom have glazed walls looking out on to both the internal planting and the distant mountain peaks.

There is a subtle shift in level between each bedroom pavilion, with the principal one set furthest from the communal areas to the right of the entrance lobby at the highest point of the site. This pavilion is the only two-storey structure in the complex, with a staircase leading to an upper-level private sitting room and partly shielded terrace. The stairwell corner is entirely glazed, with two vast pieces of frameless glass abutting seamlessly at the corner joint, giving the impression of a deep vertical cut into a solid cube.

Casa Catarina is constructed from cast concrete, with a reddish pigment that takes on the same colour characteristics as the surrounding cliffs, particularly when the sun is low in the sky. The concrete framing is inset with stone-clad walls, a material that is also used throughout the terracing around the house, as well as the bottom of the shallow reflecting pool adjacent to the entrance. This is a building of precisely composed internal landscapes that form a deliberate juxtaposition with the varied wilderness that surrounds it.

Right:
A mix of textured concrete, stone and wood gives the house its distinct, rough aesthetic.

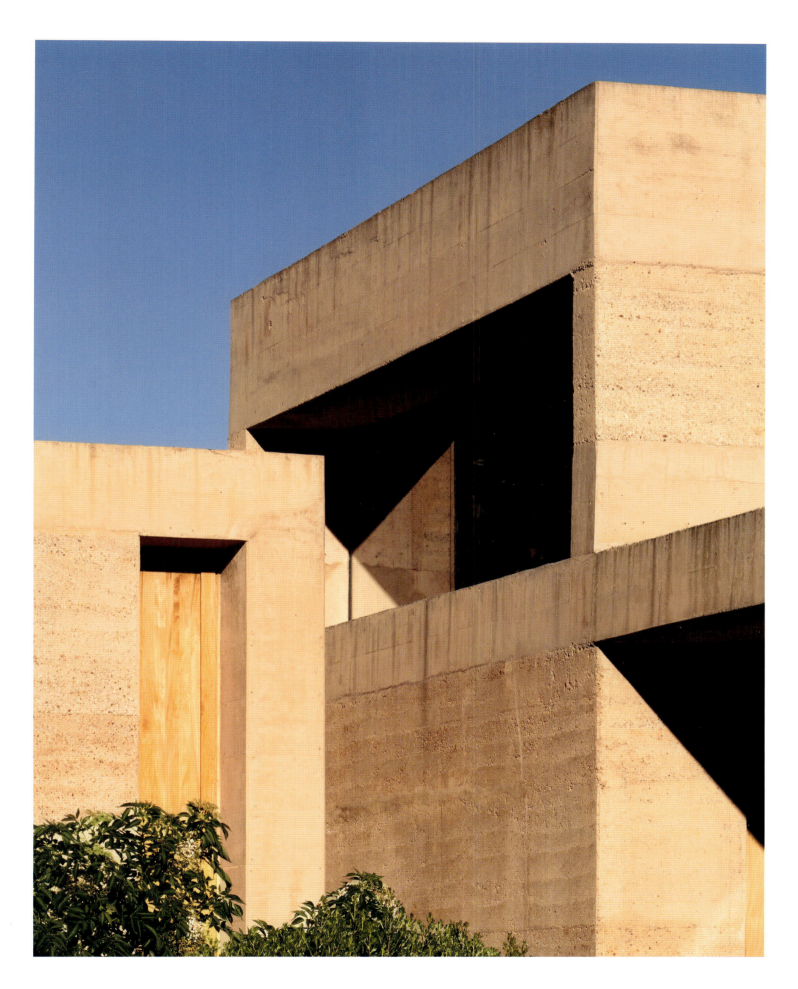

Casa Catarina

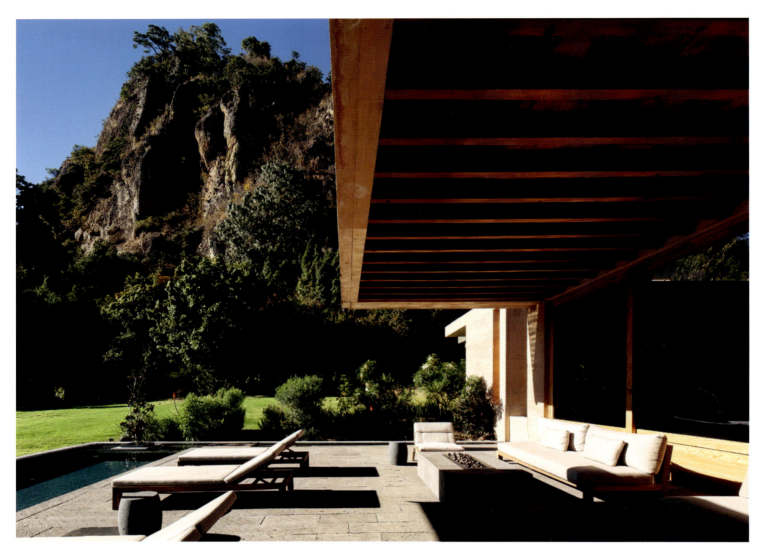

Above:
The roof oversails the main deck, providing shade at the height of the day.

Right:
Windows and openings are read as interchangeable thanks to the use of large frameless sheets of glazing.

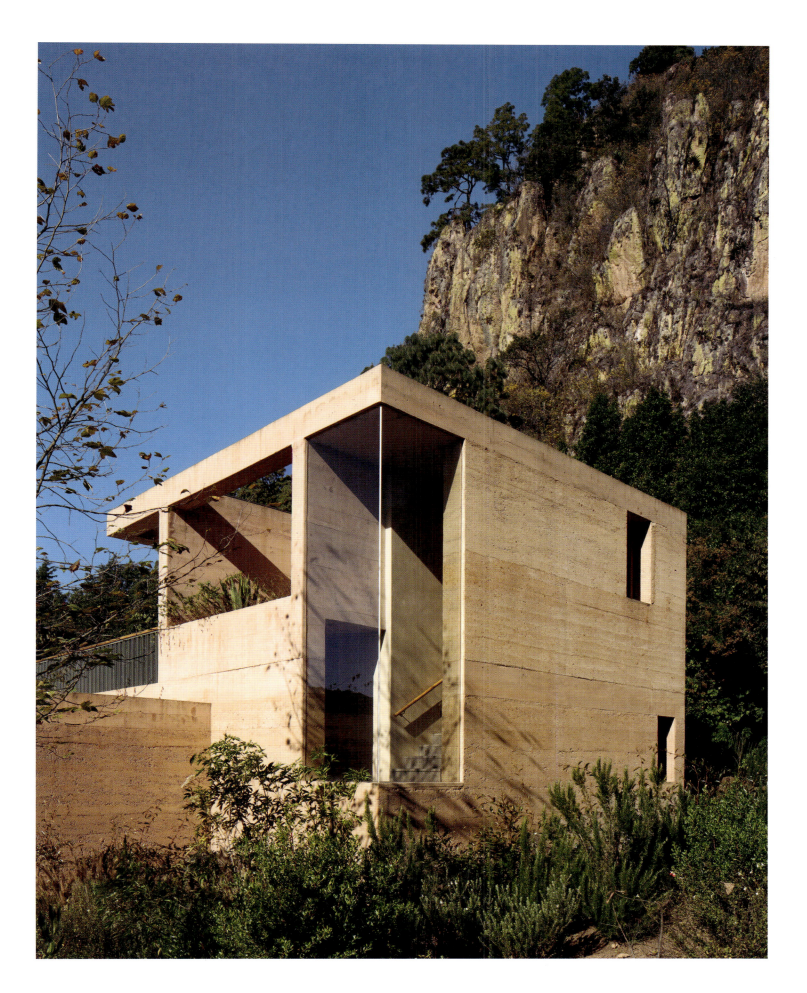

Casa Catarina

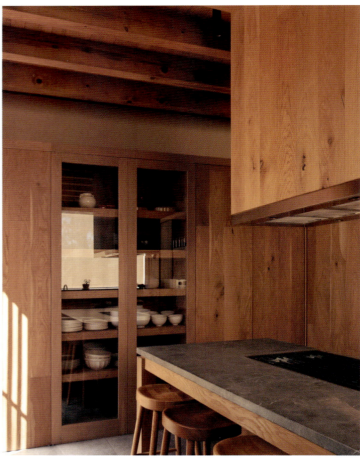
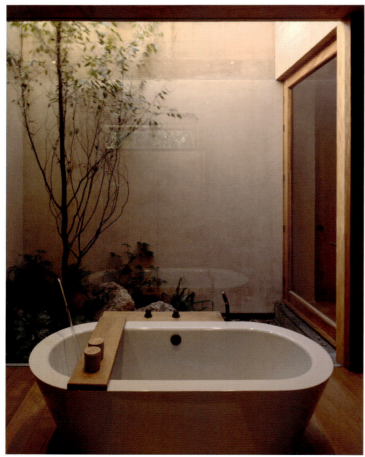

Clockwise from top-left:
Natural stone insets are a nod to the landscape beyond; interior cabinetry and shelving is handcrafted from local wood; the principal bathroom overlooks an internal courtyard.

Right:
The main living space is lit by clerestory windows.

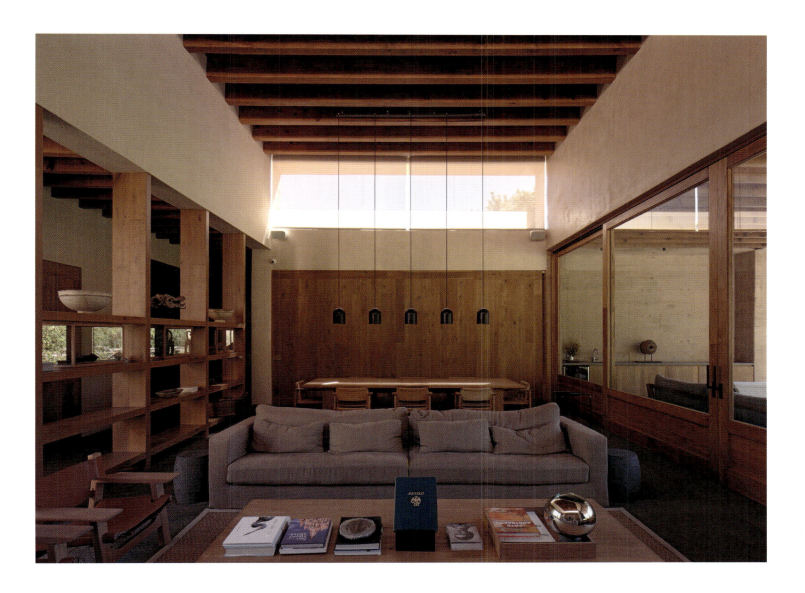

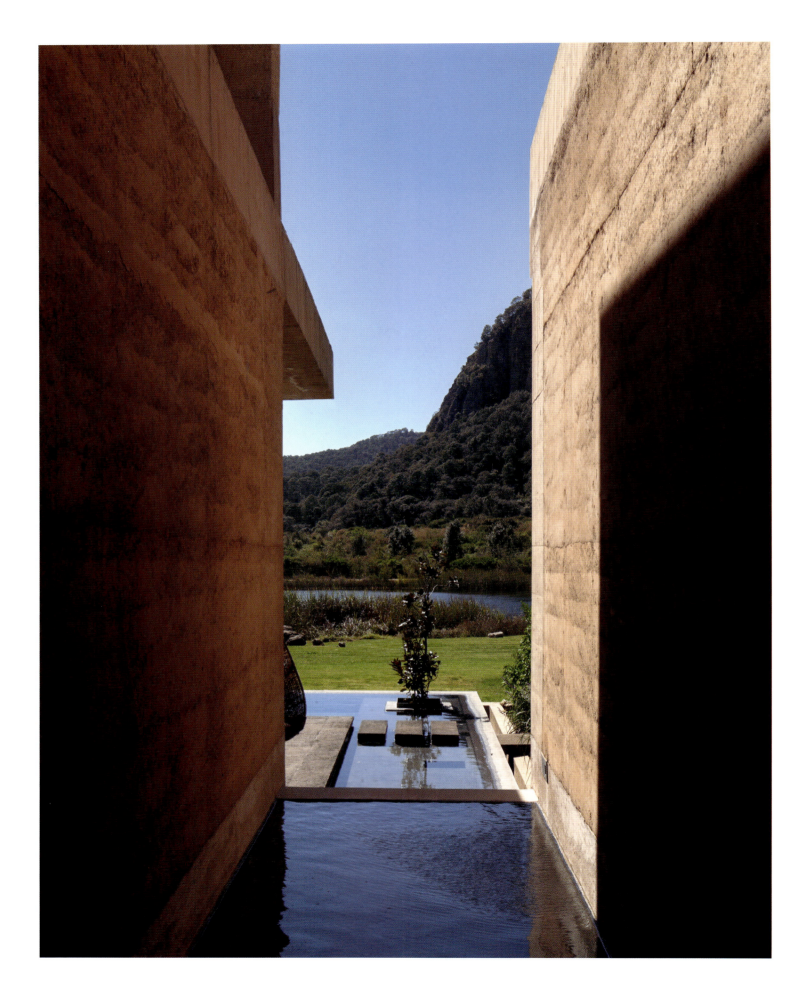

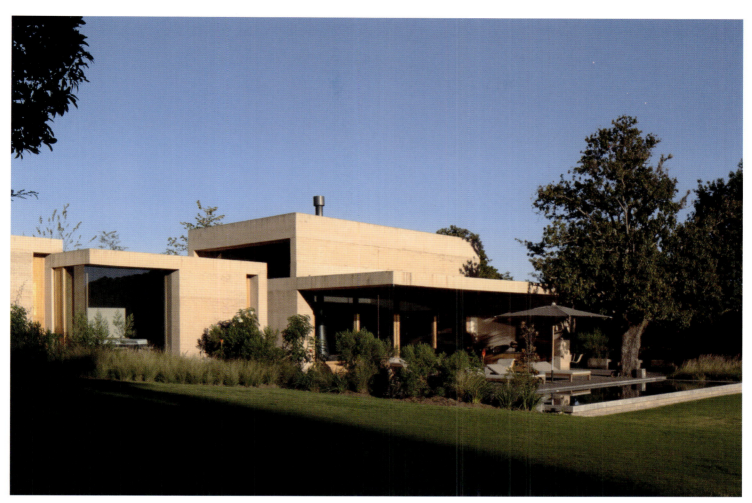

Above:
The house is arranged as
a series of low pavilions
spread across a valley site.

Left:
Water forms another key
design element, with shallow
reflecting pools helping
to cool the interiors and
disseminate the light.

Casa Catarina 181

First-floor plan

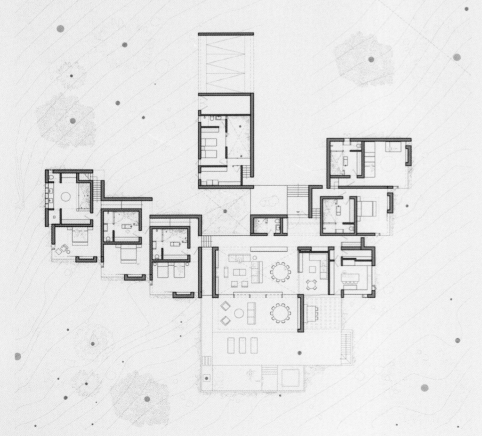

Ground-floor plan

Architectural Retreats

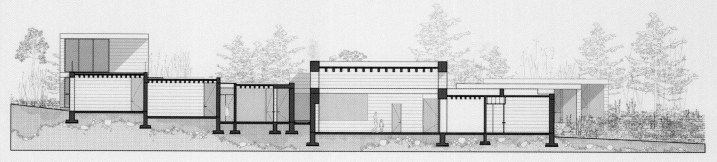
Section

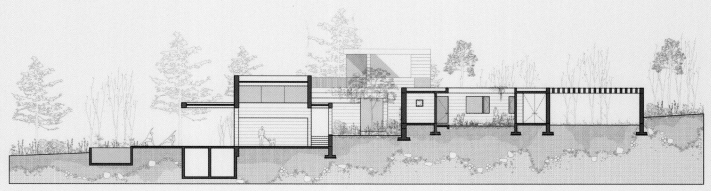
Section

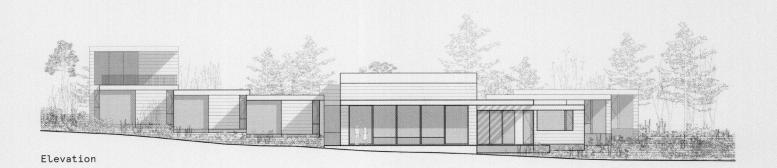
Elevation

Casa Catarina

CASA COMETA

Location: Mazunte, Oaxaca
Architect: Taller de Arquitectura Mauricio
 Rocha + Gabriela Carrillo

Casa Cometa is a complex of buildings embedded in the landscape outside the small, coastal town of Mazunte in Oaxaca. The project was designed by Taller de Arquitectura (Architecture Workshop) Mauricio Rocha + Gabriela Carrillo.

Described by the architects as a 'nature retreat', the Cometa complex includes two towers, a covered outdoor living area (or palapa), a pool and a raised terrace, all set at right angles to one another within the diamond-shaped site. Many of the core activities of the retreat take place in the open-sided palapa, a long rectangular structure that includes a kitchen, dining area and living space. The timber-framed palapa has a steeply pitched thatched roof, with the living areas set deep within the eaves, ensuring they are protected from the elements.

Set within a nature reserve on the Punta Cometa Peninsula, the most southerly point of the state of Oaxaca, the house was designed to rise above the dense jungle, reflecting the remnants of nearby Aztec ruins. The site also has an extremely varied topography, with the highest point some 28 metres (92 feet) above the lowest. In addition, all the trees had to be retained, dictating the way the plan is threaded through the site, comprising of smaller structures surrounded by the original planting. The vegetation is dense and lush in the rainy season, but arid and sparse in the dry months from November to March.

The shifting contours allowed the architects to 'dilute' the scale of the complex, with some structures set below the treeline and others rising above it. Using a series of platforms set at different heights, the principal functions are gathered into groups. The buildings are bookended by the two tower structures, one containing the principal bedroom and the other a studio space.

Set between these prominent stone-clad buildings are the platforms, some of which are left exposed, while the structure at the heart of the site, the palapa, is open on all sides to allow views up, down and across the property. This is set at right angles to a low-slung timber pavilion, complete with fully accessible roof deck. Raised up on concrete pillars, the pavilion contains three bedrooms and a den, with thick wooden window frames and pivoting shutters providing privacy when needed. Stairs lead directly down to the forest floor.

The swimming pool is also elevated above the site, a long rectangular concrete trough that stretches out across the valley. Another staircase leads down to a concrete-framed jacuzzi. The material palette used throughout is minimal, with timber, shuttered concrete, stone walls and clay-tiled terraces giving each structure a strong connection to the site. Furniture and fittings are kept deliberately low-key and brutal, with pipework and sanitaryware integrated directly into the concrete walls, concrete basins and rough-hewn cabinetry and furniture. Monumental stonework and the simple pivoting timber shutters add a layer of seemingly anti-industrial technology, re-emphasizing the connection with the history of the region. The combination of open, covered and private spaces, along with walls of shutters, gives Casa Cometa a unique relationship with the landscape; every level offers a different aspect, with views out to sea as well as directly into the foliage of the Oaxaca jungle.

Right:
Traditional stone construction was used for the facade, here on the guest house.

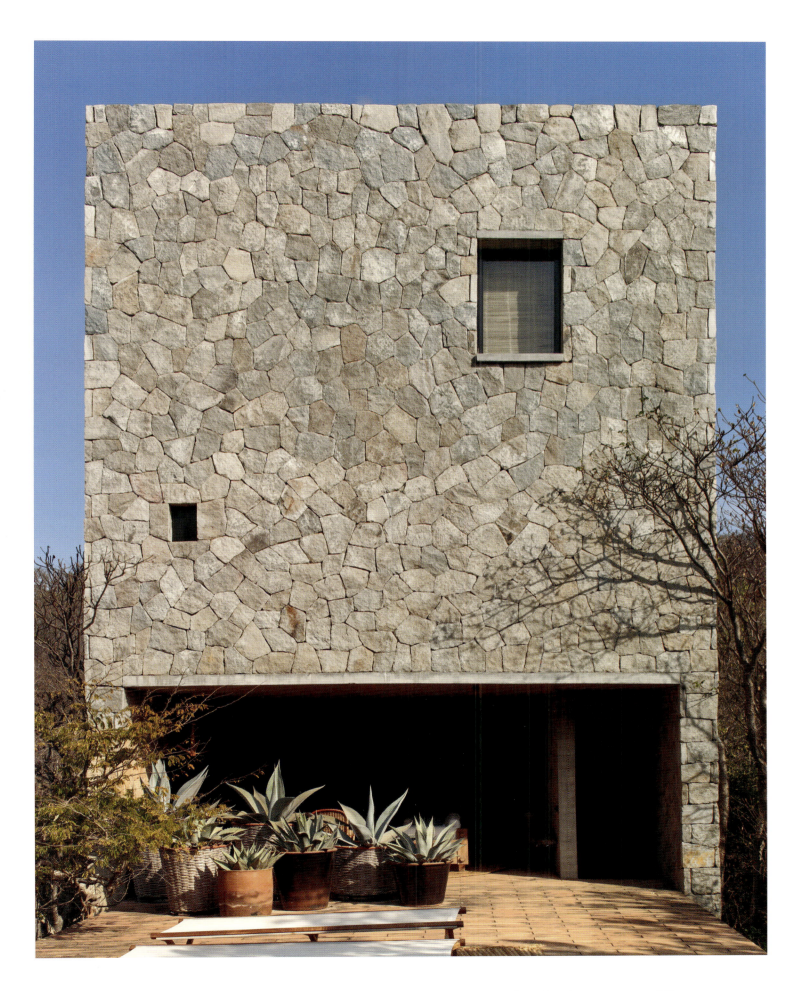

Casa Cometa

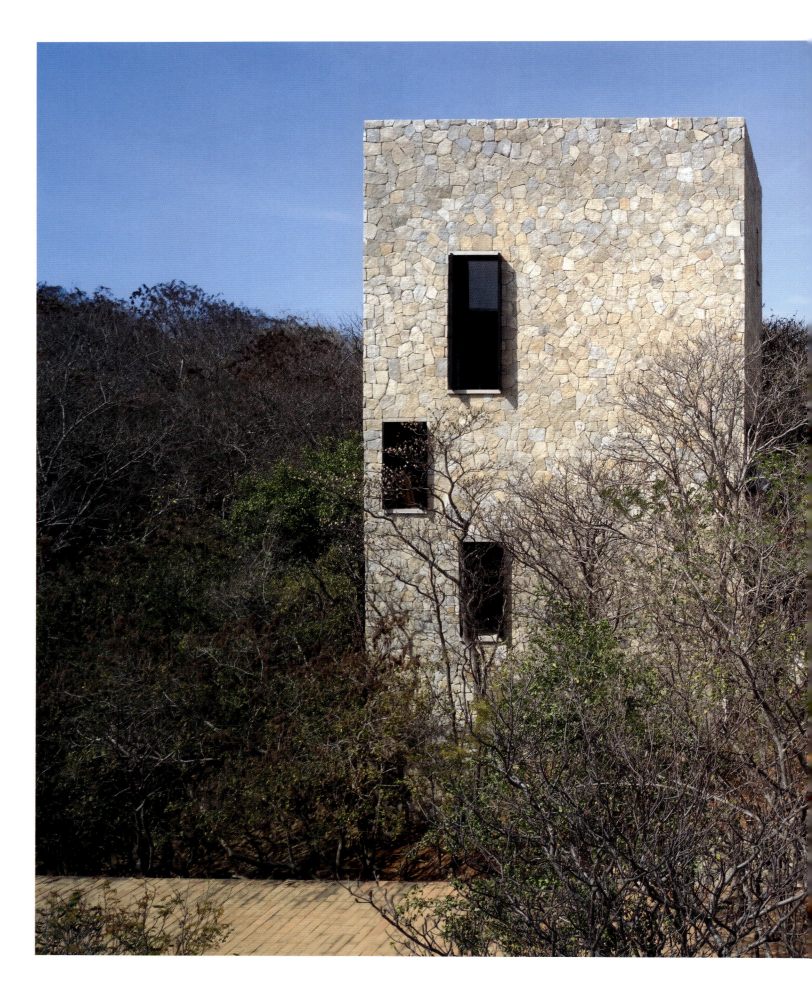

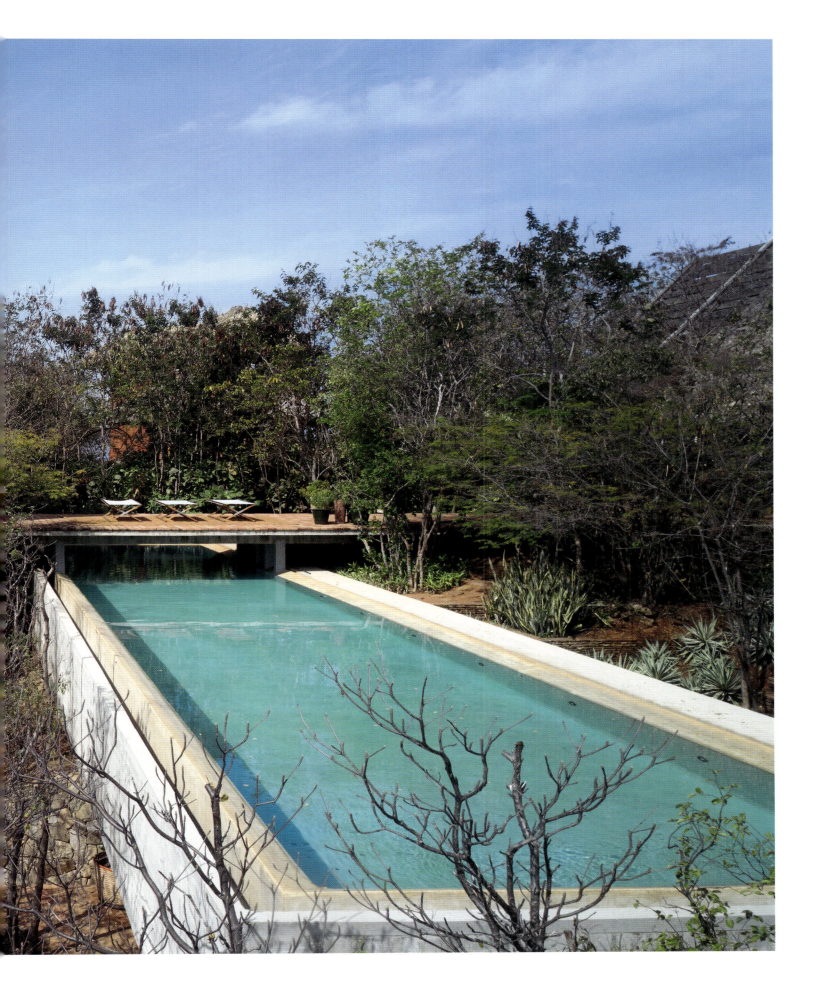

Previous spread:
A raised pool runs through
the heart of the site,
crossed by a suspended deck.

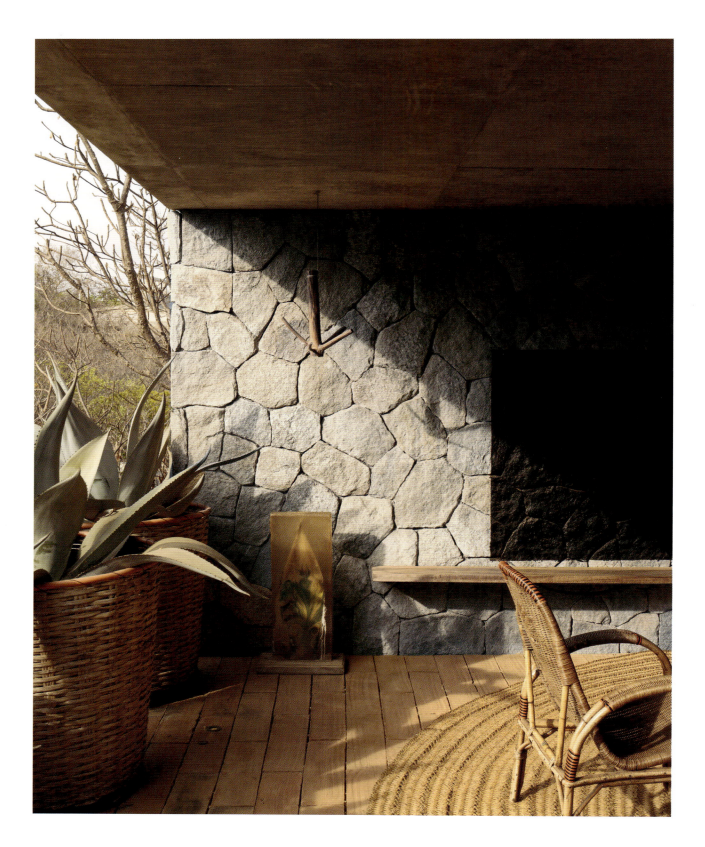

188 Architectural Retreats

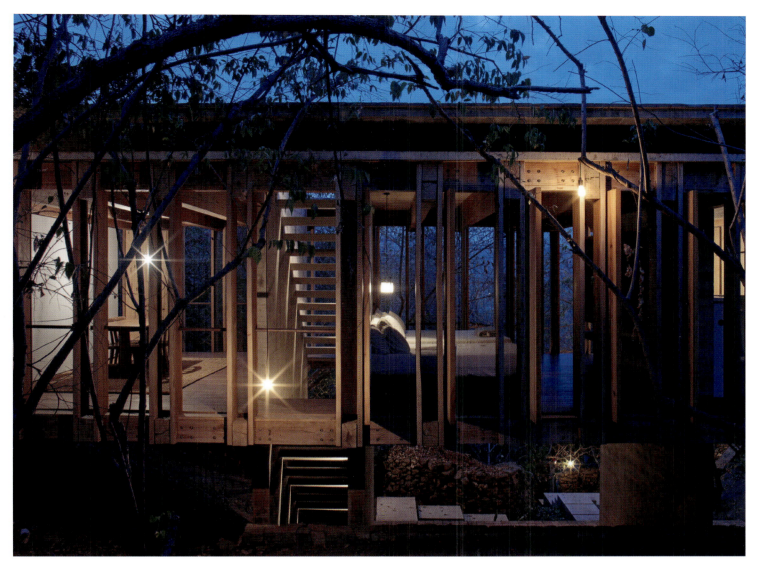

Above:
A glass and timber pavilion houses one of the main bedroom suites.

Left:
Balconies are recessed within the structure for shade.

Casa Cometa

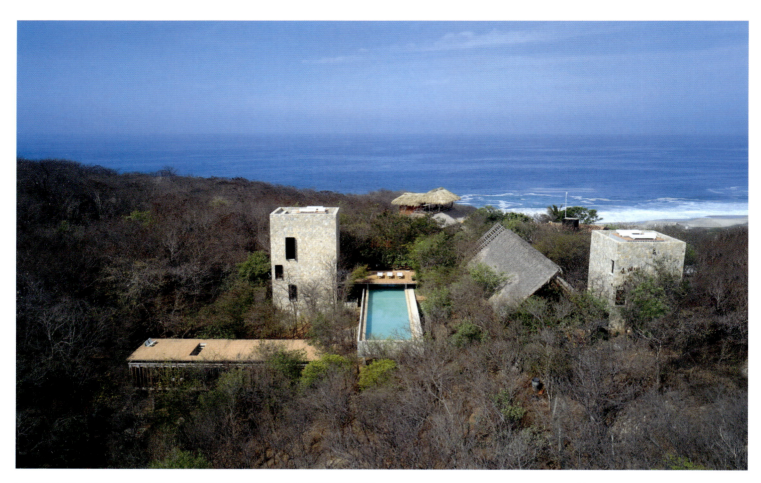

Above:
The house comprises a series of pavilions linked at ground level, presenting as independent from a distance.

Left:
The open-sided palapa serves as an outdoor living space.

Right:
Existing vegetation and planting was preserved to give the house a timeless, eternal quality.

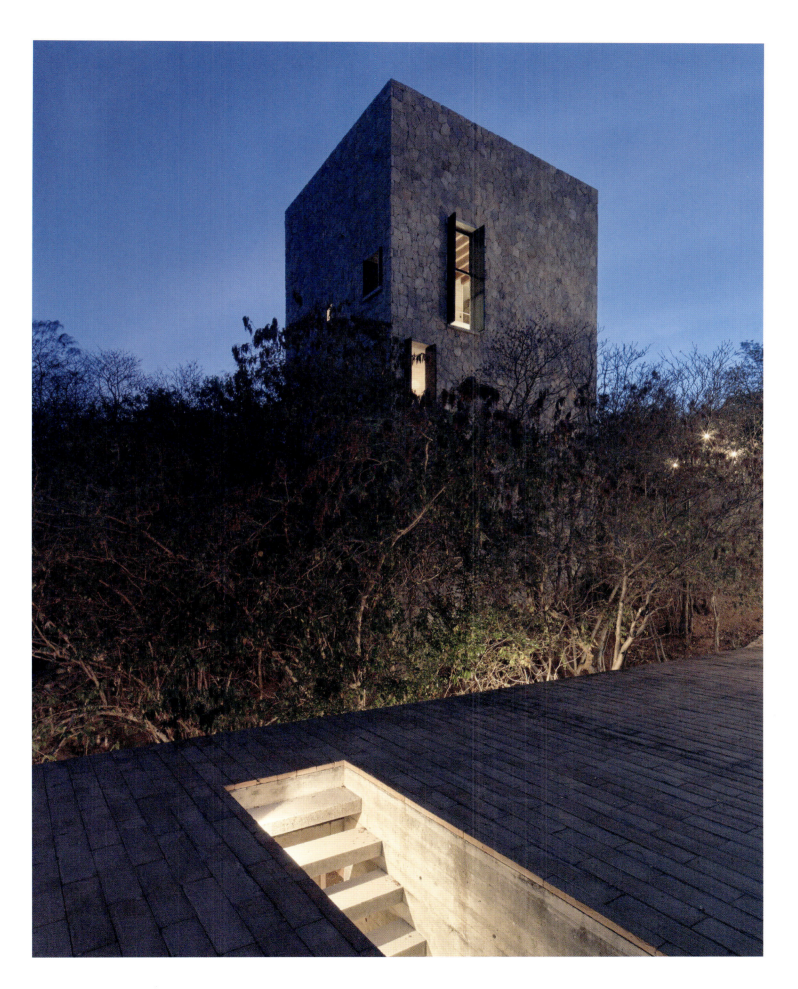

Casa Cometa

Left, top and bottom:
Details of the joinery found throughout the house.

Right:
One of the primary bedrooms has a double-height space and gallery.

192 Architectural Retreats

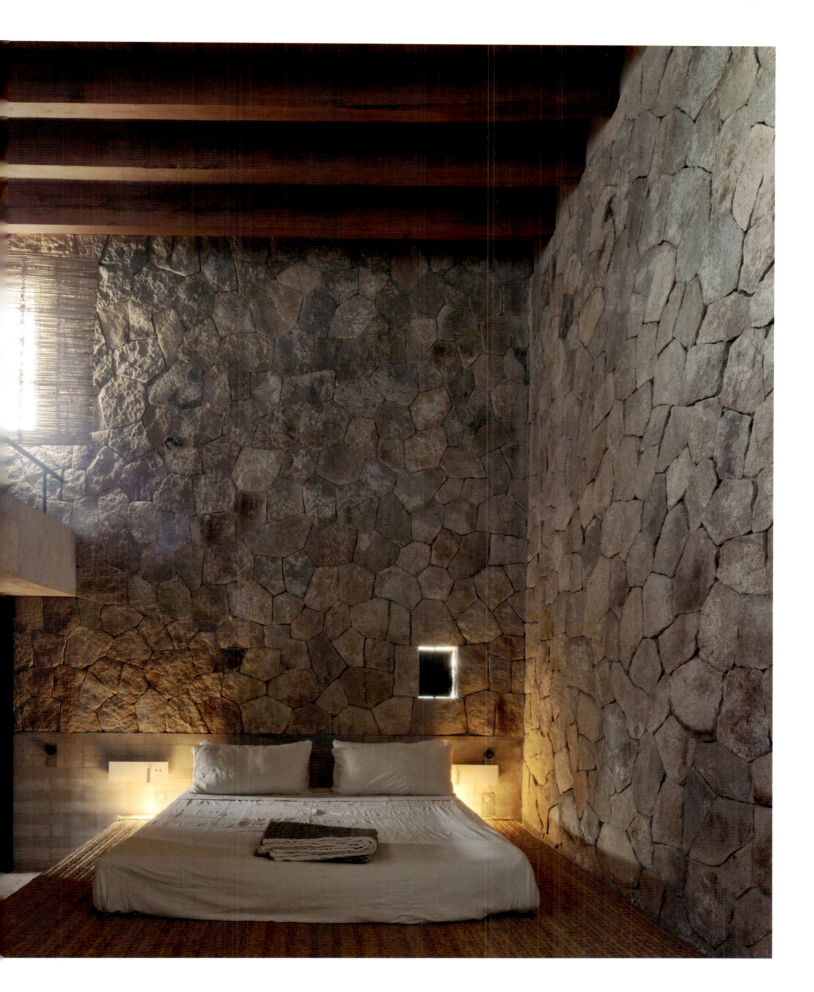

Casa Cometa

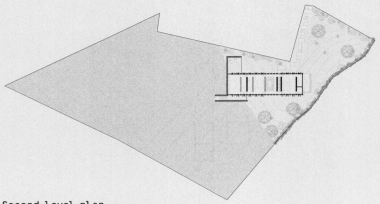
Second-level plan

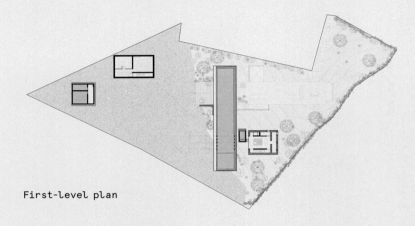
First-level plan

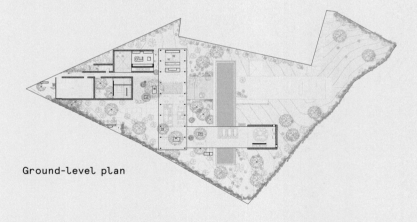
Ground-level plan

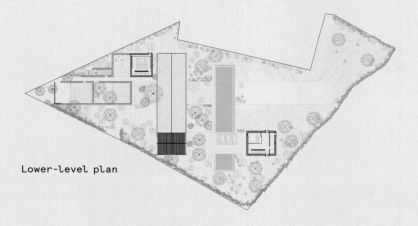
Lower-level plan

194 Architectural Retreats

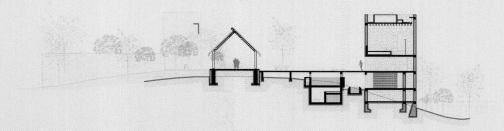
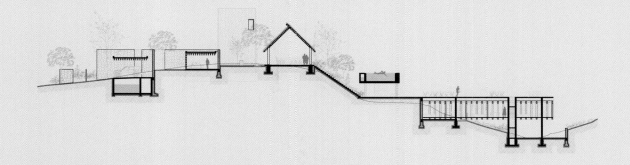
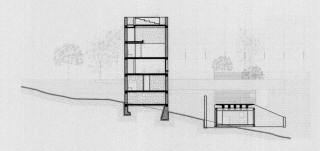

Sections

CASA VOLTA

Location: Puerto Escondido, Oaxaca
Architect: Ambrosi Etchegaray

Ambrosi Etchegaray completed Casa Volta in 2018, set in a wild location on the Oaxacan Coast close to the town of Puerto Escondido. In common with many beach houses in the region, Casa Volta is elevated above the sandy landscape, set on a plinth that not only provides structural stability, but enhances thermal cooling and gives the entire house a higher vantage point in a flat but densely overgrown landscape.

Casa Volta signals its presence with three brick vaults coming into view through the canopy of trees. Each vault crowns a compact pavilion – two for sleeping, one for living and dining – surrounded by inlaid brick patios that flank a central water feature. The architects describe the project as having the appearance of an 'abandoned classical temple', with rendered supporting columns that stalk along each side of the pool, with two bridges at either end.

The brick continues unbroken into the living spaces, with the central kitchen and living room effectively open to the elements on one side. The elevated plinth terminates in a wall of greenery in every direction, giving the impression of a structure parachuted into the heart of the jungle and built to withstand the encroachment of nature.

In plan, there is a very simple geometry at work. The rectangular plinth is divided into six elements, with three patios mirroring the pavilions on either side of the pool. The openings in the two mirrored bedroom pavilions have simple wood or reed doors that can shutter off the space, and there is a complete absence of glazing throughout the house. Although it is sited less than 100 metres (350 feet) from the coast, the sea itself is not visible from the plot, hence the pool to remind the occupants of the proximity to water.

Casa Volta is located close to Casa Wabi (see page 024), which among other cultural activities is a local centre for baking clay. The brick that makes up the vaults and terraces is formed from waste bricks and offcuts mounted within a pigmented concrete frame. The unifying palette of earthy colours contrasts with the vivid greens of the surrounding vegetation. This method of construction was also simple, fast and economical, while the open-ended vaults with reed infills allow a constant airflow through the house, cooled by the water. This combination of simple visual elements and humble construction materials creates a unified space, a retreat that appears to be adrift from the quotidian reality of the everyday.

Right:
The main bedroom beneath one of the vaulted brick ceilings that define the house's silhouette.

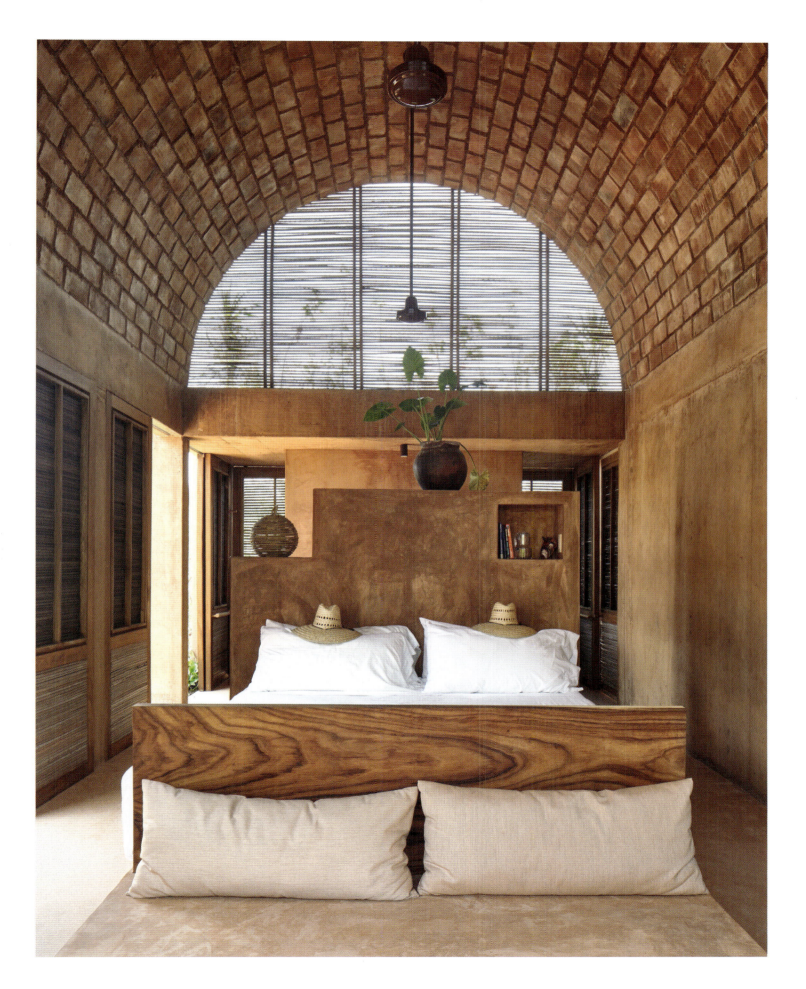

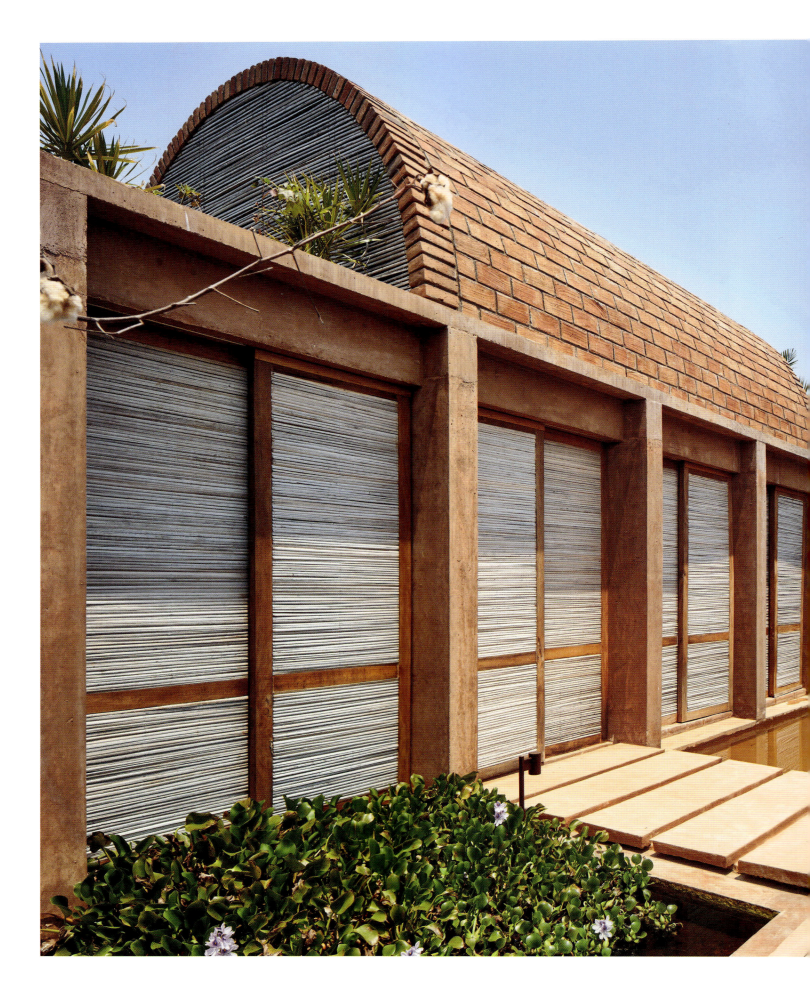

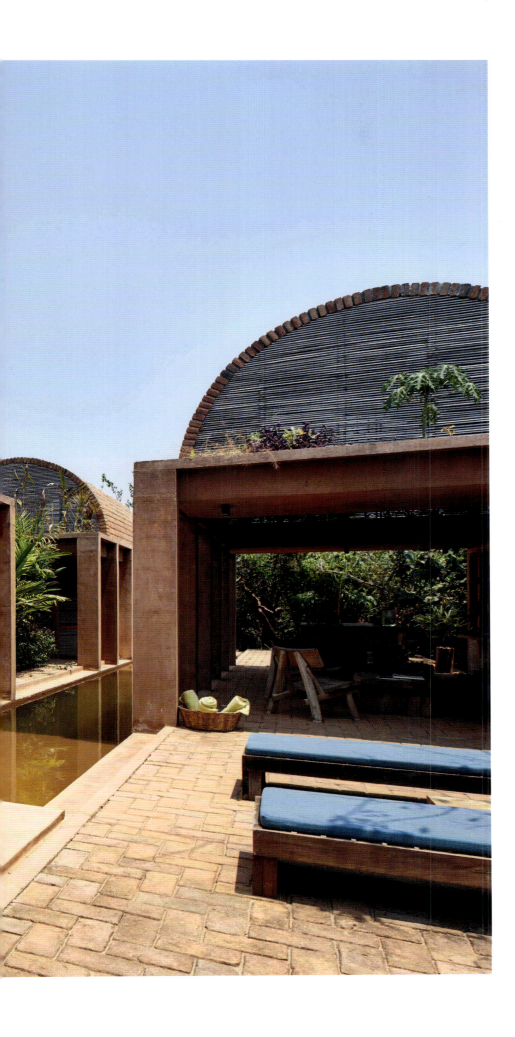

Three vaulted structures are set on a plinth, bisected by a shallow pool.

Casa Volta

Right:
Fixtures and finishes are raw and natural.

Below:
The house is designed to be opened up to the elements.

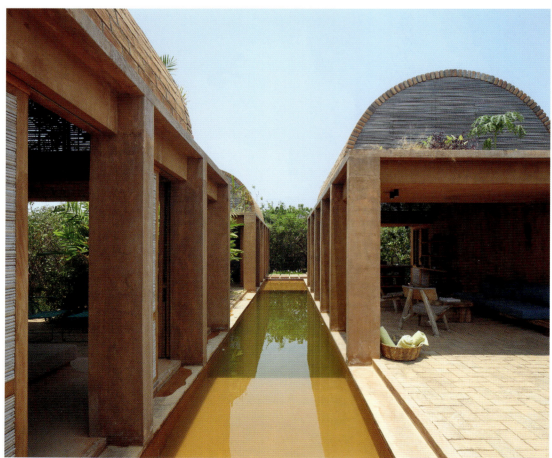

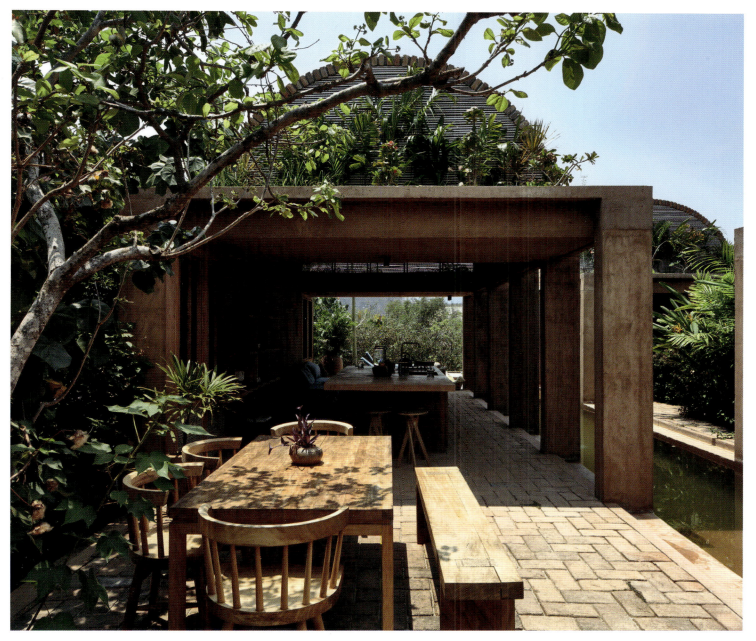

Above:
An open-air kitchen and dining room adjoins the central pool.

Following spread:
Aerial view, showing the house's proximity to the beach, as well as the integral roof planting.

Casa Volta

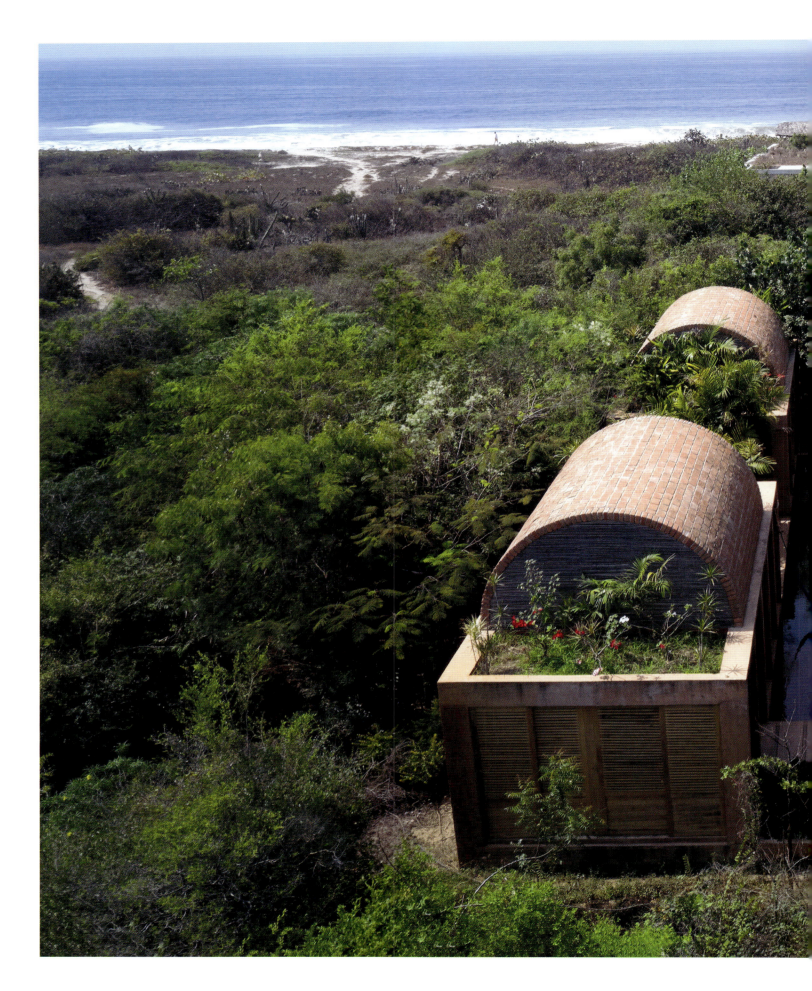

Casa Volta

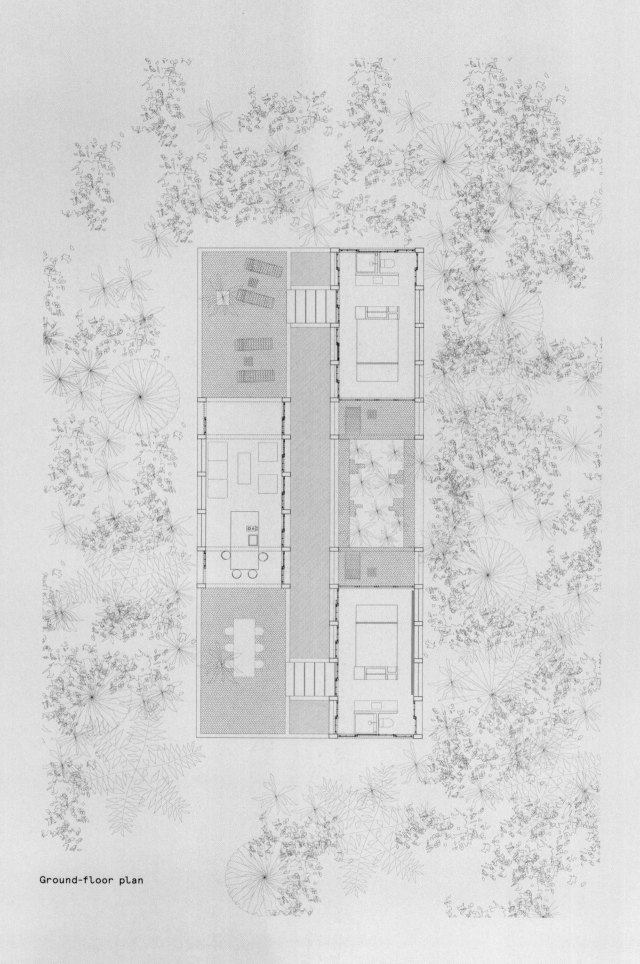

Ground-floor plan

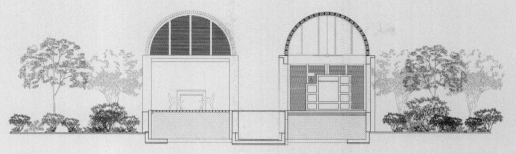

Section

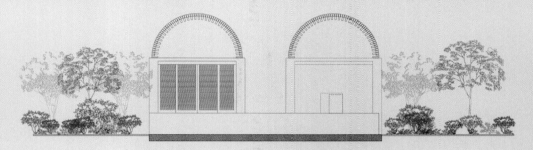

Section

Elevation

Casa Volta

PUNTA PAJAROS

Location: Puerto Escondido, Oaxaca
Architect: Alberto Kalach / T.A.X.

Alberto Kalach has been at the forefront of the new wave of Mexican architecture since rising to international prominence with his Vasconcelos Library in Mexico City. Completed in 2008, the monumental steel and concrete structure stood adjacent to a new botanical garden, with a soaring interior that emphasized the structure and organization of knowledge. With his office, T.A.X., Kalach has worked on projects ranging from sophisticated one-off houses to studies for minimal, mass-constructed dwellings, and from town-planning studies to cultural buildings.

Punta Pajaros incorporates many of these considerations in an oceanfront resort close to Puerto Escondido in the state of Oaxaca. Kalach and his collaborator, environmental engineer Luis Urrutia, combined the restoration and renewal of coastal wetlands with the addition of a number of 'eco villas', minimal in their footprint and use of materials, if not in the refinement of surfaces and finishes.

The nine-hectare (22-acre) site had been over-farmed and denuded of much of its native vegetation. After a process of restoration and reintroduction of plants and trees, including species like acacia, thevetia, mesquite, gliricidia, Bursera simaruba (known as gumbo limbo) and lantana, the stage was set to build a boutique hotel consisting of scattered cabins, each built on a 3x3-metre (10x10-foot) grid, beneath a butterfly roof made from timber and palm fronds.

A total of 74 cabins was originally planned across the plot, with a first completed phase of eleven structures. Raised up above the landscape, the living spaces are housed on a deck, each with a central 'wet core' containing the bathroom and a small kitchen. This is flanked by the bedroom and living space, with wooden screens providing privacy and protection from the climate and insects.

Located not far from Casa Wabi (see page 024), the Punta Pajaros resort follows a similar business model, creating a discreet, low-key destination for the aesthetically minded. Kalach, who also worked on the landscaping at Casa Wabi, brought his love of horticulture to this project, adding over 100,000 new plants to the beachside region.

All timber was locally sourced and certified as a renewable resource, while the project makes extensive use of solar power and biodigesters for processing waste. For the resort, 'the main objective of Punta Pajaros is to create environmental consciousness among the visitors, so that our guests can reconnect with the environment.' The close attention paid to the planting and siting of the cabins has paid off in terms of increased flora and fauna on the site, as the soil has gradually recovered.

Right:
A true beachside residence, the Punta Pajaros cabins are aimed at eco tourists.

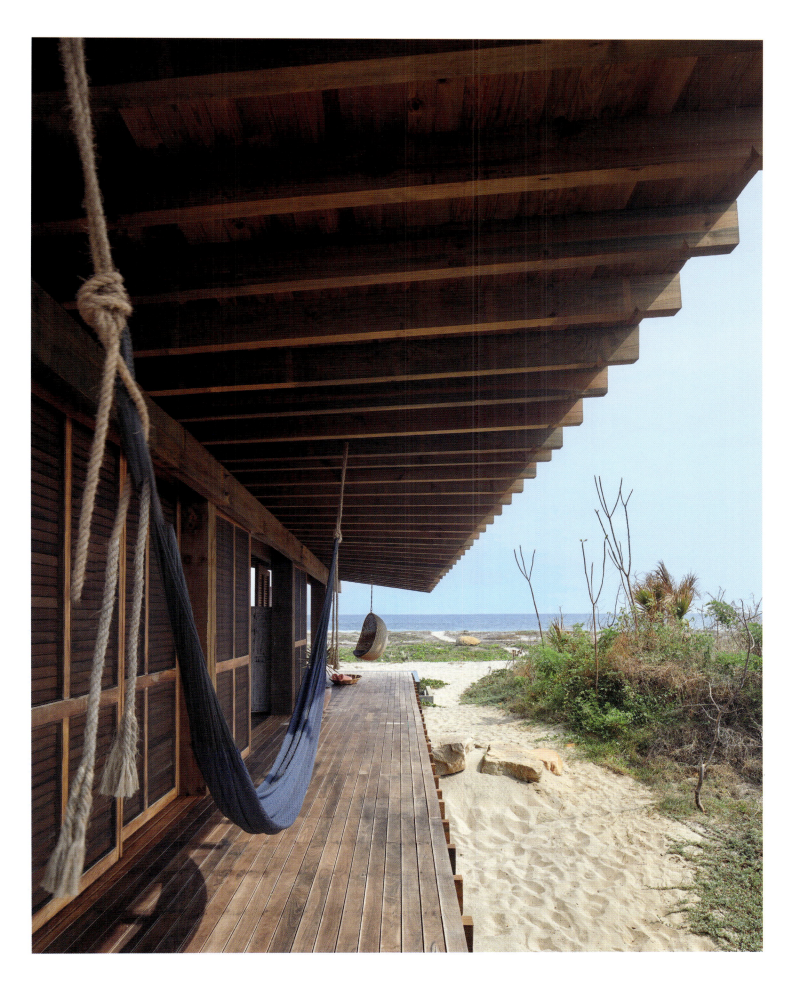

Punta Pajaros

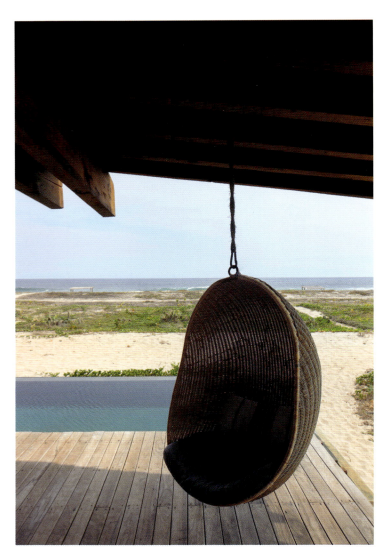

Left:
Using natural materials and methods, the villa sits lightly on its beachfront site.

Right:
Simple wooden shutters open the house up to the surrounding deck area.

Below:
Furniture and fittings are made from reclaimed local wood.

208　　Architectural Retreats

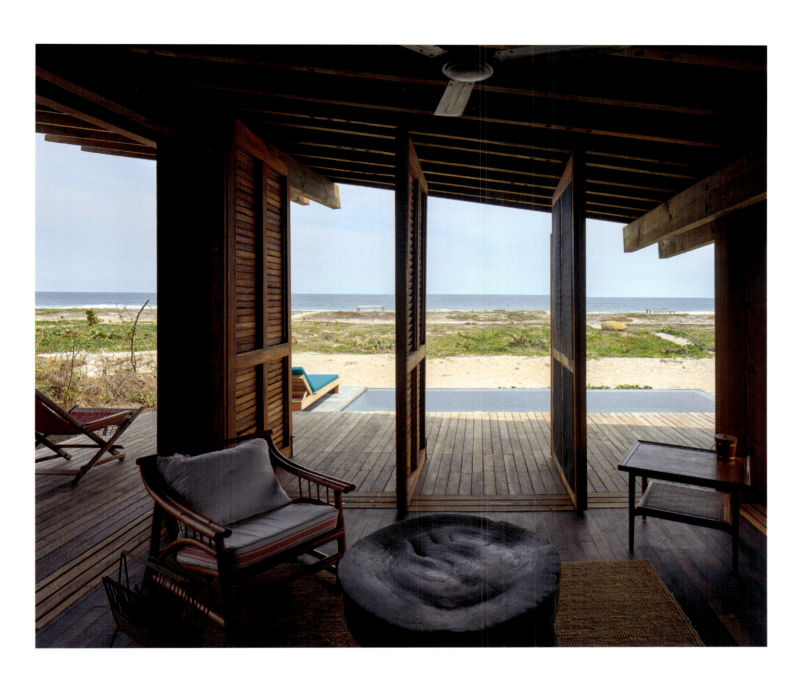

Following spread:
The house has a natural reed roof, with stripped down details and a found-object aesthetic.

Punta Pajaros

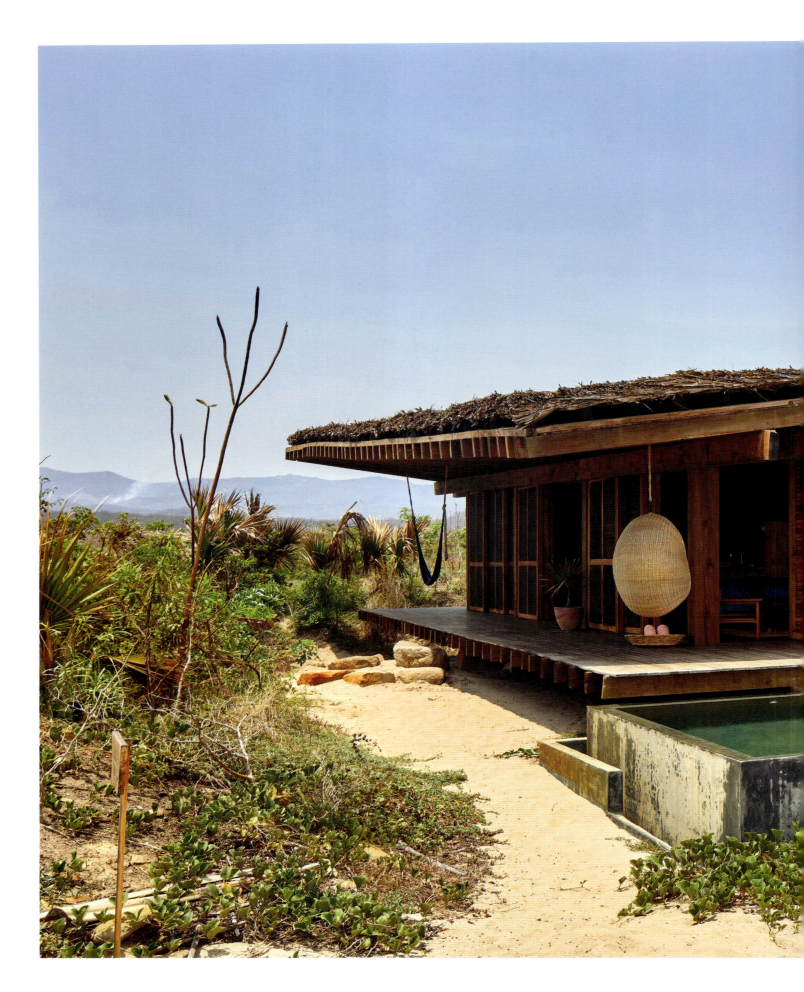

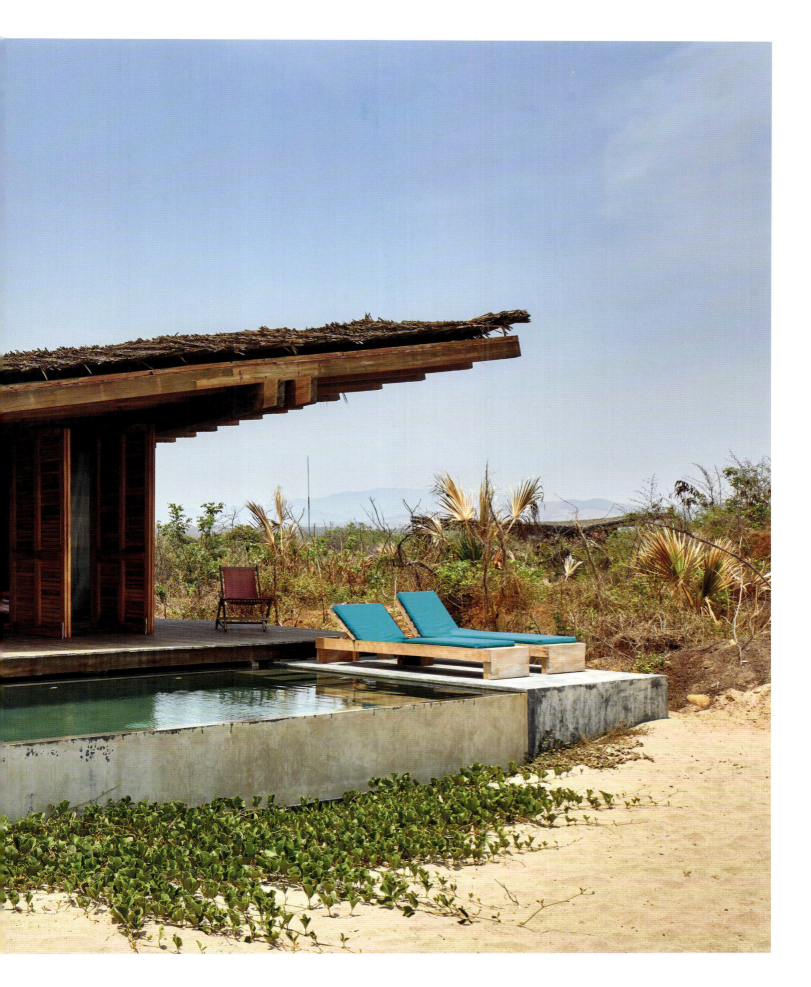

CASA CARRIZO

Location: Agua Blanca, Oaxaca
Architect: BAAQ'

A new house located in the small fishing village of Agua Blanca, near Puerto Escondido, Casa Carrizo covers a modest 160 square metres (1,722 square feet). José Alfonso Quiñones of BAAQ' designed this beach retreat as a second home for a New York-living Mexican–Peruvian couple. 'They wanted to build a house in which they could totally disconnect and feel the experience of inhabiting this particular site,' he says. The brief was intentionally simple, paring back domestic demands to the bare minimum.

The accommodation is arranged across three levels and divided into two separate but linked structures. Set back from the coastline behind another row of houses, the design maximizes views and light by placing the public areas on the upper floor, with a roof garden on the smaller tower and a covered outdoor kitchen, seating area and plunge pool on the other structure, linked by a staircase. The buildings are also connected at first-floor level by a bridge, which lifts the circulation patterns above the ground, creating the sense of a self-contained private sanctum.

Located on the mezzanine level of the smaller building, the main bedroom is raised up above a bathroom and a small seating area, which in turn lie above the garage. Guests are accommodated in a larger bedroom, designed for families to share, on the ground floor of the adjoining structure, along with a utility area and covered outside space. An internal concrete staircase leads up to a long open-plan living and dining room, with doors that open on to a central terrace between the two buildings.

Like BAAQ's other project (see page 164), the local climate has shaped the design and use of materials, with cast-concrete floors and structural frames, and palm-stem shutters to keep out the heat of the midday sun. Dirt floors on the ground floor contrast with the polished concrete, while the covered reception space is sheltered only by a Carrizo wood shade, supported by wooden columns. 'It's the simplest area but also the most important one,' the architects say, 'from here we have 360-degree views – this is where the couple can spend most of their time.' As a contrast to the hard-edged interiors, one idiosyncratic feature is the inclusion of blue and white ceramic tiles in the bathrooms. These traditional Talavera tiles were fabricated in the client's home city of Puebla, bringing a familiar item to a new location.

Right:
An infilled concrete frame, the house also has wooden elements designed to weather naturally in the seaside environment.

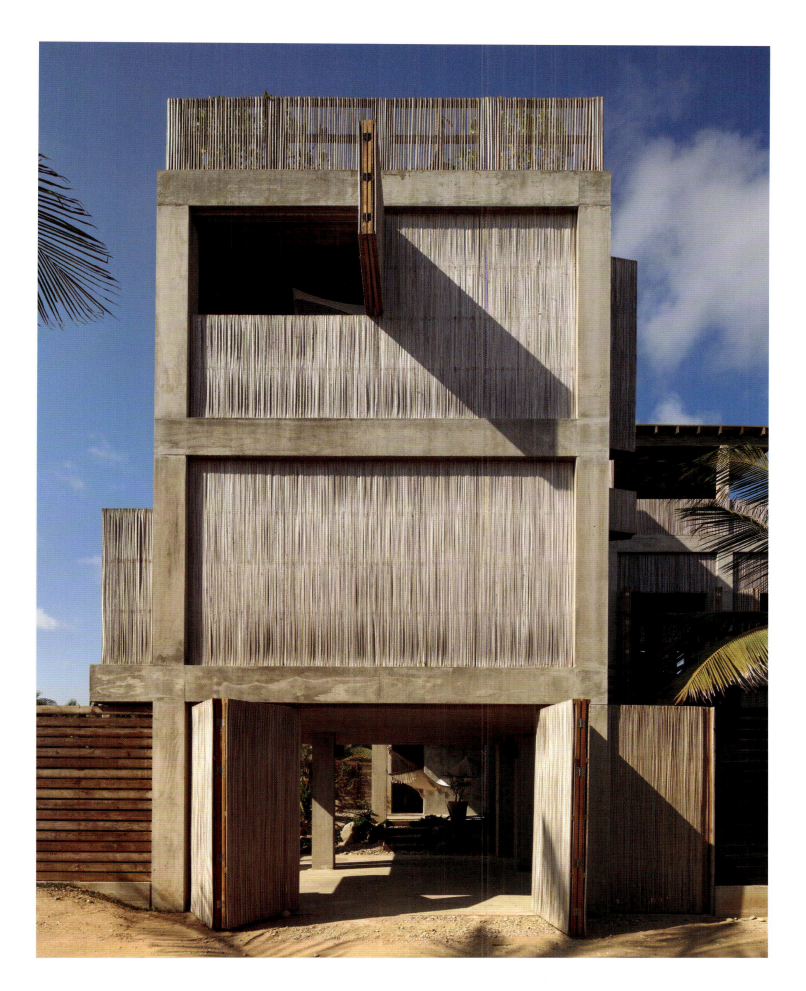

Casa Carrizo

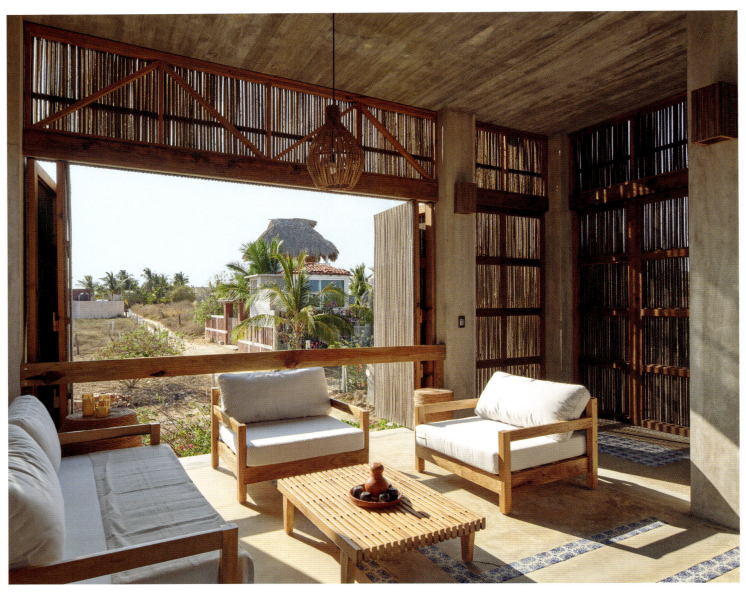

Above:
The main living space has shutters on the opening facade and traditional panelled walls.

Right:
The uppermost deck contains a dining area and external kitchen.

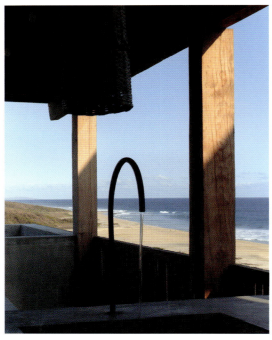

214　　　　Architectural Retreats

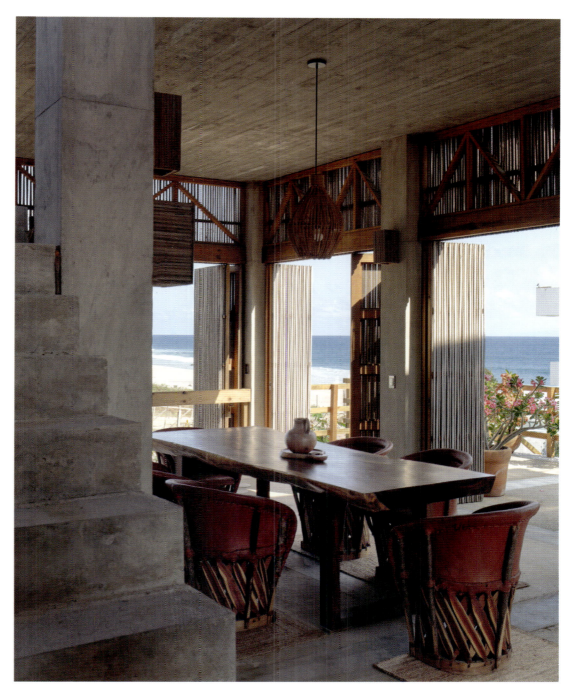

Above:
The houses are built around a concrete frame that includes internal staircases.

Casa Carrizo

A bridge links the two structures at roof level.

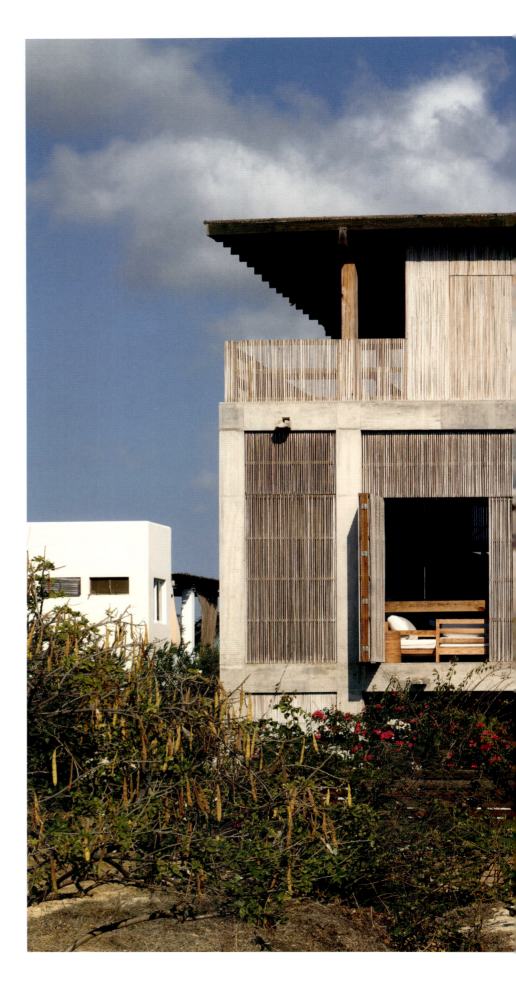

216 Architectural Retreats

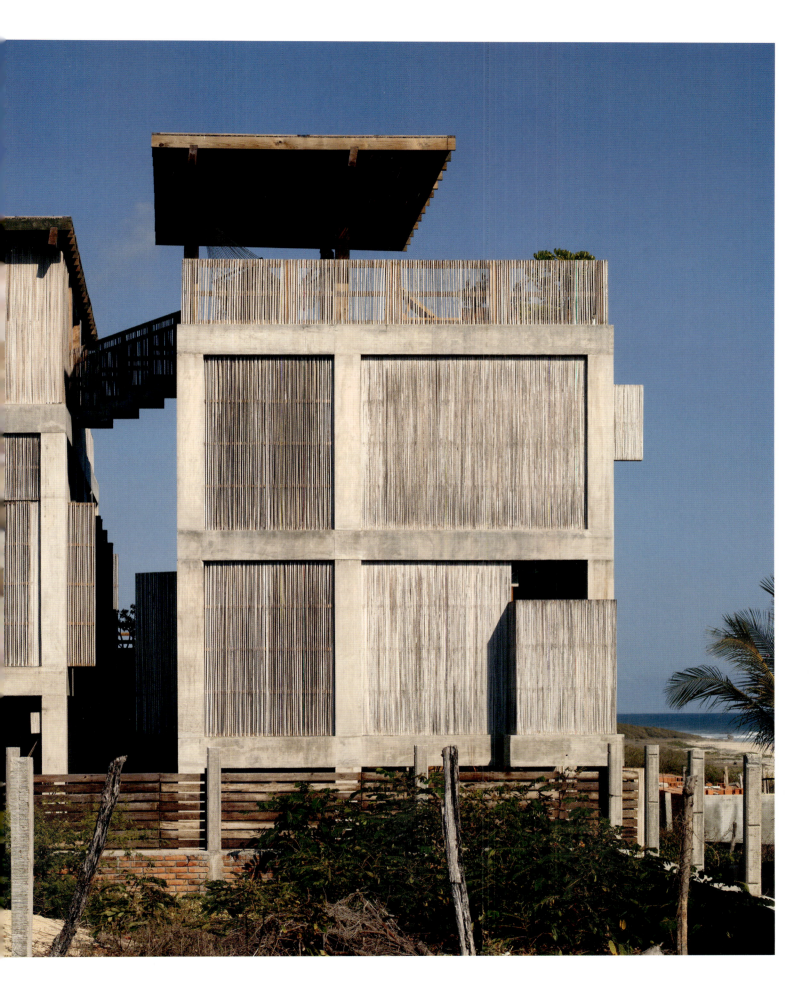

Casa Carrizo

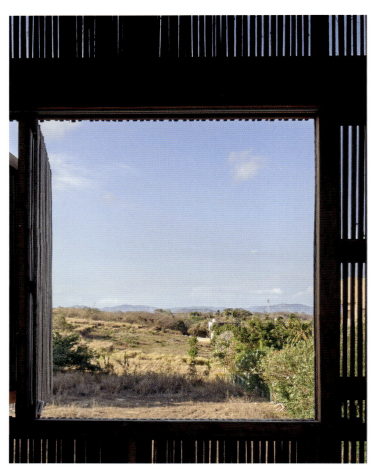
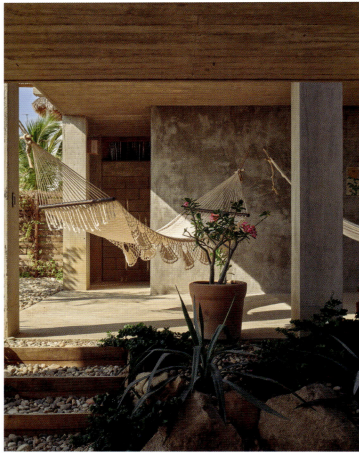
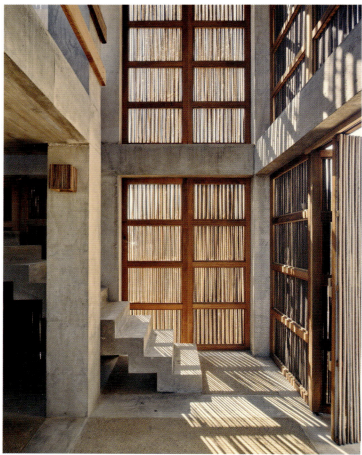
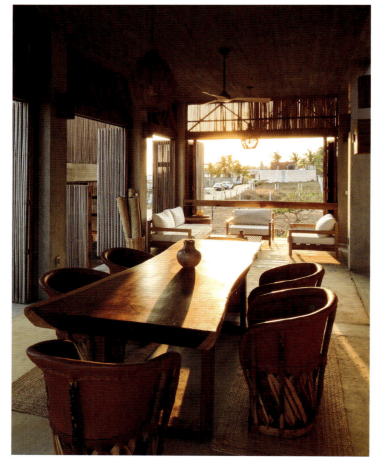

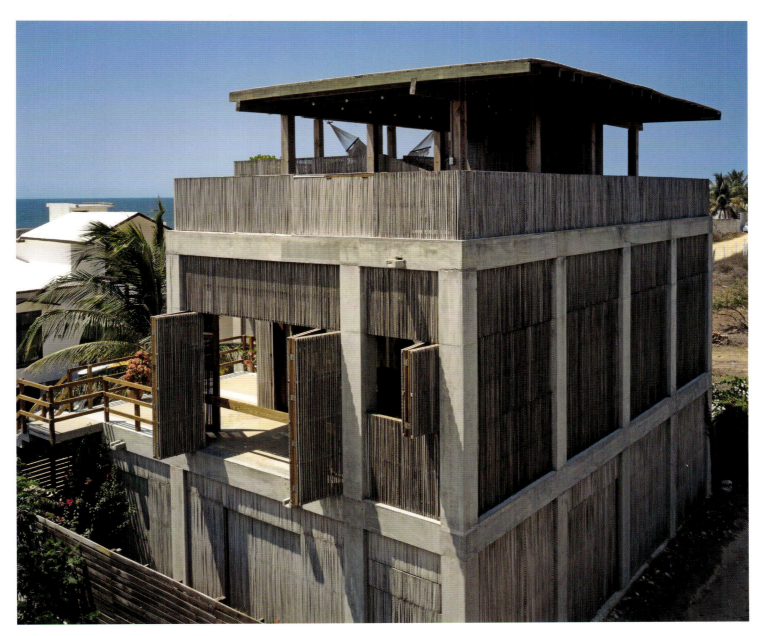

Left, clockwise from top-left:
Windows frame the dunes; natural planting encroaches on the ground floor; the living room at sunset; thin strips of wood in the walls cast striking shadows.

Above:
The arrangement of shutters, panels and the concrete frame is clearly revealed.

Casa Carrizo

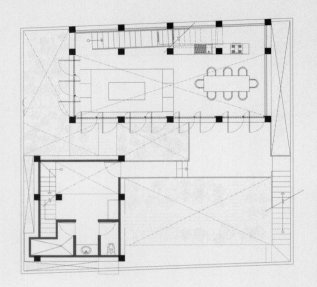

First-floor plan

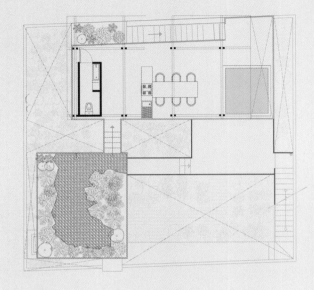

Third-floor plan

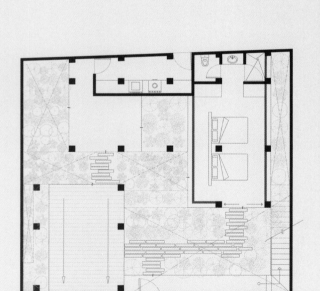

Ground-floor plan

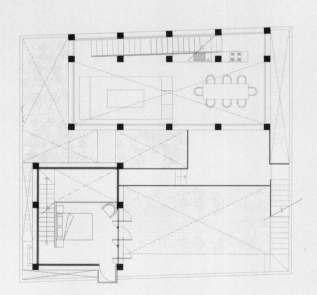

Second-floor plan

220 Architectural Retreats

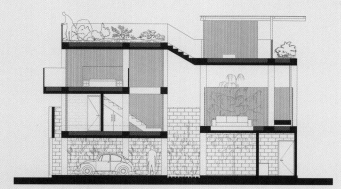
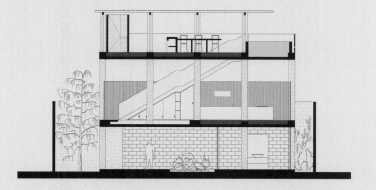

Sections

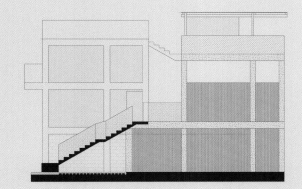

Elevations

Casa Carrizo

SAN BRUNO BEACH HOUSE

Location: Yucatán
Architect: Reyes Ríos + Larraín Arquitectos

Reyes Ríos + Larraín Arquitectos arranged this beach house in Yucatán as a series of three pavilions that cover a total of 700 square metres (7,500 square feet), strung out along a long, narrow plot close to the beach. Each pavilion is independent yet adjacent to one another, with an offset alignment creating a pathway through the site and allowing for cross-ventilation and views. This strategy is also intended to preserve the sightlines and privacy of the compound should the currently vacant plots on either side be developed in the future.

The pavilions themselves are eclectically planned, related only in materials and geometries, but serving separate purposes and united by terraces, pathways and a connecting bridge between the two structures closest to the beach. The setbacks and offsets also maximize views of the sea from deep within the property, with a covered roof terrace on the central pavilion providing the best viewpoints of all. The two structures that flank it are dedicated to bedrooms, with the chambers on the first floor having a tall, vaulted ceiling that expresses itself in the angular silhouette of each structure. This angle is also replicated in the external staircase on the first pavilion, a solid sculptural element that casts striking shadows across the red facade.

The pavilion that is furthest from the road contains the main living space, with a terrace that opens up on to a small plunge pool with an adjacent covered seating area. The open-plan kitchen and dining room is located in the central pavilion, alongside an external dining area, beneath a first floor containing a suite of rooms for guests. The principal bedroom is set above the beachside pavilion, linked to the central pavilion by a bridge, from where another external staircase takes one up to the partially covered roof space. Salvador Reyes Ríos describes this space as an essential part of the entire complex: 'In terms of metaphysical perception, a roof-covered pergola at the top of the central pavilion represents our ambition to create a strong sense of connection with the site's nature as well as a respectful sense of belonging.'

Despite its monumental appearance, the house complex has been designed to minimize its impact on the ecosystem of the dunes surrounding the lagoon. Each pavilion is set on concrete stilts, rather than built on a solid raft of concrete, and all construction materials are locally sourced and reference the local vernacular – these include bamboo, subtropical hardwoods and limestone, the latter used throughout on the flooring inside and out.

The entire complex is rendered in a pigmented mortar, created in close collaboration with Cemex, the country's leading cement supplier. A specially developed stucco finish with a rich, reddish surface, it is designed to avoid the need for repeat maintenance and repainting in the harsh seaside environment.

Reyes Ríos and his partner, Chilean-German artist Josefina Larraín Lagos, have collaborated on many new architectural projects as well as specializing in the restoration of traditional haciendas across the Yucatán region.

Right:
An external staircase leads up to the roof and the ocean view.

Architectural Retreats

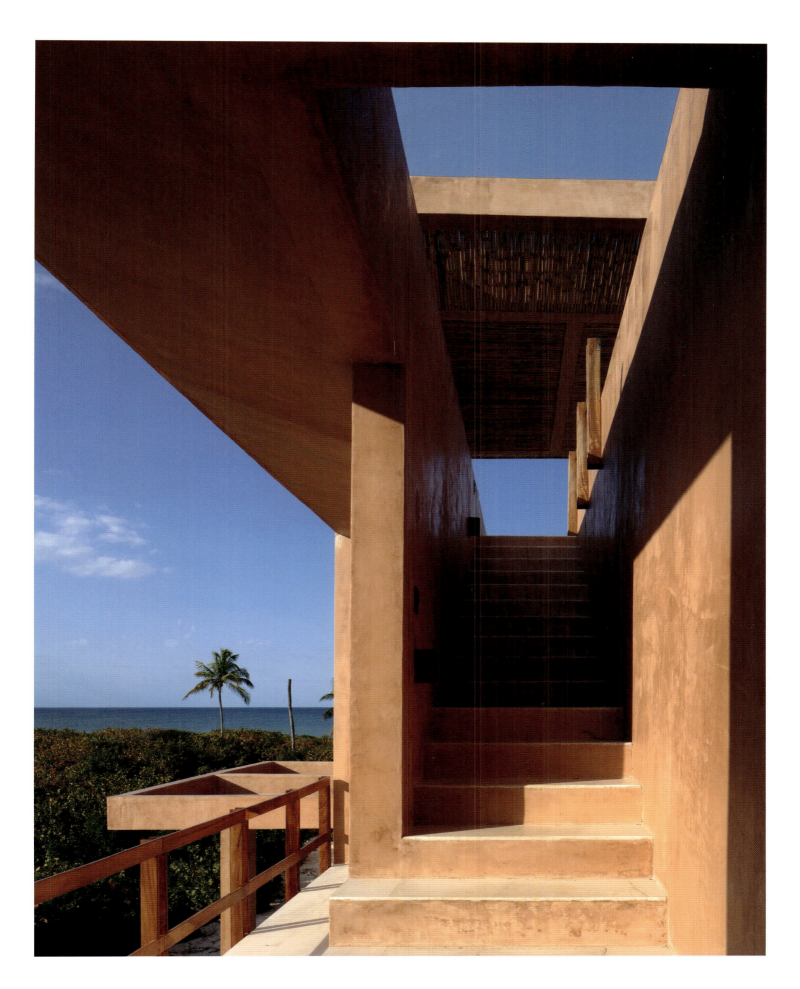

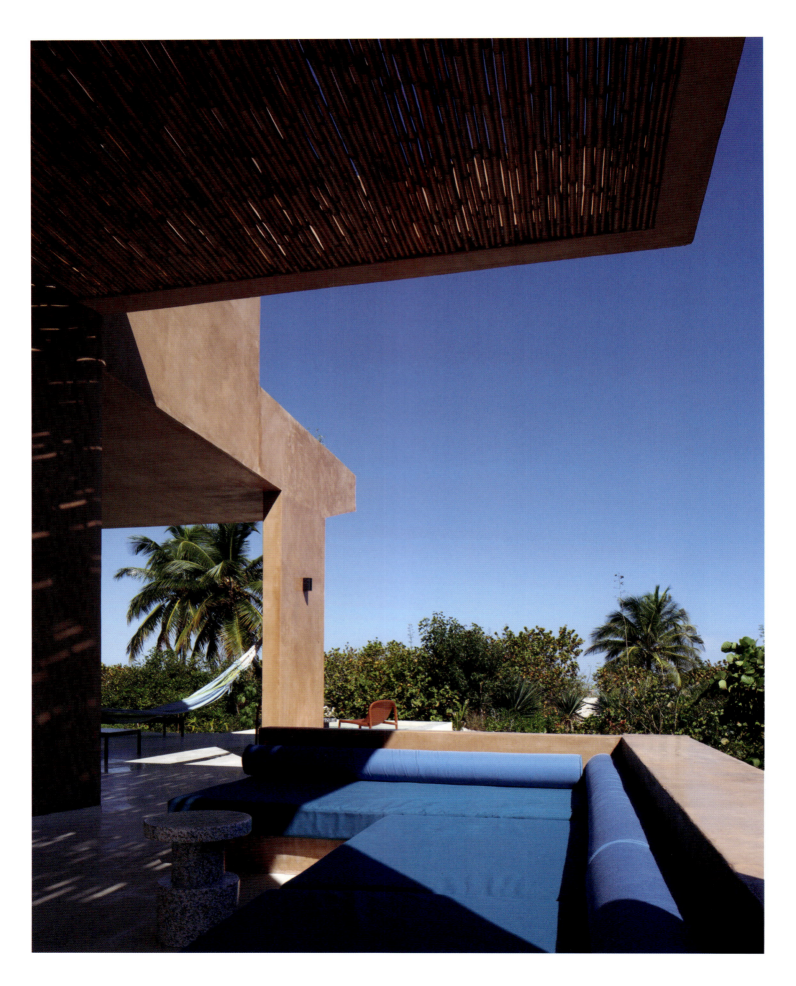

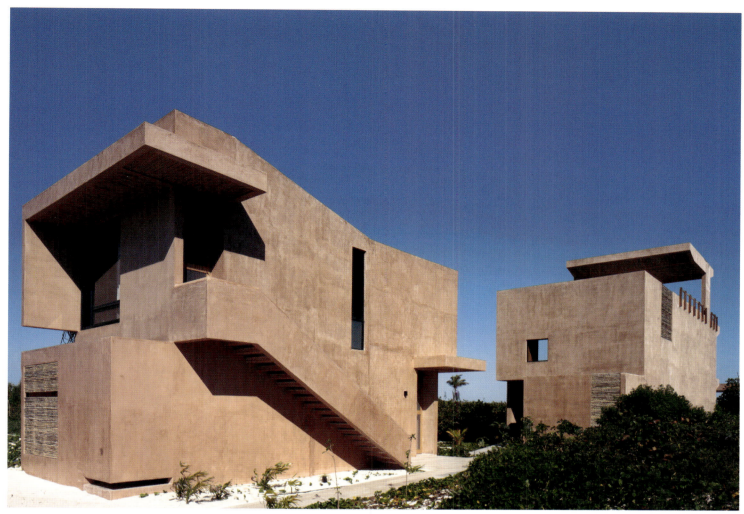

Above:
Two of the three independent elements that make up the main house.

Right:
A bridge links two of the structures and shades the walkway below.

Left:
An integral banquette is located on a shaded terrace.

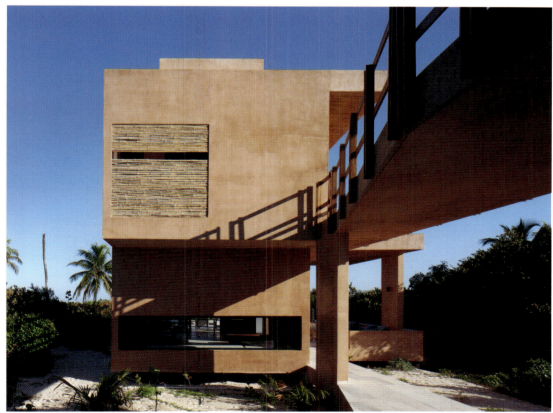

San Bruno Beach House

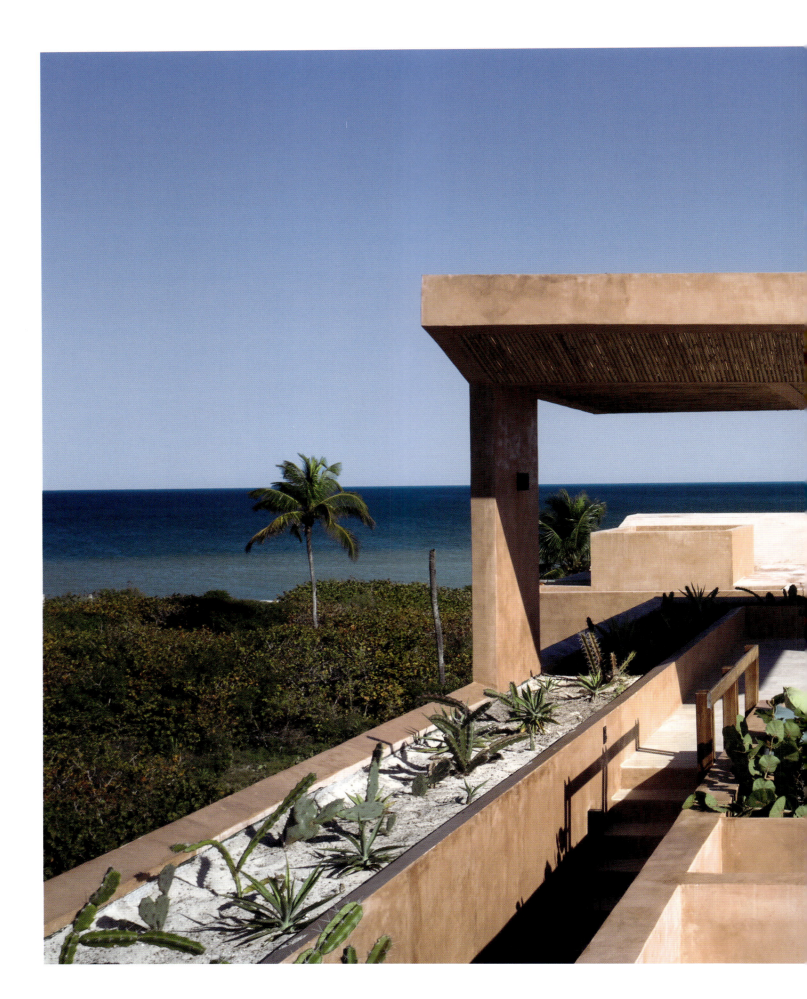

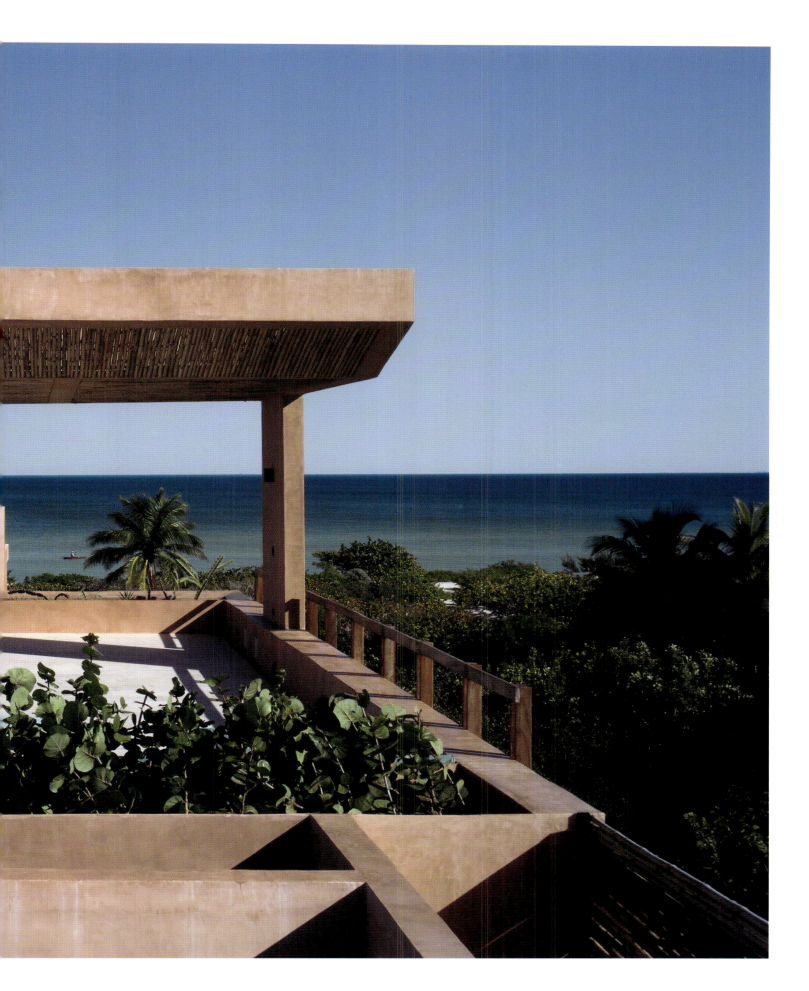

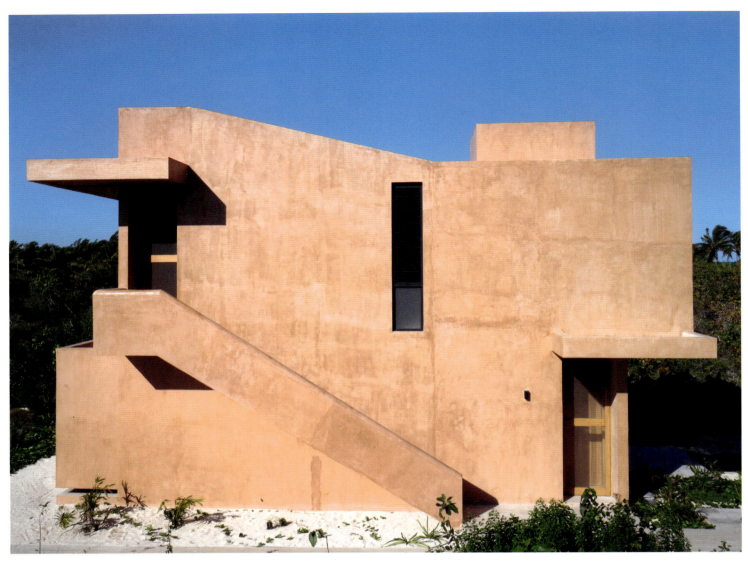

Above:
An external open staircase creates a striking geometric form.

Right:
The plan is arranged to create tantalizing views through the house to the landscape and sky beyond.

Previous spread:
The main roof terrace, showing integral planters and rooflights for the rooms below.

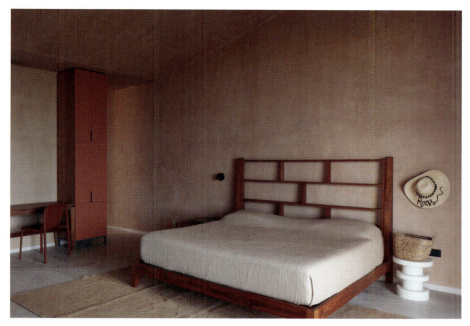

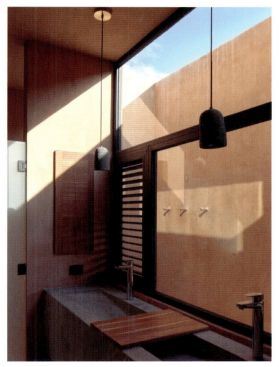

Clockwise from above: Pared-back furnishings have a mid-century feel; bathrooms retain privacy through internal, top-lit courtyards; looking back from the dining room to the pavilion beyond.

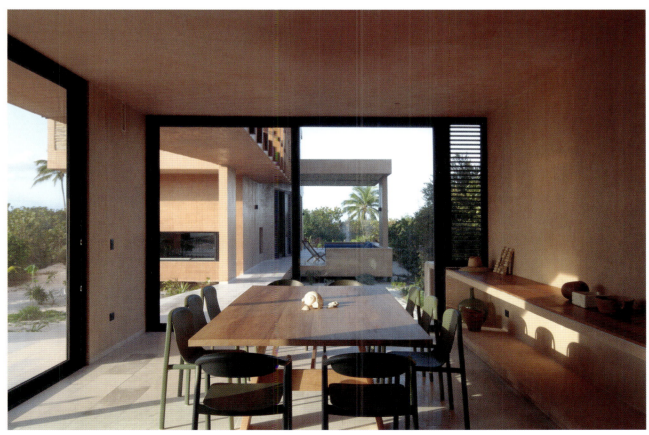

San Bruno Beach House 229

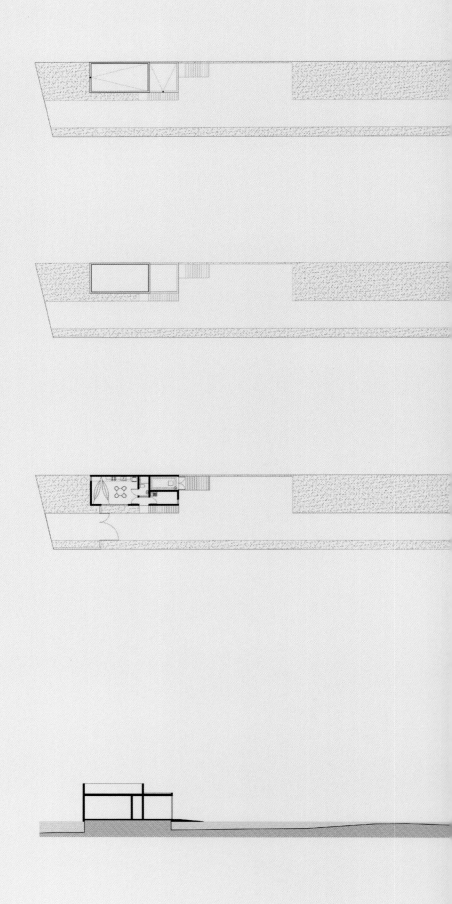

230 Architectural Retreats

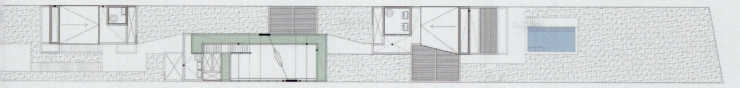

Rooftop plan

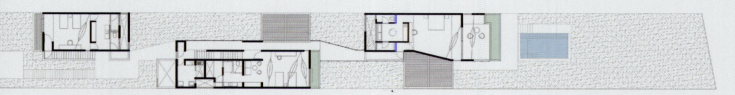

First-floor plan

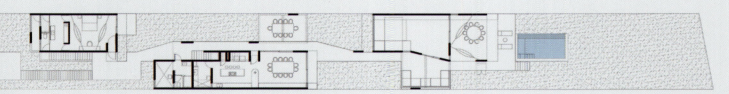

Ground-floor plan

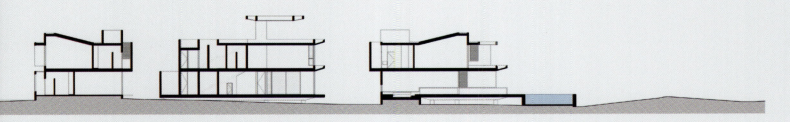

Section

San Bruno Beach House

CASA LERIA

Location: Puerto Escondido, Oaxaca
Architect: TAC

Set on the beach at El Tomatal in Puerto Escondido, the generously sized family retreat by TAC (Taller Alberto Calleja) is splintered into a series of pavilions embedded in the vegetation. New planting has been carefully deployed to enhance this sense of a structure buried between sea and jungle. The plot, which measures 3,500 square metres (37,700 square feet), contains 1,100 square metres (11,800 square feet) of accommodation, scattered across eight different pavilions. 'The scale and density of the construction is hidden by the local vegetation,' the architects explain. 'Casa Leria is meant to be discovered one space at a time and its in-between circulations full of sensorial experiences.'

The plan breaks the various sections of the house into separate spaces. The core of the living spaces are dominated by the palapa, a traditional open-sided living space with a thatched roof. This diamond-shaped structure oversails a large dining table and seating area, off which is the kitchen, utility space and a long terrace flanking the pool. The latter is raised slightly above ground level, enclosed by a wall clad in the same tiles as the pool itself.

Elevated wooden walkways lead from the palapa to the other components of the house. The first pavilion is set at 45 degrees to the other structures and contains the principal bedroom, a rectilinear concrete box with its own enclosed terrace, as well as an external cantilevered staircase leading up to a private roof deck at the level of the palm leaves.

The walkway continues to a cluster of four en-suite pavilions for sleeping, a single bedroom, two doubles with integral bunks and a final pavilion containing twin rooms for staff accommodation. A walkway leads off between these stepped pavilions to the 'social tower', a double-height square structure with a seating area, mezzanine and roof terrace with ocean views.

'By constructively isolating the modules from each other, we achieved a series of individual elements and spaces that are interconnected by the circulation bridges,' say the architects. 'This generates a minimal impact on the landscape.' The importance of vegetation and planting is emphasized by the stepped layout of the sleeping pavilions, allowing screens of greenery for privacy and shielding. New naturalistic planting is scattered throughout the plot to enhance the sense of discovery and integration with the landscape, as well as to provide natural protection from coastal winds.

Right:
The main pavilion features a large wraparound terrace set beneath the triangular palm-leaf roof.

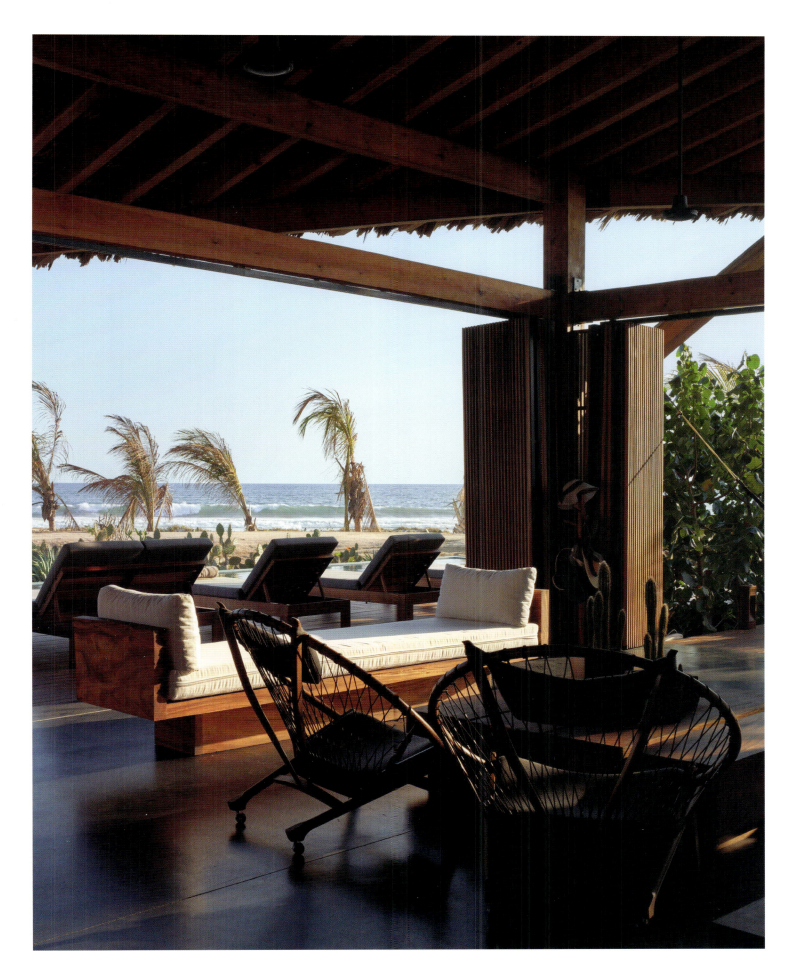

Casa Leria

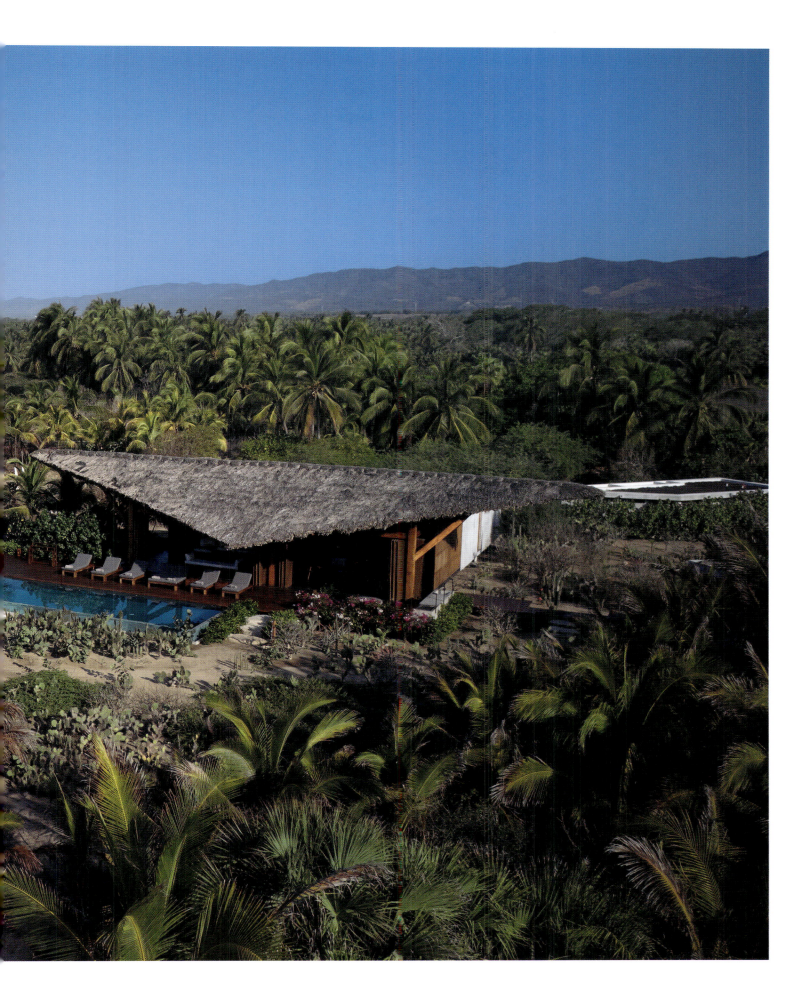

Casa Leria

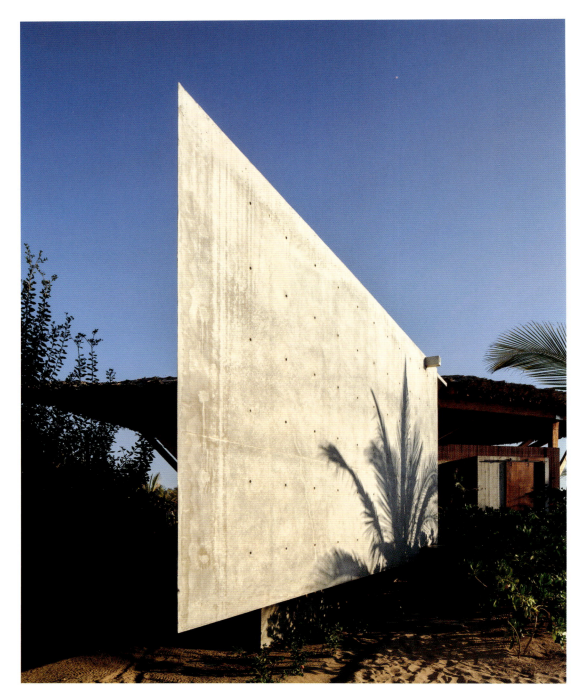

Above:
An angled concrete wall screens the sleeping pavilions from the beach.

Previous spread:
The house is perched on the edge of the ocean, with additional structures set behind the main pavilion.

Right:
Seen from above, the house's fragmentation into living pavilion and sleeping structures is clear.

Below:
A shallow pool sits at the front of the main terrace, fringed by cacti.

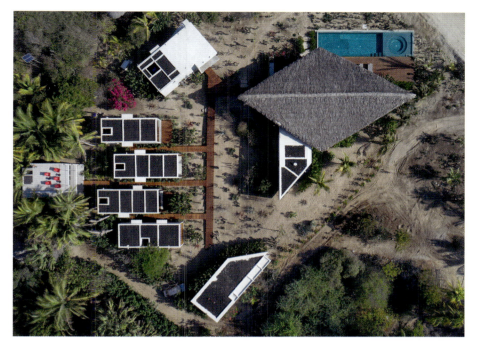

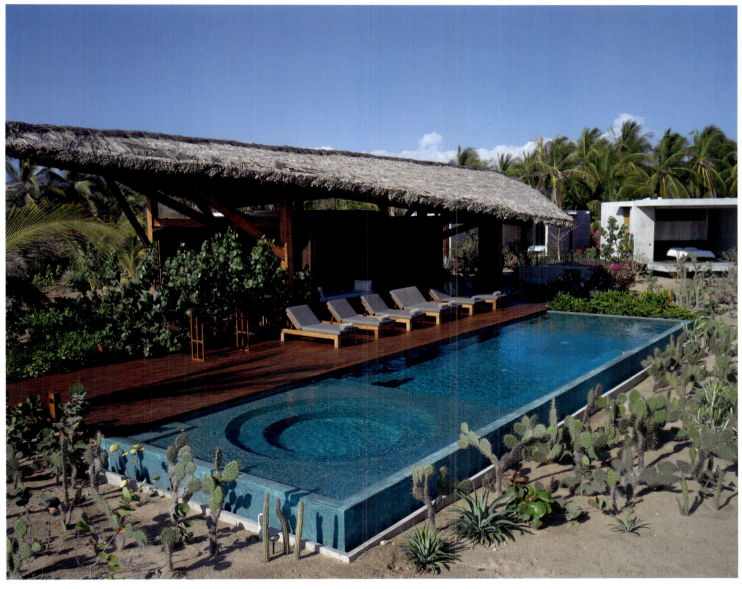

Casa Leria 237

The main living pavilion is completely open to the elements.

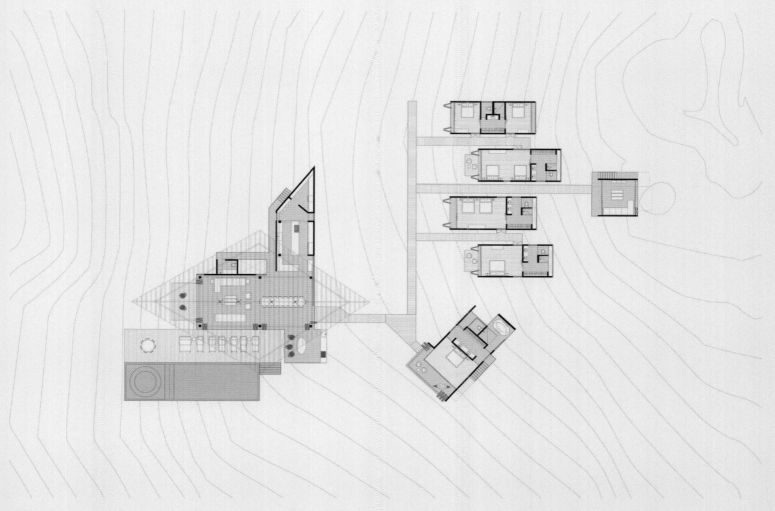

Site plan

FAMILY HOUSES

The mainstay of modern architectural practice, the family house showcases the diversity and complexity of the contemporary Mexican scene. From austere retreats planned and executed with the precision of a work of art, through large-scale structures that make the most of priviledged locations and expansive budgets, to smaller, but no less striking statements that use architectural intention and ingenuity to elevate living to an artform. The projects in this section are not dictated by vernacular or history, but instead use design to make functional family spaces for town, country and beyond.

Right:
The external pool terrace at Casa Kem.

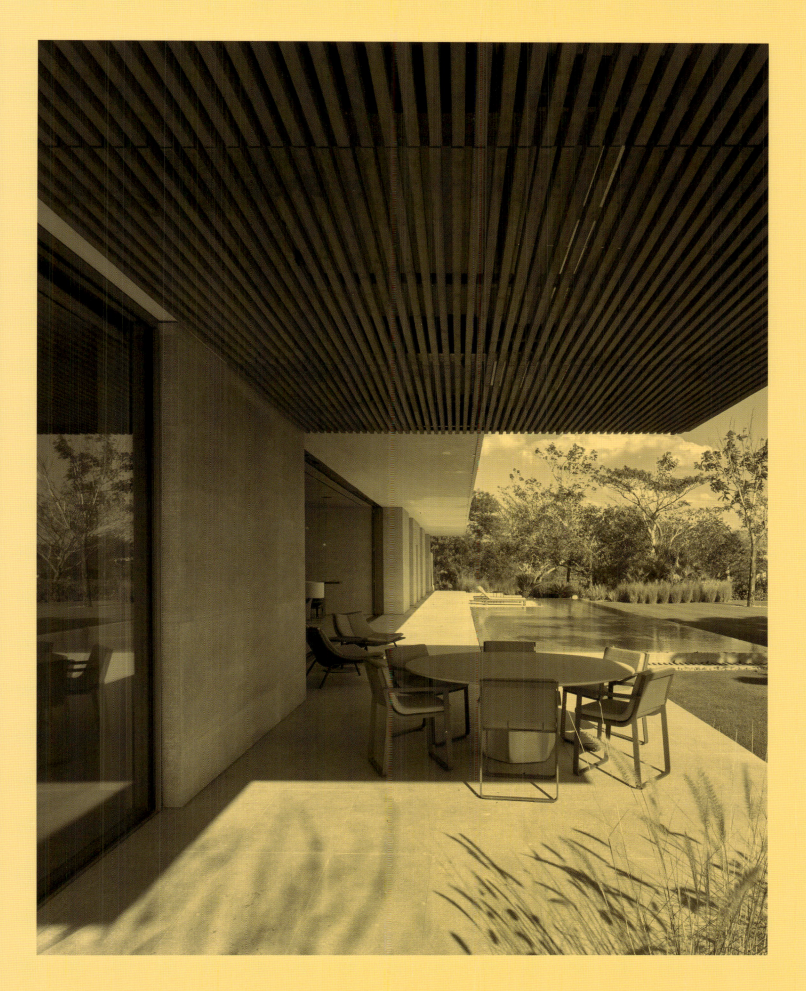

Family Houses

CASA KEM

Location: Mérida, Yucatán
Architect: Gantous Arquitectos

Gantous Arquitectos completed Casa Kem in 2020, a lavish low-built house located on the exclusive Yucatán Country Club in Mérida. The house adjoins the Jack Nicklaus-designed golf course, with living and sleeping accommodation arranged laterally across a generously scaled single storey, flanked by a reflecting pool on the street facade to the north and a long terrace and swimming pool to the south, with views across the links.

Designed for a family of five, the floor plan is bisected into living and sleeping areas. A short winding path leads up to the main entrance, which is reached via stepping stones that cross the reflecting pool. This brings one straight into the primary living space, with bedrooms to the left and a kitchen and staff area to the right. A wall of glazing on the south facade opens up the entire living and dining area to the swimming-pool terrace, where there is also a separate outdoor dining space.

A secondary entrance is accessible from the car port, bringing guests into a more conventional reception space. This has the benefit of revealing the scope of the house and the landscape beyond, creating a sense of arrival. The east wing is given over to a large principal suite, with its own substantial dressing room, terrace, study and seating area. Two additional generous en-suite bedrooms are located alongside it, their plans mirroring each other, and with a separate seating area serving as an access route to all the sleeping accommodation. This space also has a view back on to the reflecting pool and the entrance.

Exterior walls are finished in exposed white concrete. There is an extensive use of Punto marble inside and out, elevating the sense of scale and quality via the minimal palette and highly crafted application.

The 2,900-square-metre (31,200-square-foot) plot features a steep slope and considerable tropical planting to screen the house from the road. The north facade also includes sliding glazing, which opens up to form a more intimate and private indoor-outdoor space, fringed by vegetation. Each principal facade is shaded by an extended cantilevered flat roof, while through draughts provide natural cooling in the tropical Yucatán climate.

Right:
Set in an exclusive country club, the house is designed to maximize privacy and a sense of glorious isolation.

Family Houses

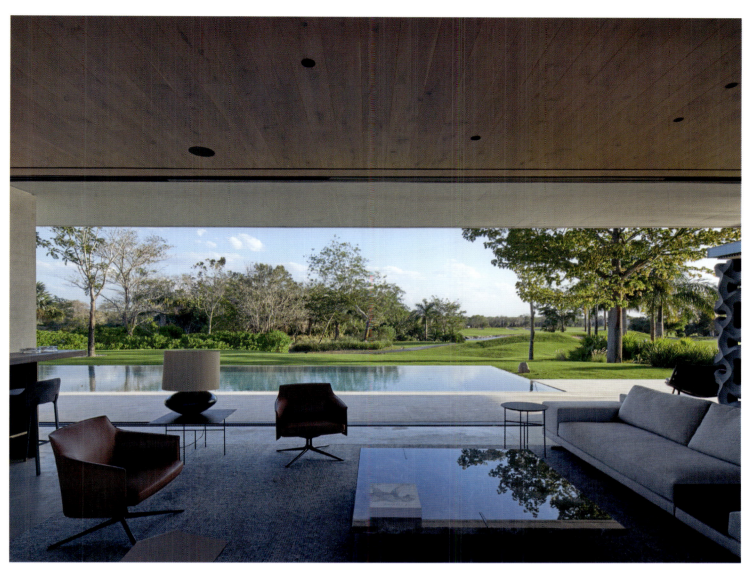

Above:
Large sliding windows open up the sitting room to the terrace and pool, and golf course beyond.

Left:
Water features break up the rhythm of the house's long, low structure, from the main infinity pool to reflecting pools at the entrance.

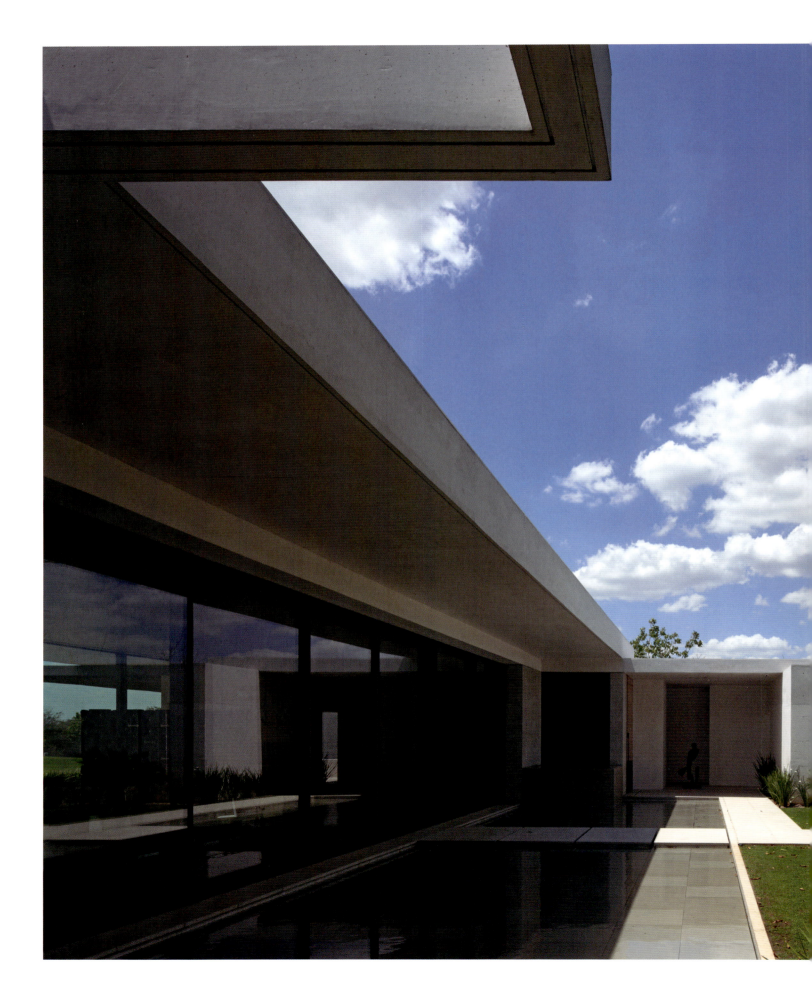

Deep overhangs shade the interior of the house in high summer. Planting is a mix of formal lawns and local species, with sculptures placed at focal points.

Casa Kem

Above:
Mature trees frame
a sculpture seen from
the study.

Right:
The pools also serve to reflect the owners' art collection.

Below:
The principal living room opens to the elements on two sides.

Following spread:
At dusk, the arrangement of openings, overhangs and unadorned stone walls has a formal simplicity.

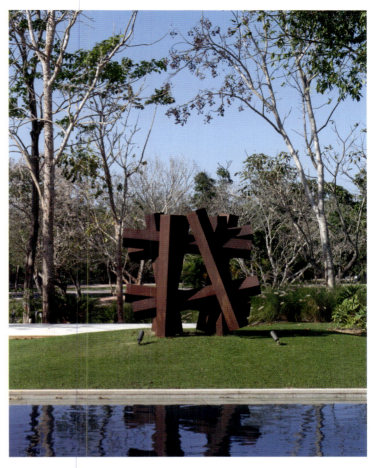

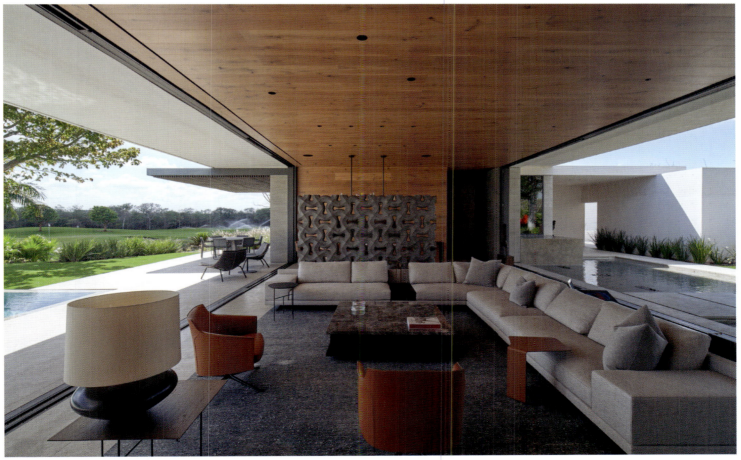

Casa Kem

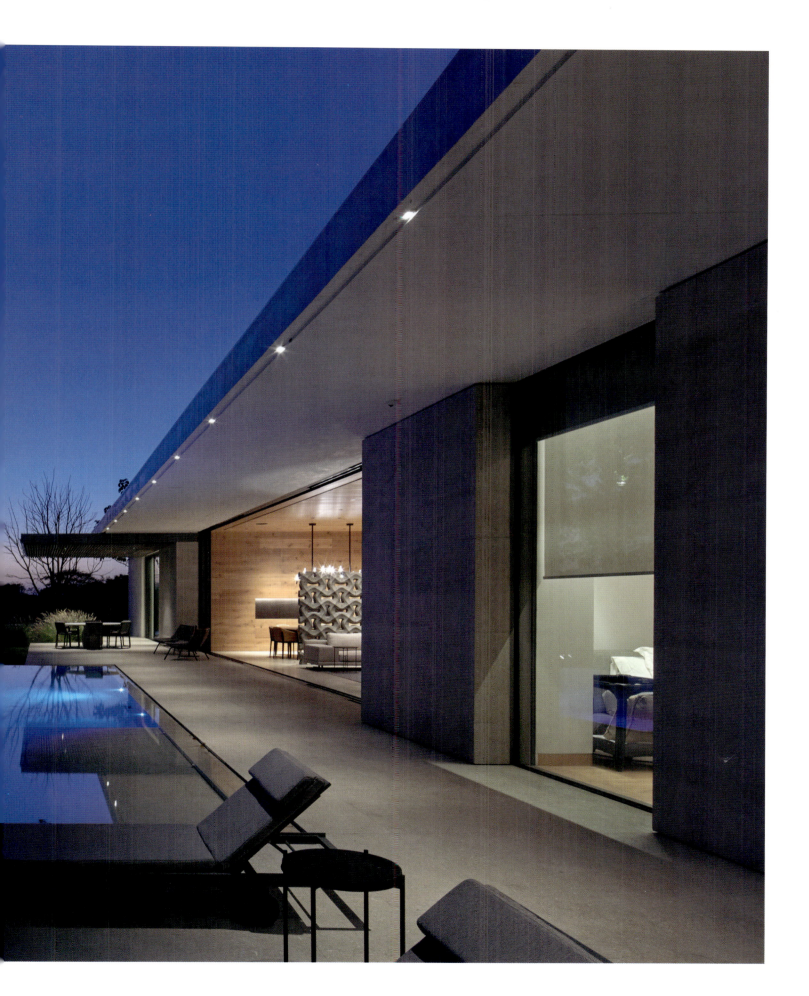

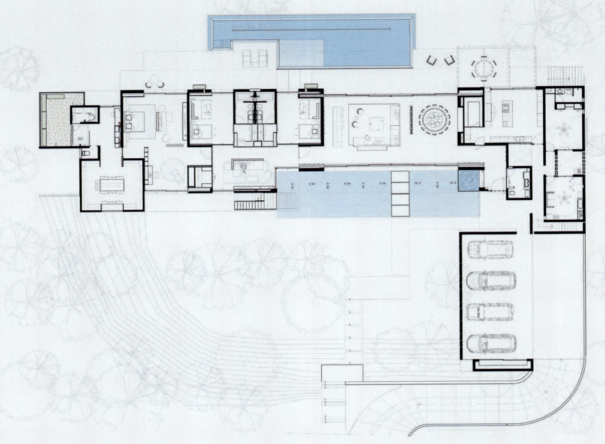

Ground-floor plan

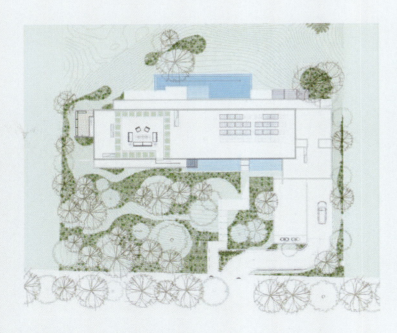

Site plan

Family Houses

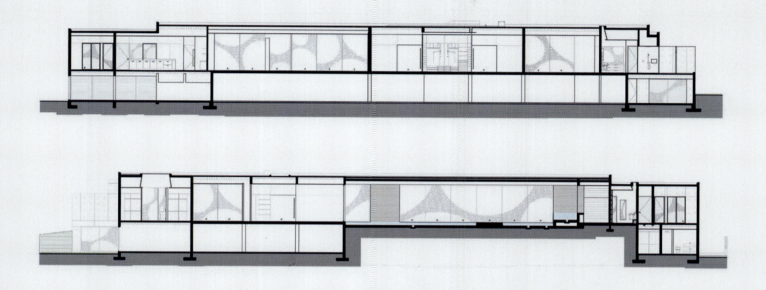
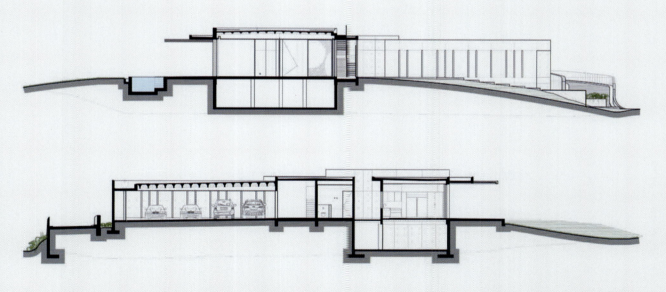

Sections

CASA MULA DE SEISES

Location: Valle de Bravo
Architect: Gantous Arquitectos

Located on a seven-hectare (17-acre) plot in Valle de Bravo, Gantous Arquitectos's Casa Mula de Seises is a sprawling residential complex that weaves in and out of the contours of a wooded site. The plot had been owned by the clients for many years, allowing them to explore every part of the site and work out the location of the most ecologically valuable areas, the best views and aspects, and the scope of the works the architects would be tasked with.

The project is divided into three structures, forming an enclosure united by new planting that feathers at the edges to blend with the surrounding woodland. The main house is joined by a small guest house and a pool, encircling a central outdoor seating area. In total, 750 square metres (8,050 square feet) of built space was added to the plot – around 1% of the total land area. 'The challenge of the project was one of careful placement and consideration of how the buildings would integrate with the surrounding landscape,' says Christian Gantous.

The main house is arranged across a single level, set beneath a series of stepped pitched roofs, each covering a designated area of the plan. The primary living space – the kitchen, dining room and seating area – is at the heart of the structure, with direct access to the central garden, via a south-facing patio that follows the stepped floor plan. The living spaces are flanked by a garage and utility area on one side, and three bedroom suites on the other. A principal suite, with a large internal courtyard, office space and walk-in wardrobe fronts on to the garden facade. Two identical secondary suites step back behind it, with a careful arrangement of terraces and planting to ensure they have a completely private outlook. There is direct guest access to these bedrooms from the entrance driveway.

The external patios are shaded by the oversailing pitched roofs. The wooden beams that support these mono-pitched structures extend out into the soffits, creating a rhythmic pattern beneath the eaves, as well as contrasting the warm ambience of the wood with the monolithic stone walls that anchor the house to the landscape. The guest house is a standalone two-storey structure, with an open-plan sleeping and living area and a terrace overlooking the pool. An external staircase leads up to a study, with the characteristic overhanging roof structure offering a covered observation point from which to appreciate the flora and fauna of the site. The main garden is dotted with huizache trees, with their distinctive feathery canopies providing shade for the lawns and seating areas. Winding stone paths lead through beds of native plants, with the primary natural building materials – basalt stone and oak – creating a harmonious composition between architecture and nature.

Gantous quotes American poet Walt Whitman in his description of the house and the relationship it conjures with its site. 'How soon unaccountable I became tired and sick, Till rising and gliding out I wander'd off by myself, In the mystical moist night-air, and from time to time, Look'd up in perfect silence at the stars.' (Whitman, *When I Heard the Learn'd Astronomer*, 1865). 'This sentiment of longing for the simplicity and serenity of nature is reflected in the design of this home,' Gantous says. 'It blends seamlessly into its surroundings and allows its inhabitants to connect with the beauty of the natural world.'

Right:
A grand house unified by a monumental roof structure that steps down as it covers different types of accommodation.

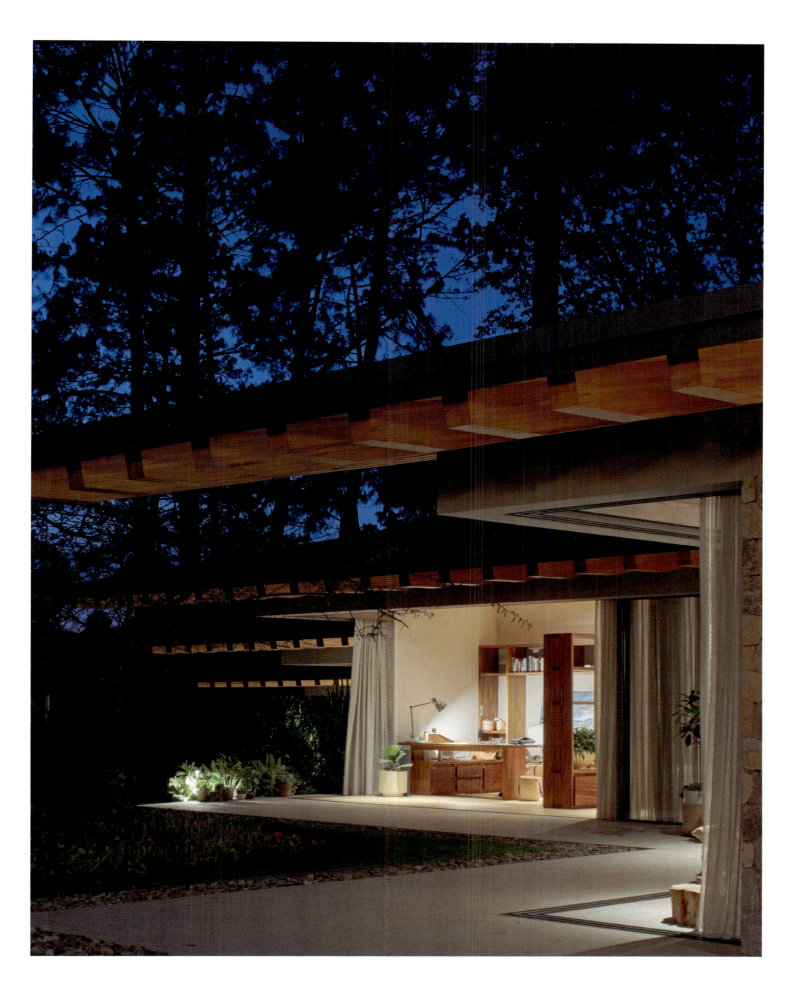

Casa Mula de Seises

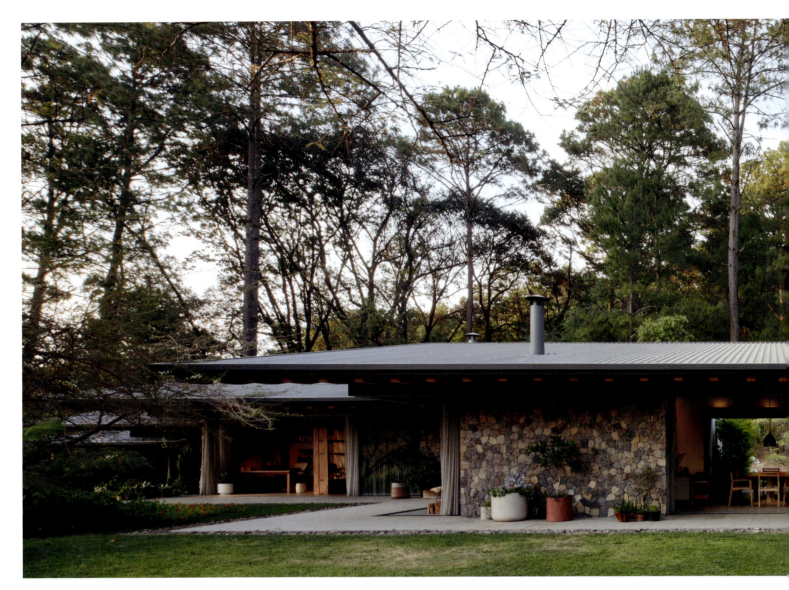

Above:
The main living area is flanked by a wing of bedrooms (at left of picture).

Right:
A separate structure accommodates a studio and roof terrace.

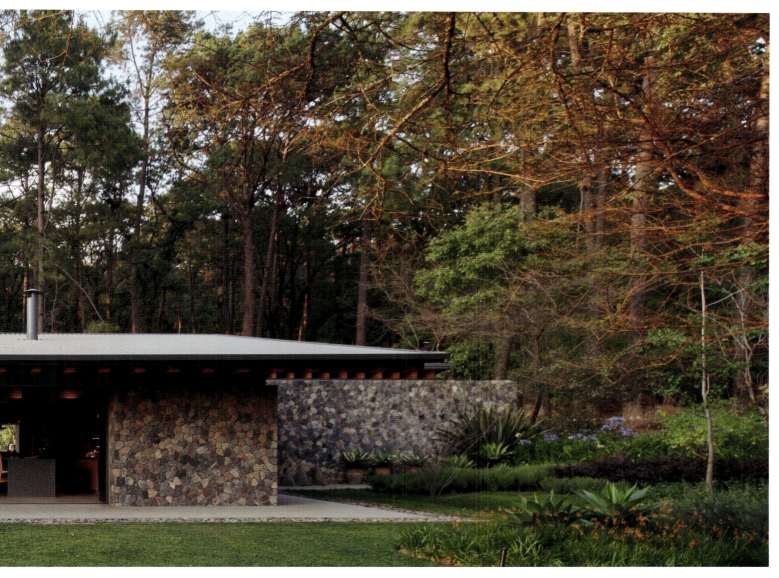
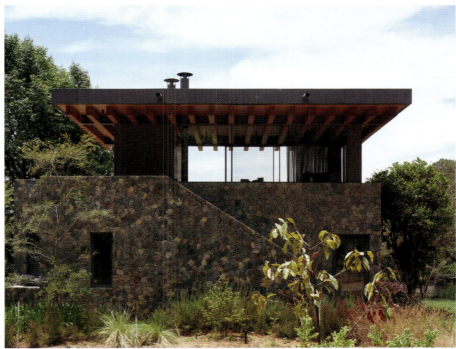

Casa Mula de Seises

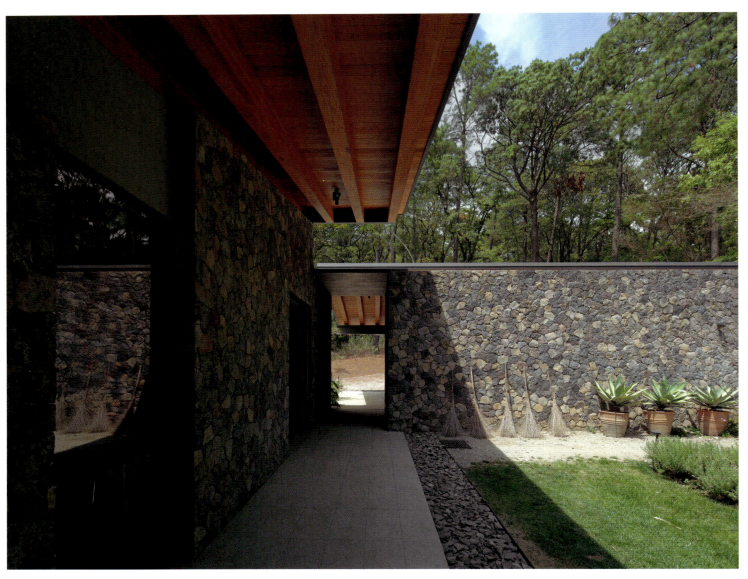
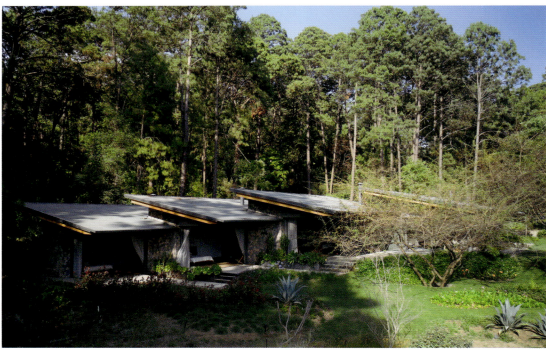

260 Family Houses

Left:
The oversailing roof and stone walls are finished to the same detail inside and out.

Below-left:
The stepped roofs of the bedroom pavilions.

Below:
A shallow monopitch roof protrudes over the terrace surrounding the main living space.

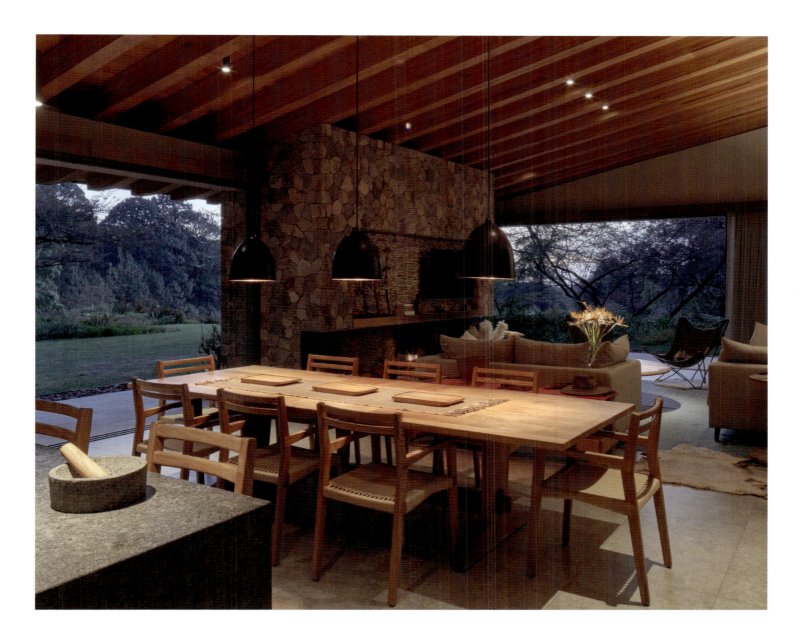

Above:
Windows frame distant views across the seven-hectare plot.

Right:
Each bedroom is effectively treated as a self-contained pavilion with fully opening facades.

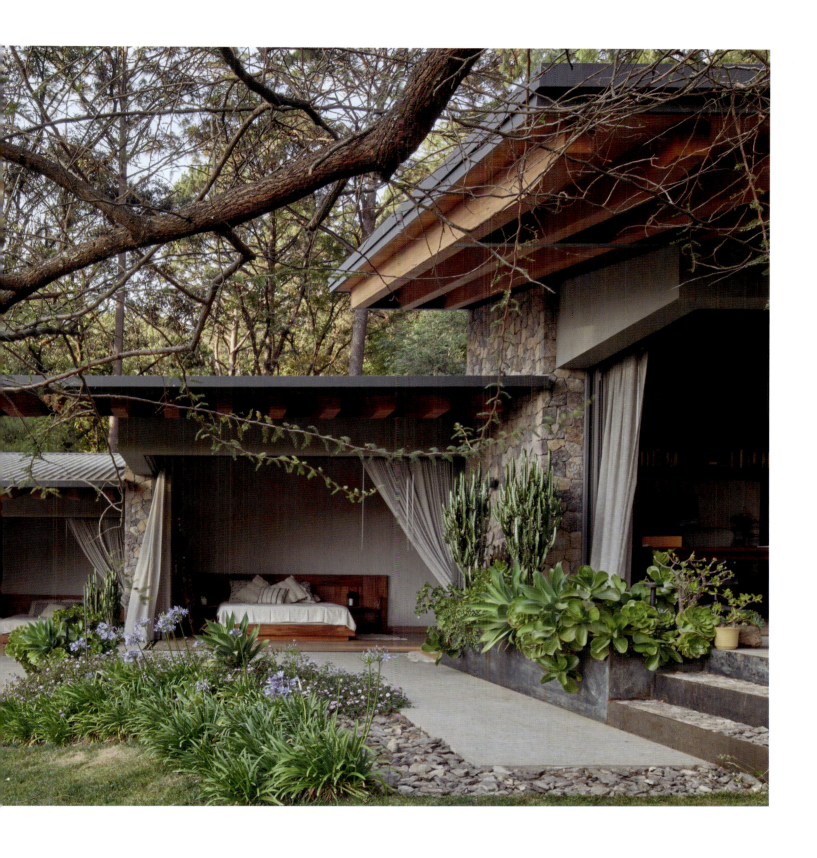

Casa Mula de Seises

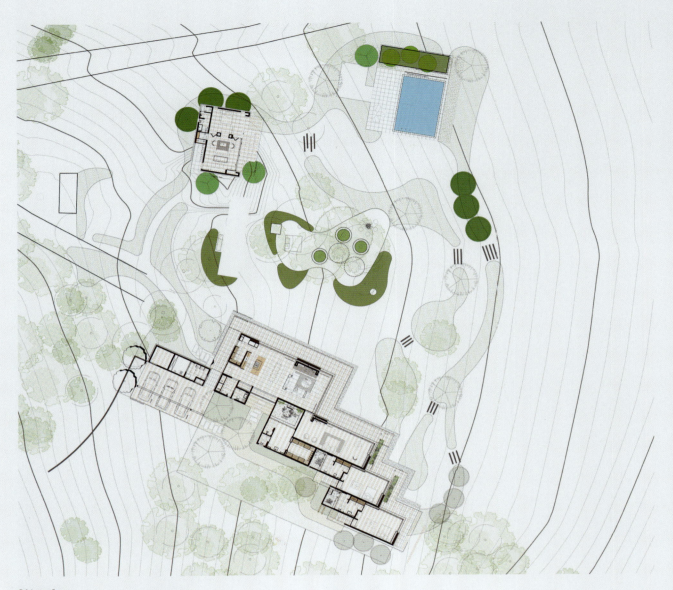

Site plan

264 Family Houses

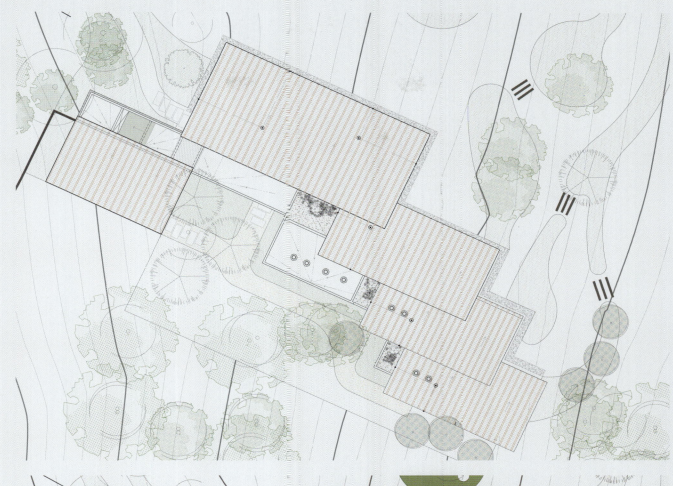

Rooftop plan

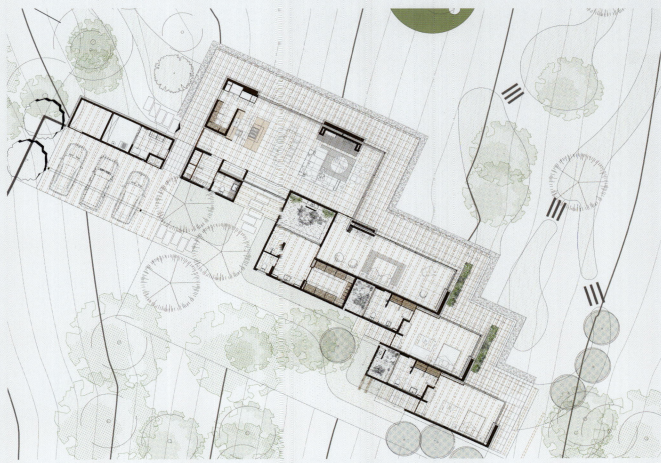

Ground-floor
plan

Casa Mula de Seises

CASA SHI

Location: Morelia, Michoacán
Architect: HW Studio

Perched on the edge of a ravine in a suburb to the east of Morelia, a city in the state of Michoacán, HW Studio's Casa Shi steps down the hillside, culminating in a spectacular terrace overlooking the valley. Broken down into two core elements – a vertical stone entrance and a horizontal 'bar' of accommodation cantilevered out over the void – the house is both private and cinematic, a statement piece that conceals its bravura engineering and forms from the road.

Access is from the upper level, with a simple plinth and concrete wall offering up almost no clue as to what lies behind it. From here, a staircase leads down into a slender entrance hall, with a dining/conference table overlooking the rest of the house. This is the vertical element of the structure, with a long stairway that descends into the heart of the house, eventually leading the visitor to a gently curving corridor that terminates with a view of the landscape beyond.

To the left of the internal entrance hall are three bedrooms, each with its own bathroom suite. Light is brought into these rooms via a narrow rectangular internal courtyard that runs almost the full length of the south facade. A screening room and office are located at the eastern end of the plan, where the structure is dug into the hillside.

The main living spaces unfold to the right-hand side of the entrance sequence and consist of an open-plan kitchen and dining area, and a living space occupying the corner of the cantilever, with glazed walls and balcony access providing the most spectacular view of the project.

Finished with stone, the exterior walls of the vertical component are designed to weather and age to become more at one with the landscape. The horizontal living space is 'white, abstract, and [has a] somewhat defiant nature [that] seeks a visual balance between the natural and the artificial.' Inspiration came in part from the Japanese ethos of combining opposing elements to generate a new reaction.

Despite its apparent isolation, Casa Shi sits alongside other houses on this stretch of mountain road. However, careful alignments ensure that it remains secluded and private, with an unspoiled view across the ravine, which is also a protected nature reserve.

Right:
Embedded in the hillside, the house is a strikingly minimal structure.

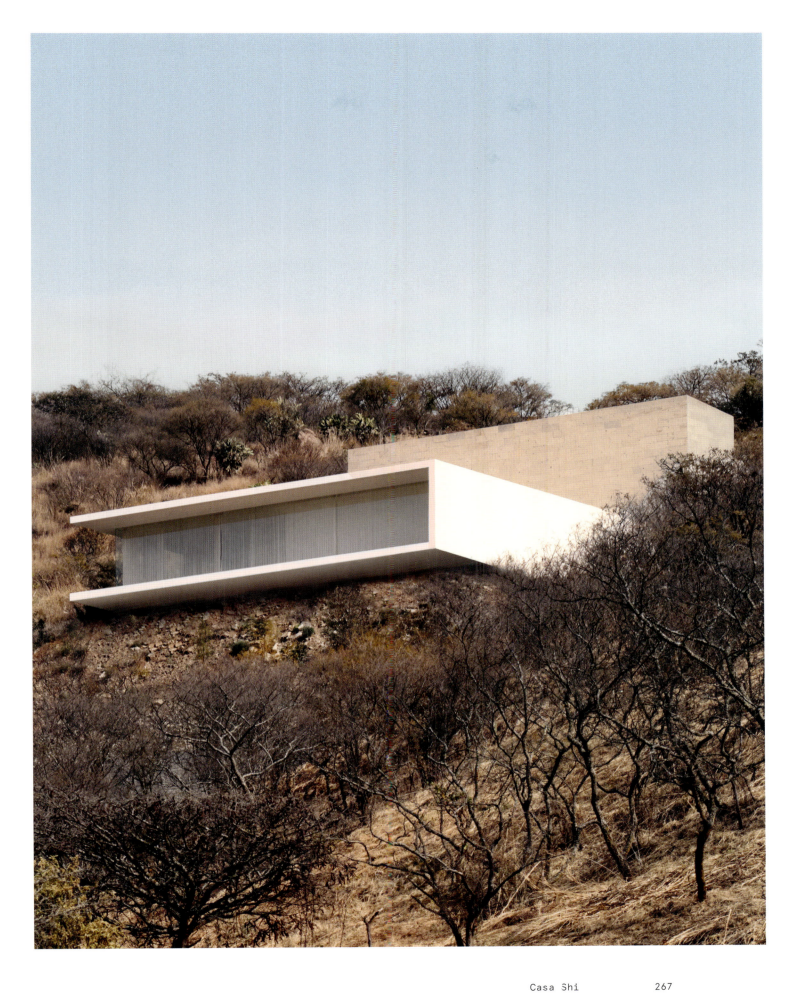

Casa Shi

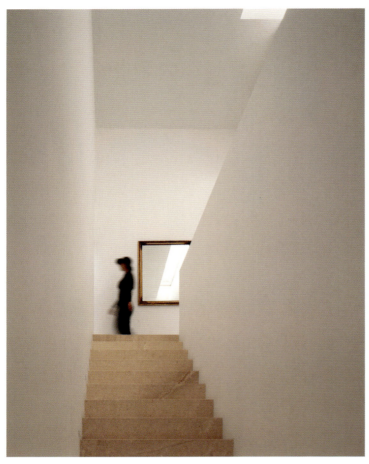

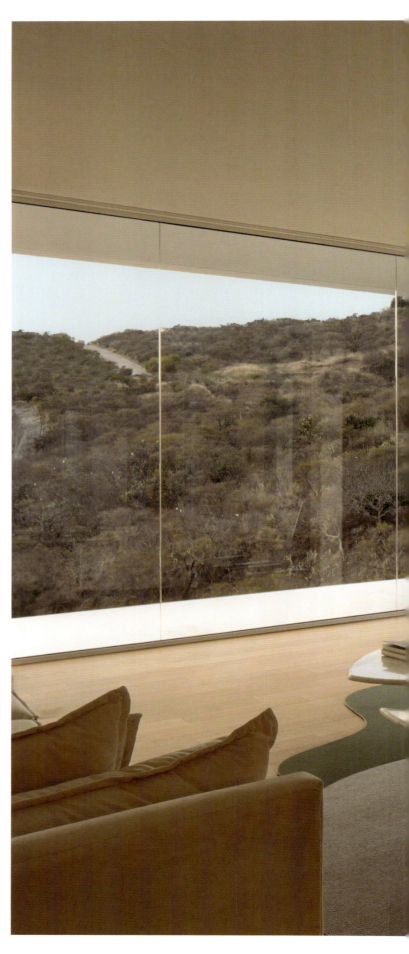

Above:
Internal details are eschewed in favour of a minimalist palette of white walls and light timber flooring.

Right:
The main living room has a dramatic double-aspect view over the landscape.

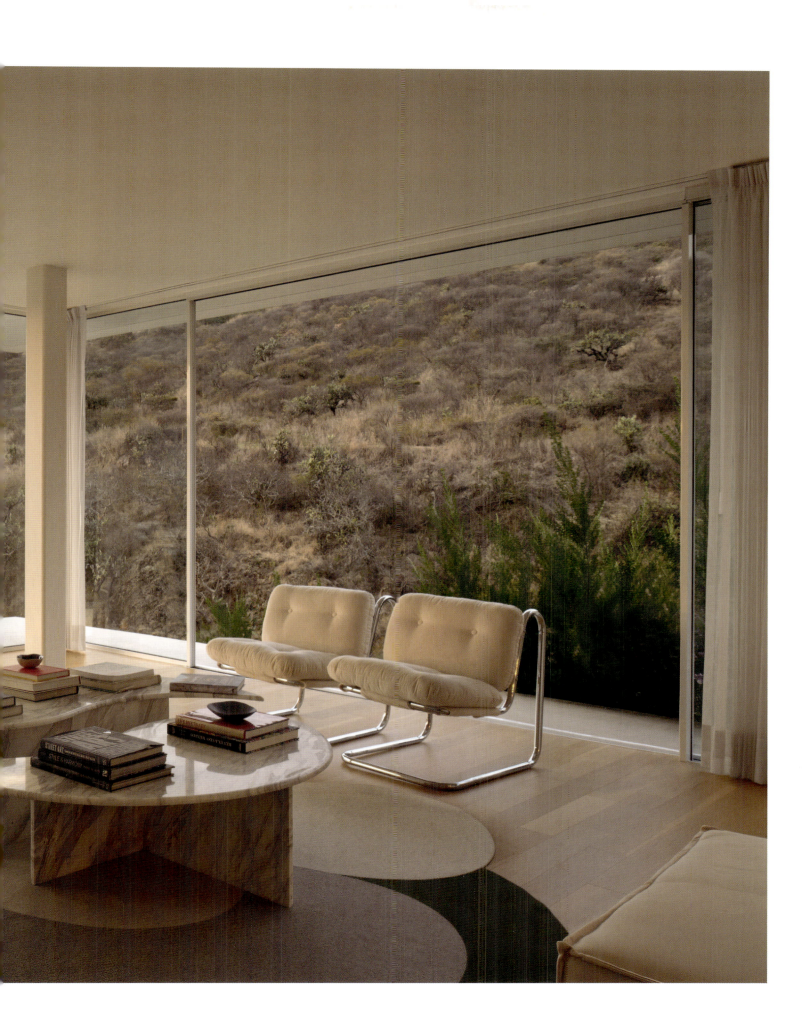

Casa Shi

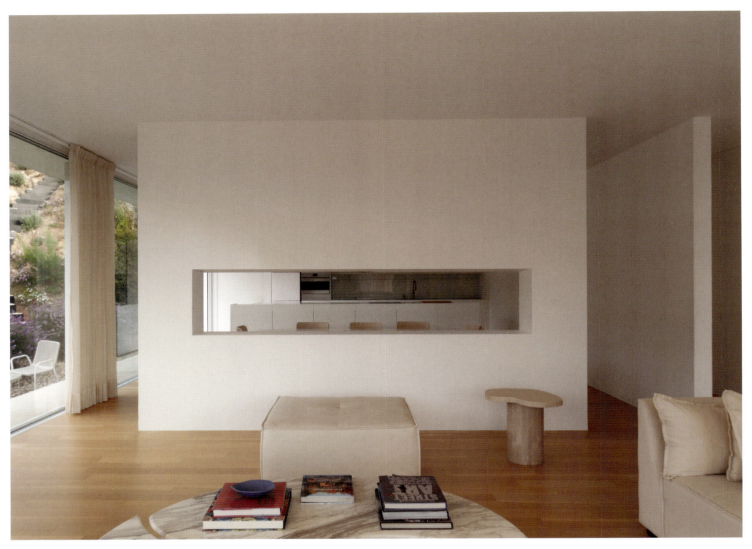

Above:
The internal window looking
into the dining room mirrors
the window in the stair
tower above the house.

Right:
A precisely engineered
balcony space runs around
the edge of the living room.

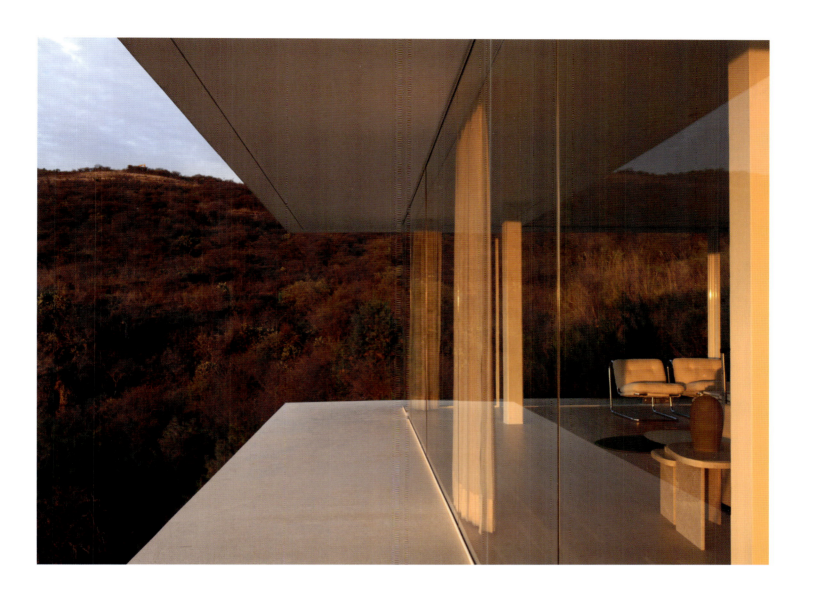

Casa Shi 271

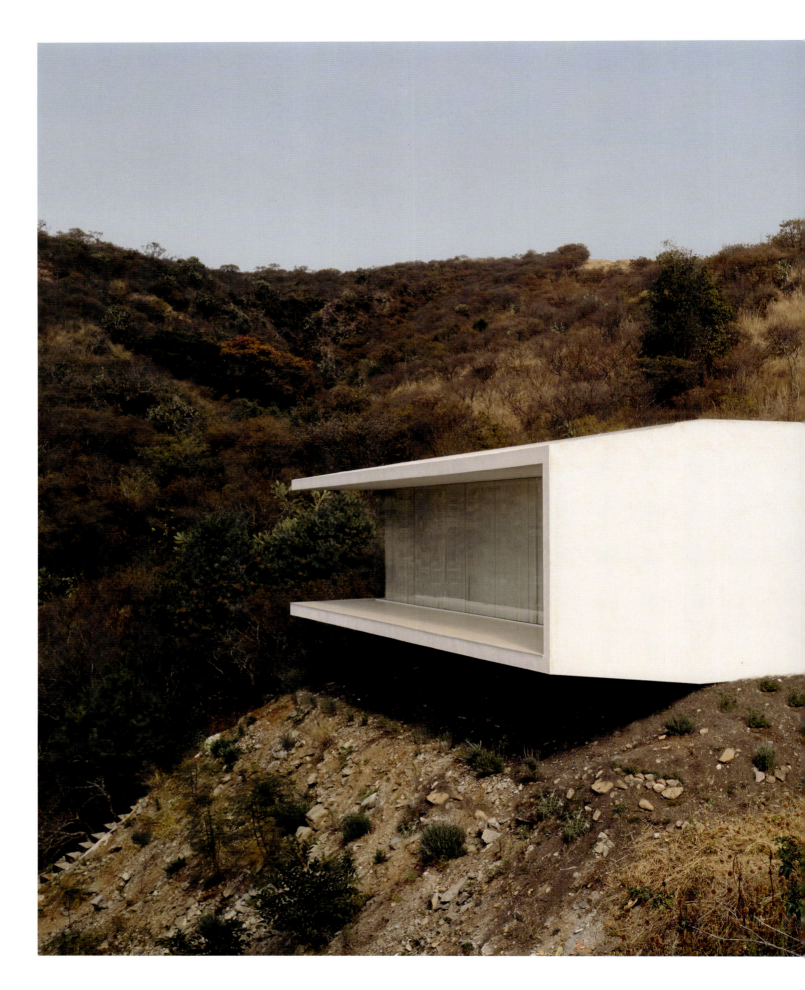

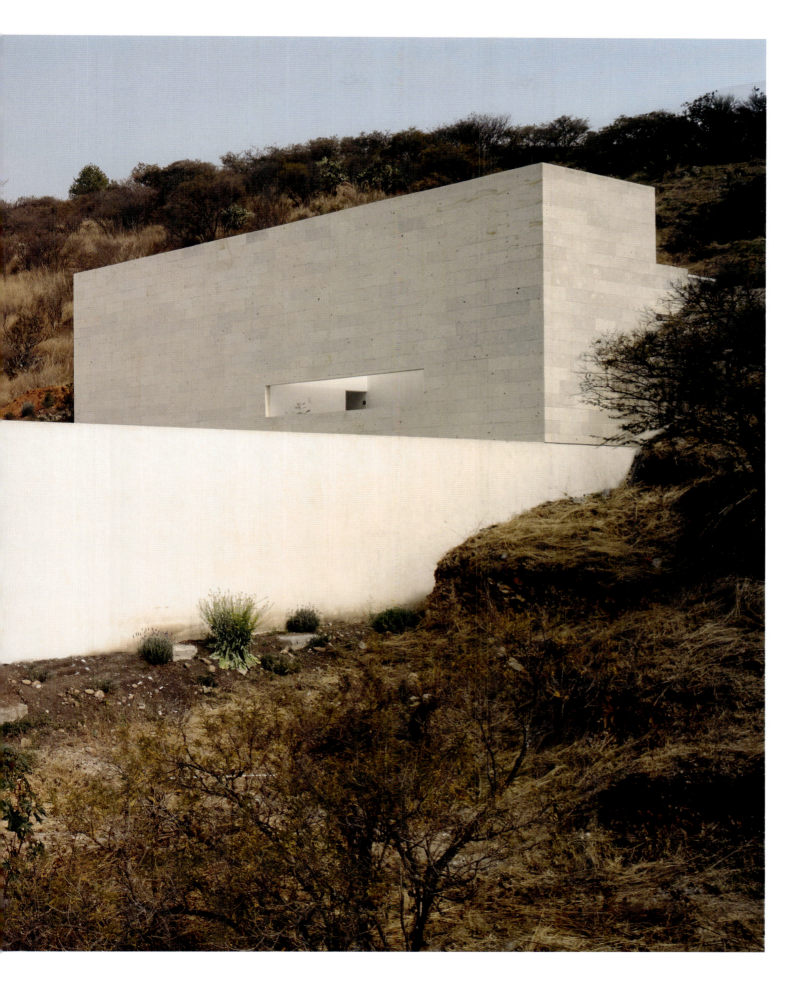

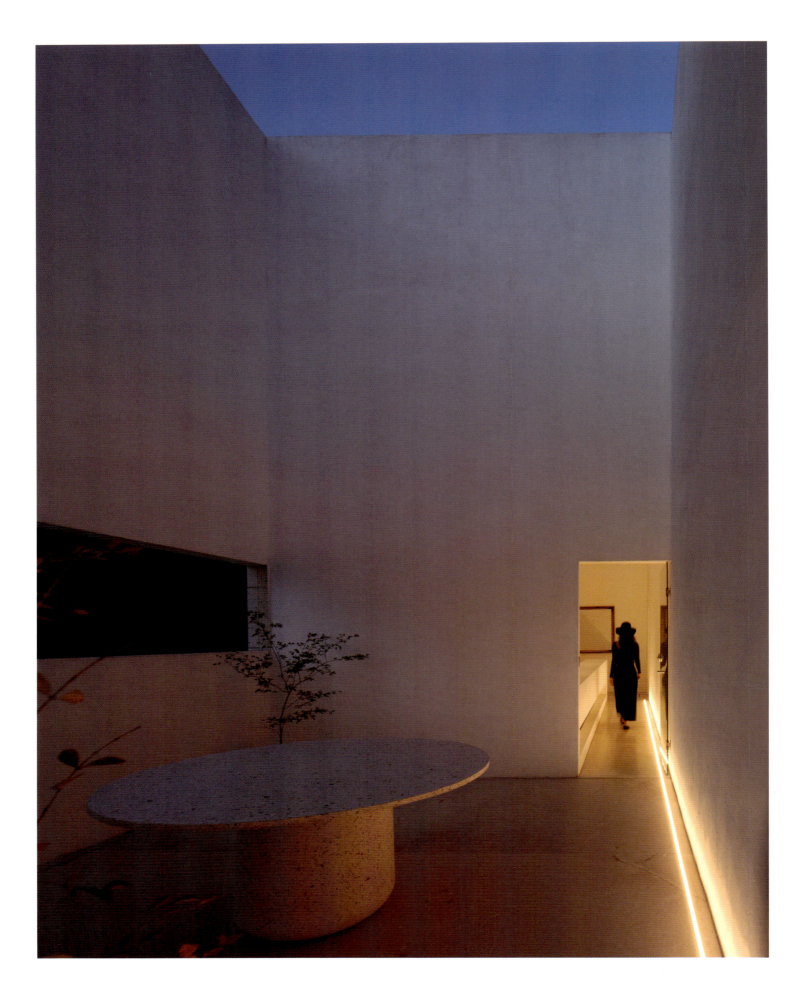

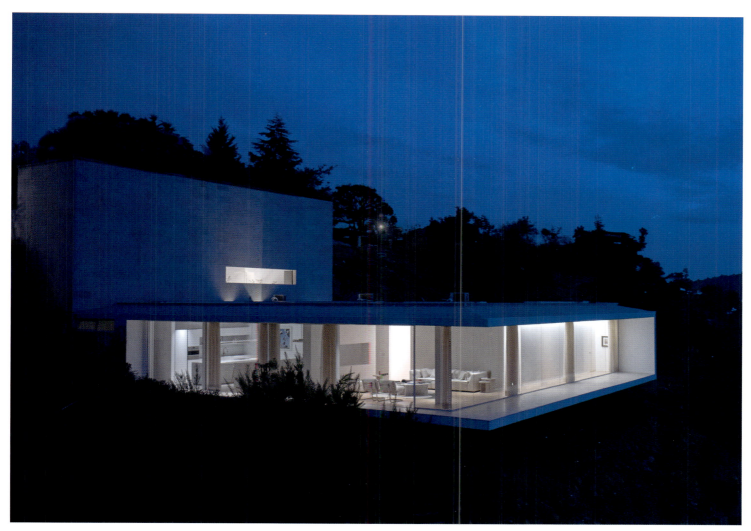

Above:
The house at night, showing
the wraparound balcony and
main living room.

Left:
A small entrance
courtyard forms part
of the stair tower.

Previous spread:
Casa Shi consists of two
elements: a stair tower
providing access from
the road above and the
long, low main volume
of the house.

Casa Shi

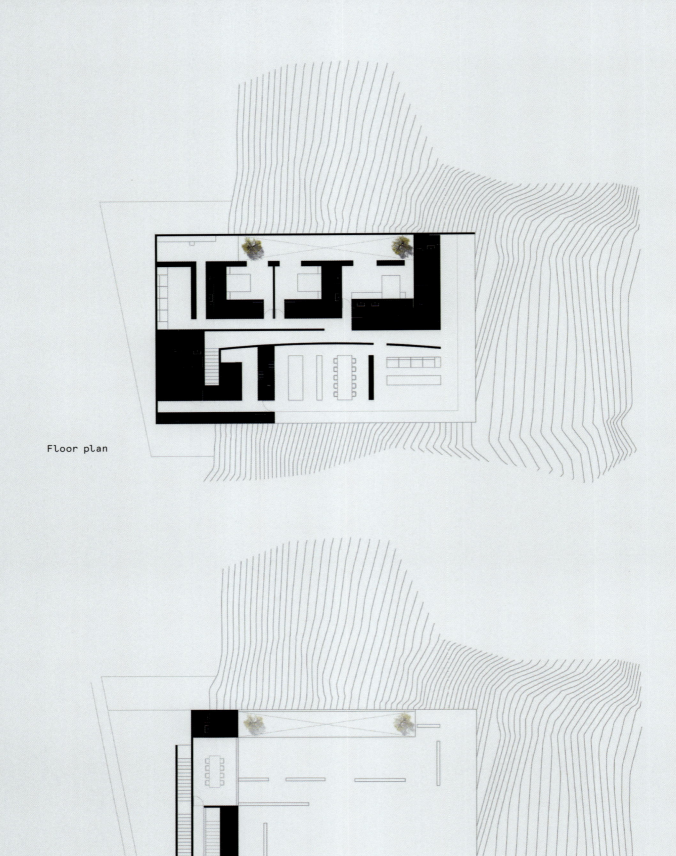

Floor plan

Lower-level plan

Family Houses

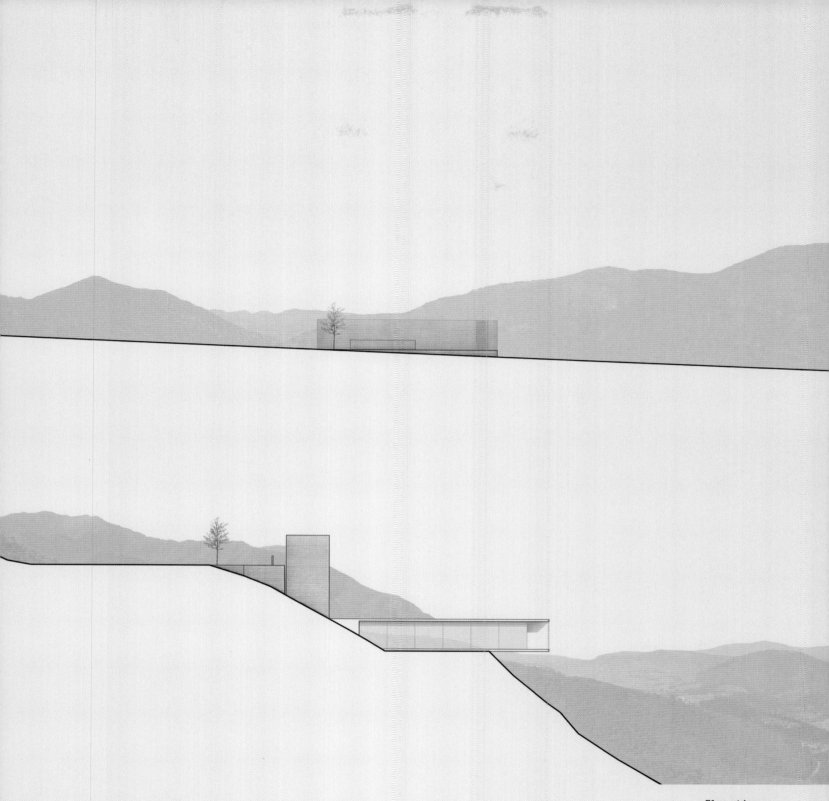
Elevations

CASA DECO

Location: Mérida, Yucatán
Architect: Reyes Ríos + Larraín Arquitectos

This restoration and enlargement of an original 1920 Art Deco house enabled Reyes Ríos + Larraín Arquitectos to engage with and extend a relatively little-known aspect of Mexico's architectural heritage. The house is situated in the heart of the city of Mérida, capital of Yucatán. The modern city was founded in the sixteenth century by the Spanish conquistadors and built on the site of the Mayan city of T'ho.

As well as hosting some of the best examples of colonial Neoclassical and Baroque architecture in the region, the city was a regional centre for the Art Deco movement in the early twentieth century. In particular, the influence of ceremonial Mayan temples can be seen directly in the grand facades of public buildings like stations and cinemas, with elaborate geometric decoration, strong symmetry and vertical design elements.

This house is sited on Paseo Montejo, one of the city's principal avenues. The architects have not just restored the original house but added to it substantially with a new two-storey extension and patio. Throughout the new addition, the Art Deco elements have been referenced but refined, with the movement's idiosyncratic geometry and decorative elements stripped back to the barest essentials.

These new elements include a pair of curving top-lit staircases, each with its own distinctive, installation-like rooflight – one a thin slit, the other a round opening. The chequerboard pattern on the ground-level flooring is mirrored in the use of cement tiles and black terrazzo on the new first-floor spaces, inside and out, evoking the strong colours and decorative chiaroscuro of the Art Deco style. In the kitchen and bathrooms, this theme continues with a mix of black granite and pure white marble.

On the upper level, the new enclosed patio marks another tonal shift, with walls finished in traditional chukum plaster. This material, which blends limestone-based stucco with pinkish resin extracted from the bark of local chukum trees, dates back to the Mayan era. Its reintroduction was driven by Salvador Reyes Ríos, who began experimenting with the process back in the 1990s and has subsequently integrated it into many of his studio's contemporary works.

In Casa Deco, this patio is a stark contrast to the interiors, with rough textured walls that are open to the sky and an outdoor tub. It echoes the larger, more formal pool area on the ground floor. This space marks a division between the front and rear of the house, where there is a garage and utility space. Open colonnades on both floors ring three sides of the pool patio, with fully restored Deco-patterned facades creating a historic oasis in the heart of the city.

Right:
Traditional Art Deco detailing has been recreated and stylized in the new build elements.

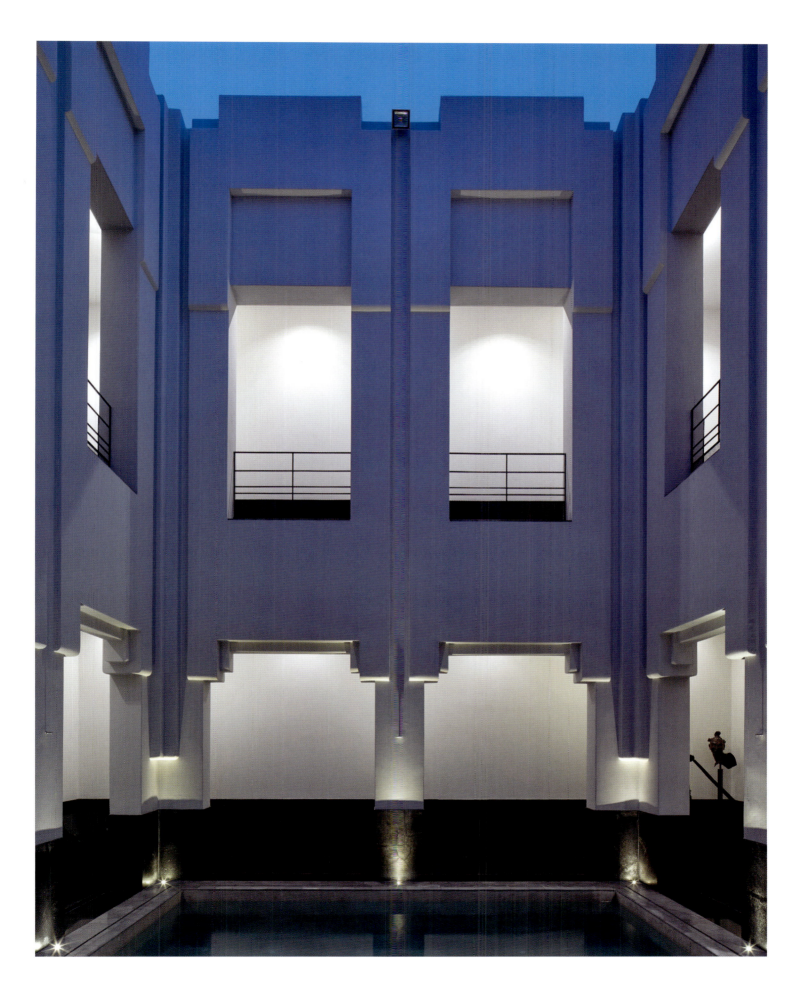

Casa Deco

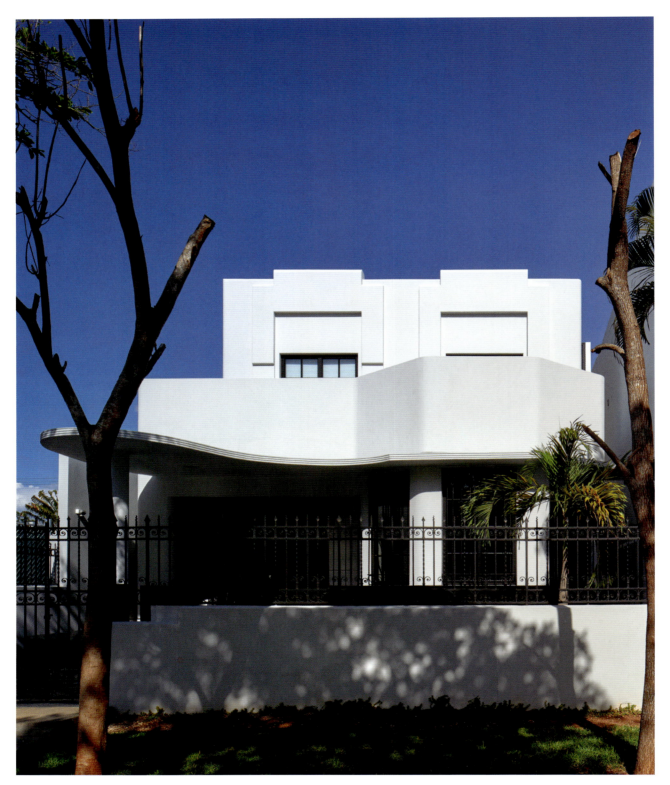

Above:
Seen from the street, an idiosyncratic wraparound canopy covers the main entrance.

Right, clockwise from top-left:
The house is a well-curated family home; a covered gallery on the first floor; the master bedroom with its classic modernist furniture; the internal courtyard and plunge pool.

Family Houses

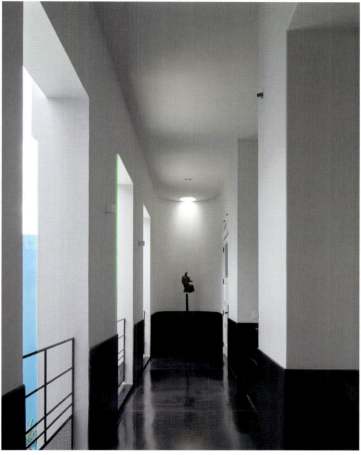
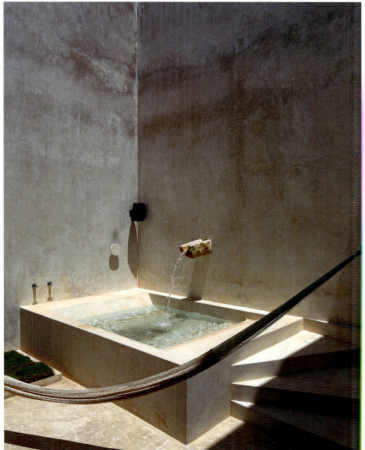

Casa Deco 281

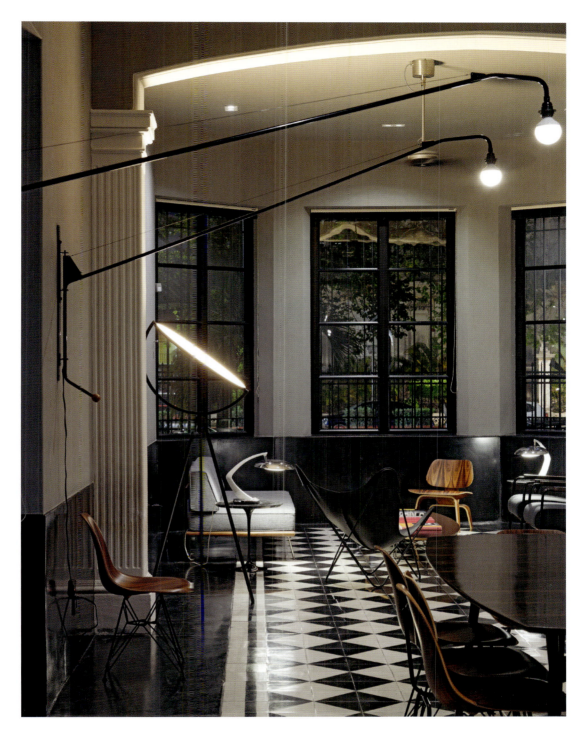

Above:
Modern light fittings and furniture old and new come together in an eclectic mix of treasured possessions.

Left:
Traditional elements and details have been carefully restored.

Above:
The rear facade is more muted but still retains a strong Deco symmetry.

Right:
Black-and-white tiles, monochrome colours and steel-framed windows create a timeless backdrop.

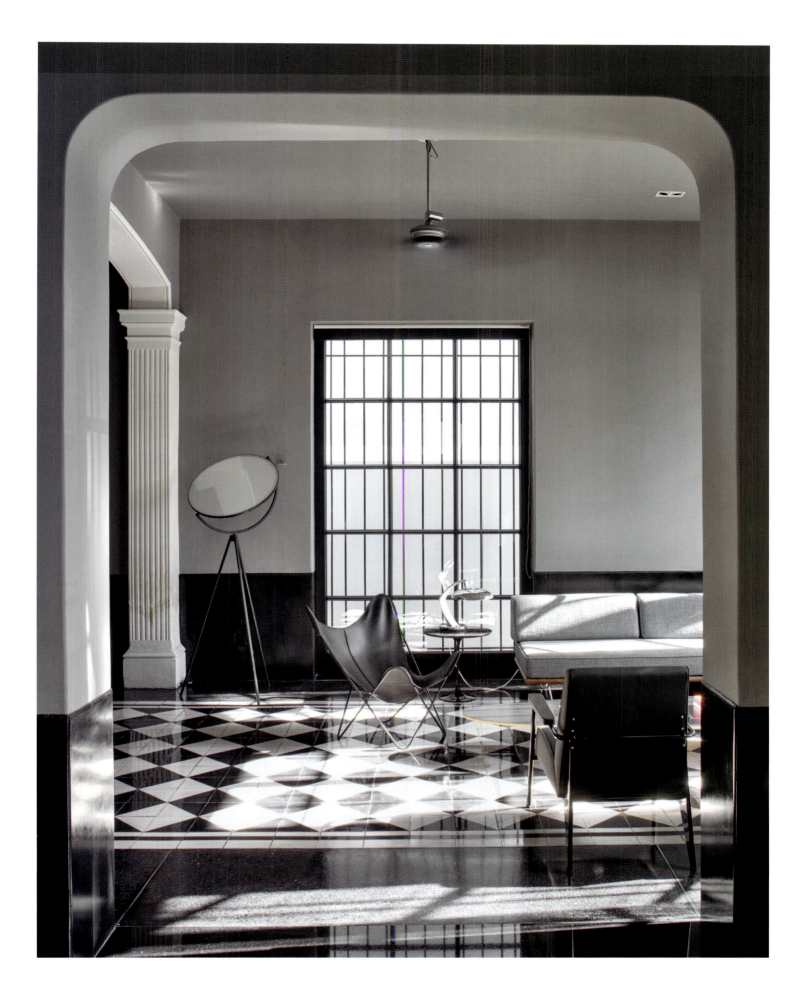

Casa Deco

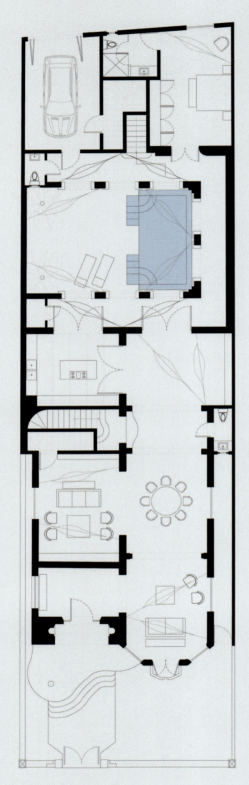

Ground-floor plan

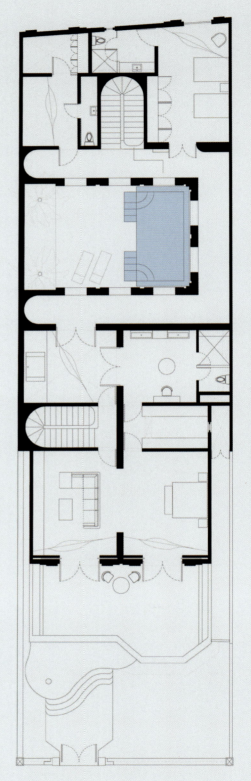

First-floor plan

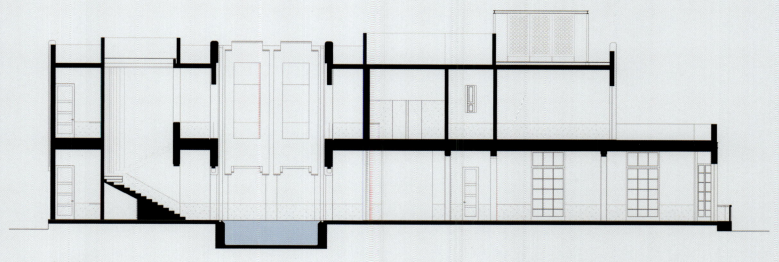

Section

CASA MO

Location: Lomas de Chapultepec, Mexico City
Architect: Lucio Muniain et al

Artist and architect Lucio Muniain shaped his own house in Mexico City in collaboration with Marielle Rivero and Jorge Arrollo. Completed in 2010 after a three-year construction process, the house has continued to evolve as new works and installations are completed by the artist.

Set in the west of the city, Casa MO is placed on a rectangular site. From the entrance, the gradient steps down as the sequence of rooms unfolds, with shallow concrete ramps occupying a triple-height space, leading up to the first floor and down to a lower level set at the rear of the site. This houses a sunken garden off which is a small media room and study, a sitting room and wine cellar. A steel spiral staircase leads up to a small kitchen and office on the floors above, overlooking the garden.

The other ramp leads directly to the main living space on the second floor, bisected by a long library wall that separates the dining and living area from the wedge-shaped kitchen. A staircase provides a direct route down into the courtyard. The principal bedroom is located on the first floor, tucked beneath the living spaces, alongside a twin room, both of which have en suites.

The courtyard fenestration harks back to the modernist era, with small-paned, steel-framed large windows that bathe the interiors in light. From the street, there is little indication of what is contained within, with just a slot window above the entrance canopy. 'The house lives inwards so from the outside it doesn't reveal its functions,' says Muniain, 'it is a "blind" cube that only shows it is a house because it has a door.'

The main interior space is treated like a large sculpture, with the ramps forming divisions within the space, appearing to part the monolithic concrete wall structures with vertical slots of light. Elsewhere, Muniain has used the concrete as a canvas for relief sculptures, with an abstracted floor plan inset into the wall at the base of the ramp.

Right:
A concrete ramp runs through the heart of the house, leading down into an art- and book-filled interior.

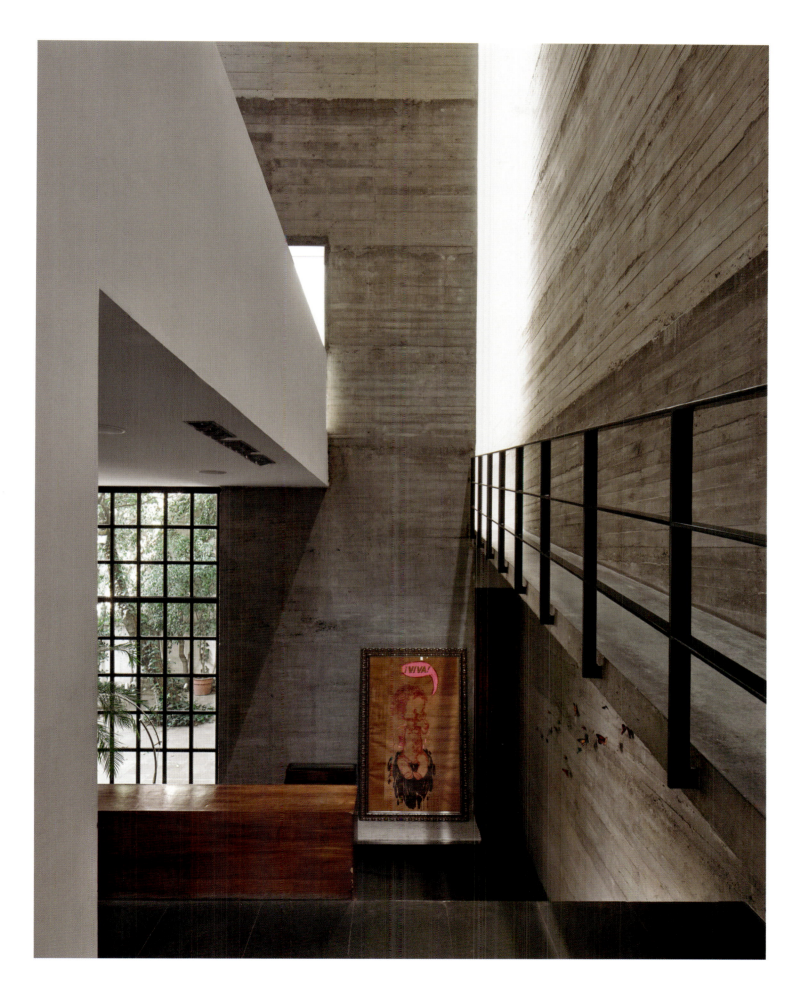

Casa MO

Right:
The spiral staircase is reduced to its barest visual elements.

Far right:
The main seating area also contains a library and study.

Below:
The ramp terminates with admirable simplicity, with different materials abutting one another without fuss or complexity.

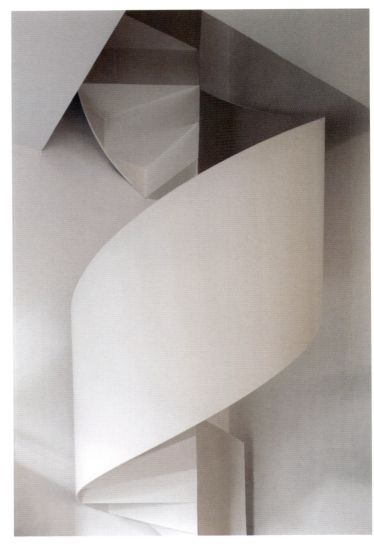

290　　　　　Family Houses

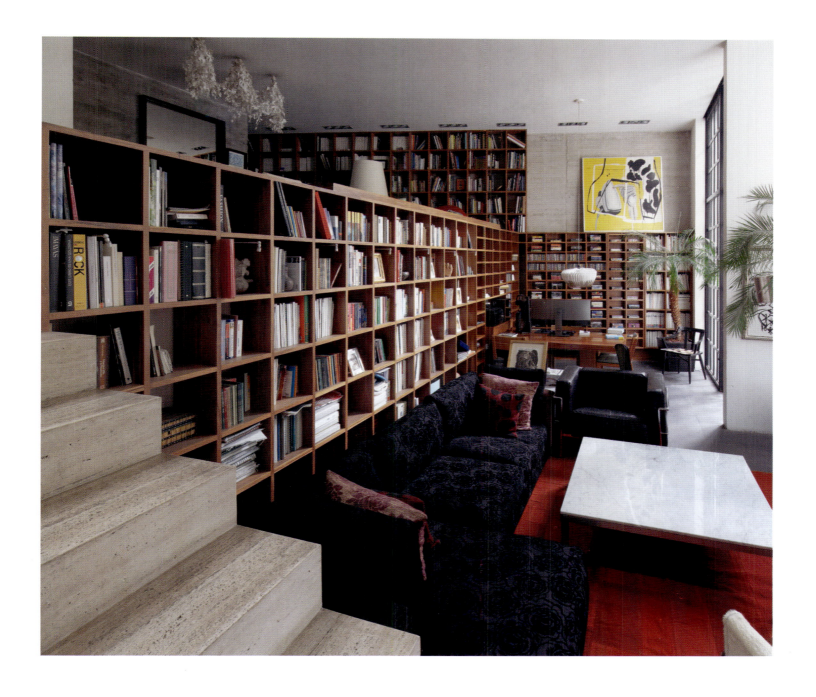

Casa MO

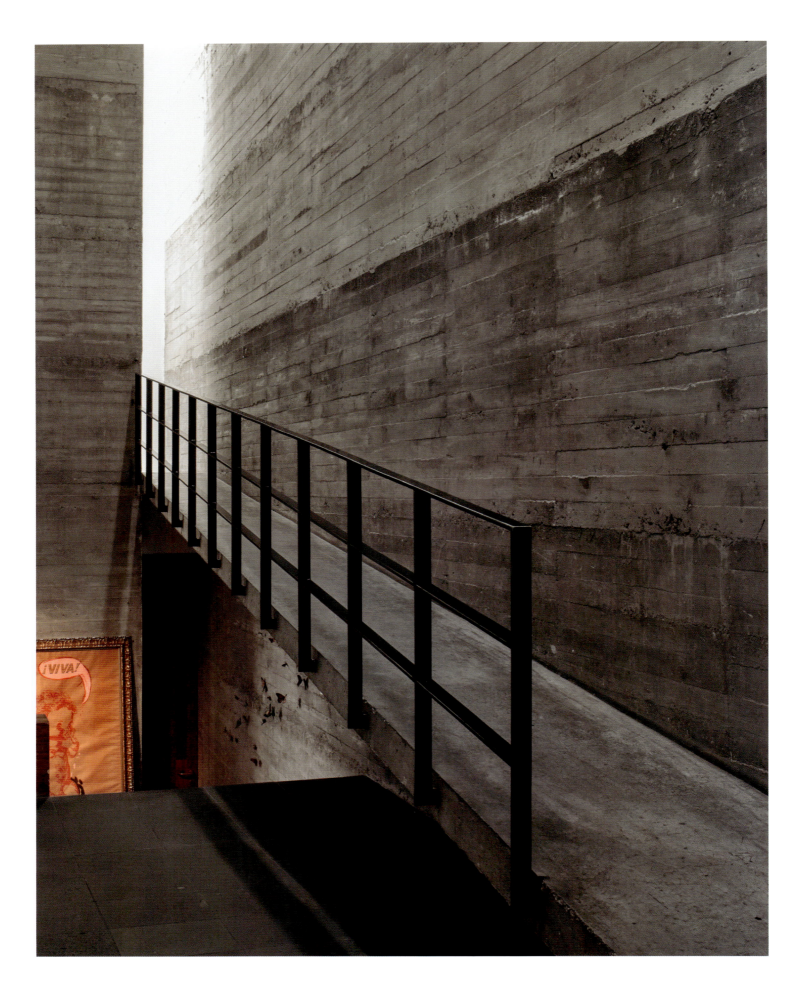

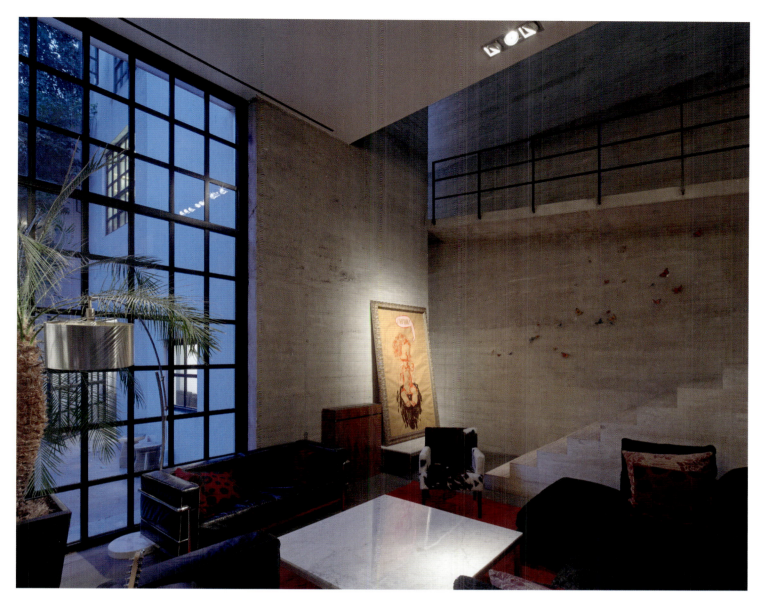

Above:
The arrangement of
stairs, ramp and window
is intended to create
maximum dramatic effect.

Left:
Details of the ramp, with
Brutalist concrete walls
softened by natural light.

Above:
A concrete relief depicts an abstracted section through the house.

Right:
Art and sculpture, old and new, is scattered throughout the building.

Far right:
The house is designed for contemplation and culture, a vessel for collections and archives.

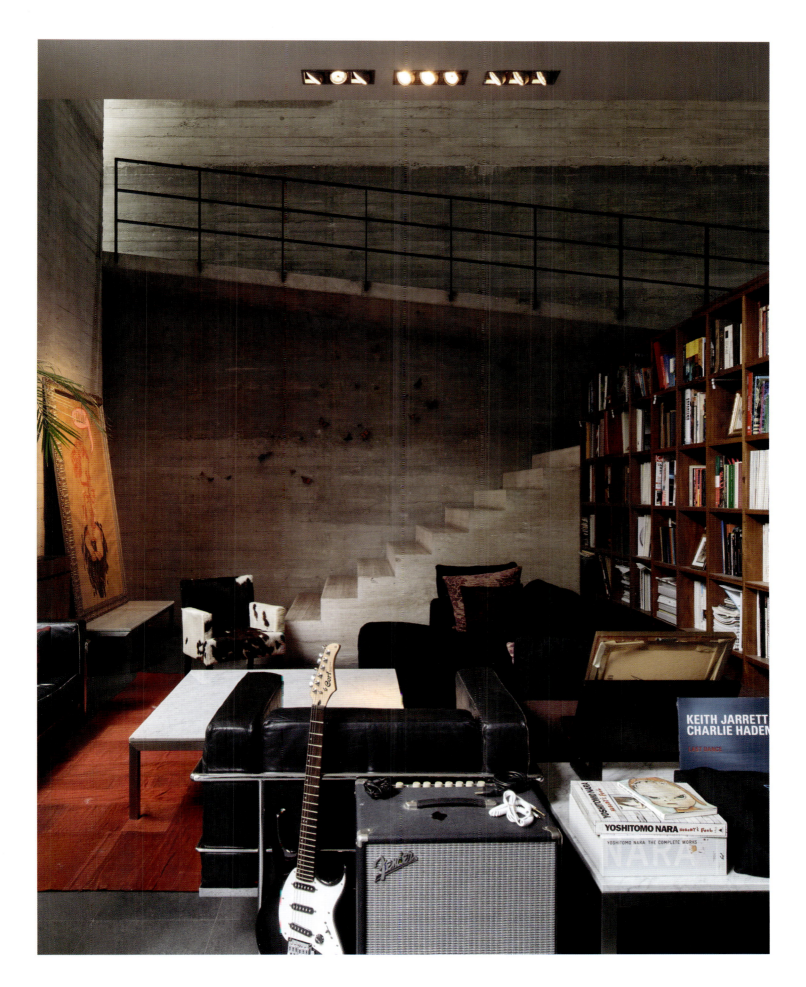

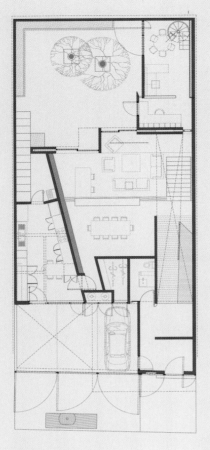

Ground-floor plan

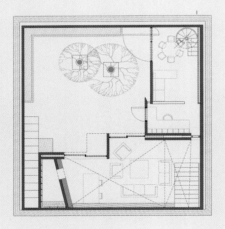

Lower-level plan

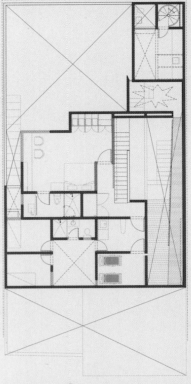

Second-floor plan

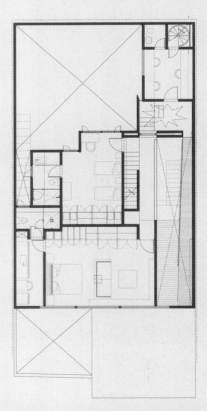

First-floor plan

Family Houses

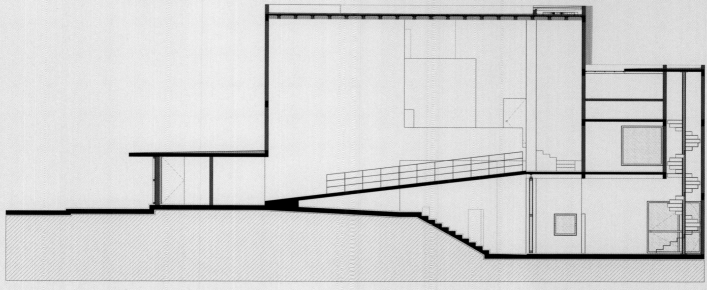

Section

ARCHITECT BIOGRAPHIES

ALBERTO KALACH / T.A.X. (p. 206)
Alberto Kalach established his architecture studio, Taller de Arquitectura X (T.A.X.), in 1981, after studying at Mexico City's Universidad Iberoamericana, and Cornell University in New York. Combining architectural design with urban planning, as well as collaborative projects, Kalach's studio has completed a broad sweep of works ranging from a $5,000 minimal house design, to large-scale urban-planning projects. Describing the studio as 'a laboratory, a greenhouse, and a learning space,' Kalach and his team are based in Mexico City.

AMBROSI ETCHEGARAY (p. 196)
Jorge Ambrosi and Gabriela Etchegaray founded their office in Mexico City in 2011. Ambrosi Etchegaray describes its work as responding to 'the notion that buildings have the power and responsibility to provide experiences and shape the future of architectural knowledge'. The roughly 20-strong team tries to bridge the realms of art and architecture, with a particular focus on housing typologies. The economics of architecture, the importance of community and the role of growth in design are all important preoccupations.

ARANZA DE ARIÑO (p. 090)
Architect Aranza de Ariño started her private practice in 2014, following studies at the Universidad Iberoamericana in Mexico City and at Harvard University Graduate School of Design in Cambridge. Casa Tiny was her first built work, completed when the architect was just 27 years old.

BAAQ' (p. 164, 212)
BAAQ' was founded in 2011 by Alfonso Quiñones and combines architectural practice with commercial development. The latter focuses on reuse and rehabilitation, with an emphasis on 'renovating, preserving and adapting buildings that have become obsolete to new uses'. The studio's approach has been defined by experience and by seeing demolition threaten economic and architectural value, especially in Mexico City, where the office is based. 'We decided that the best way to participate in this type of project was to intervene in existing buildings, and the result has been very positive.' Design becomes an integral part of the path to reuse.

FERNANDA CANALES ARQUITECTURA (p. 076, 130)
After studying in Madrid and graduating from Mexico City's Universidad Iberoamericana, Fernanda Canales set up her practice in the capital. One of the country's most prominent and acclaimed architects, Canales has published extensively and written several books. Her work was shown at the 2012 Venice Biennale and the 2017 Chicago Architectural Biennial; she is currently a Visiting Professor at Harvard University Graduate School of Design.

FUNDACIÓN JAVIER MARÍN (p. 036)
Sculptor Javier Marín established his foundation in 2013 as a means of supporting emerging Mexican artists. Born into a large family in 1962, the son of an architect, Marín used traditional clay-casting methods and tools in his early work. Now based in Mexico City, his work is represented in museums and collections around the world. Plantel Matilde, the home of the Fundación, is an artists' colony, a gallery and an inhabitable sculpture.

GANTOUS ARQUITECTOS (p. 244, 256)
Founded in 1992 by brothers Claudio and Christian Gantous, Gantous Arquitectos is a Mexico City-based firm whose projects include the Embassy of the Kingdom of the Netherlands in Mexico and the Main Altarpiece and Presbytery of the Cathedral Basilica of Zacatecas, the latter in collaboration with sculptor Javier Marín (see p. 036). Residential and hospitality work is also a speciality, and the practice works alongside many of the country's leading developers. 'We opt for simple and serene forms that give outstanding importance to details,' the architects write, 'thus achieving works that elevate the human spirit through the fundamental value of dialogue and the respectful communion of architectural creation with nature.'

HÉCTOR BARROSO (p. 174)
Héctor Barroso set up his studio in Mexico City in 2011. From the outset, Barroso's focus has been on projects that 'sink their roots into the local environment and make the most of the natural resources in each place'. This means a diverse approach to material, form and construction methods, while also preserving landscape and geographical forms. 'Our architecture thus emerges in harmony with the site.'

HW STUDIO (p. 122, 266)
Rogelio Vallejo Bores established HW Studio in 2010 in Morelia. The studio's name comes from the fusion of 'H' – representing silence in Spanish – and 'W', from the Japanese concept of wabi-sabi, or the search for and acceptance of the innate beauty in the transient and imperfect. According to the architect, the studio's purpose is to blend the architectural process 'with artistic principles', as well as to combine Eastern and Western philosophies. Peace and meditation are vital 'in a world mostly noisy and violent'.

LUCIO MUNIAIN ET AL (p. 100, 288)
The studio was founded by architect Lucio Muniain in 1997 and is based in Mexico City. The use of the Latin 'et al' is a deliberate nod to the collaborative nature of the architectural process. Muniain describes the office's work as being 'distinguished by its interest in exploring aesthetics deeply without sacrificing functionality'. Work is secured through competition entries, across all scales and typologies, but the architect is emphatic that the office 'does not participate in any biennial, triennial or architectural award of any kind'.

LUDWIG GODEFROY (p. 068, 140)
French-born architect Ludwig Godefroy set up his studio in Mexico City in 2011. He studied architecture in Paris before working for Enric Miralles/Benedetta Tagliabue, OMA/Rem Koolhaas and Tatiana Bilbao, among others. His work places great emphasis on the importance of balance and harmony, and on sharing a personal and intuitive sense of place.

MANUEL CERVANTES ESTUDIO (p. 058)
Manuel Cervantes founded his architecture studio in 2004, having originally intended to study fine art. Initially called CC Arquitectos, the studio changed its name to Manuel Cervantes Estudio in 2017 to better reflect a more personal approach. Technique, context and the traditions of modernism are all integral to the firm's approach. Projects have also been proposed in the USA, Middle East and Germany.

P+0 ARQUITECTURA (p. 150)
Based in Monterrey, Mexico, since 2013, P+0 Arquitectura was originally founded in Barcelona by David Pedroza Castañeda in 2011. Castañeda also co-founded the contracting firm P+B Arquitectura y Construcción in 2014, and together the companies share knowledge and experience, a concept signified by the '+' in the studio name. He describes the studio's 'guiding principle' as being 'worked ingenuity... where risky concepts and "naive" design and construction solutions are made possible by the balance between everyone's knowledge and experience.'

PEDRO REYES, CARLA FERNÁNDEZ (p. 046)
Artist Pedro Reyes takes an explicitly political approach to his large-scale, multimedia projects, most notably the Palas por Pistolas (Shovels for Guns) project in Culiacán that literally transforms seized firearms into shovels to plant trees. Reyes's sculpture often incorporates red and black volcanic stone, referencing Mesoamerican art. Fashion designer Carla Fernández incorporates traditional forms of artisan manufacturing in her collections. Weaving and embroidery characterize her clothes. Her fashion brand is a certified B Corp, demonstrating best practice in its sustainable and ethical perspective. They are both based in Mexico City.

RAFAEL PARDO ARQUITECTOS (p. 110)
The practice was founded in 2000 by Rafael Pardo in Xalapa, Veracruz. With an approach that prizes practicality as well as using non-standard solutions, Pardo's award-winning studio has experience across the public and private spheres. The primary material choice is concrete for its structural simplicity, its texture and richness, and the way in which it pairs with other, more natural materials.

REYES RÍOS + LARRAÍN ARQUITECTOS (p. 222, 278)
Founded by architect Salvador Reyes Ríos and artist Josefina Larraín Lagos, the studio is based in Mérida, Yucatán. Working across public and private residential projects, as well as landscape design, furniture and interior design, Reyes Ríos + Larraín Arquitectos has pioneered the sensitive restoration of historic buildings on the Yucatán Peninsula. According to the founders, 'the ultimate mission of design is to improve the quality of life for the users, with a positive impact on the sites in terms of sustainability and cultural reinforcement.'

TAC (p. 232)
Venezuelan Alberto Calleja founded his first studio, G3 Projects, in his native Caracas in 1999, following his studies at the School of Architecture and Urbanism at the Universidad Central de Venezuela. He set up an office in Panama City in 2014, followed by TAC (Taller Alberto Calleja). TAC is committed to working around Central America on a variety of proposals and projects, using similar concepts and methodologies.

TADAO ANDO ARCHITECT & ASSOCIATES (p. 024)
Japanese architect Tadao Ando was born in 1941. After a career as a boxer, Ando switched to architecture, a field in which he is substantially self-taught, including pilgrimages to significant works by major European and American architects. His studio was set up in Osaka in 1968. Ando's work is renowned for its ascetic minimalism and contemporary interpretation of Japanese concepts of calm, order and refinement. He was awarded the 1995 Pritzker Prize and the 1997 RIBA Royal Gold Medal.

TALLER DE ARQUITECTURA MAURICIO ROCHA + GABRIELA CARRILLO (p. 184)
Mauricio Rocha set up his studio in 1991, originally in collaboration with his father, architect Manuel Rocha Díaz. In 2012, project director Gabriela Carrillo became a partner, and the office subsequently changed its name to Taller de Arquitectura Mauricio Rocha + Gabriela Carrillo. The studio has won many awards, with key projects including Studio Iturbide, designed for Rocha's mother, the photographer Graciela Iturbide.

PROJECT CREDITS

CASA WABI (p. 024)
Location: Puerto Escondido, Oaxaca
Architect: Tadao Ando Architect & Associates
Lead architects: Tadao Ando, Alex Iida, BAAQ', Jose Alfonso Quiñones, Luis Muñoz Pérez
Area: 30 hectares (74 acres) (site area)
Completed: 2014

PLANTEL MATILDE (p. 036)
Location: Sac Chich, Yucatán
Architect: Fundación Javier Marín
Lead architect: Arcadio Marín
Area: 2,750 m² (29,600 ft²)
Completed: 2015

CASA REYES (p. 046)
Location: Coyoacán, Mexico City
Architect: Pedro Reyes, Carla Fernández
Lead architects: Pedro Reyes, landscape architecture Carla Fernández
Area: 1,000 m² (10,760 ft²)
Completed: 2019 (house), 2022 (studio)

CASA ESTUDIO (p. 058)
Location: Amatepec, Mexico City
Architect: Manuel Cervantes Estudio
Lead architects: Manuel Cervantes Céspedes, Mariloly Rodríguez, Misael Romero
Area: 500 m² (5,380 ft²)
Completed: 2018

CASA SANJE (p. 068)
Location: Mexico City
Architect: Ludwig Godefroy
Lead architect: Ludwig Godefroy
Area: 250 m² (2,690 ft²)
Completed: 2020

CASA TERRENO (p. 076)
Location: Valle de Bravo, Estado de Mexico
Architect: Fernanda Canales Arquitectura
Lead architects: Aarón Jassiel, Alberto García Valladares, Ángela Vizcarra
Area: 200 m² (2,150 ft²)
Completed: 2018

CASA TINY (p. 090)
Location: Puerto Escondido, Oaxaca
Architect: Aranza de Ariño
Lead architect: Aranza de Ariño
Area: 36 m² (388 ft²)
Completed: 2015

CASA HMZ (p. 100)
Location: La Loma Country Club, San Luis Potosí
Architect: Lucio Muniain et al
Lead architects: Lucio Muniain (principal), Juan Carlos García (project manager), Michel Hernández, Gustavo Morales
Area: 800 m² (8,600 ft²)
Completed: 2023

ZONCUANTLA APARTMENTS (p. 110)
Location: Xalapa, Coatepec, Veracruz
Lead architect: Rafael Pardo
Architect: Rafael Pardo Arquitectos
Area: 470 m² (5,060 ft²)
Completed: 2020

THE HILL IN FRONT OF THE GLEN (p. 122)
Location: Morelia, Michoacán
Architect: HW Studio
Lead architect: Roger Bores
Area: 250 m² (2,690 ft²)
Completed: 2021

CASA 720 (p. 130)
Location: La Reserva Peñitas, Valle de Bravo, Estado de Mexico
Architect: Fernanda Canales Arquitectura
Lead architects: Aarón Jassiel, Alberto García Valladares, Ángela Vizcarra
Area: 1,000 m² (10,800 ft²)
Completed: 2023

CASA ALFÉREZ (p. 140)
Location: Cañada de Alferes, Estada de Mexico
Architect: Ludwig Godefroy
Lead architect: Ludwig Godefroy
Area: 150 m² (1,610 ft²)
Completed: 2021

CASA NARIGUA (p. 150)
Location: El Jonuco, Monterrey, Nuevo León
Architect: P+0 Arquitectura
Lead architect: David Pedroza Castañeda
Area: 750 m² (8,000 ft²)
Completed: 2014

CASA NAILA (p. 164)
Location: El Puertecito, Puerto Escondido, Oaxaca
Architect: BAAQ'
Lead architects: José Alfonso Quiñones,
Inca Hernández, Itzae Carrasco,
Ainhoa Jiménez, Alfonso Sodi, Liliana Tamayo
Area: 250 m² (2,690 ft²)
Completed: 2019

CASA CATARINA (p. 174)
Location: Valle de Bravo, Estado de Mexico
Architect: Héctor Barroso
Lead architects: Alan Rojas, Alonso López,
Paloma Sánchez, Paulina Robledo
Landscape: Hugo Sánchez Paisaje
Interior design: Habitación 116
Area: 900 m² (9,700 ft²)
Completed: 2022

CASA COMETA (p. 184)
Location: Mazunte, Oaxaca
Architect: Taller de Arquitectura Mauricio
Rocha + Gabriela Carrillo
Lead architects: Andres Berjon,
David Noble, Francisco Ortiz
Area: 700 m² (7,500 ft²)
Completed: 2019

CASA VOLTA (p. 196)
Location: Puerto Escondido, Oaxaca
Architect: Ambrosi Etchegaray
Lead architects: Jorge Ambrosi, Gabriela
Etchegaray, Ivo Martins, Santiago Bonilla
Area: 120 m² (1,290 ft²)
Completed: 2018

PUNTA PAJAROS (p. 206)
Location: Puerto Escondido, Oaxaca
Architect: Alberto Kalach / T.A.X.
Lead architects: Iván Ramírez,
Juan Pablo de la Rosa, Ainhoa Jiménez,
Aldair Melo, María Riveroll
Area: 3,000 m² (32,300 ft²)
Completed: 2017–2024 (the master plan)

CASA CARRIZO (p. 212)
Location: Agua Blanca, Puerto Escondido, Oaxaca
Architect: BAAQ'
Lead architects: José Alfonso Quiñones,
Itzae Carrasco, Mario Conde, Christian Godoy
Area: 160 m² (1,722 ft²)
Completed: 2019

SAN BRUNO BEACH HOUSE (p. 222)
Location: Yucatán
Architect: Reyes Ríos + Larraín Arquitectos
Lead architects: Salvador Reyes, Josefina Larraín
Area: 700 m² (7,500 ft²)
Completed: 2024

CASA LERIA (p. 232)
Location: Puerto Escondido, Oaxaca
Architect: TAC (Taller Alberto Calleja)
Lead architects: Alberto Calleja,
Jorge Herrero, Pedro Pesqueira
Area: 1,100 m² (11,800 ft²)
Completed: 2022

CASA KEM (p. 244)
Location: Mérida, Yucatán
Architect: Gantous Arquitectos
Lead architects: Christian Gantous,
Claudio Gantous
Area: 1,000 m² (10,760 ft²)
Completed: 2020

CASA MULA DE SEISES (p. 256)
Location: Valle de Bravo, Estado de Mexico
Architect: Gantous Arquitectos
Lead architects: Christian Gantous,
Claudio Gantous
Area: 750 m² (8,050 ft²)
Completed: 2020

CASA SHI (p. 266)
Location: Morelia, Michoacán
Architect: HW Studio
Lead architect: Roger Bores
Area: 440 m² (4,740 ft²)
Completed: 2023

CASA DECO (p. 278)
Location: Mérida, Yucatán
Architect: Reyes Ríos + Larraín Arquitectos
+ Proyecto Inefable
Lead architects: Salvador Reyes,
Josefina Larraín, Alejandra Hochstrasser
Area: 610 m² (6,565 ft²)
Completed: 2019

CASA MO (p. 288)
Location: Lomas de Chapultepec, Mexico City
Architect: Lucio Muniain et al
Lead architects: Lucio Muniain (principal),
Marielle Rivero, Jorge Arrollo
Area: 520 m² (5,600 ft²)
Completed: 2010

DIRECTORY

ALBERTO KALACH / T.A.X. (p. 206)
Av Constituyentes 41,
San Miguel Chapultepec I Secc,
Miguel Hidalgo, 11850 Hidalgo, CDMX
kalach.com
@kalach_tax

AMBROSI ETCHEGARAY (p. 196)
C. Popocatépetl 11, Hipódromo,
Cuauhtémoc, 06100 CDMX
ambrosietchegaray.com
@ambrosietchegaray

ARANZA DE ARIÑO (p. 090)
@aranzadearino

BAAQ' (p. 164, 212)
Cuernavaca 140, Colonia Condesa,
Cuauhtémoc, 06170 CDMX
baaqarquitectura.com
@baaqtp

FERNANDA CANALES ARQUITECTURA (p. 076, 130)
fernandacanales.com
@fernandacanales_arquitectura

FUNDACIÓN JAVIER MARÍN (p. 036)
C. Orizaba 190, Roma Nte.,
Cuauhtémoc, 06700 CDMX
fundacionjaviermarin.mx
@fundacionjaviermarin

GANTOUS ARQUITECTOS (p. 244, 256)
Calle 2 2, Reforma Soc,
Miguel Hidalgo, 11650 CDMX
gantousarquitectos.com
@gantous.arquitectos

HÉCTOR BARROSO (p. 174)
Calle Parral 23 A, Colonia Condesa,
Cuauhtémoc, 06140 CDMX
tallerhectorbarroso.com
@tallerhectorbarroso

HW STUDIO (p. 122, 266)
Enrique González Martínez No. 82-J,
Col. Santa María de Guido,
58090, Morelia, Michoacán
hw-studio.com
@hwstudioarq

LUCIO MUNIAIN ET AL (p. 100, 288)
Marsella 53, Second Floor,
Colonia Juárez, 06600 CDMX
lmetal.com.mx
@luciomuniain

LUDWIG GODEFROY (p. 068, 140)
Mexico City
ludwiggodefroy.com
@ludwiggodefroy

MANUEL CERVANTES ESTUDIO (p. 058)
Paseo de las Palmas 820 5°,
Piso Col. Lomas de Chapultepec,
11000 CDMX
manuelcervantes.com.mx
@manuelcervantes

P+0 ARQUITECTURA (p. 150)
Calzada del Valle 510 pte. Local 306,
San Pedro Garza García, Nuevo León, 66220
pmascero.com
@pmascero

PEDRO REYES, CARLA FERNÁNDEZ (p. 046)
pedroreyes.net
carlafernandez.com
@_pedro_reyes_
@carlafernandezmx

RAFAEL PARDO ARQUITECTOS (p. 110)
Juan Soto Street #9, 91000 Xalapa, Veracruz
@arq.rafaelpardo

REYES RÍOS + LARRAÍN ARQUITECTOS (p. 222, 278)
Calle 49 510c Colonia Centro,
97000 Mérida, Yucatán
reyesrioslarrain.com
@reyesrios_larrain

TAC (TALLER ALBERTO CALLEJA) (p. 232)
talleralbertocalleja.com
@taller_alberto_calleja

TADAO ANDO ARCHITECT & ASSOCIATES (p. 024)
5-23 Toyosaki 2 Chome Kita-ku 531-0072 Osaka,
Japan
tadao-ando.com

TALLER DE ARQUITECTURA MAURICIO ROCHA + GABRIELA CARRILLO (p. 184)
Av. Miguel Ángel de Quevedo 95, Chimalistac,
Álvaro Obregón, 01070 CDMX
tallerdearquitectura.com.mx
@maurocha
@taller_mauricio_rocha

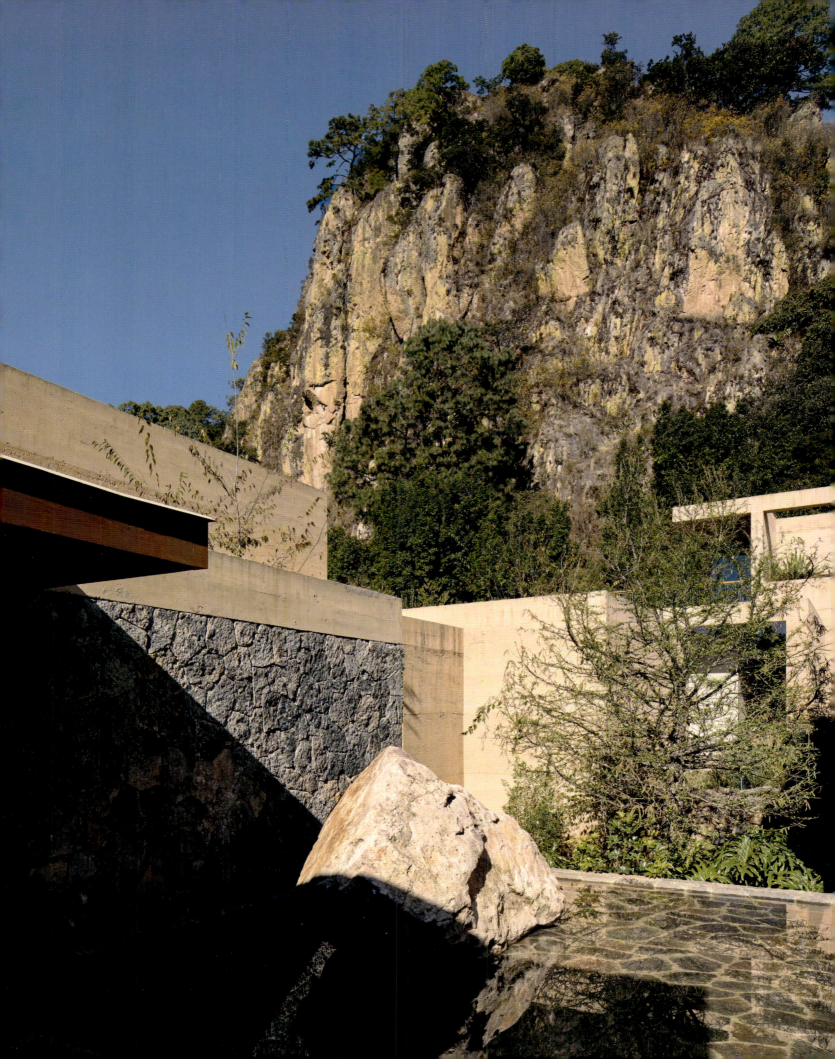

On the cover: *Front* BAAQ', Casa Carrizo, Agua Blanca (photo: Edmund Sumner); *Back (L-R)* Aranza de Ariño, Casa Tiny, Puerto Escondido; BAAQ', Casa Naila, El Puertecito; Fernanda Canales Arquitectura, Casa 720, Valle de Bravo; Ambrosi Etchegaray, Casa Volta, Puerto Escondido (photo: Edmund Sumner)

First published in the United Kingdom in 2025 by Thames & Hudson Ltd, 181A High Holborn, London WC1V 7QX

First published in the United States of America in 2025 by Thames & Hudson Inc., 500 Fifth Avenue, New York, New York 10110

Casa Mexicana © 2025 Thames & Hudson Ltd, London

Prologue © 2025 Fernanda Canales
Text by Jonathan Bell © 2025 Titled as Found Ltd
Photographs © 2025 Edmund Sumner

All plans and drawings supplied by the architects.

Designed by Tim George

All Rights Reserved. No part of this publication may be reproduced or transmitted in any form or by any means, electronic or mechanical, including photocopy, recording or any other information storage and retrieval system, without prior permission in writing from the publisher.

British Library Cataloguing-in-Publication Data
A catalogue record for this book is available from the British Library

Library of Congress Control Number 2024936843

ISBN 978-0-500-027974

Impression 01

Printed and bound in China by Toppan Leefung Printing Limited

Be the first to know about our new releases, exclusive content and author events by visiting
thamesandhudson.com
thamesandhudsonusa.com
thamesandhudson.com.au

With many thanks to Edmund for bringing me onto this project and trusting me to accompany his amazing images. My thanks to all the architects and designers for their help and co-operation, and to the team at Thames & Hudson. For Alex, Toby and Pippa.
Jonathan Bell

This publication is a tribute to the talent – both established and emerging – that I have encountered since my first travels to Mexico in the early 2000s. These pages are a culmination of over a decade of exploration, a journey through the geographic, ecological and cultural richness of Mexico. The architecture featured here is not merely a feat of engineering; it is also an expression of spirit, imagination and the cultural poetics of modern-day Mexico. As Mexico continues to evolve, its future will be shaped by the architects, designers and artisans who infuse their creations with innovation, ingenuity and a profound respect for the country's rich cultural heritage. This book is a celebration of that vision.
Edmund Sumner

Jonathan Bell is a freelance writer and an editor at *Wallpaper** magazine. He is also the author and editor of nine books, including *Carchitecture*, *The 21st Century House*, *Penthouse Living* and *The Modern House*.

Edmund Sumner is a London-based architectural photographer who has collaborated with leading architects, publishers, government departments and curators worldwide since 1988. He has also acted as a creative consultant for design festivals and exhibitions such as the Sharjah Architecture Triennial and Arab Design Now. Sumner has worked on several publications including *Contemporary House India* (2021), which he photographed for Thames & Hudson. Notable clients include Tadao Ando, Foster + Partners, Fernanda Canales and Gianni Botsford.